ultimate art bible

A Complete Reference with Step-by-Step Techniques

**Consultant Editor
Sarah Hoggett**

COLLINS & BROWN

First published in the United Kingdom in 2013 by
Collins & Brown
10 Southcombe Street
London
W14 0RA

An imprint of Anova Books Company Ltd

Copyright © Collins & Brown 2013

Distributed in the United States and Canada by
Sterling Publishing Co, 387 Park Avenue South, New York, NY 10016, USA.

ISBN 978-1-90844-901-6

A CIP catalogue for this book is available from the British Library.

10 9 8 7 6 5 4 3 2 1

Repro by Rival Colour Ltd, UK
Printed by Craft Print, Singapore

This book can be ordered direct from the publisher at
www.anovabooks.com

contents

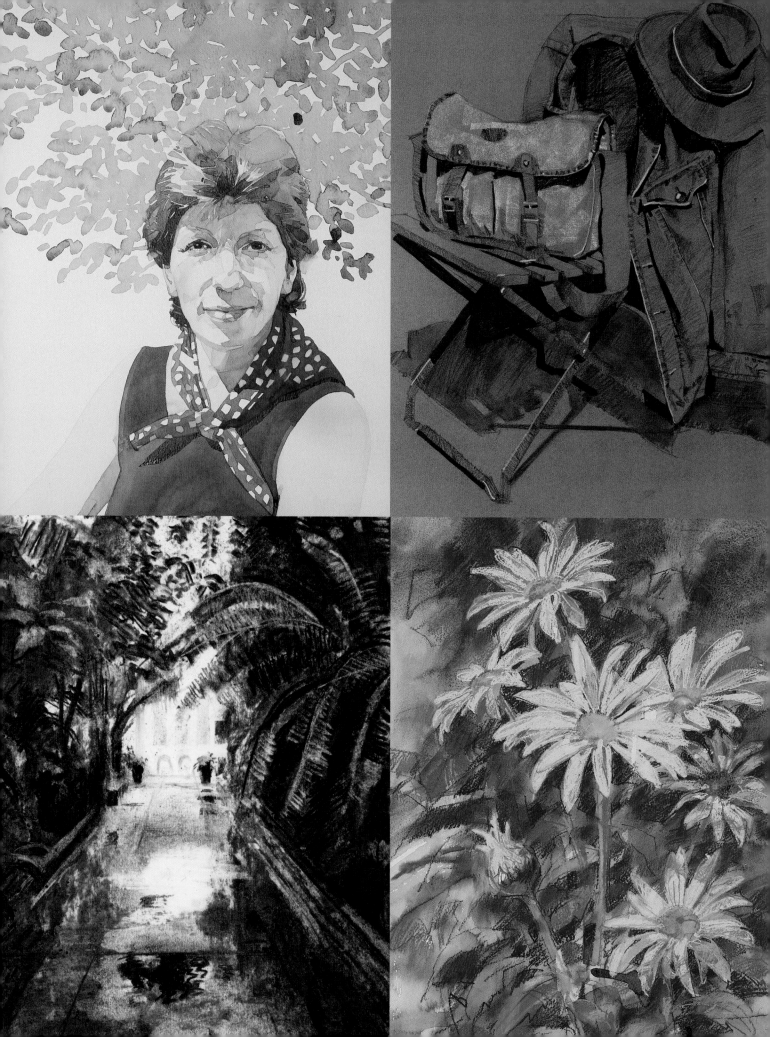

about this book

In this electronic age of computer games and Internet downloads, it's comforting to know that more and more people are discovering the joys of creating their own works of art – but if you have never had a chance to take art classes, or were made to feel that you were 'no good' at art when you were at school, picking up a stick of charcoal or a paintbrush for the first time can seem like a very daunting prospect.

The *Ultimate Art Bible* takes the mystique out of drawing and painting by setting out everything you need to know in a clear, easy-to-follow fashion. It begins with a chapter on Tools and Materials, which provides an introduction to all the major drawing and painting media along with information on different types of support and other pieces of equipment that you may find useful.

Getting Started explains the concepts that you will need to master whatever medium you choose to work in. This chapter covers observational skills, training yourself to translate colour into tone, and the basic principles of perspective, colour theory and composition. It will give you a really solid foundation as an artist, so it's important to work through this section, even if you decide to ignore one or other of the medium-specific chapters that follow.

The next three chapters – Drawing, Watercolour, and Oils and Acrylics demonstrate the essential techniques for each medium through a series of simple exercises that you can easily replicate at home, so that you can gradually build up your skills and confidence. If you're a complete beginner, work through them step by step; if you have some experience already, use them as a refresher course to dip into as and when you feel you need to.

Combining different media in the same work opens up all kinds of artistic possibilities, so in the Mixed Media chapter you will find a range of ideas that you can build on in your own work.

Finally, the last three chapters are based around the three most popular subject areas for leisure artists – still lifes, landscapes and portraits. Here you will find useful technical information relating specifically to that subject, as well as longer projects that you can either copy exactly or adapt to your own circumstances.

Some people seem to assume being able to draw and paint is a talent that just comes naturally – you either have it or you haven't. The reality is that everyone can learn to draw and paint: all it takes is the willingness to learn and practise. With the *Ultimate Art Bible*, you will soon be creating works of art that you will be proud to hang on your wall.

materials

If you're new to drawing and painting, going into a good art store can be a bewildering experience: there is so much choice available that it's hard to know where to start. This chapter looks at all the main media and types of art equipment, so that you can make an informed decision about what you really need to buy.

drawing media

Walk into any art store and you will be confronted by a bewildering array of drawing media, each with its own characteristics. Only by experimenting with different drawing tools will you find out what each can do.

Charcoal

Charcoal is made from burnt vine, willow or beech twigs, each of which makes a slightly different-coloured mark: willow and beech charcoal have a slight blue cast, whereas vine charcoal has a blue-black one.

Charcoal is available as natural sticks, compressed sticks and in pencil form. It can create a surprisingly wide range of marks, from fine detail and delicate tones to areas of dense tone.

Natural sticks are soft, and give a lovely flowing line. Graded as hard, medium and soft, sticks are available in varying thicknesses in lengths up to 15 cm (6 in.).

Compressed charcoal is made from charcoal powder mixed with gum binder, compressed into round or square sticks; the amount of binder determines the hardness of the stick. It is stronger than natural charcoal and less prone to shattering. Compressed charcoal is also used in charcoal pencils. Compressed and pencil charcoal produce a more controlled line than natural sticks, which is useful for detailed work or hatching. They leave a slightly more permanent mark than natural charcoal and are marginally more difficult to erase.

Lead pencils

Although they are traditionally known by the term 'lead', these pencils are, in fact, made from graphite. Pencils are graded according to hardness. The scale runs from 9H, the hardest, to 9B, the softest. Pencils in the H series make fine, hard grey marks, whereas B pencils made a rich, dark line: think of H for hardness and B for blackness. H, HB and B are the middle grades and are good all-round drawing pencils.

Each grade of pencil is only capable of achieving a certain depth of tone, and no amount of pressure will make the tone any darker. If you want to create a darker tone, you will have to switch to a softer grade of pencil.

The graphite strip is encased in wood; with most pencils, this tends to be cedar. The wooden casing may be either round or

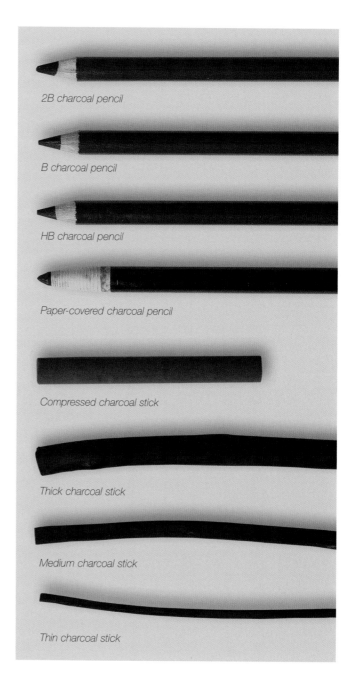

2B charcoal pencil

B charcoal pencil

HB charcoal pencil

Paper-covered charcoal pencil

Compressed charcoal stick

Thick charcoal stick

Medium charcoal stick

Thin charcoal stick

hexagonal in shape. Round pencils are easy to rotate between the fingers, thereby making fluid strokes easy to apply. Hexagonal pencils are easier to hold and offer a more stable grip. Wooden pencils are best sharpened with a knife, which enables the point to be fashioned into a number of shapes.

Coloured pencils

Coloured pencils are made in the same way as graphite pencils, with a coloured pigment taking the place of the graphite. A number of major manufacturers make artist's quality coloured pencils and most brands are available in over 100 colours. As you cannot mix colours to create new colours and shades (unlike paints and pastels), most artists who work in coloured pencil have an extensive collection.

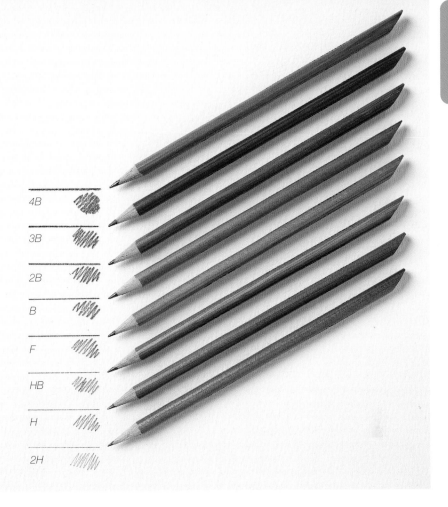

4B
3B
2B
B
F
HB
H
2H

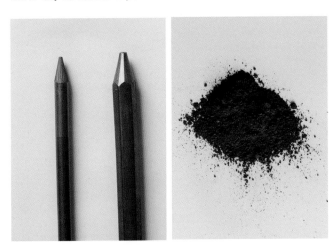

Coloured pencils are available in many different shades, but they do not come in the same range of hardnesses as graphite pencils.

Graphite

Graphite sticks are made using the same materials as conventional pencils; the difference is that they are thick, solid strips of graphite without a wooden case. They are usually given a plastic or painted coating to keep the hands clean; this coating is removed as the stick is sharpened. Sticks are graded in the same way as traditional pencils for relative softness.

Graphite stick, Graphite pencil, Graphite powder

Pastels and chalk

The words 'chalk', 'pastel' and 'crayon' are often confused. Chalks are made from natural materials – iron oxide (red), chalk or gypsum (white) and carbon (black). Pastels are made by mixing pigment powder with an extending agent such as French chalk; they are held together with a weak binding substance made from gum tragacanth. The more binding substance added, the harder the pastel.

Soft pastels are usually round and wrapped in paper to help prevent them from crumbling. Hard pastels are invariably square in profile. Pastel pencils are encased in wood and are useful for line work and details. You will also come across Conté crayons and pencils (named after the original French manufacturer), in which pigment is mixed with wax or clay; they are similar to hard pastels in that they can be sharpened to create fine, precise lines and details.

Soft pastels cover the paper quickly and can be smudged and blended in a similar way to charcoal. Large round pastels are good for laying broad areas of colour. Conté pencils and crayons are harder than soft pastels and capable of producing fine lines.

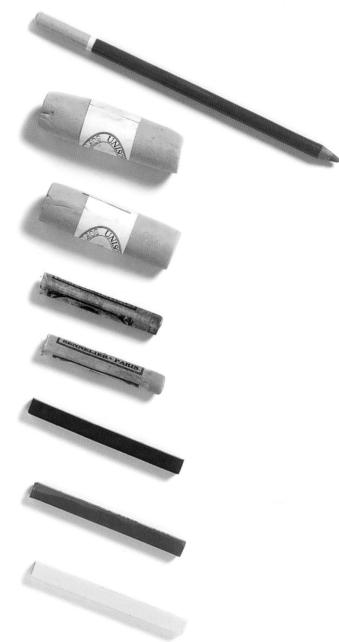

Conté pencil

Large round soft pastels

Soft pastels

Conté crayons

Storing pastels
Because they are so soft, pastels break very easily. Put them back in a box when you have finished using them.

Oil pastels

Do not be confused by the term 'pastel': oil pastels are completely different to soft and hard pastels and should not be mixed with them. Because they are quite fat and chunky, oil pastels lend themselves to broad marks and thick strokes and are wonderful for large-scale work; however, they are not really suitable for detailed work. If used on canvas or oil-painting paper, the marks can be blended using a rag or brush dipped in white spirit or turpentine, or even by dipping your finger in water and smoothing the marks out. You can also blend the colours optically by using techniques such as hatching.

Oil pastels are covered in a paper wrapper, which helps keep the pastel intact and your hands clean when you are working. Simply tear away the wrapper as the pastel wears down.

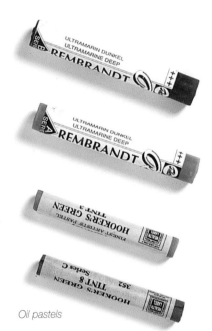

Oil pastels

Pen and ink

Many drawing tools use ink in some form, ranging from traditional drawing instruments such as quill and reed pens to modern inventions such as ballpoint and fibre-tipped pens. Each has its own characteristics. Choose between those that have an ink reservoir and those that require a separate ink supply. The former are simpler to use, especially on location, but the flowing lines of 'dip' pens are very appealing.

Working in ink requires a little planning and a sure hand; indecisive and tentative work is easily spotted. Both waterproof and non-waterproof inks can be diluted with water, and non-waterproof inks remain soluble when dry, which makes it easier to correct small mistakes. With waterproof ink, mistakes are often best ignored or incorporated into the finished work.

Indian ink is waterproof when dry and has a gloss finish. Dilute it with water to create different tones. Lines drawn in waterproof ink will not bleed when a wash is laid over them. Coloured inks can fade with time if the work is subjected to strong light.

Indian ink, Coloured inks

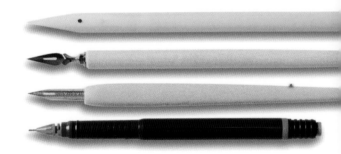

Bamboo pen, Medium steel nib, Fine steel nib, Technical pen

watercolour and gouache

Watercolour and gouache are water-soluble paints that can be used to create a range of effects; they share many of the same techniques. The main difference between them is that watercolour is transparent while gouache is opaque.

Types of watercolour paint

Watercolour paint is available in the form of semi-moist pans, half pans and tubes. Pans are easier to use when working on smaller-scale works; it is all too easy to squeeze too much paint out of a tube. Tube colour is better if you are working on large paintings that require greater quantities of paint, as it is easier to mix a bigger wash. They dry out easily, so only buy large tubes of colours that you use a lot. It is possible to use small amounts from tubes, but you are more likely to waste paint this way.

Watercolour paint is sold in two standards: one for students and one for artists. The quality aimed at artists tends to be stronger, mixes easily and merits the additional cost.

You can also buy liquid concentrated watercolour in bottles with dropper caps. The range of brilliant colours is, however, of limited use. Originally intended for use by illustrators, they are made using dyes, not pigments, and are therefore not permanent. You can squeeze a few drops into water to dilute them for painting washes or use them direct from the bottle, without adding any water.

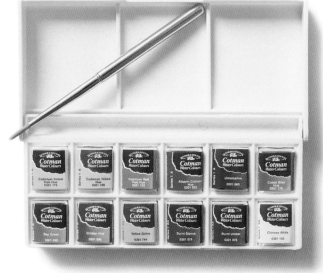

Basic watercolours
Watercolours are available in basic sets, covering a range of colours, or as individual pans, tubes and bottles.

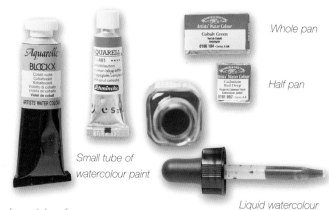

Whole pan

Half pan

Small tube of watercolour paint

Liquid watercolour

Large tube of watercolour paint

Watercolour pencils and crayons

Water-soluble pencils combine the precision of a pencil with the soft edges and washes of watercolour. On a damp surface or with a moist tip, they create blurred effects and subtle gradations of colour and tone.

Water-soluble crayons can be used in the same way as water-soluble pencils, but they are less precise.

Water-soluble pencils

Water-soluble crayons

Gouache

Gouache, also called 'body colour' or 'poster colour', is an opaque form of watercolour. It is available in tubes and jars. Pure gouache creates colours that are strong and defined, with a chalky bloom. Its particular appeal is its intensity of colour. Gouache can be laid as flat, gradated or variegated washes, similar to watercolour. It can also be applied as semi-transparent scumbles or straight from the tube with a brush or a knife for impasto effects.

Because gouache is opaque, you can paint a light colour over a dark one, completely obliterating it if necessary, so you can add any highlights at the end of a project or overpaint and correct any mistakes. This also means that, unlike watercolour, you can paint on dark paper.

The most popular gouache is Chinese white, which is listed and sold as a watercolour even though it is opaque. You can dilute Chinese white gouache to a milky consistency for pale washes over darker colours, or you can mix it with watercolours to create opaque, creamy colours. Watercolourists also use Chinese white to paint highlights or white areas on top of watercolours that have already been laid down. It dries to a chalky and flaky finish, in contrast to the flat translucency of watercolours.

Tube of gouache paint *Chinese white gouache*

Jar of poster paint

Palettes for watercolour and gouache

Many watercolour boxes have built-in palettes for mixing, but these provide very little space. Although you can mix watercolours on the surface of the paper, artists usually mix paint on a separate palette. There are many varieties, available in ceramic, plastic and enamelled metal. You will need one with a deep well to mix a sufficient wash to cover a large area. A round china dish with a lid enables you to cover and store paint, and it will keep the paint wet for longer than if it were exposed. A partitioned china palette is perfect for colour mixing. You can also improvise by mixing your colours on a china plate or saucer – but use a white plate, as coloured china will make it harder for you to judge your mixes accurately.

As both watercolour and gouache are water soluble, palettes can be easily cleaned by washing them in the sink.

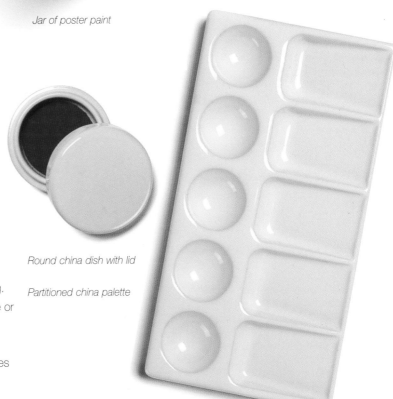

Round china dish with lid

Partitioned china palette

oil paints

Oil paint is favoured by artists for its richness, intensity and versatility. You can use it on location for small, quick sketches or in the studio for more considered, planned works developed over days, months or years.

Paints and thinners

Oil paint is sold in tubes from 21 ml (0.7 fl. oz) to 120 ml (4 fl. oz) in 'artist's' and 'student's' colours. Tins of paint are also available for large-scale work. Alkyd oil paints are fast-drying oils that can be used alone or mixed with ordinary oil paints.

Oil paint is incredibly versatile. When used in a traditional way, building up careful layers of glazes or scumbles, it produces a smooth, jewel-like surface in which the mark of the brush is virtually absent. However, it can also be applied thickly (impasto), retaining the mark of the brush, knife or even your fingers.

A thinner, or diluent, is added to oil paint to thin it so that it can be mixed and is easy to apply. Turpentine is the traditional thinner for oil paint. Use rectified or double-distilled turpentine and store it in sealed metal cans or dark glass bottles, as it thickens and discolours when exposed to the light. Other thinners include white spirit, which has a weaker odour than turpentine, dries more quickly, and is ideal for cleaning brushes and palettes. Low-odour thinners are modern alternatives to turpentine. They do not deteriorate and are less flammable.

Use more thinner in the first stages of your work and add more oil in the later stages.

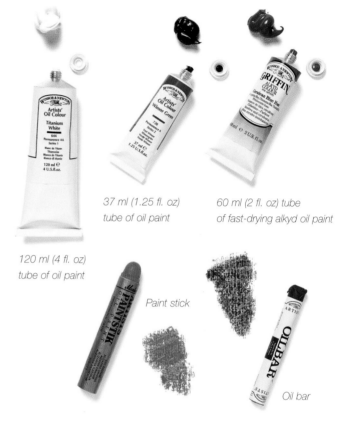

37 ml (1.25 fl. oz) tube of oil paint

60 ml (2 fl. oz) tube of fast-drying alkyd oil paint

120 ml (4 fl. oz) tube of oil paint

Paint stick

Oil bar

Palettes

Traditionally, an oil palette is made of wood (usually mahogany) and is kidney-shaped with a thumbhole so that you can support it on one arm as you stand before the canvas. A white plastic palette makes a good mixing surface; tear-off disposable paper palettes are a clean and convenient alternative. Choose a large palette: your mixes may become contaminated and muddy on a small palette.

Metal 'dippers', which clip onto the edge of the palette, are designed to hold the thinner and the medium. Dippers with lids are ideal for working on location.

White plastic palette

Single dipper

Double dipper with lids

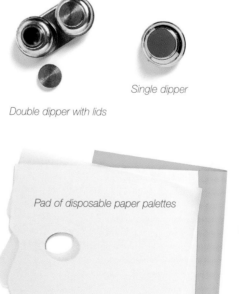

Pad of disposable paper palettes

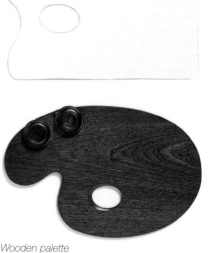

Wooden palette

Mediums and additives

These products can be added to oil paint. They affect the paint's consistency and texture, how it holds the mark of the brush and the speed at which it dries.

Bleached linseed oil

Linseed oil is the most popular drying oil used with oil paint. This pale version dries slightly faster than refined linseed oil. It is particularly useful with pale colours, which might be muddied by using darker oils.

Cold-pressed linseed oil

The best-quality linseed oil, used to produce a paint film that is flexible and less likely to crack. It is also used to bind pigments to make paint.

Sun-thickened linseed oil

This slightly thicker version of bleached oil is sometimes known as 'fat oil'. It has a honey-like consistency and is used to improve the flow and handling of oil paint. It is transparent and fast drying, producing an enamel-like, gloss finish.

Poppy oil

A pale, slow-drying oil with a buttery consistency, poppy oil is used as a binding and painting medium for light-coloured pigments. It is used for impasto as it holds the mark of the brush.

Liquin

Alkyd mediums are quick drying and suit both oil and alkyd paints. Liquin improves the flow and transparency of paint and is used for thinning paint, glazing and creating a glossy finish.

Oleopasto

A gel-like, quick-drying alkyd impasto medium, oleopasto is good for knife painting and other impasto techniques. It dries to a matt sheen.

Win-Gel

A honey-coloured, quick-drying alkyd medium. Mix with paint and leave for a short while before use for moderate impasto effects. If worked with the knife, it can create smooth brushwork and transparent glazes.

Varnish

Varnishes are made from resin dissolved in a spirit such as turpentine or an oil. They are sometimes applied to a finished painting to give a glossy, protective finish.

acrylics

Acrylic paint is an ideal medium for beginners, and has characteristics that are similar to both oil and watercolour paints. However, it is different from both in many respects and should not be thought of as a substitute for either.

Paints

Acrylic paint is made by suspending pigment particles in an acrylic resin. When the paint is mixed with water and applied to the paper, the water evaporates, leaving the resin to hold the pigment permanently in place. Although acrylic paint can be thinned with water, it becomes completely insoluble when dry, which happens within 15 to 20 minutes. This rapid drying time can be an advantage or a hindrance, depending on which technique you happen to be using.

The paint, which can be used thin in transparent washes or thick and opaque, is available in tubes, jars and pots. Tube colour is of a toothpaste-like consistency, while the pot colour is slightly thinner to facilitate brushing out and covering large areas. Liquid acrylic is sold in small bottles and used for semi-transparent wash work, in a similar way to watercolour.

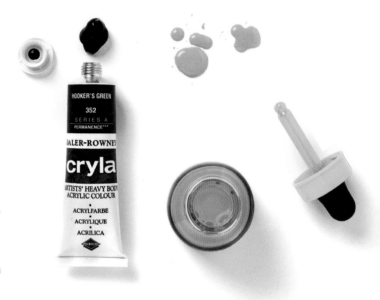

Small tube of heavy-bodied acrylic paint

Liquid acrylic with a dropper cap

Lightening acrylic colours

One way to lighten acrylics is to add water: the more water you add, the more transparent the colour becomes (as with watercolour paints). Alternatively, you can add white paint, which maintains the opacity (thickness) of the paint; this is known as 'tinting'. Tinting is not always the best solution, however, as adding white changes the colour; if you mix red with white, for example, you will end up with pink rather than a lighter red. The colour may also look rather chalky. If you're new to acrylics, try both methods on scrap paper, so that you get used to how the paint behaves.

Large jar of acrylic paint

Palettes

The quick-drying, insoluble nature of acrylic paint means that only palettes with an impermeable surface should be used. These can easily be washed, as paint only dries to create a film on the palette surface. Glass, plastic, ceramic and melamine are all good choices, as are disposable palettes with tear-off paper sheets. Paint can be made to stay workable for longer by using a stay-wet palette, in which paint is laid out and mixed on a replaceable sheet of semi-permeable paper that absorbs moisture from a reservoir beneath, preventing the paint from drying out. Alternatively, spray your palette with water and cover it with plastic food wrap at the end of each painting session.

Plastic palettes

Stay-wet palette

Cleaning your palette

If your palette does become encrusted with paint, soak it in hot water until the paint peels off.

Acrylic mediums

The handling qualities of acrylic paint can be altered by using mediums or additives. These are added to the paint as it is used, and are soluble in water when wet but insoluble once dry.

Matt medium, as the name suggests, imparts a matt finish to the dry paint, while gloss medium imparts a glossy finish. They can be mixed together, giving varying degrees of gloss.

Gel mediums, available in either gloss or matt finish, thicken and extend the paint. Flow mediums, on the other hand, reduce the water tension and improve the capacity of the paint for brushing out. Retarding medium slows the drying time. Texture gels and pastes resembling various materials, including sand, stucco and blended fibres, can also be added.

Acrylic paintings can be protected with matt or gloss varnish.

Acrylic gloss medium

Acrylic flow enhancer

Acrylic matt medium

supports

The surface on which a picture is made is sometimes called the support. Many kinds of paper and canvas are available and choosing which type to use for the job in hand is part of the process of drawing and painting.

Papers for drawing

Different media suit different drawing surfaces.

Pastels require a surface that has sufficient 'tooth' or texture to shave off the pigment from the pastel and hold it in place. Just as important as texture is colour: on white paper, colours look pale and lack crispness. More effective are the toned and tinted papers made especially for pastel work.

Charcoal, like pastels, works best on papers that are not too smooth. Graphite produces better results on smooth white paper, such as cartridge paper or hot-pressed watercolour paper. Ink drawings made using a dip pen require a smooth paper to enable the nib to move smoothly over its surface.

Brown pastel paper
Green pastel paper
Grey pastel paper
Cream drawing paper
Fine board
Heavy cartridge paper
Light cartridge paper

Papers for watercolour

Watercolour papers are available in different weights from light (190 gsm/90 lb) through to heavy (640 gsm/300 lb). There are three types of watercolour paper surface: hot-pressed (HP), cold-pressed (CP) or NOT (not hot-pressed), and rough. Hot-pressed papers are smooth with very little texture. They are often more heavily sized than other papers, which can cause washes to be repelled by the paper and settle in puddles. Rough papers have a pitted surface; they accept paint well and are usually capable of withstanding rough work and techniques such as scratching into the paper surface. Cold-pressed papers fall between rough and hot-pressed and have a reasonable degree of texture.

Watercolour paper is usually white, but tinted papers are also available (although they are sometimes frowned upon by watercolour purists). Tinted papers can be useful as a way of establishing an overall colour key; alternatively, lay a flat wash (see page 114) over the whole paper.

300-gsm (140-lb) HP paper has a smooth surface and the paint is absorbed slowly.

640-gsm (300-lb) CP paper is semi-rough. The texture of the surface gives the paint mark and uneven quality.

640-gsm (300-lb) rough paper has a pitted surface. The paint is absorbed quickly but unevenly, leaving a textured finish.

Papers for gouache

Due to its covering power, gouache can be used on dark tinted paper. Choose a medium tone that relates to your subject or a colour that provides a complementary contrast or a temperature contrast.

Forest green *Dark blue* *Mid-blue*

Stretching paper

Lightweight papers need to be stretched before use, otherwise they are likely to buckle when water is applied to them. Any paper over 300 gsm (140 lb) in weight should not need to be stretched. You will need a roll of gummed paper tape, a board, a tray of water and a sponge.

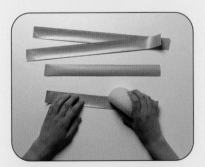

1 Cut the paper to size and lay it on a wooden board that will not warp. Leave a margin around the edge for the paper tape.

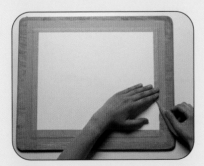

2 Cut four lengths of tape, one for each side of the paper. The strips should be a little longer than the paper.

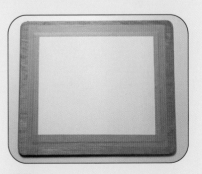

3 Lay the paper in a tray of clean water. Make sure that it is evenly wet, but not soaked. Lift it out and drain off excess water.

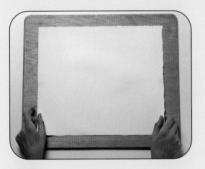

4 Lay the tape on a separate surface. Dip a clean sponge in water and moisten the adhesive side of the tape strips.

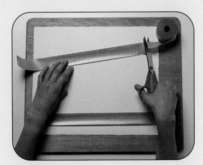

5 Lay the wet paper flat on the board, smoothing out any bubbles with a damp sponge. Tape the paper to the board, starting with one of the long sides. Make sure the tape strip is attached to both the paper and the board.

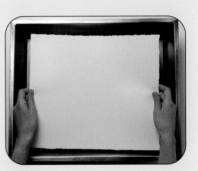

6 Lay the board flat and allow to dry, ideally overnight. Any wrinkles in the paper will flatten out as it dries.

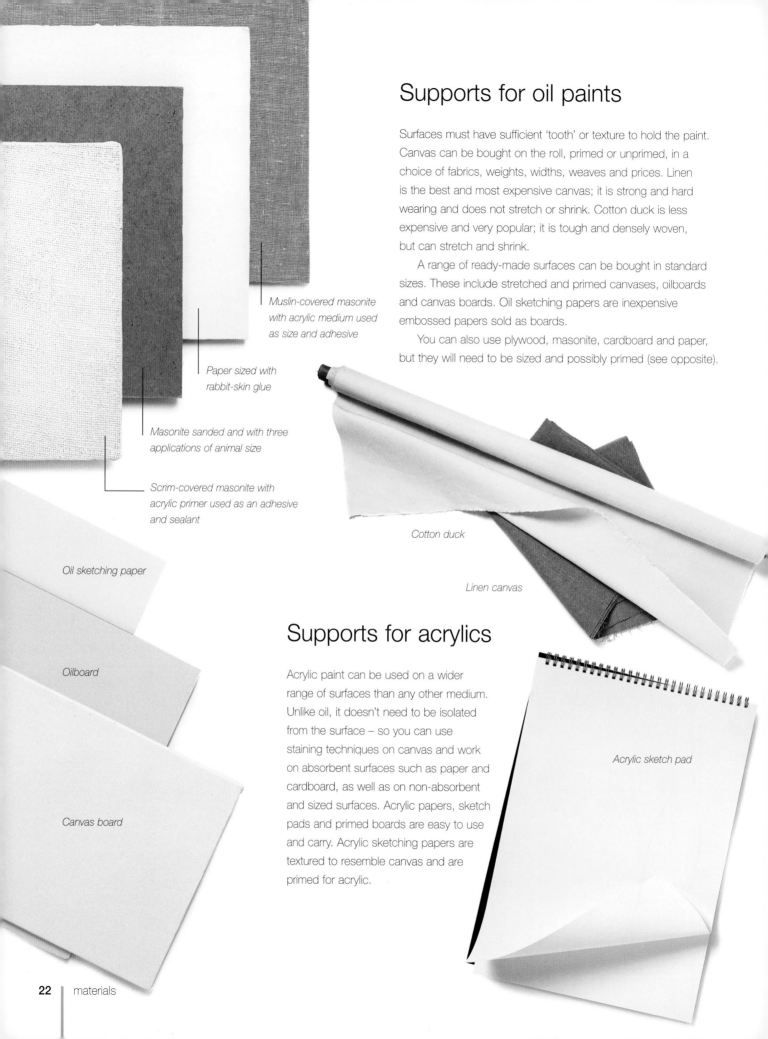

Supports for oil paints

Surfaces must have sufficient 'tooth' or texture to hold the paint. Canvas can be bought on the roll, primed or unprimed, in a choice of fabrics, weights, widths, weaves and prices. Linen is the best and most expensive canvas; it is strong and hard wearing and does not stretch or shrink. Cotton duck is less expensive and very popular; it is tough and densely woven, but can stretch and shrink.

A range of ready-made surfaces can be bought in standard sizes. These include stretched and primed canvases, oilboards and canvas boards. Oil sketching papers are inexpensive embossed papers sold as boards.

You can also use plywood, masonite, cardboard and paper, but they will need to be sized and possibly primed (see opposite).

Muslin-covered masonite with acrylic medium used as size and adhesive

Paper sized with rabbit-skin glue

Masonite sanded and with three applications of animal size

Scrim-covered masonite with acrylic primer used as an adhesive and sealant

Cotton duck

Linen canvas

Oil sketching paper

Oilboard

Canvas board

Supports for acrylics

Acrylic paint can be used on a wider range of surfaces than any other medium. Unlike oil, it doesn't need to be isolated from the surface – so you can use staining techniques on canvas and work on absorbent surfaces such as paper and cardboard, as well as on non-absorbent and sized surfaces. Acrylic papers, sketch pads and primed boards are easy to use and carry. Acrylic sketching papers are textured to resemble canvas and are primed for acrylic.

Acrylic sketch pad

Canvas is absorbent and must be sealed with size to separate the paint from the fabric. You can paint directly onto the sized canvas or apply a white ground (primer). An oil primer may take several months to dry; an acrylic primer will dry more quickly.

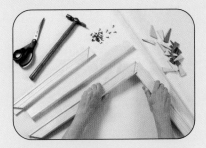

1 Fit the four stretcher pieces together and tap the corners gently for a firm fit.

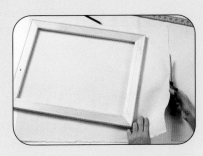

2 Lay the stretcher edges parallel to the canvas weave so that the canvas is square. Draw a cutting line, allowing a 5-cm (2-in.) overlap. Cut out.

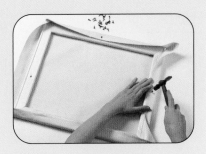

3 Fold the fabric over one stretcher and tack it in the centre, as shown. Repeat for all sides, making sure the canvas is taut.

4 Continue tacking from centre to corner, finishing with a flat fold.

5 Tap two wedges in each corner to increase canvas tension.

Sizing and priming canvas

1 Insert card between the canvas and the stretcher to prevent the stretcher bars from showing through.

2 Place a tub of size in warm water to melt, then brush it onto the fabric. Leave to dry.

3 Holding the brush vertically, work a small amount of primer into the weave. Hold the card against the back of the canvas and move it when you start the next section. Leave to dry.

brushes and painting knives

Most painting is done using brushes of varying shapes and fibres, but you can also use painting knives for impasto work in oils and acrylics. It's also well worth experimenting with sponges, rags, textiles and other materials to find out what kind of marks you can create.

Brushes for watercolour and gouache

Watercolour and gouache brushes can be made from synthetic polymer, nylon fibre or natural hair and bristle. The best brushes are made from hair taken from the tail of the sable. Whichever type of brush you choose, it should hold its shape and point. A good brush should also hold a decent quantity of paint and have a firm but pleasant spring to it when applied to the paper.

Brush shape is of equal importance and there are three main options to choose from. Round brushes are most often used, and a good one can make a wide variety of marks. Flat brushes are chisel shaped and are sometimes known as one-stroke brushes. Mop or wash brushes are used for covering large areas.

More specialized brushes include fan brushes, which are designed to be used for fine feathering and delicate blending, and rigger or lettering brushes, used for fine lines.

Most watercolourists rarely use the smallest brushes – those marked 000, 00 and 0 – although they can be useful for fine lines and minute details. As a rule of thumb, use the largest brush possible for the job. A good basic selection might include a no. 4 or no. 6 round brush for detail, a no. 10 or no. 12 round brush for blocking in washes over larger areas, a small flat brush and a medium-sized mop.

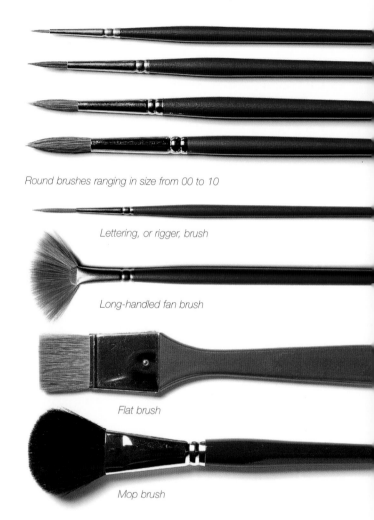

Round brushes ranging in size from 00 to 10

Lettering, or rigger, brush

Long-handled fan brush

Flat brush

Mop brush

Brushes for oil paints

Oil painting brushes are traditionally made from bristle from the back of a hog. They hold their shape well and can hold a substantial amount of paint. Synthetic brushes are less expensive, but also less hard wearing. Natural-hair brushes are also available, but because the bristles are soft it is not easy to move thick oil paint around on the canvas; they are perhaps best reserved for water-soluble paints.

As with watercolour and gouache brushes, oil brushes come in a range of shapes and sizes. Round brushes are good general-purpose brushes. Large flat brushes are good for blocking in large areas, while short flats (also known as 'brights')

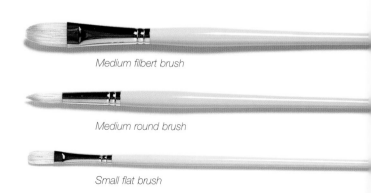

Medium filbert brush

Medium round brush

Small flat brush

make short strokes and are ideal for impasto work. Wash brushes are used for covering large areas with a flat, uniform wash of paint; flat wash brushes are generally more suited to oils and acrylics than the round wash brushes used for watercolour. A filbert brush (a narrow, flat brush with hairs that come to a rounded point) combines some of the qualities of a flat and a round brush. Used on its side, a filbert gives a thin line; used flat, it produces a broad brush stroke.

Brushes for acrylics

Acrylic paint can be applied with any brush or paint applicator; as painting in acrylics draws on techniques that are used in both watercolour and oil painting, it is best to have a selection of hard and soft brushes. However, you should avoid using sable watercolour brushes for work in acrylics, as these can easily be ruined. Several manufacturers market ranges made from synthetic fibre for use specifically with acrylic paint.

Knives

Two types of knife are used by oil and acrylic painters. Palette knives, which have broad, straight, flexible steel blades and wooden handles, are used for mixing paint, cleaning palettes and scraping paint off the canvas. Painting knives have offset handles and flexible steel blades and are available in a range of shapes.

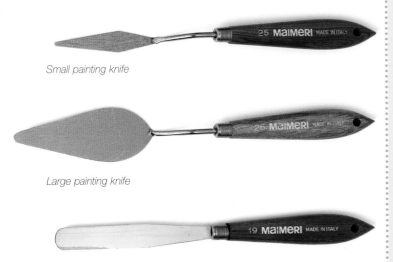

Small painting knife

Large painting knife

Palette knife

Caring for brushes

Any brush will be ruined if paint is allowed to dry on it, so it is important to clean brushes after use. Careful cleaning and storage will prolong the life of your brushes.

For water-soluble paints, gently massage warm, soapy water into the hairs, working right up to the ferrule. Rinse under warm running water until the water runs clear, then shake off any excess water. With your fingertips, gently tweak the hairs back to their original shape after washing.

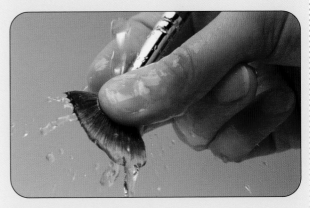

Cleaning brushes of water-soluble paint

To clean brushes of oil paint, wipe off any excess wet paint, using an old rag or a piece of newspaper. Using a palette knife, scrape off as much paint as you can. Pour enough household white spirit into a jar to cover the bristles. Agitate the brush in the white spirit, pressing it against the side of the jar to dislodge the paint. Rub washing-up liquid into the bristles. Rinse under running water until the water runs clear.

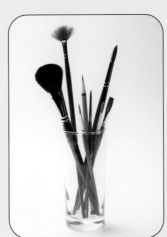

Storing brushes
Always store brushes on their tips, otherwise you will break the hairs. Stand them upright in a glass or jar until you need them for your next painting session.

other equipment

There are a number of tools that are useful to have close at hand or are simply fun to experiment with; some are designed specifically for use by artists, but many are everyday items that can easily be found around the home. There are no hard-and-fast rules in painting and you may discover new ways of applying and mixing paint. Defy convention and develop your own techniques!

Erasers

Plastic erasers (left) are used for rubbing out hard pencil marks; a kneaded, or putty, eraser (right) is best for charcoal and soft pencil.

Torchons

Torchons (also known as tortillons or paper stumps) come in a range of sizes. Made of tightly rolled paper, they are used to blend charcoal and soft pastel marks.

Sponges

Sponges – both natural (left) and synthetic (right) – can be used to dampen areas of the paper and also to apply paint (see page 130), creating an interesting mottled texture that cannot be achieved using a brush.

Cotton buds

Use a cotton bud to lift off small unwanted pools or runs of watercolour paint. (For larger areas, blotting paper, paper towels, sponges or a cotton rag are better, although their texture may show up in your painting.)

Masks

Masks are used to block out areas of your paper so that they remain free of paint (see page 127). There are three commonly used masking materials: masking tape, coloured masking fluid and transparent masking fluid (not shown).

Gum arabic

Adding gum arabic to watercolour paint increases its transparency and depth of colour. It also slows down watercolour's drying time. Mix it with the paint before you apply the paint to the paper.

Ox gall

Adding a few drops of ox gall to the mixing water when painting in watercolour has the effect of reducing its surface tension and improving its flow; this is helpful when working on heavily sized papers, as these tend to repel watercolour washes.

Toothbrush

An old toothbrush makes an excellent tool for spattering paint over the paper (see page 132).

Plastic palette knife

A plastic palette knife is useful for scraping into the surface of wet paint, developing lines and crosshatching. You can create similar effects using the tip of a brush handle and ordinary household items such as knives, forks and even paperclips.

Paint shapers

Paint shapers, which have a flexible silicone tip rather than bristles like a brush, come in range of shapes and sizes. They can be used to apply oil or acrylic paint, push paint around on the support, remove wet paint and blend pastel colours.

Fixative (not shown)

Charcoal, soft graphite and pastel drawings are very easily smudged. Fixative comprises resin dissolved in a colourless spirit. When sprayed onto a drawing the spirit evaporates, leaving a thin coating of resin that fixes the drawing in position. Fixative can be applied from an aerosol, from a hand-operated spray bottle, or by using a spray diffuser through which you blow the material.

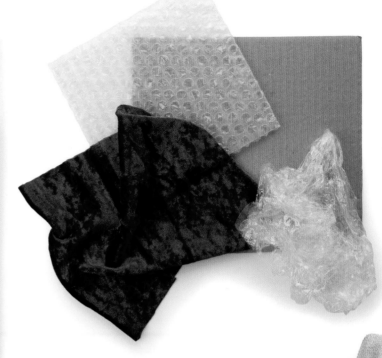

Improvised paint applicators

There are no hard-and-fast rules in painting and, by experimenting, you may discover new ways of applying and mixing paint. To add texture to your paintings, try pressing a piece of fabric, bubble wrap or scrunched-up plastic food wrap into wet paint to leave an interesting pattern on the surface, or dipping the edge of a piece of corrugated card into paint to create an irregular-shaped line.

Mahl stick

Used in oil painting, a mahl stick is a light rod of wood, with a soft leather ball on one end. It is useful when painting in a large area where the paint is still wet and you want to avoid touching the surface accidentally. Rest the ball end of the mahl stick on the edge of the canvas, on the easel or even on a spot of the painting that's dry. Hold the other end up with your non-painting hand and rest your painting arm on the rod to steady your arm while you paint. The one shown here comes in two parts that can be screwed together to make one long stick – useful when working on a large canvas.

Brush roll

If you regularly paint on location, a fabric brush roll protects your brushes and pencils in transportation.

easels

A good easel can make painting easier and more enjoyable, allowing you to stand back and review your work. Most easels can be adjusted to different heights and can be angled to suit the medium in which you are working.

Portable easels

If you like to paint outdoors, you will need an easel that is easy to carry. Aluminium easels with telescopic legs are simpler to erect than the wooden versions, but a little more expensive.

Sketching easels are available in both aluminium and lightweight wood. They can hold boards and canvases up to about 130 cm (50 in. or so), and are compact when folded, making them easy to carry and store.

Seat easels are a compact solution if you prefer to sit down when painting on location. Some sturdier versions, such as the box easel, can also be used in the studio.

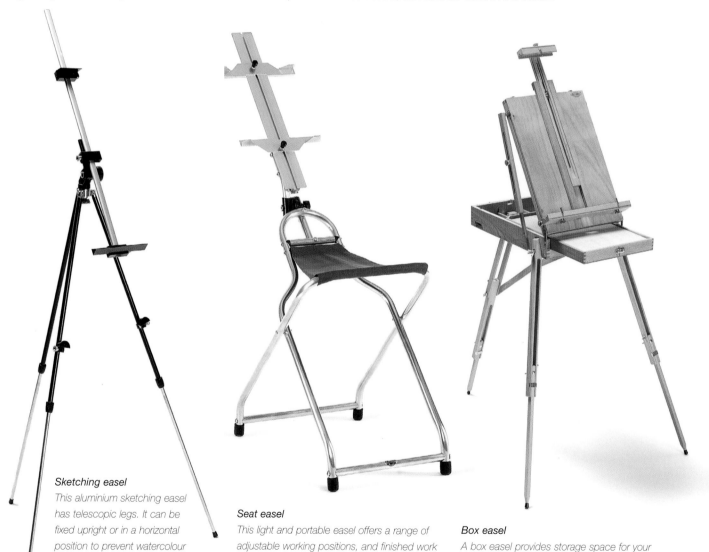

Sketching easel
This aluminium sketching easel has telescopic legs. It can be fixed upright or in a horizontal position to prevent watercolour washes from running; note that you cannot alter the angle to the same degree as a table easel (see opposite).

Seat easel
This light and portable easel offers a range of adjustable working positions, and finished work can be carried on the folded easel.

Box easel
A box easel provides storage space for your materials and folds down to a box with a handle for ease of carrying. The legs can be adjusted for sitting or standing positions.

Studio easels

Studio easels are designed to hold large canvases. They are bigger and more solid and stable than sketching easels. Some can be folded away for storage, but the largest often become permanent fixtures in the studio. Studio easels have either a tripod or an H-shaped base, and some have castors so that they can be moved with ease. The height and angle can be adjusted.

A table easel is ideal if you work on a small scale or if you have limited space. It sits on top of a table and can be folded away after use.

Table easel
This table easel can be adjusted to a variety of angles or to lie flat, allowing you to change the angle to suit the technique. Check before you buy: some table easels can only be set at very steep angles, which makes them unsuitable for watercolour work.

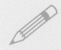

The right angle

Oils and acrylics (if used reasonably thickly) are usually painted with the support vertical. With thin acrylic washes, watercolour or gouache, the paint will be very fluid; if the easel is angled too steeply, paint may trickle down the paper into areas where you don't want it to go. For these media, choose an easel that can be used flat or propped up at only a slight angle.

Studio easel
This tripod easel is ideal for large oils and acrylics. It can hold canvases up to 135 cm (53 in.) high and can be tilted forwards and back. It folds flat when not in use.

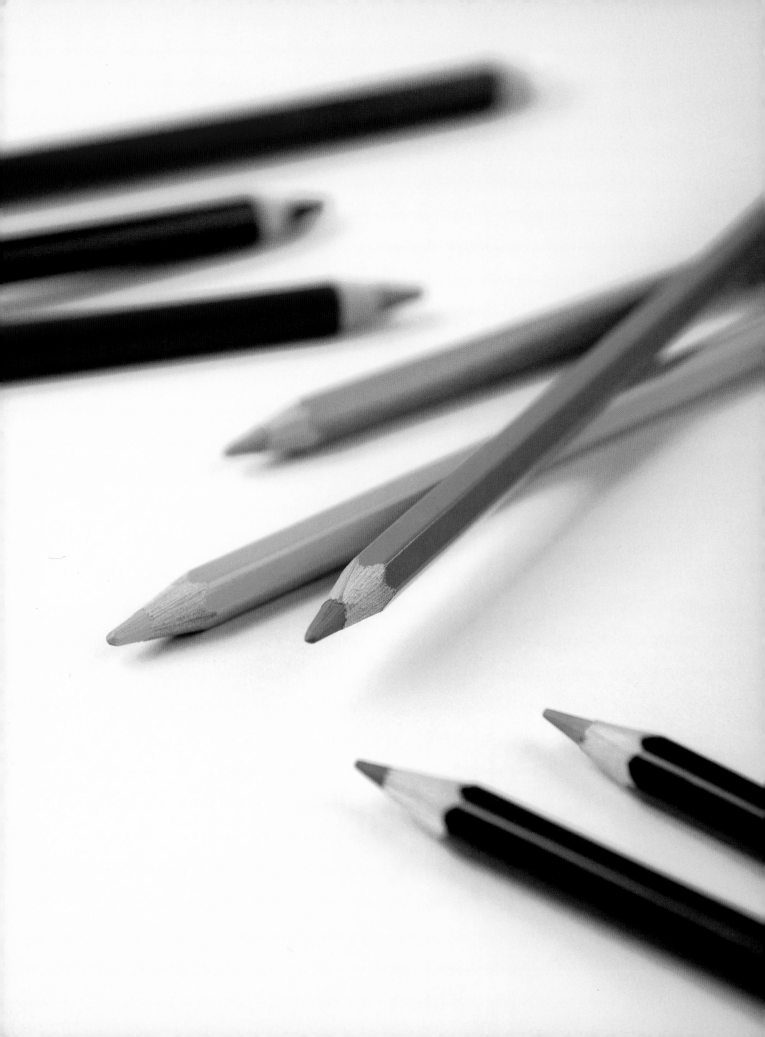

getting started

Whatever medium you use as an artist – watercolour, pencil, pastel, oils or acrylics – there are some fundamental principles that you need to master, including translating colour into tone, measuring, perspective, colour theory and composition. This chapter sets out all the basics.

basic shapes

For beginners, it's very tempting to draw things as an outline, in much the same way that children draw. Instead, you should train yourself to think of every subject as a three-dimensional form. Try to look at everything as a variation on one of four basic geometric shapes – as a sphere, cone, cylinder or cube.

Start with objects that you have at home or see around you every day. Fruit such as apples and oranges, for example, are spheres; the basic form of a bottle is usually a cylinder; most buildings are cubes. They may be elongated or compressed, particularly when viewed in perspective (see page 46), but essentially the shapes remain the same. It is also helpful – particularly with objects that do not have straight sides – to lightly draw a box shape around your subject as this helps you to see how far your subject deviates from true horizontal or vertical lines. So always think about how your subject is constructed and even put in the construction lines very lightly to help you. Once you've established the basic shape, you can gradually add tone and detail. In the examples shown below, the construction lines are drawn in green.

Apple (sphere)
Even though this apple is not perfectly round, it is essentially a sphere. Once you've established the overall sphere shape (drawn in green), it's much easier to see where the edges of the subject deviate from that shape.

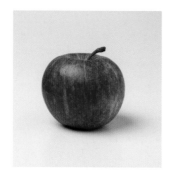

Wooden container (cylinder)
This wooden container is cylindrical. Although the rim and base are complete circles when viewed from directly above, they become ellipses when seen in perspective, so make sure you draw them at the correct angle.

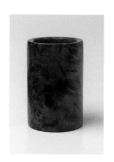

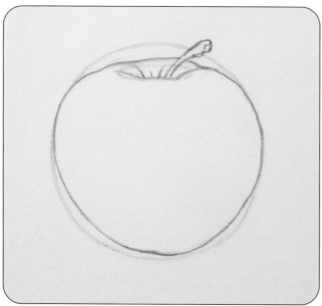

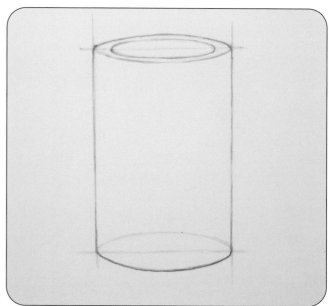

Flat-sided bottle (cube and cylinder)

With transparent glass subjects, it's much easier to assess the geometric shape as you can see through to the other side. Note how the green lines in the centre reveal the box shape of the main body of the bottle. The neck of the bottle is a short cylinder with slightly sloping sides.

Wine glass (cylinder and sphere)

The shape of the glass is contained within a cylinder; drawing straight vertical lines up from the base makes it easier to assess how far the sides of the bowl curve in. The bowl itself is a sphere.

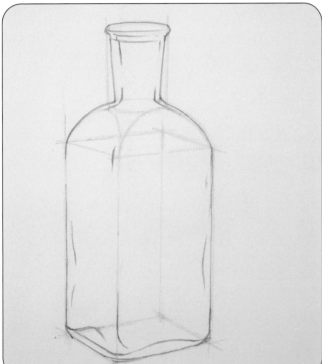

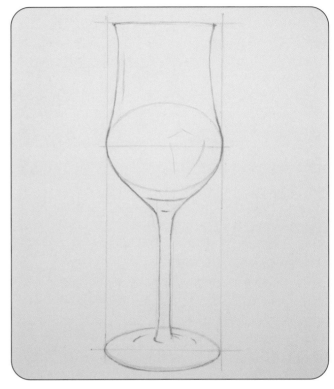

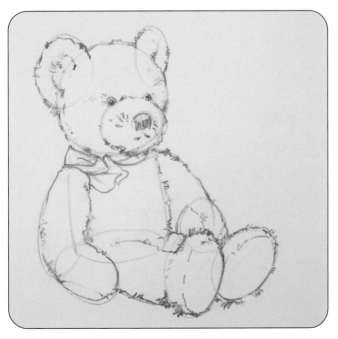

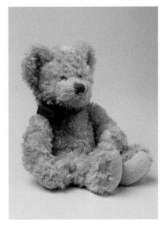

Teddy bear (interlocking cylinders and spheres)

The same principles apply with more complex subjects where you may have to analyse several different elements. This teddy's face, ears, muzzle and paws are basically spheres, albeit slightly elongated into an 'egg' shape in the case of the muzzle and far ear, while his torso and limbs are cylinders.

negative and positive shapes

'Postive' shapes are the shapes of objects themselves; 'negative' shapes are the spaces in between. It may seem paradoxical, but looking at the spaces rather than at the objects themselves can help you make your drawing more accurate.

Sometimes, it's hard to see shapes clearly – especially when you're dealing with intricately shaped outlines such as leaves or twigs, as we often tend to draw them bigger than they actually are. This is partly to do with the way the different hemispheres of our brain work. The left side of the brain, which is dominant in many adults, is concerned primarily with verbal skills, so when we're drawing or painting we often tend to concentrate on the things that we can actually name – the 'positive' shapes.

By concentrating on the 'negative' shapes, we switch our thinking from the left to the right side of the brain – the visual side. Instead of being distracted by the physical objects and thinking in verbal terms ('I need to draw all the fiddly edges of that leaf'), we make ourselves really look at the shape and relative sizes of what's in front of us.

Experienced artists switch instinctively between the negative and positive shapes in a drawing. Although the approach shown in this exercise is somewhat artificial, in that you're asked to focus primarily on the negative spaces, it's a skill and habit that's well worth cultivating. The most important thing is to spend plenty of time looking at your subject before you begin drawing.

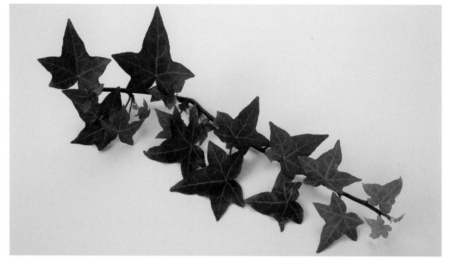

The subject

Arrange a sprig of ivy or other nicely shaped leaves on a plain white background, so that there is nothing to distract you from looking at the spaces between the leaves. If necessary, tweak the leaves with your fingers to get more interestingly shaped spaces between them; you may even need to remove some leaves if they overlap each other and make the whole composition too confusing.

You will need

Dark green pastel paper
Soft pastels: Venetian red, peachy-pink, dark brown, dark green, yellow-green, white
Kneaded eraser
Fixative

1 Choose a dark green pastel paper that approximates to the colour of the leaves, so that any drawing of the leaves themselves will be minimal. Using the chisel-shaped side of a Venetian red soft pastel, begin blocking in the spaces to the top and bottom of the ivy leaves. Start with the biggest spaces, as they are the easiest to define. Continue blocking in, assessing the shapes and sizes carefully as you go. The outline shapes of the leaves themselves will soon begin to emerge.

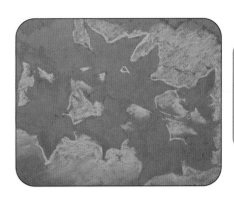

2 The diagonal line of the sprig of ivy is now clear, so you can start blocking in the smaller negative spaces that run down the centre.

Shaping erasers

Use your fingertips to pull the eraser to a sharp point so that you can create a crisp edge.

3 Soft pastel smudges very easily, so use a kneaded eraser to clean up the edges of the shapes and define them more clearly. You may find that it helps to place a sheet of clean paper over your drawing to mask off the pastel marks that you've already laid down and prevent you from accidentally smudging and blurring them as you work.

4 Leave the darkest areas of the background and the shadows cast by the leaves as pure Venetian red and go over the rest of the red pastel with a peachy-pink colour. Define the edges of the leaves using the tip of the peachy-pink pastel.

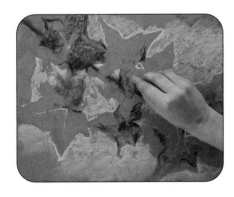

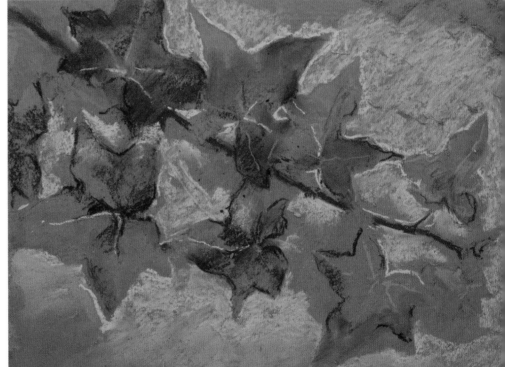

5 Using a dark brown pastel, put in the main stalk of the ivy and any little protruding stems that you can see. Note that not all the stalk is visible: some of it is covered by the leaves that overhang it. Block in the darkest areas of green to begin to develop some form on the leaves. Use a lighter yellow-green for the lighter parts of the leaves and some of the veins, and white for the very lightest veins.

The finished drawing

Although the artist has concentrated on the spaces and has drawn very little detail on the leaves themselves, their shape is evident and there is enough tonal variation to give them some sense of form. The choice of dark green paper also helps, as the paper colour stands for the mid-toned green of the leaves.

drawing in line

A line that is of a standard thickness and density will show little more than the shape of an object. With practice, however, a simple line can be made to work harder and show far more.

By varying the amount of pressure that you apply and/or the speed with which you make the mark, the line can provide information about the angle at which a surface slopes and clues to the surface texture and contour of the subject. By varying its thickness or density, you can give a good indication of the direction and intensity of the light source. Using a combination of these line qualities distinguishes a good line drawing from a poor one.

Still life with onions and garlic

The simple fluid shapes and the linear texture and patterns on the dry, parchment-like onion and garlic skins make them a perfect subject for practising line control with a stick of charcoal. Note that three objects have been used: arranging still lifes using odd, rather than even, numbers always seems to create a more satisfying composition

You will need

White drawing paper
Thin charcoal stick
Paper towel
Fixative

The subject
One onion has been sliced in half to reveal the inner pattern of lines. The uneven, rather knobbly shape of the garlic contrasts with the smoother profile of the onions.

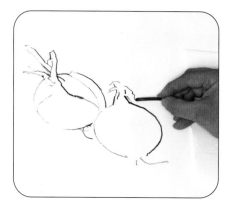

1 Sketch in the shape of the left-hand onion, which is basically just a circle with a few wavy lines at the top. Use a thin line on the side of the onion that is in the light and make the lines on the shaded side darker. Alter the density of the line by applying more or less pressure. Draw in the second (cut) onion, paying attention to its posiion in relation to the first. Rest your hand on a paper towel to avoid smudges.

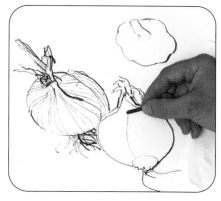

2 Draw in the garlic, relating its position to the two onions. Lightly draw in the lines on the outer skin of the first onion. Make sure you place these accurately, as they show the way in which the onion is facing. The second onion has been cut in two and the half shown has its cut face uppermost; it is almost flat, with only a few lines visible on its surface. Underplay these lines so that the surface does not appear to be curved.

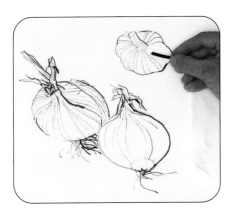 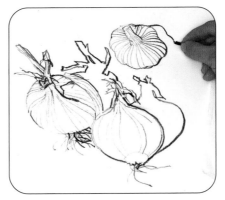 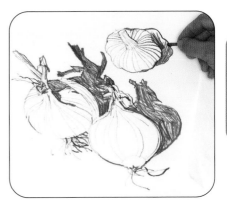

 3 Apply the same drawing technique to the bulb of garlic. Make the linear marks work to indicate the hidden shape of the cloves of garlic hidden beneath the surface of the skin.

4 Draw in the shape and extent of the cast shadows with a basic, linear outline.

5 To give the drawing more solidity, block in the shape of the shadows loosely. This immediately throws the onions and bulb of garlic into relief, and gives an exaggerated quality of depth to the work. Apply a spray of fixative once you are satisfied with the work.

Broken charcoal

When making dark marks, hold the charcoal with your fingers closer to the paper, otherwise the stick is likely to shatter. If this does happen, do not panic; simply blow away the bits and continue.

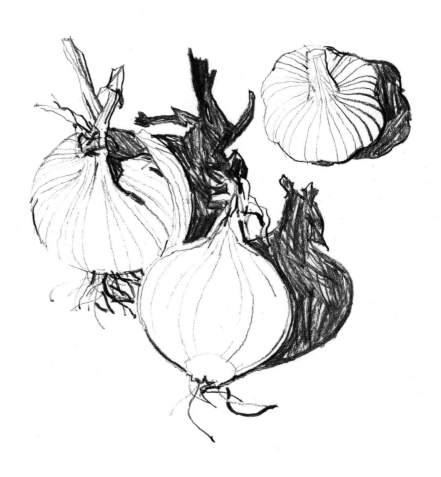

The finished drawing

Although it consists of only a few lines, the drawing is a very convincing image of its subject. The areas of shadow, which have been loosely scribbled in, have an openness that maintains the quality of line work.

understanding tone

The term 'tone' simply means the relative lightness or darkness of a colour. Being able to judge tones correctly is essential, as it enables you to create a convincing impression of light and shade, which is one of the things that helps to make your subjects look three-dimensional.

The tone of an object depends on the degree and quality of light falling on it. If one side of a building is in sunlight and the adjacent side is in deep shadow, the shaded side will appear considerably darker – even though both sides are made from the same materials and are the same colour.

It can be difficult to work out which tones are light and which are dark: colours that are close in intensity and hue can appear to be the same tone. You may find that it helps to imagine your subject as a black-and-white photograph.

Light that falls consistently all over a subject will make it appear flatter than it is in reality; this is due to a reduced range of tonal values. Stronger directional light, with a wide tonal range and a greater degree of contrast, has the effect of accentuating shape, form, contour and texture.

Tonal drawing

This simple still life is a good opportunity to practise translating a range of colours into tones. The near-black aubergine gives the darkest tone, while the lightest tones are provided by the lemon. The red radishes and green leaves are both mid tones.

You will need

Mid-grey drawing paper
4B and HB graphite pencils
Fixative

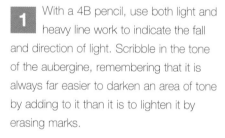

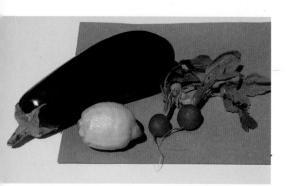

The subject
Fruit and vegetables make the ideal subject for a tonal drawing. The purpose of placing them on a sheet of grey paper is twofold: first, the group of objects is held together; and second, the grey colour increases the tonal depth of the shadow cast by the aubergine.

Black-and-white version
Converting the colour photo to black and white makes it clear how similar in tone the red and green of the radishes are.

1 With a 4B pencil, use both light and heavy line work to indicate the fall and direction of light. Scribble in the tone of the aubergine, remembering that it is always far easier to darken an area of tone by adding to it than it is to lighten it by erasing marks.

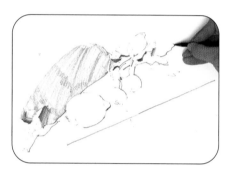

2 Block in the uniform grey tone of the sheet of paper with the harder HB pencil. This makes the lemon shape more distinctive, but it is now apparent that the tone of the aubergine is too light and will need to be darkened later.

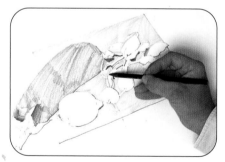

3 Using the HB pencil, establish the overall tone of the lemon. Add a little texture and shadow to the underside of the lemon and scribble in the slightly darker tone of the red radishes. Then draw in the detail on the green leaves of the radishes.

The finished drawing
By keeping the graphite marks loose and open, the drawing maintains a certain vitality that can often be lost by trying to make the tones too flat and consistent.

4 At this stage, the image is flat and has a limited tonal range. The solution is to darken the aubergine, making it several tones deeper than its background. This also has the immediate effect of making the lemon appear lighter in tone.

5 Using the softer 4B pencil and a little pressure, draw in the dark shadows beneath the vegetables. Where these fall on the grey paper, they are the darkest tone in the picture – but note how much lighter the shadow is when it falls on the white background. Complete the drawing by adding a little detail onto the radish leaves and the dimpled surface of the lemon. Finally, apply a spray of fixative to prevent the graphite from smudging.

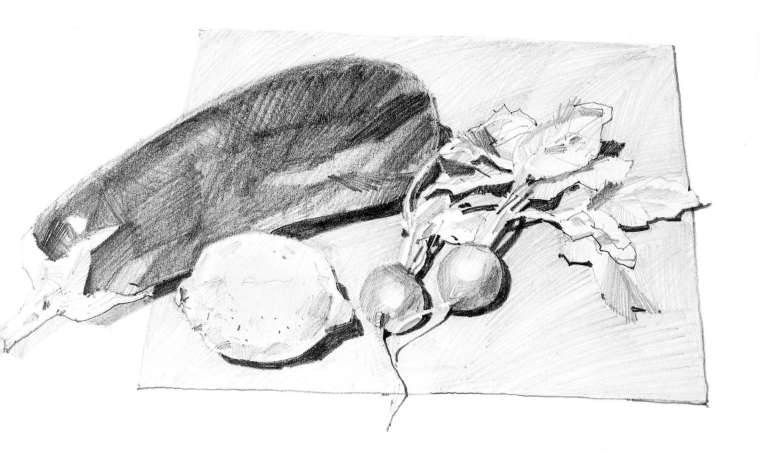

Tonal painting in monochrome

In this exercise all the wooden objects are exactly the same colour, but in order to make them look three-dimensional, you need to assess the tones and work out how dark and how light to make them.

As this exercise is done in watercolour, start by applying the very lightest tones and then build up layers of paint for the mid- and dark-toned areas. Watercolour paint always looks a little darker when wet than it does when dry, so you will probably find that you need to paint the mid- and dark-toned areas again in order to get the right tone.

You will need

HP watercolour paper
2B pencil
Plastic eraser
Watercolour paints: ultramarine blue, raw umber
Medium round brush

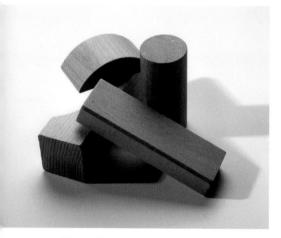

The subject
Arrange a selection of wooden shapes on a white surface, with a light (a table lamp will do) positioned to one side, so that the objects cast strong shadows.

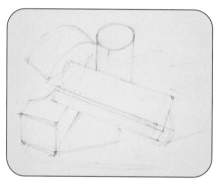

1 Using a 2B pencil, lightly sketch the outline of the shapes.

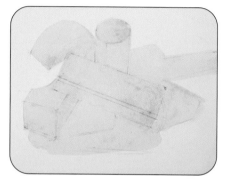

2 When you're happy with your sketch, knock back the outlines with a plastic eraser so that you can only just see where the lines are. Mix five tones of blue-grey from ultramarine blue and raw umber. Apply the very lightest tone over all the objects, including the shadows, and leave to dry.

Be generous!

Mix plenty of each tone, so that you don't have to stop halfway through the exercise to mix more.

3 The lightest tones are on the tops of the cylinder, semi-circle and curved piece on the left-hand side of the image, so these areas will receive one layer of paint only. Apply the second lightest tone over the remaining areas (but not the shadows) and leave to dry.

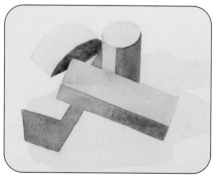

4 Apply the third tone to the shaded areas of all four objects. Note that there is a gradual transition in tone on the cylinder: only the right-hand side, which is furthest from the light source, needs this third tone. Leave to dry.

Avoiding smudges

If you're working on several areas, turn the painting around, so that you don't accidentally smudge wet areas with your hand.

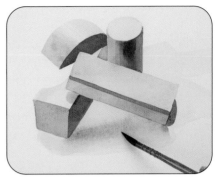

5 The right-hand sides of the semi-circle and the curved piece of wood, and the dark strip along the edge of the rectangular block need to be darkened still further: apply the fourth tone here and leave to dry.

6 The tone on the two curved surfaces (the top of the semi-circle and the sides of the cylinder) is gradated, because they curve gradually away from the light. To achieve this gradation, add water to your mix to lighten it. Put in the dark shadow cast by the rectangular block on the curved block and table top.

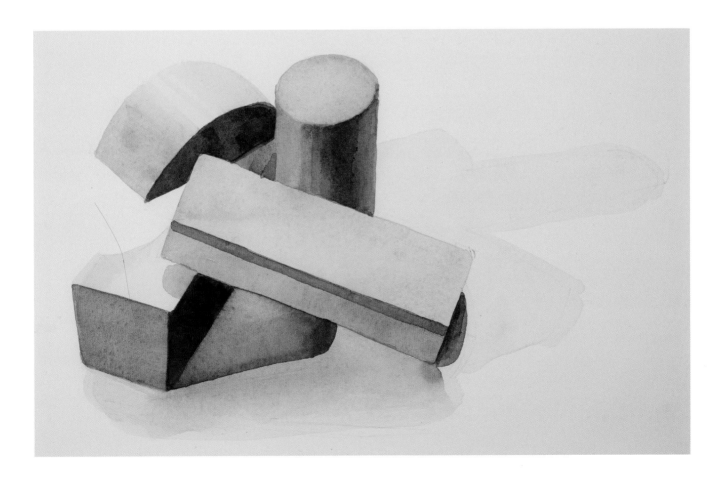

The finished painting
Careful observation and rendering of the different tones has resulted in a sketch that looks convincingly three-dimensional.

measuring systems

Getting the relative sizes of the things you are drawing right is one of the most important things to master. Scale is very deceptive, and without some method of checking what you see in front of you, mistakes are almost inevitable.

Sight sizing

Sight sizing is a measuring method that transfers the size of the object seen by the eye to the same size when drawn on the paper. Imagine a sheet of glass in front of you and that you are tracing your subject onto the glass: the subject will be drawn at sight size.

To achieve this when drawing, close one eye and, holding your arm straight, hold up a pencil against your chosen subject so that the top of the pencil aligns with the top of the object. Move your thumb down the pencil to record the total height or width of the object. Then, without moving your thumb, place the pencil on the paper and mark off the measurement. It is important to close one eye: try measuring the same object with both eyes open and the difference will become apparent.

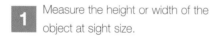

1 Measure the height or width of the object at sight size.

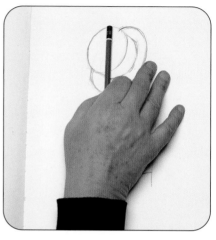

2 Then transfer the same measurement to the drawing.

Arms straight!

To directly compare one part of your subject with another, it's essential that you keep your arm absolutely straight when measuring, so that the pencil remains a constant distance from your subject.

Comparing measurements

You can use your pencil or pen to assess the proportions of your subject and compare one part with another. Choose one key area to measure: it might be the height of a tree or the width of your model's face.

Hold your pencil or pen vertically with your arm fully extended, aligning the top of the pencil with the top of the object you are measuring. Mark the base of the key measurement with your thumb. Then, still keeping your arm fully extended and without moving your thumb, use this measurement to compare against the size of other objects.

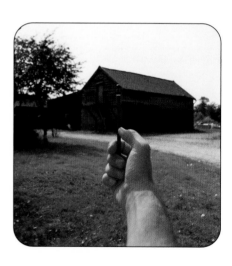

Here, the pencil is being used to 'measure' the height of the near corner of the barn. Note that this is approximately the same as the width of the gable end and half the length of the long side. By comparing and marking off these measurements on your drawing, it will be accurate.

Using a drawing frame

A drawing frame, or system, was a device used in the sixteenth and seventeenth centuries by artists as an aid to the accuracy of a drawing, especially for analysing the effects of foreshortening and perspective (see pages 44–49). The subject is viewed through a grid divided into squares. A grid is then drawn on the drawing surface using the same number of divisions: for example, ten across and ten down. The artist looks through the frame and plots the image by transferring the position of the subject seen through the grid. The artist's head must remain completely still and the distance from the frame remain constant in order for the drawing to be accurate.

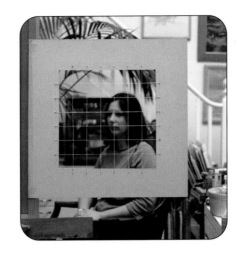

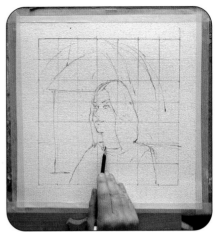

1 Make a homemade drawing frame from a piece of stiff card divided equally with thread into a grid. (The artist's view through the grid is different from the camera's view in this shot.)

2 Transfer the position of the subject, seen through the grid, to the grid on your drawing paper. Use the grid to plot the position of the key features of the pose.

Using a homemade angle frame

Angles are sometimes difficult to assess by eye, but easy to check using a pencil or homemade angle frame.

Hold your pencil up to the subject and align it along the slope to be measured – a roof or the line of a receding road, for example. Carefully maintain that slope and lay the pencil on your paper to check the angle of the drawn line.

To make your own angle frame, cut two strips of stiff cardboard, measuring approx. 5 x 25 cm (2 x 10 in.). Pierce them at one end and fix them together with a paper fastener.

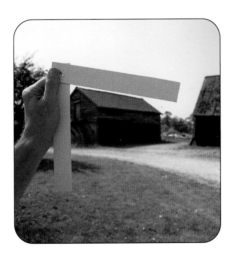

1 Align one strip of the frame with a vertical, such as the side of the barn in this example, then adjust the angle of the top strip to match the slope of the roof. You may be surprised at how acute the angles actually are.

2 Lay the frame on your paper, carefully maintaining the measured angle. Lay the vertical strip against a corresponding vertical and check or trace the slope of the roof.

perspective

Over the centuries, artists have devised methods for creating the impression of spatial depth on the flat, two-dimensional surface of the paper or canvas. It all sounds very complicated, but the basics are relatively easy to understand. In Western art, an impression of distance is largely created through changes in tone and scale. There are two types of perspective: linear and aerial.

Linear perspective

The further away from you objects are, the smaller they appear to be – so when you're drawing a series of objects receding away from you (a line of telegraph poles, for example), you have to make the ones in the far distance smaller than those close to you even if, in reality, they are all exactly the same height.

One-point perspective

One-point, or single-point, perspective applies when all straight lines that recede away from you are parallel; all these lines will appear to meet at a single point, which is known as the vanishing point – the point at which they disappear from view.

The vanishing point coincides with your eye level (also known as the horizon line).

In one-point perspective, the vanishing point is always directly in front of you, in line with your centre of vision. Parallel lines that are above your eye level will appear to slope downwards, whereas parallel lines that are below your eye level will appear to slope upwards.

Let's continue with the example of telegraph poles given above. Hold a pencil out in front of you, aligning it horizontally with the tops of the poles, and work out the angle at which the pencil lies. The tops of the poles are all parallel to each other – but as they are above your eye level and receding away from you, the pencil will slope downwards. Eventually, it will coincide with a point on the horizon – the 'vanishing point'.

Repeat the process, aligning the pencil with the base of the poles. Because the bases of the poles are below your eye level and receding away from you, the pencil will slope upwards.

Vertical lines – the poles themselves – will remain unchanged.

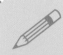

Up or down?

Horizontal lines above eye level appear to slope down to meet the vanishing point. Horizontal lines below eye level appear to slope up to meet the vanishing point. Vertical lines remain vertical.

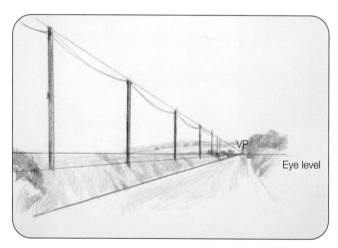

Parallel lines receding away from the viewer
In this simple illustration, the telegraph poles – which are all the same height – appear to get smaller the further away they are. The perspective line of the tops of the poles is above eye level, so it slopes down to the vanishing point (VP), while the line of the base of the poles is below eye level, so it slopes up to the vanishing point.

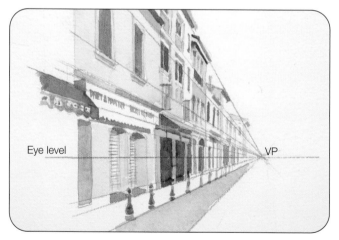

Parallel lines receding to one side
In this street scene, all the elements on the front facades of the buildings (the tops and bottoms of the windows, for example) are on the same plane, so they all meet at the same vanishing point.

Two- and multiple-point perspective

Two-point perspective occurs when two sides of an object can be seen – for example, two sides of a box or a building. The principles are exactly the same as those of one-point perspective, but each side has its own perspective lines and vanishing point. Lines on the left-hand side will meet at a vanishing point to the left of your centre of vision; lines on the right-hand side will meet at a vanishing point to the right of your centre of vision.

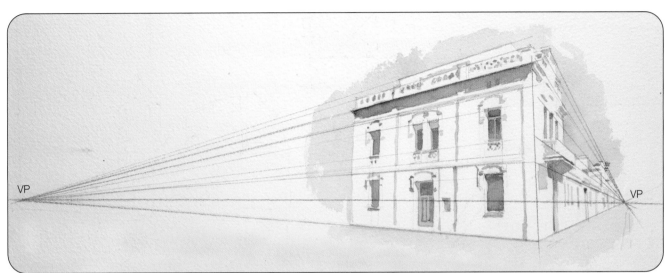

Two planes visible
Here we can see two facades of the building.
Each side has its own perspective lines and vanishing point.

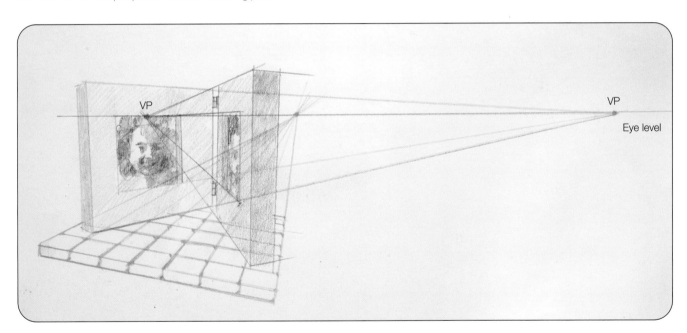

When you have several objects arranged at different heights and angles, then multiple-point perspective comes into play. As you might expect, the perspective lines and vanishing points of each object need to be plotted separately. You may well find that some or even all of the vanishing points lie outside the picture space, but all that's really important is that you plot the angles of the perspective lines accurately.

Objects at different angles
In this sketch of a hinged photo frame on a tiled table mat, we've only shown one plane of each object for clarity – the front plane of each section of the photo fame and the top plane of the mat – although, of course, the side planes of each object also have their own perspective lines and vanishing points. The key to drawing a subject such as this is to measure the angles of the different planes as they recede away from you very carefully.

Curved forms in perspective

Most shapes appear slightly distorted when seen in perspective. A circle, for example, will become an ellipse. It is your eye level in relation to the subject that determines the extent of the ellipse. If it is viewed from directly above, the circle will appear to be completely round, with no distortion at all. If you lower your viewpoint, however, the circle will become an ellipse, because you are looking across it from front to back: the span is somewhat foreshortened. As your viewpoint becomes progressively lower, so the ellipse will appear narrower. Finally, when your eye level is level with the top of the object, the ellipse will disappear completely and the top of the object will appear to be a flat line.

Viewed from above, the circle is completely round

From a lower viewpoint, the circle becomes an ellipse

Viewed from eye level, the ellipse disappears

Drawing smooth ellipses

Try to draw ellipses in one fluid movement, rather than in two halves – otherwise you may make the ends of the ellipse pointed or blunt.

Foreshortening

Foreshortening is a type of perspective, but the term is almost always used in relation to a single object or a part of an object, rather than to a scene or a group of objects. With foreshortening, the object appears shorter than it actually is, because it is angled towards the viewer, since parallel lines appear to converge towards the vanishing point; those parts of the object that are furthest away from the viewer will also appear to be smaller than those close by.

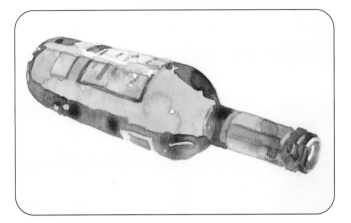

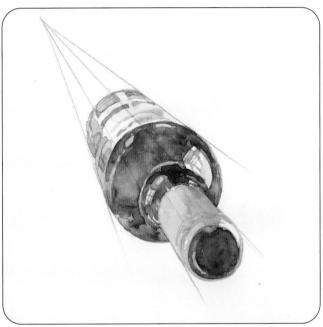

Foreshortened bottles
In the sketch above, the wine bottle is only slightly angled away from the viewer, so there is virtually no foreshortening. In the sketch on the right, however, not only do the parallel sides of the bottle appear to slope inwards (towards the vanishing point), so that it looks narrower at the base, but its length also appears to be considerably compressed.

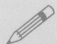

Give yourself guidelines

No matter how carefully you measure, it's often difficult to assess the degree of foreshortening – especially if you're a beginner. You may find that it helps to draw a faint box in perspective around your subject and lightly plot the vanishing points.

Foreshortened figure
With a longer subject, the effect of foreshortening is even more pronounced. The feet appear to be enormous and the legs considerably longer than the torso; in reality, in an adult male the torso is usually only slightly shorter than the legs.

Aerial perspective

Aerial – or atmospheric – perspective is the term used to describe the effect that the atmosphere has on the appearance of things viewed from a distance.

Before the Renaissance, artists generally drew objects higher in the picture plane, or made them smaller, to imply that they were further away – but the colour saturation (or tone) and amount of detail that could be discerned remained the same. It was not until the fifteenth century, when artists such as Leon Battista Alberti (1404–1472) and Leonardo da Vinci (1452–1519) began to seriously study the effects of the atmosphere on the way we perceive objects, that any real theories of atmospheric perspective were put forward. Leonardo described it as 'the perspective of disappearance'.

As we've already seen on pages 44–47, objects appear to diminish in size the further away they are. When you're drawing or painting a scene in which there is a considerable distance between the foreground and the background, you also need to exploit apparent differences in tone. Dark-coloured objects or shadow areas in the foreground will appear much stronger in tone than those in the middle distance, while those in the background will appear paler still. These contrasts in tone help to make clear the spatial relationships in a scene. If you were to paint a range of mountains all in the same tone, for example, they would all appear to be the same distance away. Make the mountains in the far distance paler than those in the mid-distance, however, and you create the impression that they are further away from the viewer.

Detail and textures are more evident in things that are closer to the viewer. This is partly due to limitations in human vision, but also to the effect of the atmosphere. Without going into too much scientific detail, skylight is scattered by dust, particles of moisture and molecules of air as it enters the atmosphere. This scattered skylight combines with the light reflected from the object, like a kind of haze or veil, so distant objects appear slightly hazy. As an aside, skylight usually contains more of the shorter wavelengths of visible light – violet and blue – which is why both the sky and distant objects appear bluish in colour.

Finally, you need to think about colour temperature. Distant objects tend to look cooler and bluer than those close to the viewer, while foreground objects appear cooler, so use cool hues towards the horizon and warmer colours in the foreground.

It's also important to remember that aerial perspective applies to the sky, as well as to the land. Directly above you, the sky will be warmer and bluer, gradually becoming paler towards the horizon. Clouds also appear larger when they are directly overhead.

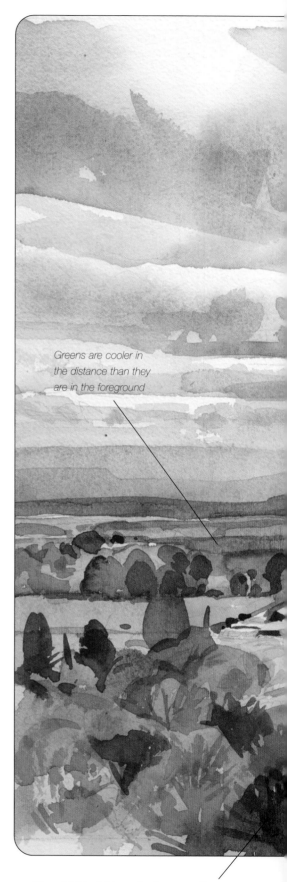

Greens are cooler in the distance than they are in the foreground

More detail is visible on the foreground trees

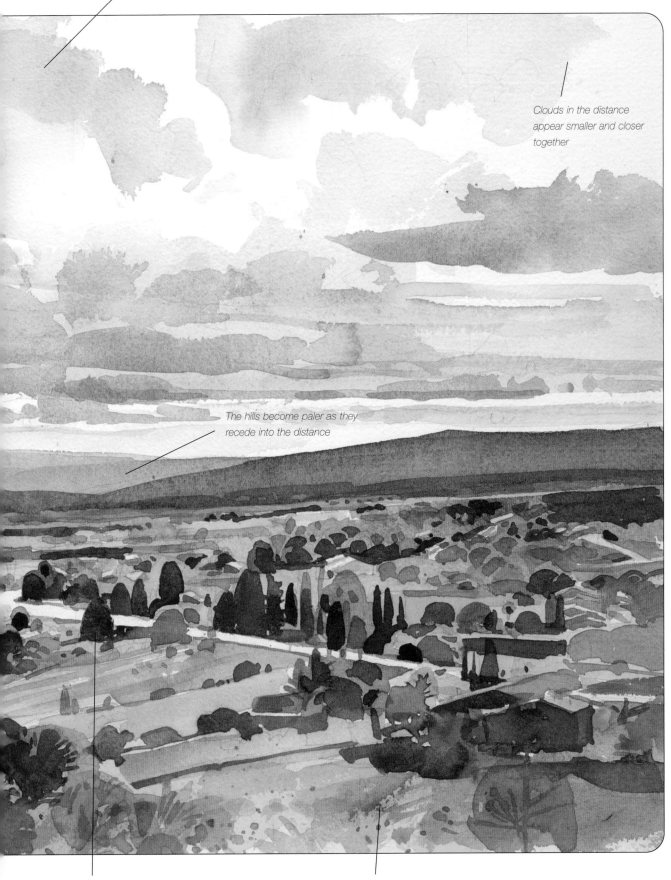

Clouds directly overhead appear larger

Clouds in the distance appear smaller and closer together

The hills become paler as they recede into the distance

Shapes in the mid-distance and distance are simplified as less detail is discernible

Foreground colours are warmer

understanding colour

At first glance, colour theory can seem complex and daunting – but once you understand the basics, you will begin to see why some colour mixes work better than others.

The primary colours – red, yellow and blue – are those that cannot be created by mixing other colours. The secondary colours – orange, green and purple – appear when each primary is mixed with its neighbour. Mixing a primary colour with one of the secondary colours that lies next to it on the colour wheel creates what is known as a tertiary colour. Complementary colours are those that are opposite each other on the colour wheel; mixed together they tend to neutralize each other (a useful way of creating neutral greys and browns), but placed next to each other they appear to increase in intensity.

The colour wheel
*The colour wheel is a classic way of illustrating
the relationships between different colours.*

Yellow (primary)

Yellow-orange

Yellow-green

Orange (secondary)

Green (secondary)

Red-orange

Blue-green

Red (primary)

Blue (primary)

Red-purple

Blue-purple

Purple (secondary)

Colour temperature

Although many people believe that reds, oranges and yellows are warm while greens, blues and purples are cold, no colour in your palette is pure: any red, yellow or blue has a warm or a cool bias. Cadmium red, for example, is a warm red; mixed with cadmium yellow, it creates a warm orange. Alizarin crimson (a bluish red) mixed with cadmium yellow gives a cool orange. Warm colours appear to come forward in a painting, while cool ones recede – so one way to make something appear further away is to paint it in a cooler hue.

In order to be able to mix a full range of colours, you need to include a warm and a cool version of each of the three primary colours in your set of paints.

Warm colours seem to advance, while cool ones recede – so one way of creating a sense of form and space in your work is to use touches of warm colours in the foreground and cooler ones in the distance; see Aerial perspective on pages 48–49.

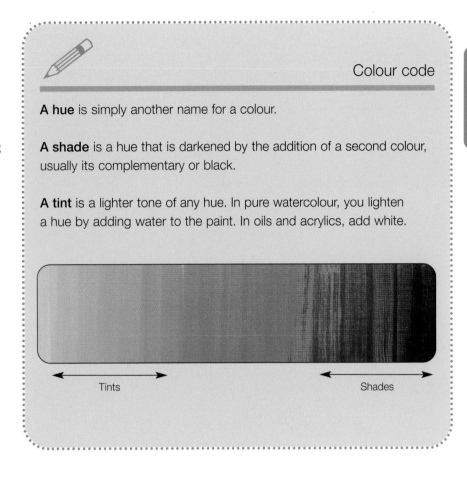

Colour code

A hue is simply another name for a colour.

A shade is a hue that is darkened by the addition of a second colour, usually its complementary or black.

A tint is a lighter tone of any hue. In pure watercolour, you lighten a hue by adding water to the paint. In oils and acrylics, add white.

Tints Shades

Colour for mood

The temperature of the colours that you use can have a profound effect on the mood of your painting. Think, for example, of the difference between an icy blue that you might find in a winter snow scene and the warm, rich blue of a summer sea. Cool colours are often used to create a calm, tranquil mood, or even a mood of sadness. Warm and hot colours can create a joyful, energetic mood.

Relating colours to one another

One of the most important things to remember is that colours should always be viewed in terms of how they relate to the colours around them. Every time you add a colour to a painting, it alters the relationships of the colours already on the canvas. A bright colour such as red, for example, looks richer if it is placed next to a neutral colour such as brown or grey. Placing two bright, complementary colours such as red and green together, however, can look jarring – particularly if they are used in similar amounts – but a small splash of red in a larger expanse of green (a few red poppies in a field, for example) can be quite dramatic and exciting.

Contrasts of tone – light and dark areas – can be used in the same way. The Dutch artist Rembrandt (1606–1669) was a master of juxtaposing light and shade to heighten the drama of his portraits.

This is where colour theory overlaps with composition, as you can use colours and tones as a means of leading the viewer's eye through a painting. Keep your eye moving around the painting as you work, assessing how the colours and tones relate to one another, and be prepared to make adjustments as you go. On the following two pages, you will find some accepted schemes and strategies for using colour to good effect.

Putting the theory into practice

The colours that you use have a profound effect on the overall mood of a painting. Harmonious colour schemes are generally calming, while strong colour contrasts can be dynamic and dramatic. There are many different schemes and strategies for using colour in art, some of which are shown below. This is a good starting point but it is not set in stone and experienced artists rely on their instincts as much as, if not more than, conventional theories. If you feel that a particular colour, or combination of colours, isn't working, try to analyse the colour relationships within the scene and see if you can work out why.

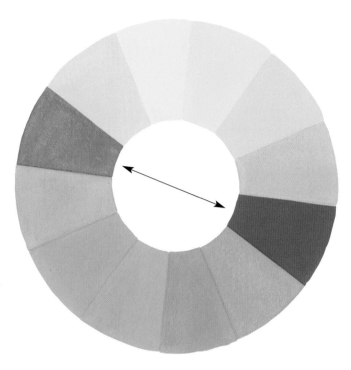

Complementary contrast
Complementary schemes use colours that are opposite each other on the colour wheel. These colour pairs seem more intense when placed next to each other and can create a very dynamic mood, even when only a small amount of the complementary colour is present.

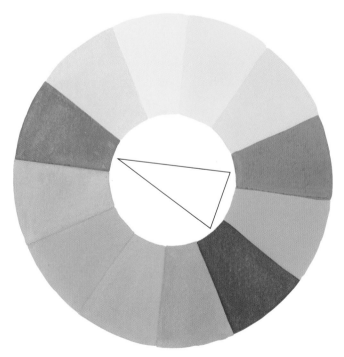

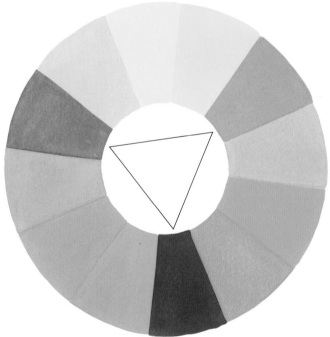

Split complementary contrast
A split complementary colour scheme is a variation on the complementary colour pairing – but instead of a secondary and a primary, it uses a secondary and the two tertiary colours on each side of the primary. It gives strong visual contrast, but creates less tension than a complementary scheme.

Triadic harmony
Triadic harmony uses three colours evenly spaced around the colour wheel. Triadic colour harmonies tend to be quite vibrant, so use one as the dominant colour and the others for accents.

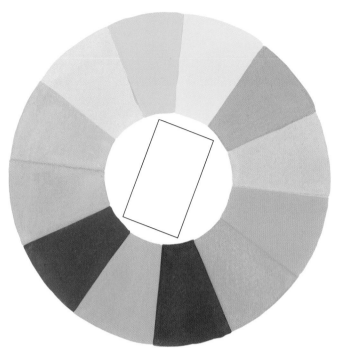

Tetradic harmony
This colour scheme uses four colours arranged in two complementary pairs. Again, it works best if you let one colour dominate.

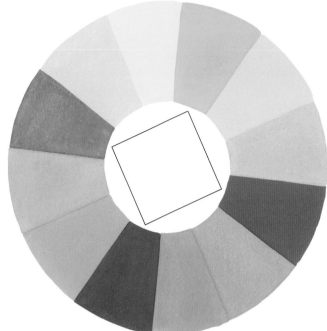

Square
This is similar to tetradic harmony, but the four main colours are evenly spaced around the colour wheel.

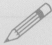

Colour contrasts

Harmonious colour schemes can sometimes seem a little monotonous. Liven things up by introducing a complementary accent – but remember that a little goes a long way! Just a small touch of a complementary colour – a splash of red flowers or a red-tiled roof in a predominantly green land-scape, for example – may be enough to completely lift the image.

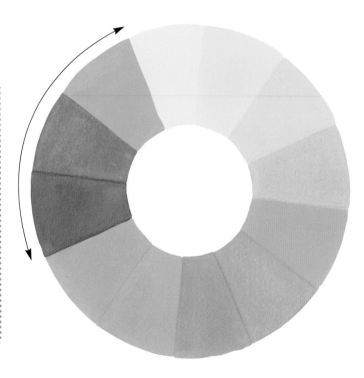

Analogous harmony
Analogous colour schemes use colours that are next to each other on the colour wheel. They tend to create a calm, peaceful mood.

Exercise in basic colour

The best way to learn about colour is to experiment with a limited range of combinations. This exercise uses acrylic paints, but you could also try repeating it using water-soluble pencils.

You will need

Canvas board
4B pencil
Acrylic paints: cadmium red, alizarin crimson, ultramarine blue,
 titanium white, cadmium lemon, cerulean blue, cadmium yellow
Small flat brush

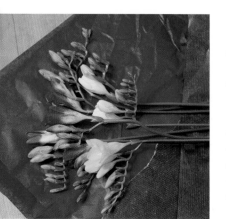

The subject
The flowers were chosen for their intense primary and secondary colours. Opening up the bunch and placing the flowers flat on a work surface not only avoids the clichéd image of flowers in a vase, but also means that you can include the dark green wrapping paper as part of the composition; a muted blue tissue paper beneath the flowers sets off their brightly coloured petals.

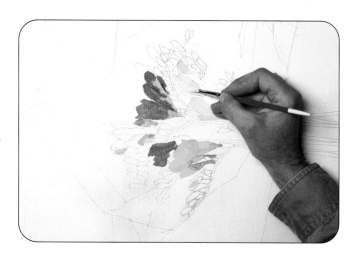

1 Using a 4B pencil, sketch in the position of the flowers and the tissue wrapping paper on the canvas board. Use a mixture of yellow, white and red to paint the flower heads. Cadmium red, and a mixture of alizarin crimson and ultramarine blue produce darker reds, while adding white and yellow to the mixes lightens them.

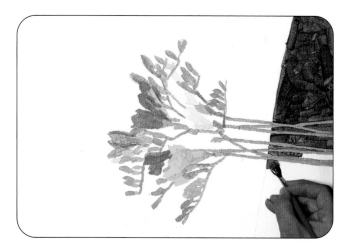

2 Mix ultramarine blue and alizarin crimson, lightened with a little white, for the purple flower. A cadmium lemon, cerulean blue and white mixture gives a good light green for the flower buds and stems. Add ultramarine to the light green mixture to complete the flower stems. Make the colour for the dark green wrapping by combining alizarin crimson, ultramarine blue and cadmium yellow.

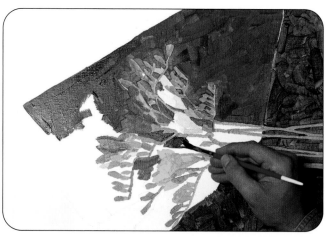

3 Mix ultramarine and cerulean blue to create the colour for the blue tissue-paper background.

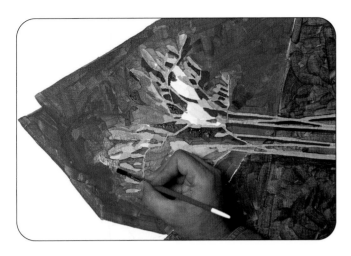

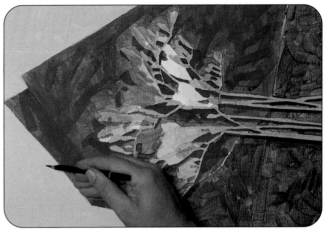

4 As soon as the background is dry, darken the blue mixture by adding a little alizarin crimson. Use this colour for the shadows around the flowers.

5 Mix cadmium yellow, cadmium red, a little cerulean blue and titanium white to produce the colour for the wooden table top. Once this is dry, draw in the grain of the wood with the 4B pencil.

The finished painting

Very simple colour mixes can produce a lifelike image. This painting demonstrates the effect that can be created by variations based on only six colours plus white.

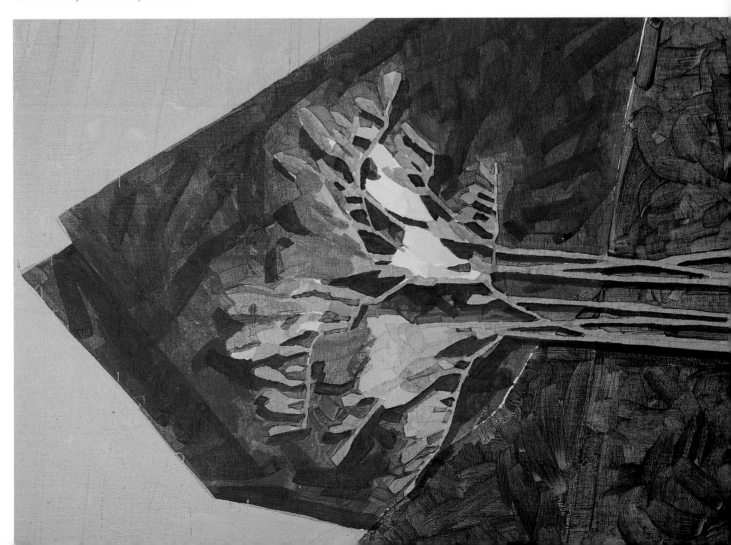

composition

Composition is about organizing the elements within the picture space to achieve a pleasing balance. It also leads the eye into and around the painting. Although there is no absolute right or wrong way to compose an image, there are some useful guidelines that you can follow.

The very best way to learn about composition is to look at works of art that you like and try to analyse how the artist composed them. Composition can be simple and conventional, with the 'rules' being strictly followed, or the 'rules' can be broken, which often results in a work having a more edgy and dynamic feel to it. It all depends what kind of mood you want to create.

All compositions are either 'open' or 'closed'. An open composition is one that implies that the subject or scene continues beyond the confines of the picture area (a device often used in landscapes), while a closed composition is one in which the subjects are contained within the picture area (often, but not always, the case in portraits and still lifes).

What lies beyond?

This is an open composition: the boats break the edge of the frame and we are aware that they are part of a much larger scene that continues beyond the boundaries of the picture area.

Frame within a frame

This is a good example of a closed composition: the louvre doors frame the balcony and the scene beyond, while the interior of the room has been painted in just enough detail to provide a context for the scene without detracting from the main subject.

Deciding what to include

Before you start your drawing or painting, it's a good idea to try out different compositions to find what works best. One way to do this – particularly when you're painting a large-scale scene such as a landscape – is to use a homemade viewfinder, which you can make from two L-shaped pieces of card. Hold it up in front of you and look through it to isolate different sections of the scene in turn so that you can check where the main focus should be.

Take the time to move around your subject to find the best viewpoint, as even a small adjustment can make a

considerable difference to the final composition. And think about your eye level, too: sometimes, crouching down low and looking up at your subject can produce dramatic-looking results.

Making a quick pencil 'thumbnail' sketch also helps: not only can you check the composition, but you can also work out the tonal values – the light and dark areas – of the scene.

Using a viewfinder

Hold your viewfinder in front of you to see different sections of the landscape in isolation. For a tight crop, hold it at arm's length; for a wide-angle view, hold it close to your eye.

Format

The next decision you have to make is about the format, or shape, of your painting. Most paintings are either landscape (wider than they are tall) or portrait (taller than they are wide), but square and letterbox formats are also used. The landscape format allows the eye to sweep from side to side and suggests stability and calm. The narrow base of the portrait format forces the eye up through the painting, and can be used to focus on a single vertical feature. (Needless to say, landscapes do not have to be in landscape format, any more than portraits have to be in portrait format!) A square format is the most contained and stable of all. The eye tends to move around the picture in a circular motion, which focuses attention on the centre; it is ideal for intimate subjects. Letterbox-format paintings are perhaps less common, but horizontal letterbox shapes can be useful for broad, sweeping panoramas and vertical ones for tall, thin subjects such as a building or a narrow mountain pass.

Placing the horizon line

In a landscape painting, one of the decisions that you need to make is where to place the horizon line. It's rarely a good idea to have the horizon going right across the centre of the image, as this cuts the scene in two, giving equal space to each half. So decide whether it's the land or the sky that is the most important part of the scene. If there's lots of visual interest in the land, you can place the horizon line high in the picture area, reducing the sky to just a small sliver, or even eliminate it altogether. If the sky is the main feature, however, reverse the proportions.

Low horizon
In this dramatic and colourful sunset, the main subject is the sky; the land, which is seen almost entirely in silhouette, occupies only about one-third of the picture area.

High horizon

Here, the main interest is the foreground shoreline, leading up to the castle on the headland. The sky is relatively bland and featureless and has been allocated less than a quarter of the total picture space.

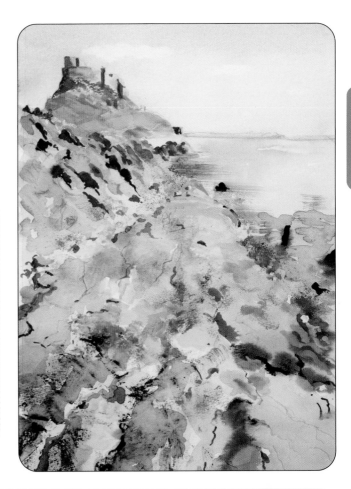

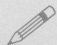

Ring the changes

A useful practice exercise is to sketch the same subject several times, changing the composition each time. Draw the same scene in landscape and portrait format, then change where you place the horizon and the main subject within the frame. Gradually you'll develop an instinctive feeling for what works best.

The 'rule of thirds'

Over the years, many formulae have been used to divide the picture area into an invisible grid upon which to construct the visual elements. A relatively simple way to begin composing your picture is to base it on the 'rule of thirds'. Mentally divide your paper into thirds, both horizontally and vertically, which gives an invisible grid consisting of nine sections, with lines crossing at four points. Placing the most important features of the painting on or near these lines and their intersections will generally give a pleasing result.

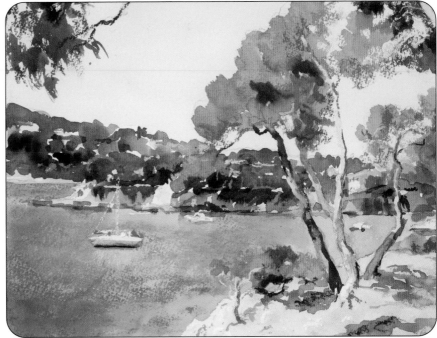

Careful placement

The large tree in the foreground of the image is positioned 'on the third', its branches pointing diagonally down into the picture space towards the yacht. The line of the sea, too, is roughly 'on the third'; don't feel that you have to stick rigidly to the 'rule' – it is simply a guide to help you impose an order on the picture. In successful compositions, the viewer is not necessarily aware of the underlying structure.

Leading the eye

In a successful composition, the viewer's eye should be directed towards the focal point. An obvious way of doing this is to have some kind of pathway – either real or implied – leading up to the main subject. In a landscape, this might be an actual path leading up to a building or the shadow of a tree pointing in from the edge of the picture towards the main subject. In a still life, it might be the edge of a table or platter pointing in towards a bowl of fruit. In a portrait, you might ask the sitter to pose with his or her hand cupped under the chin, so that the viewer's attention is directed up the arm to the face.

Colours, too, can be used to direct the eye through the painting, as can patches of light and shade. They can also link and balance one part of the image with another.

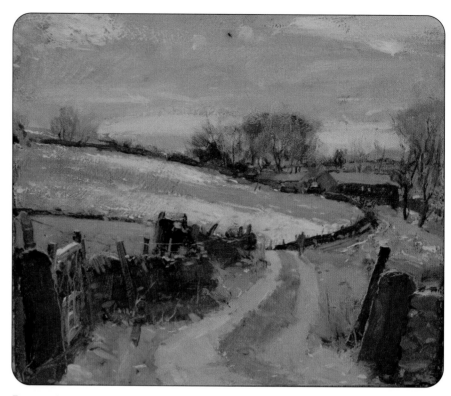

Farm track

In this rural winter scene, our eye instinctively travels along the track towards the farmhouse in the distance. The diagonal line of the hill on the left also points down towards the building – a less obvious 'pathway' through the image, perhaps, but no less effective in directing our attention.

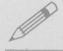

Curves and diagonals

S-shaped curves and diagonal lines (either real or implied) leading up to the main subject are always strong, effective ways of leading the eye through an image.

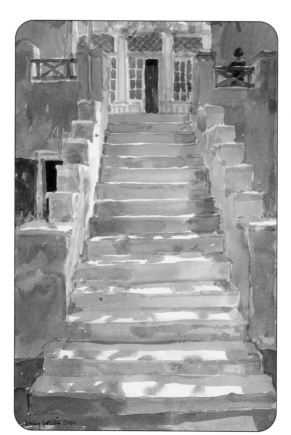

Steps

In this painting, the steps lead our eye up to the terrace at the top of the image, although the play of light on the steps themselves is just as important. Note that the steps are slightly off-centred: totally symmetrical compositions are generally not advisable, as they can make for a rather static image.

Exercise in basic composition

Several simple but effective compositional devices are employed in this simple landscape. If the paper were divided into thirds, the lighthouse and building would sit on the intersection of two lines. The headland runs across the painting a third of the way down, and ends a third of the way from the edge of the paper. The interest on this plane is balanced by the expanse and texture of the rocky foreground. The curving shoreline and white surf bring the eye back towards the centre of the drawing, and the low viewpoint and bank of clouds both help to add drama.

You will need

Mid-green pastel paper
Charcoal pencil
Pastel pencils: cerulean blue, cobalt blue, white, black, brown, range of greys, reddish brown, range of greens, Naples yellow, yellow ochre
Fixative

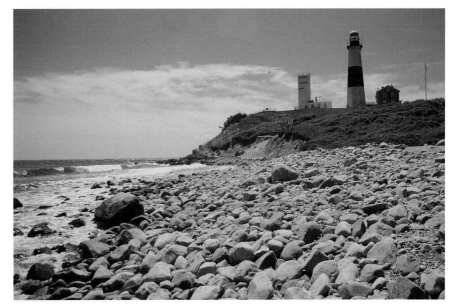

The scene
When deciding on a composition, experiment with different viewpoints and eye levels. Moving just a short distance (backwards, forwards or to one side) can make a big difference, while selecting a low viewpoint, as here, can add drama to even the simplest of scenes.

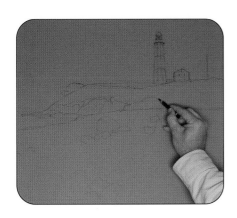

1 Use the black charcoal pencil to position the basic elements of the composition on the paper.

2 Using both cerulean and cobalt blue pastel pencils, block in the expanse of sky. Then position and shape the clouds with a white pastel pencil.

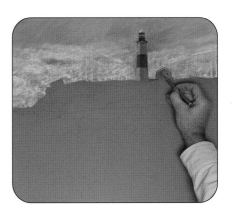

3 Draw in the lighthouse using black, reddish brown and grey pastel pencils. Work over it again, using a darker grey and black to darken the side of the building in shade. Use a blue-grey pastel pencil to draw in the wooden building to the right of the lighthouse.

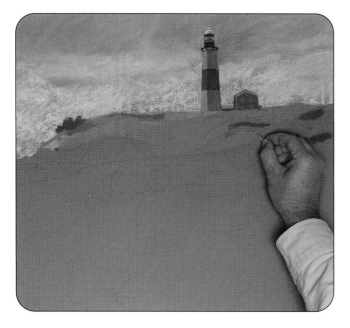

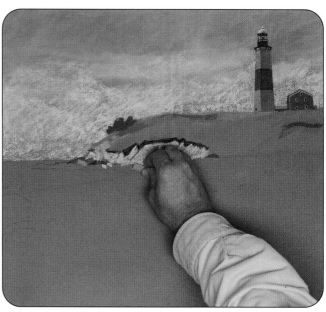

4 Use a range of greens to draw in the grass and foliage on the spit of land. Allow the mid-green colour of the paper to show through in places.

5 Use Naples yellow, grey and yellow ochre for the sandy-coloured cliffs, and black for the shadow cast by the grassy overhang.

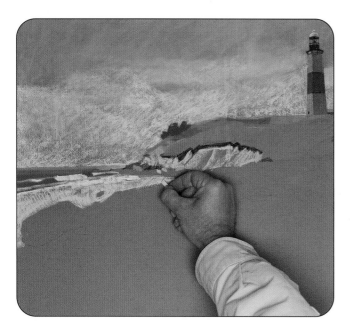

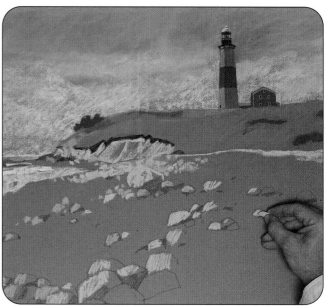

6 Select the same shades of blue as you used for the sky to draw in the sea. Scumble together white and cerulean blue for the surf.

7 Draw in the rocks with a dark grey pastel before scribbling in the light surface with a light, warm grey one. Add a few darker passages between the rocks, and a suggestion of sand, with strokes of yellow ochre. While the beach is an important part of the picture, don't overwork it. Suggesting a few of the rocks and stones, and their relative size, is more than enough to complete the drawing and to give the foreground a sense of recession.

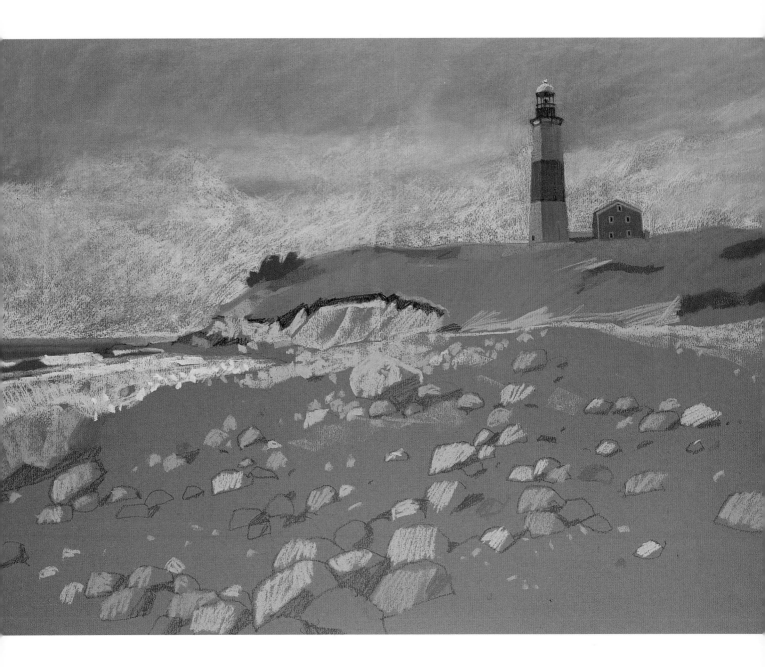

The finished drawing

The positioning of the elements, the low viewpoint and the curve of the shoreline leading into the picture all combine to make this a simple, but pleasing, composition. Note, too, the use of complementary colours – the reddish brown of the lighthouse against the vibrant green of the grass.

Alter your eye level

Experiment with different eye levels – crouching down low and looking up at your subject can give dramatic results, while looking down tends to flatten perspective and can produce some unusual and interesting shapes.



drawing

This chapter contains a series of easy-to-follow step-by-step demonstrations that you can easily replicate in your own home, enabling you to master a wide range of drawing media, from charcoal and water-soluble pencils to oil pastels and eraser 'drawing'.

shading techniques

Shading, or adding tone, is what makes your subjects look three-dimensional. Depending on the medium you are using, there are several ways of doing this.

It's impossible to overestimate the importance of being able to assess tones accurately when drawing and painting, so it's worth taking every opportunity you can to practise. Before you do so, however, experiment with the shading techniques shown on these two pages. You may be surprised at the range of tones you can create with a single drawing tool, simply by varying the density of your marks or applying more pressure. It is, of course, perfectly acceptable to combine different shading techniques in the same picture – your choice will be dictated partly by personal preference and partly by the medium in which you are working.

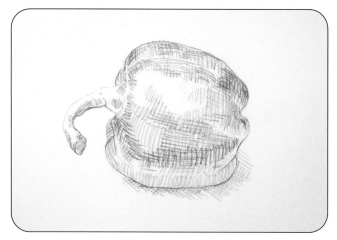

Pencil: Hatching and crosshatching
Hatching simply means drawing a series of parallel lines; crosshatching means drawing another series of lines at an angle across the first set. Here, both hatching and crosshatching have been used. Note how crosshatching in the darker areas gives an indication of the form of the pepper – the undulations in the surface mean that some areas are slightly recessed, and hence more in shadow.

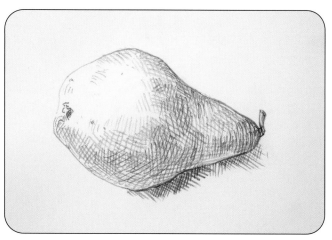

Pencil: Contour shading
In contour shading, the lines follow the form of the object to denote the often quite subtle changes from one plane to another. Here, the darkest area – the shadow under the pear – is created by applying more pressure to the pencil and by placing the shading lines closer together.

Practice makes perfect!

This is a very tricky area, so start with a straight-sided subject, as it's much easier to see the transitions in tone (see page 68). Then move on to objects with rounded surfaces, and finally ones with undulations in the surface.

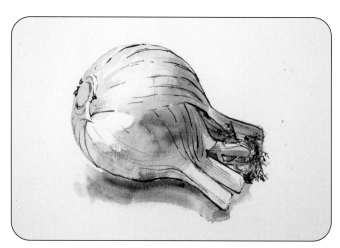

Ink: Line and wash
In pen-and-ink work, you can create tone by using washes of ink: simply dilute the ink with clean water until you have the tone that you want. Note how the paper is left white for the very brightest highlights.

Charcoal: Blending and lifting off tone

Here, the darkest tones are unadulterated charcoal, while the mid tones were created by blending the charcoal to soften the tone and give a less dense coverage; you can use your fingertips, a torchon or even a cotton bud to do this. The highlights were created by wiping off pigment with a kneaded eraser. Always apply fixative to charcoal or soft pastel drawings, so that the marks do not smudge.

Oil pastel: Stippling

Stippling – applying small dots or dashes of colour or tone – works with all media. You can create subtle gradations of tone by varying the density of the dots: leave space between them for a light tone and place them closer together for a darker tone. The colours blend optically, not physically, giving a vibrant, luminous effect.

Graphite pencil and powder: Hatching, finger blending and removing tone with an eraser

Hatching lines of varying degrees of density have been used in this simple kitchen still life. Graphite powder, stroked over the surface with a piece of paper towel, provides the mid tones, while the lightest areas were created by wiping off the graphite powder with a kneaded eraser.

shading straight-sided objects

Shading is how you make your subjects look three-dimensional and the ability to assess tones is critical (see pages 38–41). For your first attempts, try shading straight-sided objects: the transition from one plane to another is very sharp, so it's easier to see where the tonal changes occur.

It's a good idea to choose a monochromatic subject, so that you don't have the added complication of translating colour into tone. Books, cardboard boxes, plastic storage containers, children's play bricks: there are plenty of everyday objects around the home that you can use.

Instead of attempting to put in the correct tone in one go, build up the shading gradually and assess how each tone affects what you've already done. You will almost certainly find that you need to go back over areas to darken them further; in fact, you will probably be surprised at how dark the very darkest areas turn out to be.

The exact shading technique that you choose is entirely up to you: you can use hatching or crosshatching, contour shading, loose scribbles, dots or dashes, or any combination of these.

Multi-faceted puzzle in graphite pencil

This wooden puzzle is a challenging subject, as its facets receive differing amounts of light and therefore need to be drawn in different tones. For this exercise, use only one pencil: vary the amount of pressure that you apply to create darker or lighter tones, rather than switching to a harder or softer grade.

You will need

Good-quality drawing paper
2B pencil
Kneaded eraser

The subject
Positioning a strong, single light source to one side, as here, makes the tonal assessment somewhat easier. A plain white background also avoids having any element that might distract from the subject.

1 Using a 2B pencil, begin sketching the wooden puzzle. Establish one plane first (here, the artist has started with the plane that is virtually parallel to our viewpoint) and then develop the others around it. You may find that it helps to use small dots or shades to indicate the edges of each plane; you can erase these 'construction lines' later when you're happy with their position.

2 Block in one of the darkest facets of the first plane, simply to give yourself something to relate the other tones to. (You'll have to darken it much more later on.) There's a pyramid shape coming out of the centre of the puzzle towards us, each face of which is a different tone: establish its outer points, then roughly block in an approximation of the tones with loose scribbles of the pencil.

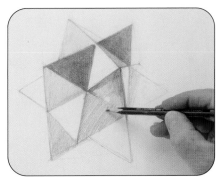

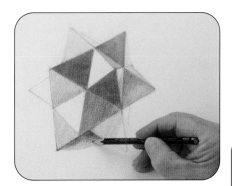

3 Continue mapping out the other facets that radiate out from the puzzle. Don't assume that all the lines intersect exactly: use your eyes and draw what's actually in front of you! Very lightly put in the outline of the cast shadow on the table top.

4 Block in the mid tones; you will probably find at this stage that you also need to darken the darks that you've already put in.

5 Continue building up the tones, assessing each area in relation to the others and adjusting as necessary. The differences can be quite subtle: half closing your eyes makes it easier to see them. Block in the very dark cast shadow under the puzzle, giving it a soft edge so that it doesn't appear to be part of the construction.

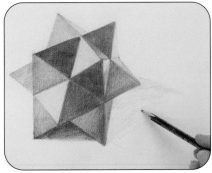

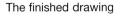

✏️ **Light touch**

For very light pressure, hold the pencil halfway or more down the barrel instead of near the tip.

6 Apply a very light tone over the very lightest facets, stroking the pencil gently over the surface of the paper. Bring the shading up to the edges of each facet rather than drawing a harsh line and shading in the shape; the edges of the facets should not be darker than the tone within them. Very loosely and lightly block in the cast shadow on the right.

7 Smudge the graphite of the cast shadow with your finger to blend it to a smooth, soft tone, then use a kneaded eraser to 'draw' a clean edge to the shadow.

The finished drawing

The puzzle looks convincingly three-dimensional, with the tones ranging from a very dense, almost black coverage in the darkest areas to a grey so light and pale that it is barely darker than the paper. Note how the cast shadow helps to anchor the whole drawing.

shading rounded objects

With rounded objects, the transition from one tone to the next is not as obvious as it is with straight-sided objects. Nonetheless, there is a definite fall-off of light, which you need to train yourself to observe and render.

Most of us tend instinctively to start by drawing a line around the edge of an object, but in reality, there is no line there: all that happens is that there comes a point where the object curves away out of our sight. An outline can be both too harsh and too dark, and destroy the subtle illusion of light and shade that you're trying to create. By all means, use an outline to map out the basic shape of your subject first to be sure you've got the proportions right – but only a very faint line as a guide, which you can shade over later. Bring the shading up to the point at which you want it to stop instead of drawing an outline and filling it in with shading.

Look for the extremes of tone – the very lightest and the very darkest areas – and then let your eye travel slowly over the objects to work out where tonal shifts occur and how light or dark you need to make them in relation to the extremes.

Contour shading

To denote changes from one plane to another, make your pencil marks follow the form of the object. This is known as contour shading.

Apples and orange in graphite pencil

This exercise is a little more complex than the one on the previous two pages, as you also need to work out how to convey different colours as tone. Orange, red and green might seem, at first glance, to be very different from one another, but as you'll see as this demonstration progresses, in tonal terms they can be quite similar.

You will need

Good-quality drawing paper
2B pencil
Kneaded eraser

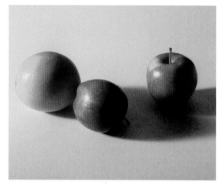

The subject
Set the fruits on a plain white background, with a light to one side so that they cast interestingly shaped shadows on both the table top and on each other.

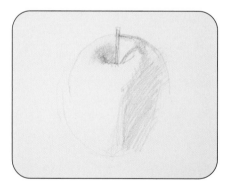

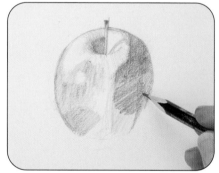

1 Using a 2B pencil, very lightly map out the upright apple and loosely indicate the darkest areas of tone with loose shading. Note how the shaded, hollow pit at the base of the stalk helps to define it. If you find that you need to modify the shape of the apple, just bring the shading further out; do not draw a new outline.

2 Strengthen the shading, bringing it up to the curved edge of the apple where the fruit turns away from the light. Think carefully about the tones: is the red darker than the green, or vice versa? Here, the area of green that is in the shade is considerably darker than the red on the left-hand side of the apple – but the green that is in the light is lighter than both the shaded green and the red.

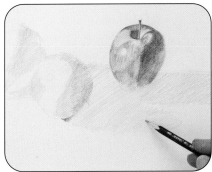

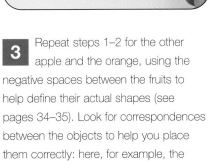

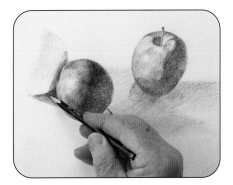

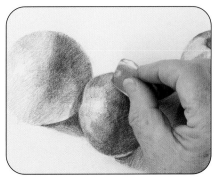

3 Repeat steps 1–2 for the other apple and the orange, using the negative spaces between the fruits to help define their actual shapes (see pages 34–35). Look for correspondences between the objects to help you place them correctly: here, for example, the base of the orange is roughly in line with the base of the upright apple.

4 Gradually strengthen the shading on the left-hand apple and orange, making your marks follow the form of the fruits, as before. The left-hand apple is darker in tone than the apple on the right: this is due to its local colour, rather than to much of it being in shade. Scribble in the shadow cast by the orange and left-hand apple, which hits both the table top and the apple on the right: tonal variations within the fruits and the cast shadows give us clues to their form. Scribble in the very dark cast shadow between the orange and left-hand apple, too.

5 Shade the orange in the same way as the apples. If any areas do seem to be too dark, dab off graphite with a kneaded eraser.

The finished drawing

Through the use of contour shading and scribbled tone, the artist has successfully conveyed the rounded forms of the fruit. Note how wide the tonal range is: the white of the paper stands for the very brightest highlights, while the darkest areas are a rich, dense black.

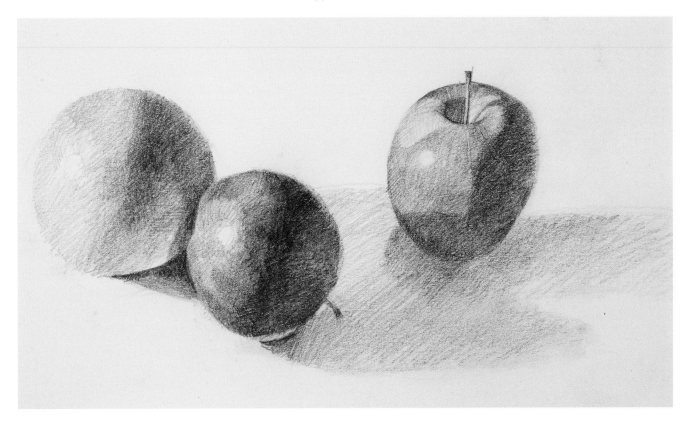

drawing with a technical pen or fineliner

The linear qualities of technical pens and fineliners make them ideal for rendering the hard lines found in architectural subjects. Their design enables you to make only a single, standard thickness of line; if a line of different thickness is required, use a pen with a different-sized nib.

Crosshatching

To make a tonal drawing using one of these pens, you will need to use a series of hatched and crosshatched lines. The density of the lines dictates the density or depth of tone. Crosshatching the lines by making a line, or a set of lines, run in a different direction is easy to control and is, in addition, a quick way to build up density within the drawing. The direction of the lines can also show any contours and the direction of surfaces.

You will need

Smooth good-quality drawing paper
4B pencil
Technical pen or fineliner

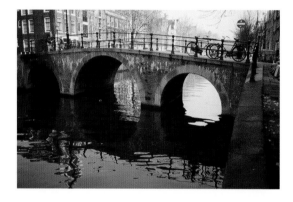

The scene
In this scene of a bridge over a canal in the Dutch city of Amsterdam, the simple geometry of the bridge's arches is reinforced by the strong shadows on the water beneath. The presence of the two bicycles adds a touch of human interest.

1 Use a 4B pencil to make your initial marks on the paper, as any major mistakes will be difficult, if not impossible, to correct once you begin working with the pen. Take careful measurements (see pages 42–43) to ensure that you get the proportions and distances right.

2 Using the pen, draw in the lamppost, followed by the railings. Follow the general direction of each object when making your marks and do not overdo the drawing: you can always make areas denser by adding more lines later on.

3 Sketch the tree and crosshatch to build up the density of the foliage. Add the bicycles, giving them a darker tone by again concentrating on the hatching and crosshatching. Put in the bollards, keeping the lines close together to create a dark enough tone.

4 Draw in the arches of the bridge, focusing on the lines that run parallel to the water level. Then follow the curve of the arches, showing their surface direction, or contours.

5 The dark reflections of the bridge are distorted by the movement of the water. Make the hatching multi-directional here, so that the reflections, although they are similar in tone, look different from the underside of the actual bridge.

6 Continue to build the bridge's reflections with lightly crosshatched lines. Indicate the courses of brickwork with a series of hatched parallel lines.

7 Apply some widely spaced cross-hatching to give the bridge and its reflection an overall tone and to darken the density of the area beneath the arches.

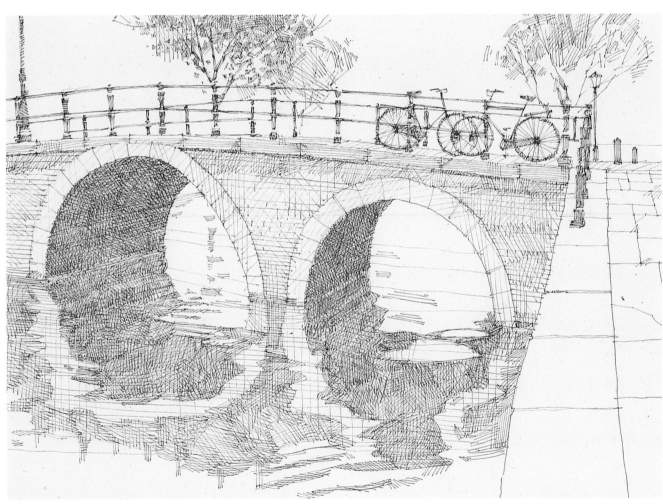

The finished drawing

The web of lines results in surprising depth and tonal range. This could be extended further by reworking the areas beneath the bridge and filling in the background; however, in a drawing such as this, where corrections can be difficult to make, it is often better not to overwork.

line and wash

When used with a dip pen and nib, ink is strictly a linear medium; any dense tonal or coloured areas are shown by building up a web of dots, dashes or lines. When ink (diluted with water) is used with a brush, however, it is possible to cover areas with washes of tone and colour.

Both waterproof and water-soluble inks are available. Once it has dried, waterproof ink will not run if a wash is applied on top of it. With water-soluble ink, however, you can brush clean water over lines to create areas of tone. Using a combination of waterproof and water-soluble inks in the same drawing enables you to achieve interesting effects – but you must work out in advance where you want to retain the pen lines and where you want to blend them. The line work can be done first, with the colour, or tonal, brushwork coming later. With this approach, however, there is a tendency simply to work between the lines. A freer way of working is to apply the washes of colour or tone first, as in the exercise opposite. Once these are dry, the pen is then used to search for the outline and any linear details.

Waterproof and water-soluble ink effects

Some water-soluble inks blur and spread more than others, so experiment to find out what effects you can achieve.

Waterproof ink	Water-soluble ink	Creating an area of tone with water-soluble ink

1 Scribble a few lines in waterproof ink and leave to dry.

1 Scribble a few lines in water-soluble ink and leave to dry.

1 Crosshatch an area of the paper using water-soluble ink and leave to dry.

2 Apply a wash of colour over the ink; the lines remain as drawn and do not blur or spread.

2 Apply a wash of colour over the ink; the lines blur and are less distinct.

2 Brush clean water over the ink; some of the ink colour is pulled onto the unhatched areas, creating a pale wash of tone.

Still life with langoustines and lemons

This simple still life is a wonderful subject to draw, as the shape is made up of a pleasing combination of flowing curves and sharp angles. The crisp linear detail required on the langoustines, combined with the subtle colours of pink and lemon yellow, make it the perfect subject for a line-and-wash treatment.

You will need

HP watercolour paper
6B pencil
Dip pen with medium nib
Medium round watercolour brush
Inks: cadmium yellow, crimson red, cobalt blue, sepia
Paper towel

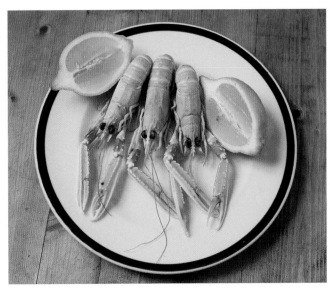

The subject
Arrange the langoustines and lemons on a plate, with one lemon overlapping the edge to break up the outline. Here, we used a white plate with a blue rim: the white china does not distract from the objects and can be left as white paper in the drawing, while the blue rim provides a colour contrast and holds the whole composition together. Place a table lamp off to one side so that the objects cast small but distinct shadows.

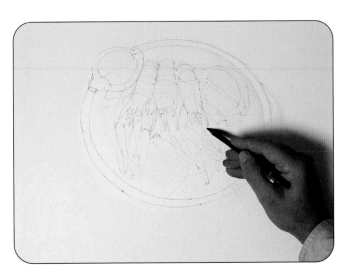

1 Make a soft pencil drawing, which will act as a guide for future work. The coloured washes will cover this drawing, making it impossible to erase, so keep them as light as possible; indicate only the position and major shapes of the objects.

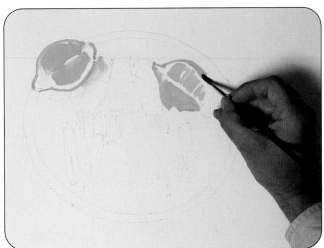

2 Using the medium round brush and cadmium yellow ink, paint in the lemons. Dilute the ink with water for the centre of the fruit; use the ink at full strength when painting the peel.

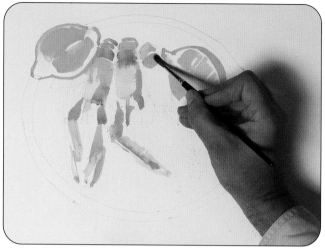

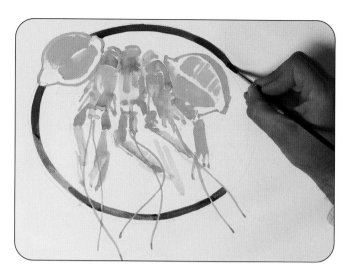

3 Mix together a little yellow and crimson red ink diluted with water; this will give you an orange-pink mix for the legs and claws of the langoustine. Work around any light or highlighted areas, allowing these to show through as white paper.

4 With fluid strokes, brush in the antennae or feelers. Allow the ink to dry, then carefully paint in the blue line around the edge of the plate.

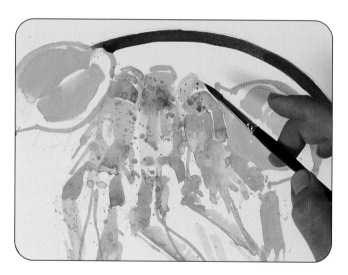

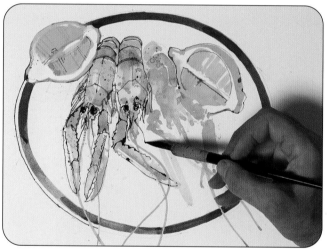

5 Once the blue ink is dry, you can add texture and pattern to the langoustine by spattering (see page 132) the relevant areas with the orange-pink mix. Load the brush, hold it over the area to be spattered and then tap it sharply to dislodge drops of ink. Use a paper towel to blot up any droplets that land where they are not wanted.

6 As soon as the wash work is dry, use the dip pen and sepia ink diluted with a little water to redefine the shape and textures of the lemons. Use full-strength ink to draw in the edge of the plate, and work over the langoustines, containing and defining their respective shapes. Try to capture the smooth and jagged surfaces and lines by turning the nib and applying varying pressure to release more ink and alter the thickness of the lines.

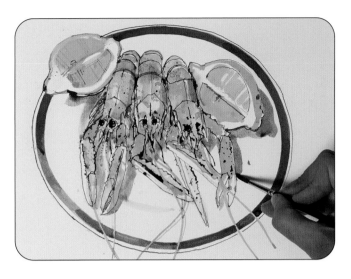

7 Once the line work has been completed, paint in the shadow areas with a mixture of cobalt blue and sepia thinned with water. Complete the drawing by adding a dark shadow beneath the plate; this helps to create the illusion of lifting the plate from the paper or drawing surface.

The finished drawing

The graphic precision of the line produced by a fine-nibbed pen is ideal for rendering the sharp, spiky shells of the langoustines, while the soft washes of ink provide a subtle touch of colour.

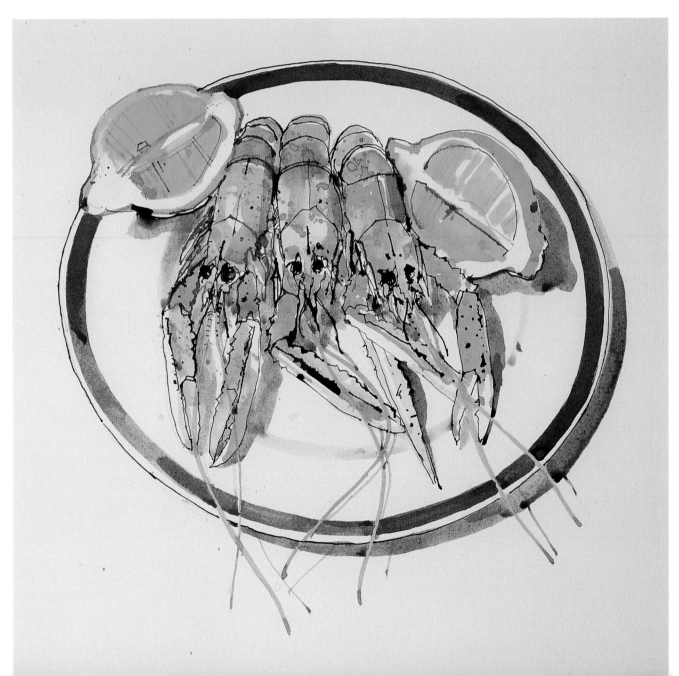

drawing with charcoal

At first glance, the marks made by a stick of charcoal may seem remarkably direct and lacking in subtlety – but it is a remarkably versatile material and an ideal medium for beginners.

Charcoal skims over the surface, encouraging you to work quickly and freely, and makes a very positive mark that, as long as it remains unfixed, can be easily removed simply by using a soft brush or flicking with a soft rag. The residue of the charcoal mark not only adds to the drawing, but also acts as a guide for later work.

People often assume that charcoal cannot be used to draw fine detail. In fact, charcoal can be used effectively for rendering detail as long as you work in a broader manner than you would do if, for example, you were using a pencil.

When using charcoal, choose a paper that has a slight texture or tooth. On smooth papers the charcoal dust cannot take hold, and the charcoal stick seems to slide. The drawing will look grey and lack any depth as it is almost impossible to make a full black mark, no matter how much pressure you apply. A reasonably substantial cartridge paper will suffice or a sheet of NOT watercolour paper.

Lifting out
Use a kneaded eraser to correct errors, lift out highlights or 'draw' back into the dark tones by pulling off charcoal.

Charcoal techniques

Charcoal is an ideal medium for conveying tone, as it is easy to blend. Marks can be varied by simply changing the pressure as you go. Charcoal can easily be erased or removed. Blending produces a smooth, matt effect.

Blending
Draw a series of lines. Using your finger or a torchon, gently rub the lines together. Create lighter or darker tones by varying the pressure.

Laying in solid tone
Gently rub the side of a thick stick of charcoal across the paper surface. This is especially effective on textured paper.

Still life with shells

In this exercise, you will have to vary the qualities of your line work, and pick out the subtle forms with a range of tones, in order to draw the shells successfully and to show the differences between them.

You will need

NOT watercolour paper
Charcoal pencil
Thin and thick sticks of charcoal
Paper towel
A soft rag
Fixative

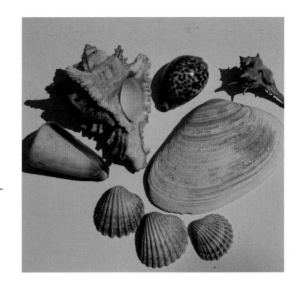

The set-up
Select shells of varying shapes and sizes, aiming for a contrast between those with smooth, flowing lines and those with sharp, angular edges. Arrange them on a plain background (a sheet of paper will do) and place a lamp to one side to create some shadow and throw the shells into relief.

1 Sketch in the basic shapes with a charcoal pencil. These marks are only a guide and should be barely visible; if they appear too dark, dust the surface of the paper with a soft rag to lighten them. Rest your hand on a sheet of paper towel to prevent smudging.

2 Complete your basic drawing, paying particular attention to the spaces, shapes and distances between the shells. Do not apply too much pressure with the pencil as this would make these marks too dense. Apply a light spray of fixative to prevent any smudging.

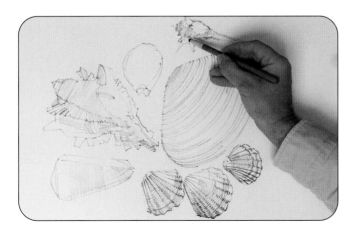

3 Draw any internal linear marks on the shells' surface. These marks describe the surface texture, and also follow the overall shape of the shells and the direction of their surfaces. By applying more or less pressure to the pencil, you can vary the thickness and depth of tone in the line work.

4 Use the thick stick of charcoal to scribble in the dark markings on the smooth-surfaced shell in the background.

5 Use the thin stick of charcoal in a loose and fluid manner to create textural quality. Always consider the surface direction of the particular shell and follow those contours. Then apply a spray of fixative to retain these marks in position.

6 Use your finger to blend and smudge the lines over the surface of the shells to create tone and further texture.

7 Scribble in further details and shading within the shells, using the thin charcoal stick.

8 Once you are satisfied with the shells, turn your attention to the shadows. Scribble these in carefully, as they consolidate the shape of the shells and create a three-dimensional illusion. Apply a final spray of fixative to the drawing.

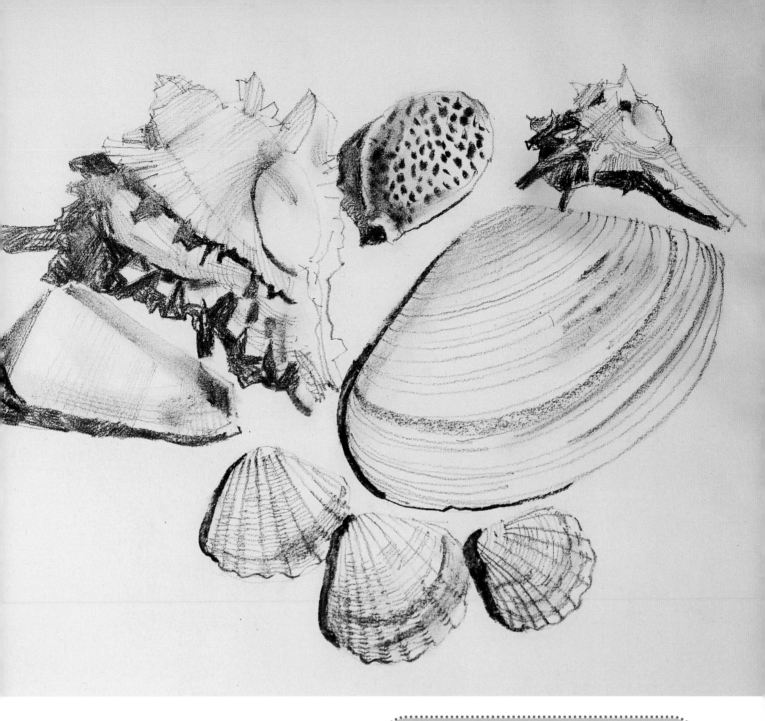

The finished drawing

Working on a broader scale than usual has meant that the charcoal has been allowed to show its true potential, creating a combination of fine lines, smoothly blended areas of tone and dense, intense scribbles for the shadow areas. The NOT watercolour paper used here has a definite 'tooth', which also contributes to the textures.

The versatility of charcoal

Experiment to see how many different kinds of mark you can make: delicate linear details using the tip of a thin charcoal stick; light, broken lines that help to convey texture; dense scribbles; finger-blended marks to create areas of soft tone; broad areas of tone laid in with the side of a medium or large charcoal stick.

eraser 'drawing'

An eraser is perhaps not the most obvious drawing tool, but it can be used very effectively to remove graphite, coloured pencil, charcoal and even soft pastel to create light areas and highlights.

The technique works best with subjects that contain both very dark and very light tones. Kneaded erasers can easily be moulded into specific shapes simply by pulling them into shape with your fingers, making it possible to use them for very tiny, precise marks, but they do get dirty very quickly.

Plastic erasers are harder and can be used with softer drawing materials such as charcoal without becoming completely clogged. If the eraser picks up pigment as you use it, take care not to transfer the pigment to areas where it is not wanted.

Eraser 'drawing' techniques

'Drawing' with an eraser is very simple: just hold it in the same way as a pencil and wipe it across the paper to remove pigment. You can also pull dark lines out from a patch of charcoal onto clean, white paper using a torchon, paint shaper or even your fingertips.

Kneaded eraser
Wipe a kneaded eraser across an area of charcoal or pastel to remove the dust or pigment and create white lines. For finer lines, either use the chisel-shaped edge or pull the eraser out into a sharp point with your fingertips.

Paint shaper
To pull dark lines out of a patch of charcoal or soft pastel onto white paper, 'draw' into the pigment with a rubber-tipped paint shaper.

Silhouetted tropical plants in charcoal

This scene in a hothouse of tropical plants has a wide tonal range, from the dense blacks of the plants to the bleached-out sky and its reflections on the wet pathway. Applying a covering of charcoal dust and then wiping out the light areas and highlights allows you to work in a bold, spontaneous fashion that would be difficult to achieve in any other way. This exercise uses a kneaded eraser, as it can easily be moulded to a fine point.

You will need

Heavyweight drawing paper
Thin and medium charcoal sticks
Kneaded eraser
Rubber-tipped paint shaper
Fixative

The scene
The sculptural leaves of tropical plants in a hothouse silhouetted against a blank, featureless sky cry out for a bold, dynamic treatment; given the almost monochromatic nature of the scene, charcoal is the obvious choice. Note how the wet pathway leads the eye through the picture.

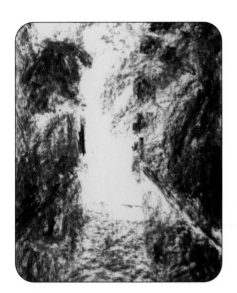

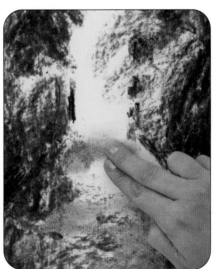

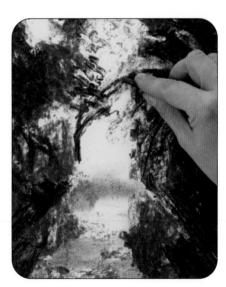

1 Using the side of a medium stick of charcoal, block in the darkest areas of the scene, leaving the sky and pathway with only a light coverage. Don't press too hard: these areas will need to be much darker still and all you're trying to do at this stage is establish the overall tonality. Put in some more linear marks for the edges of the raised beds alongside the path.

2 Using your fingertips, blend the charcoal on the pathway to create a softer, mid-toned area.

3 Using a thin stick of charcoal, draw in the main trunks and branches of the trees overhanging the pathway, scribbling in the lines quite vigorously.

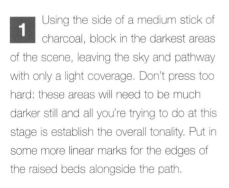

Eraser too dirty?

If your kneaded eraser gets completely clogged up with charcoal dust, to the point where you find you're actually applying dust rather than removing it, simply cut or tear off the dirtiest portion and reshape it.

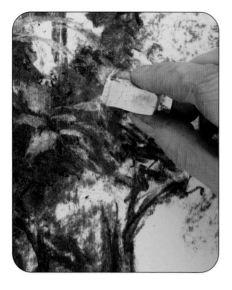
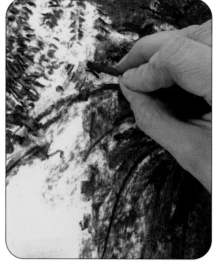
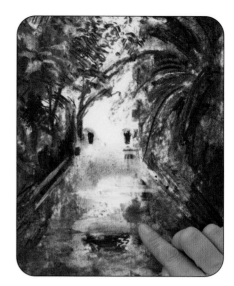

4 Pull a piece of kneaded eraser to a fine point and 'draw' the shapes of the broad leaves on the left of the image, pulling off charcoal dust to reveal mid-toned shapes.

5 Using small strokes and dots, scribble in the silhouetted leaves at the very top of the picture. Up to this point, you've mostly been applying broad areas of tone; here you need to be a little more precise and look at the shapes and sizes of the leaves in more detail.

6 Using the side of the charcoal, apply more tone to the path in the foreground. Using the tip, draw in the dark, wet puddle in the centre of the path and the large flowerpots on either side of it. Blend the mid-toned areas of the path with your fingers. Where necessary, use the eraser to lift off pigment and create highlights on the wet paving.

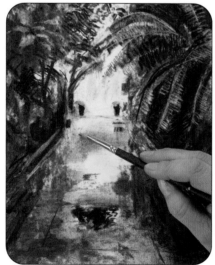
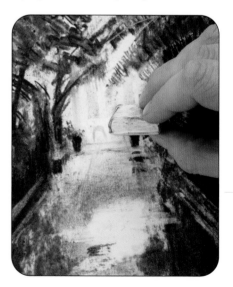

7 Pull the edge of your kneaded eraser to a fine point and begin wiping out the spaces between the palm fronds, where the sky is visible.

8 Using the tip of the thin charcoal, draw in the lines of the paving, noting carefully how they appear to converge as they recede away from you. Towards the back of the image, where the sunlight hits the wet floor, make your marks less distinct: use the tip of a paint shaper to pull charcoal out into thin lines.

9 The large glass windows at the end of the pathway are very bright. Cover this area with a thin coating of charcoal, then use the kneaded eraser to pull off charcoal and create the shapes of the window panes.

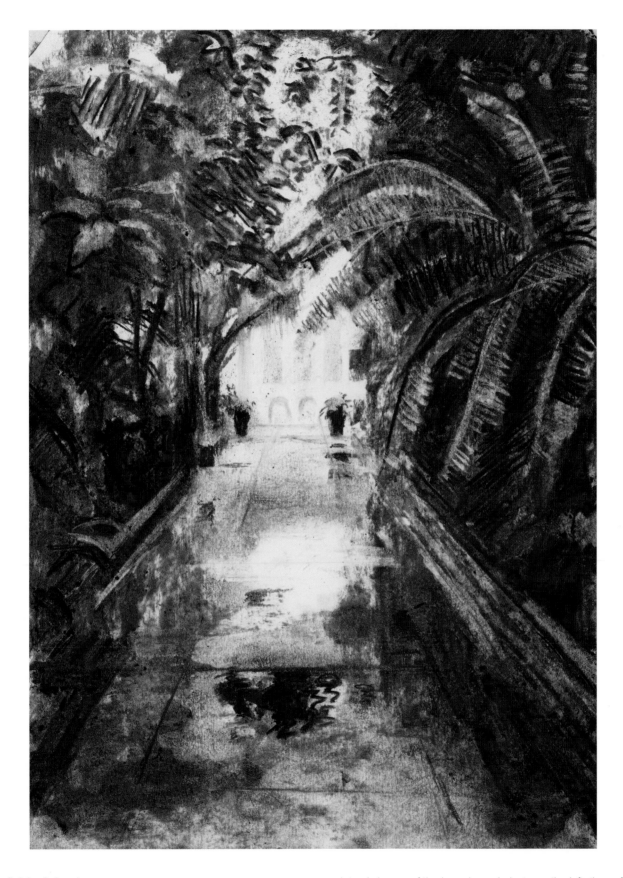

The finished drawing

This is an atmospheric drawing that is full of interesting textures and shapes: the bold, precise lines of the palm fronds; the sculptural shapes of the large-leaved plants on the left; the softly blended areas of tone on the floor; the bleached-out sky and reflections on the wet path.

drawing with soft pastels

Works in soft pastel have a wonderful freshness and sparkle that makes them very appealing. They combine the colour of painting with the immediacy of drawing.

Using a toned ground

Papers for pastels are coated with pumice powder or tiny cork particles that hold the pigment and allow for a build-up of colour. Pastel drawings are best made on a tinted paper that is sympathetic to the subject, either in contrast, colour or tone; this is known as a 'toned ground' (ground simply being another term for the prepared surface on which a drawing is made). This eliminates the need to cover the surface completely, as the paper inevitably shows through in places, helping to consolidate the work. Pastels drawn on white paper can look pale and insipid and lack bite and sparkle.

Mixing colours

Colour mixes using pastel are achieved in a number of ways. Colours can be placed next to each other and then blended together using a finger, a paper torchon or a blending stump. This is the traditional way of using pastel and the result is a very smooth transition from one colour or tone to another.

The alternative is to allow the colours to work with each other by mixing them optically on the paper itself.

Finger blending
The easiest way to blend soft pastels is to use your finger – but do make sure your hands are clean and free of grease.

Blending with a torchon
A torchon, made from compacted paper pulp, can also be used to blend soft pastels. As it has a pointed end, it is ideal for small areas. (A cotton bud is a good alternative.)

Cleaning pastels

Pastels can get dirty very quickly. Colours rub against each other in boxes and fingers transfer colour from one pastel to another. Fill a box or glass jar approximately half-full with rice and drop in the dirty pastels. Shake the jar lightly for a few minutes: the abrasive action will remove the dirty areas and reveal the clean colour beneath.

Optical colour mixing
Each colour or tone used is scribbled onto the paper with open strokes, which allows the background colour, or previously applied pastel, to show through.

Glazing
Soft pastels can also be mixed by applying a thin glaze (covering) of one colour over another.

Still life with fruit and vegetables

A few fruit and vegetables, a cloth and a plate make a simple subject for a still-life drawing, and they are also a perfect match for the colours found in an inexpensive box of pastels. This drawing is done on a toned ground – a dark green pastel paper that perfectly complements the subject.

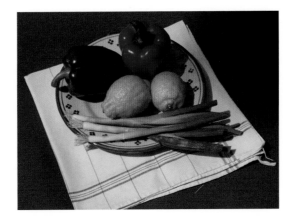

The subject

Placing the objects on a dark-coloured background brightens the colours to a considerable degree, while positioning the dish towards the back of the cloth breaks what would otherwise have been a near-symmetrical arrangement. Tilting the cloth within the picture frame gives the composition a sense of visual dynamism.

You will need

Dark green pastel paper
White pastel pencil
Soft pastels: cadmium red, crimson, pink, range of greens and yellows, orange, white, Naples yellow, purple, ultramarine blue
Fixative

1 Using a white pastel pencil, establish the basic position of the objects. The dark green pastel paper gives a density in the shadow areas and helps the colours to appear vivid and bright in contrast.

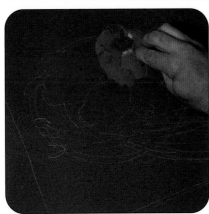

2 Use cadmium red and crimson, together with pink for the highlighted areas, to draw in the red pepper. Use the chiselled edge of the pastel to make firm and direct strokes to the surface of the pepper.

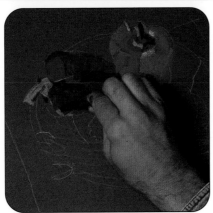

3 Using a range of greens, add the pepper stalks and the pepper itself. The pastels will probably not match the colour of the objects exactly, but this is not important. Choose colours that are close; once the work is finished, it is surprising how correct they can appear.

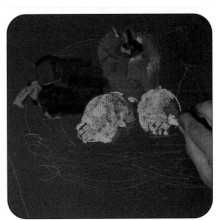

4 Add the lemons, using a range of yellows together with a touch of orange to suggest the reflected red from the pepper. Apply a dull green colour for the deep shadows.

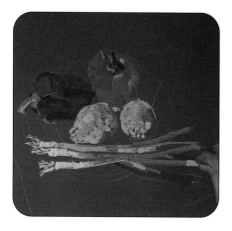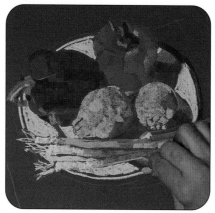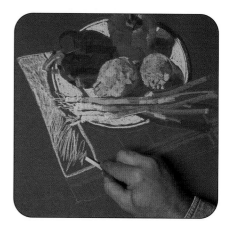

5 Using acid greens, make long strokes for the stalks of the spring onions. White mixed with a touch of Naples yellow suggests the small bulb and its roots.

6 Once the fruit and vegetables are complete, draw in the shadows on the plate with a dull purple. Block in the plate itself with Naples yellow.

7 Paint in the pattern on the cloth with crimson, and then block in the cloth itself with scribbled white. Work around the red linear pattern, rather than placing the white first and then drawing the red lines over it. This keeps the red colour strong as it does not pick up any of the white, which would turn the red to a shade of pink. Complete the sketch by adding a touch of ultramarine blue in the shadow area.

The finished drawing

This sketch uses very few different colours, yet the careful choice of colour for the pastel paper, and the direct strokes, result in a solid picture that belies its simplicity.

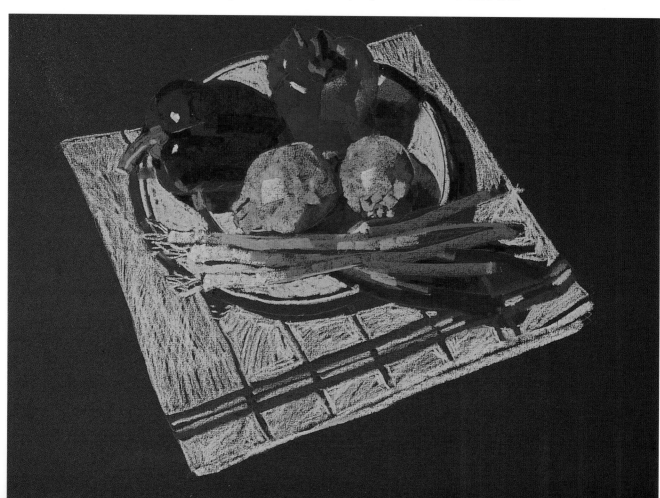

Fishing boats on beach

A small beach or harbour will have more than enough visual material to hold an artist's attention for hours, if not days. The colours are usually bright, yet weathered by the elements over a long period of time. Owing to the reflective qualities of the sea, the light, even on dull days, can be quite intense.

Pastels are a quick medium for capturing these scenes. They enable the image to be built up, as would be the case if working on an oil painting. This project focuses on boats, which are a challenge to draw and paint as their shapes are often very subtle, with many smooth lines and curves. Start with thin glazes to establish the image before completing it with crisp, heavy impasto work to represent the pebbled beach and the dappled light on the sea.

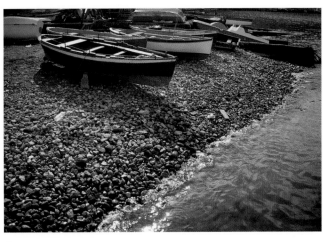

The scene
This is an unusual composition in that the main subject is close to the top of the image frame. A sense of dynamism is provided by the diagonal division between beach and water.

You will need

Brown pastel paper
Black charcoal pencil
Soft pastels: burnt umber, black, range of reds and greens, light
 and dark ultramarine blue, light grey, white, yellow ochre,
 Naples yellow, light and dark cobalt blue
Fixative

 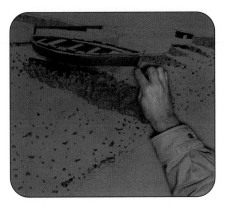

1 Use a black charcoal pencil to sketch in the main elements of the composition. Work lightly and make any corrections by drawing over your previous marks. As all the initial drawing will later be covered, there is no need for you to erase any mistakes.

2 Using the side of a short length of burnt umber pastel, block in the dark shadows beneath the boats, the dark areas inside the boats, the wall and the shadows cast by the stones. Add density and detail into the shadow areas with the side of a black pastel.

3 Establish the shaded sides of each boat, using a combination of several shades of red and green. Scribble one shade on top of another one to get a rough idea of the correct colour to use.

4 Use a selection of light and dark ultramarine pastels to indicate the brightly painted timbers on the far boat.

5 Pick out the white paintwork and some of the highlights on the boats with light grey and white pastels.

6 Using a combination of scribbled yellow ochre and Naples yellow, and hard, more direct marks than before, begin building up the layers of sand and stone on the surface of the beach. Once you have established the beach, apply a spray of fixative. Already, the deep shadows and bright highlights reflect both the intensity of the light and the warmth of the atmosphere.

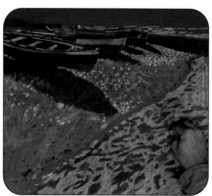

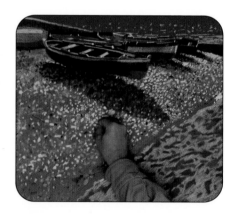

7 Combine light and dark cobalt blue to suggest the shadows and ripples in the sea along the line of the shore.

8 Use the light cobalt blue to fill in the distant sea at the top of the painting and also to add in a few highlights. Then add more detail to the rippling sea surface in the foreground.

9 Using hard, short, direct strokes, apply light grey, yellow ochre and Naples yellow to build up the pattern of the pebbles on the beach. Work across the area, using one colour before switching to another, and vary the size of the marks.

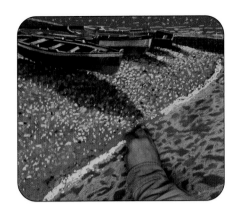

Start lightly!

Never apply thick, heavy pastel early on in a drawing, as it clogs the texture of the paper, making the application of subsequent layers difficult, if not impossible.

10 Use a white pastel, applied with heavy strokes, to insert the dappled light along the edge of the sea. Once complete, apply the final coat of fixative.

The finished drawing

The contrast between the pattern of the pebbles on the beach, the heavy texture of the waves and the view of the far distance at the top of the image creates a dynamism that make this drawing quite striking. The technique of applying the pastel as thick impasto helps recreate the effect of sunlight glinting on the rocks and stones littering the beach.

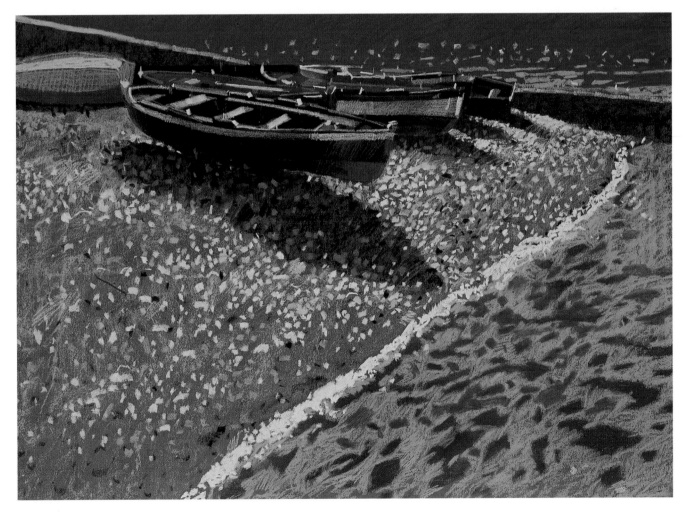

drawing with oil pastels

Because of their size, oil pastels are not really suitable for detailed work. Instead, work on a broad scale and take advantage of the textural qualities and rich, buttery colours that they can offer.

Oil pastels can be used on any of the usual oil supports, specially prepared oil painting paper and even unprimed drawing paper. The rougher the surface, the more broken the colours become; a smoother texture will result in a less broken look. You do not need to fix oil pastel drawings.

You can use oil pastels on top of dried oil paints, watercolour and even charcoal and pencil, so if you're interested in mixed-media paintings, they're incredibly versatile. You can also scratch into them with a craft knife or other sharp implement to create sharp, incised lines.

One disadvantage, however, is that the range of colours for oil pastels is nowhere near as great as that for soft pastels, so you may find it difficult to achieve completely realistic-looking colours. Another is that they never completely dry and can, over a long period of time, permeate and degrade the paper.

Still life of vegetables

Although you can use white paper, a toned ground (see page 144) is a good option. This demonstration uses oil pastels in several ways: vigorous scribbles, pressing hard on the pastels to create a solid coverage; blending with solvent; and scratching into the pastel with a sharp-tipped pencil to create linear detail.

You will need

Heavyweight grey paper
Oil pastels: pink, pinky-peach, bright red, dark green, dark blue, black, burgundy, bright blue, bright green, bright yellow, white, orange, greenish yellow, pale grey, mid-grey
Small brush
White spirit or turpentine
Sharp-tipped 5B pencil

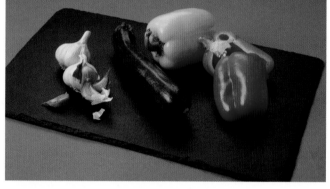

The subject
Here, a few vegetables from the kitchen have been arranged on a piece of black slate. Although this is just a simple practice exercise, it's worth taking a little time over the composition: look at the negative spaces in between the objects and cut or break some of the vegetables open to make the arrangement more interesting.

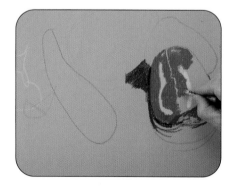

1 Using the tip of the pastels, roughly outline the shapes. Using pink or pinky-peach, scribble in the highlights on the red pepper, then work around them in bright red to block in the rest of the pepper. Establish the cast shadows using dark green, dark blue and black.

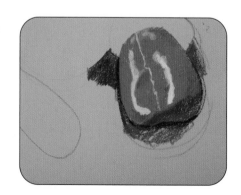

2 At the base of the pepper, which is in shadow, crosshatch burgundy over the red.

Blending oil pastels optically

Blending oil pastels physically

Loose scribbles
You can blend oil pastels optically on the support by working in scribbled layers.

Crosshatching
Alternatively, work a series of crosshatched lines in different colours; the resulting optical mix is more lively than a physical blend of the two colours would be.

Blending with a solvent
You can blend the colours on the support by applying white spirit or turpentine with a brush or rag.

Applying a light colour over a dark one

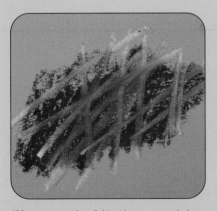

Applying a thin wash of colour

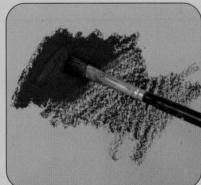

When you apply a light colour over a dark one, it picks up the underlying colour: here, applying white over red has resulted in a series of pale pink marks.

1 Scribble some oil pastel onto scrap paper, then brush over it with white spirit or turpentine.

2 Pick up some of the colour on a brush and apply it to your chosen support. The result is a thin wash of colour.

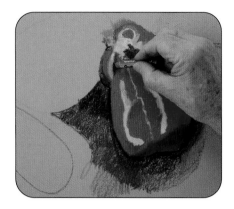

3 Loosely hatch in a little more of the background in bright blue, allowing some of the paper to show through. Scribble in the stalk, using bright green and bright yellow. Use a peachy-pink for the pith and seeds on the inside of the pepper, and overlay bright blue on the red for the shaded recesses inside.

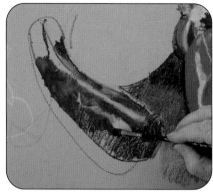

4 Block in the courgette, using dark green with a brighter green for the highlights. Dip a small brush in white spirit or turpentine and brush over the green to soften and blend the pastel marks. You may need to use some white for the very brightest parts of the highlights. Loosely and lightly hatch over the courgette with a bright yellow to create some texture and tonal variation on the surface.

Be bold!

Scribble the colour on vigorously, making your strokes follow the form of the vegetables. You can press quite hard on oil pastels without them breaking.

The exact colours of the shadows are not important, but the green, in particular, forms a complementary contrast to the red, which is often a useful technique for creating shadow colours.

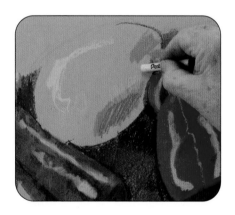

5 Use a bright yellow for the highlight areas of the yellow pepper, with orange and red on the shaded parts.

Don't overblend

Don't blend the pastel colours completely: it's important to have some tonal variation, as the courgette is not a uniform hue throughout.

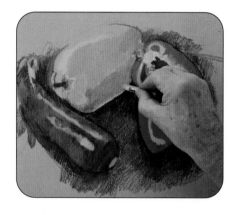

6 Keep scribbling blues and greens onto the background as you go, keeping the hatching quite loose so that the background looks less substantial than the vegetables. Use a greenish-yellow for the mid tones on the yellow pepper, then apply pink and orange to the base, where there is some reflected colour from the red pepper alongside.

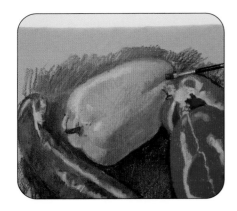

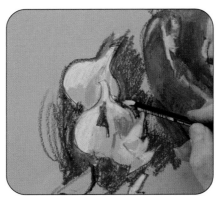

The finished painting

The rich, dense colours of oil pastels are perfect for capturing the shiny, reflective surfaces of the vegetables. Colours are blended both physically (using white spirit) and optically by crosshatching one colour on top of another, which gives the work a lively, spontaneous feel.

7 Blend the colours with solvent, as you did on the courgette in step 4, but allow some hatching to remain visible on the surface.

8 Apply white and pale grey with hints of yellow over the garlic bulbs, with burgundy and orange/pink for the pink, papery cloves inside. Allow the mid-toned grey of the paper to stand for the darker grey areas of the garlic. Draw into the oil pastel with a sharp-tipped 5B pencil: it adds linear detail that contrasts well with the flatness of the colour on the other vegetables.

drawing with water-soluble pencils

Water-soluble pencils combine the characteristics of both ordinary coloured pencils and watercolour paint in one drawing tool.

They can be used dry in exactly the same way as non-soluble coloured pencils for linear detailing and shading. Like ordinary pencils, you can hatch, crosshatch and scribble one colour over another to blend them. When you apply water, however, the dry pigment becomes liquid colour and behaves like watercolour paint. This makes them incredibly versatile – and also a great and easily portable medium for drawing and painting on location.

Farmyard chickens

This exercise allows you to use water-soluble pencils as a dry drawing medium for linear marks and as a kind of watercolour, by brushing clean water over the pencil marks to blend them into a delicate wash.

You will need

Watercolour canvas board
4B pencil
Ruling drawing pen or old brush
Masking fluid
Water-soluble pencils: burnt sienna, Vandyke brown, violet, magenta, pink, yellow ochre, dark blue, yellow, orange, red, range of greens, pale charcoal grey, reddish-brown

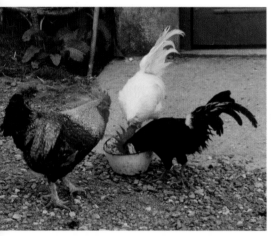

The scene
Although the background and foreground of this scene is quite messy and unattractive, the shapes and the wonderful colours of the birds' plumage make this a rewarding subject to draw. With scenes like this, take lots of reference photos: it's almost inevitable that one or more of the birds will have its head largely hidden from view and you may have to combine several reference shots to get a composition and viewpoint that works.

1 Using a 4B pencil, sketch the main elements of the scene, paying particular attention to the angles of the birds' bodies. Even though you're only putting down a quick outline drawing here, try to think of them as rounded, three-dimensional forms. Using a ruling drawing pen or an old brush, mask out the white feathers so that you can preserve the white of the canvas board in these areas (see page 126).

2 At first glance, the chicken on the right looks as if it's almost entirely black, with some white feathers on the tail, but in fact these dark feathers are almost iridescent: look closely and you will see dark purples, blues and greens. Start by scribbling in the legs and feet with burnt sienna, then block in the base colour of the body with Vandyke brown. Apply violet over the tail feathers, taking care not to dislodge any of the masking fluid.

Water-soluble pencils are easy to work with – you simply need to get used to how much water you need to apply if you're using them wet, so that you don't flood the paper with water or dilute the colour too much.

Creating a wash with water-soluble pencil

1 Loosely hatch or scribble some colour onto your paper.

2 Brush over the pencil marks with clean water to blend them into a wash.

Using the pencil as a 'palette'
Load your brush with clean water, brush it over the tip of the water-soluble pencil and apply the colour directly to the paper, in the same way as you would when picking up paint from a palette.

Spattering
Load your brush with clean water and flick it over the tip of the water-soluble pencil to spatter colour onto the paper; see also page 132. Practise on scrap paper first, to get a feel for how much pressure you need to apply and how large and how far apart the spatters will be.

Dry water-soluble pencil over dry paint
Using either conventional watercolour paint or a water-soluble pencil, lay down a wash and allow it to dry. You can then work over it with a water-soluble pencil; the lines will remain clear and distinct. If you accidentally wash over linear marks that you want to retain, just draw them in again once the water has dried.

Lifting off colour
While your water-soluble pencil wash is still damp, you can lift off colour using a brush dipped in clean water (above) or a piece of paper towel.

drawing

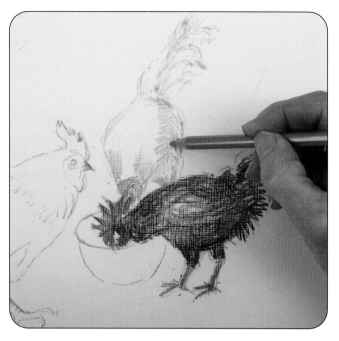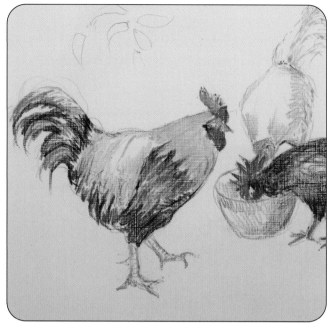

3 Scribble in the combs of the two right-hand chickens with magenta and pink, as appropriate. Very little of the chicken in the centre of the image is actually pure white: there are lots of yellowy-brown areas. Put these in with a yellow ochre pencil, making your pencil strokes follow the direction in which the feathers grow.

4 The chicken on the left is the most colourful of the three. Put in the underlying colours of the base feathers with dark blue, violet, yellow, orange and burnt sienna, allowing some of the white board to show through for the highlights. Don't worry too much about getting the colours exactly right at this stage – concentrate on establishing the overall colour temperature and tonal values, as you can always adjust the colours later on. Scribble in the comb and crop with red and orange.

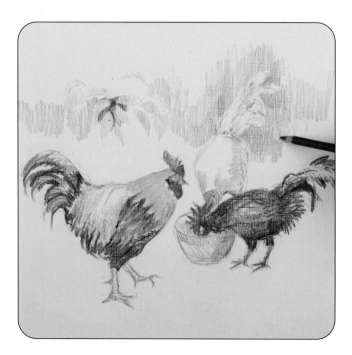

5 Decide how much detail you want to include in the background; here, the background is rather dull and uninspiring, so the artist decided to block in the colour quite loosely, without including every single detail, in order to focus attention on the chickens. Loosely block in the leaves with various greens and yellows, then lightly scribble in a pale charcoal grey for the patch of concrete immediately behind the birds.

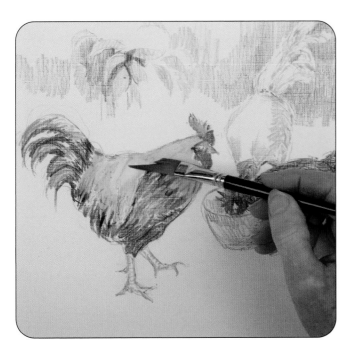

6 Load your brush with clean water and brush it over the patches of colour on the left-hand chicken to blend the pencil marks into a wash.

Keep your colours separate

Try not to let one colour merge into another, or you will end up with muddy mixes.

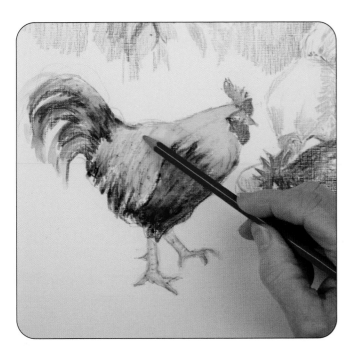

7 While the washes are still damp, use a reddish-brown pencil to create some textural detailing and give an impression of the large wing feathers. As the underlying wash is still damp, the pencil lines will blur and spread a little.

8 Blend the colours on the bodies of the other two chickens in the same way, then wash water over the background, pulling the colour across the support with the tip of the brush. Make the colour slightly uneven, as this will add visual interest to an otherwise bland area of the scene.

drawing

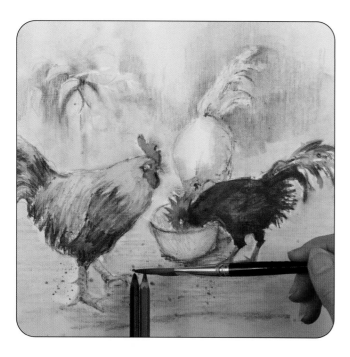

9 Scribble yellow ochre over the foreground, working around the chickens' feet, adding a few strokes of charcoal grey and even orange. Brush over the foreground with clean water. Hold a violet and a blue pencil in one hand and drag a brush loaded with clean water over the tips to spatter colour onto the support and create an impression of the loose, dark-coloured pebbles on the ground.

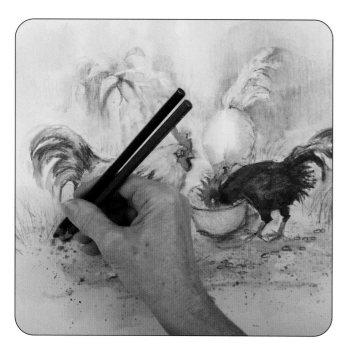

10 Allow the foreground to dry slightly, then randomly scribble small circles of Vandyke brown over the foreground for the larger pebbles. Leave to dry. Hold a dark blue and a dark green pencil together in your hand and draw vigorous, slightly curving strokes to create the impression of small grasses.

11 Using your fingertips, rub off the masking fluid to expose the pure white of the support in the very brightest areas such as the white tail feathers.

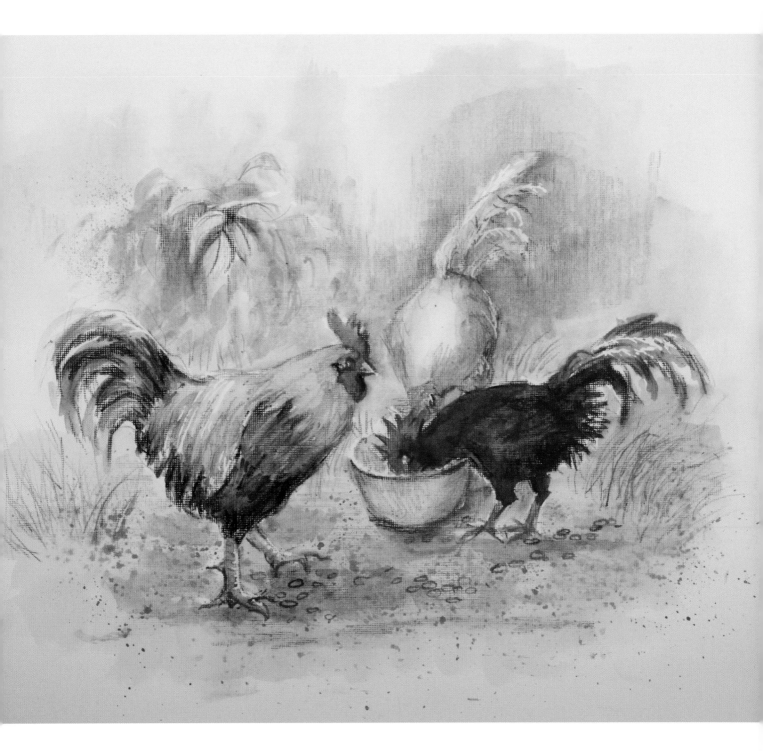

The finished drawing

This drawing is a good demonstration of the versatility of water-soluble pencils: linear marks (the pebbles and grasses) contrast with vibrant washes on the birds' bodies. Note how the background has been simplified: the concrete doorstep and the door in the original scene have been reduced to a pale grey wash so as not to distract from the main subject.

drawing textures

Texture describes the surface of an object. All but the smoothest or shiniest of objects have a discernible texture and artists are at constant pains to find ways of representing this texture without slavishly copying the original.

When developing any mark-making shorthand, you should think not only of the technical limitations of the tools and techniques being used, but also of the way in which the marks are made. This could be sure, direct and firm or nervous, hesitant and timid: each mark brings to the work a quality of its very own. In the same vein, the choice of support is vital and should complement the medium being used; experiment to find the best combination.

Textures in pen and ink

This scene offered the opportunity to experiment with a number of textural effects to explore the different surfaces of foliage, a gnarled tree trunk, stony earth and the fleece of the goat. Emphatic and confident pen lines, soft washes of ink, a wax resist and smudging are all used here – but experiment with your own ideas to see what you can achieve.

You will need

HP watercolour paper
3B pencil
Dip pen with medium and fine nibs
Indian ink
Small round brush
Bamboo pen
Plain white candle
Small piece of stiff card
Scrap paper

The scene
With a gnarled twisted tree trunk, small spiky leaves and the stony ground beneath, this is the perfect subject for practising textural drawing techniques. Note how the arching shape of the tree neatly frames the goat below.

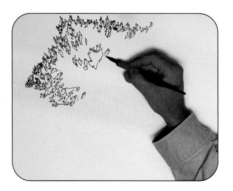

1 Use a 3B pencil to make a light initial drawing. Draw in the linear pattern of the leaves with the dip pen, using a medium nib and Indian ink. Do not fill in the area too much or you will not have enough room for subsequent work.

2 Dilute the ink with a little clean water. Use the round brush to paint in the darker areas of foliage in deep shadow.

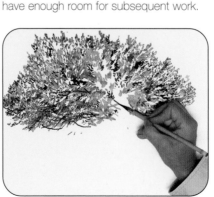

3 You can bring another quality to the foliage and thin branches by using the chisel-shaped end of the bamboo pen with undiluted ink. If necessary, add more detail to the tree with either the brush or dip pen.

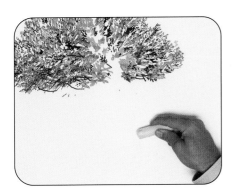

4 Use a plain white candle to draw in the texture on the trunk of the olive tree, and on the shaded area of ground beneath it.

5 Paint over these areas with diluted ink; the candle acts as a resist, pushing the ink away from the waxy surface and creating an attractive textural effect.

6 To bring yet another quality to the work, dip a chisel-shaped piece of stiff card into the ink and use it to darken and draw in the shaded branches. By drawing with one corner, or the edge, of the card, you can make lines of varying thicknesses.

7 Use the dip pen with a fine nib to draw the goat standing beneath the tree and also to suggest the linear patterns in the fleece.

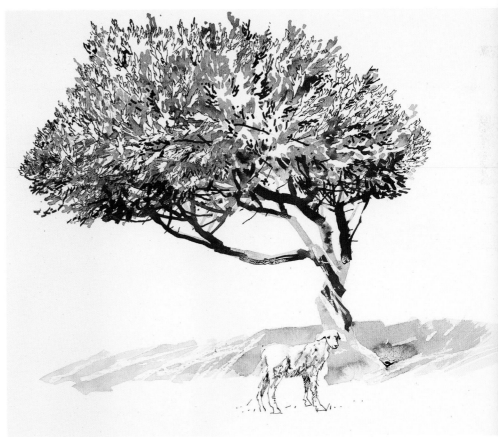

8 Using your finger, carefully add some smudge effects. So as not to make these marks too dark, dab your finger onto scrap paper after dipping it in the ink.

The finished drawing

This drawing could have been made using only one tool and a single technique. However, using several methods adds interest; each part seems to possess its own distinctive textural quality.

Frottage

There are several drawing techniques that, although not used extensively, can be applied on certain occasions to great effect. One such is frottage, which is derived from the French verb meaning to rub, and resembles brass rubbing.

Frottage works best when it is introduced subtly so that it blends into, and looks a part of, the actual drawing rather than a glaring addition to it. The technique is simple: a textured surface is placed beneath the paper, and a soft dry material such as charcoal, graphite or pastel is rubbed over the paper. The drawing material picks up on the textured surface underneath, and shows up as a dark impression. In order to allow this texture to show through, the paper should not be too thick, nor should the drawing material be too soft. It is worth having a few trial runs on various weights of paper prior to beginning the drawing itself.

There are many surfaces from which you can take impressions, including brick and stone, wood, corrugated card, textured wall coverings and even leaves.

You will need

Thin cartridge paper
Drawing board
Pastels pencils: lemon yellow, cadmium yellow, burnt sienna, light and dark orange, cobalt blue, terracotta, dark grey, yellow ochre, black
Plank of rough wood
Fixative

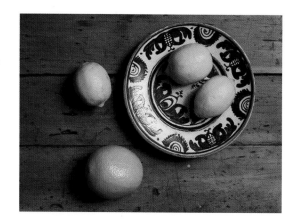

The subject
The overhead viewpoint allows the patterned and distressed table top, which is replicated perfectly using the frottage technique, to become an important element within the composition.

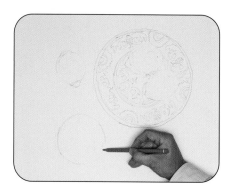

1 Using a range of pastel pencils sympathetic to the colours of the objects being drawn, sketch in the composition. At this stage, disregard the pattern of the wood grain on the surface of the table.

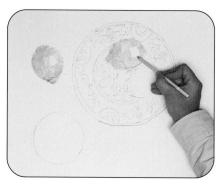

2 Using a combination of lemon yellow, cadmium yellow and a darker burnt sienna, establish the colour of the lemons. Use a combination of hatched and crosshatched, scribbled strokes (see pages 66–67).

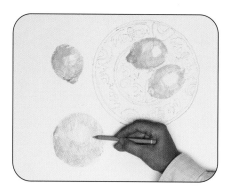

3 Establish the colour of the orange using light and dark orange pencils. Keep the pencil work open and loose, and vary the direction of your strokes.

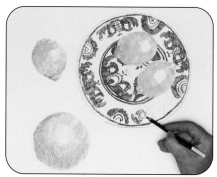

4 Scribble in the blue pattern on the plate with a cobalt blue pencil.

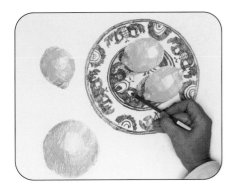

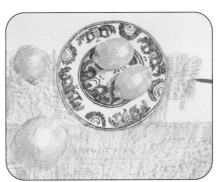

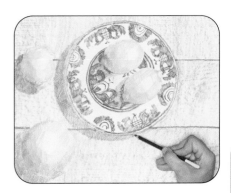

5 Draw in the edge of the plate with a terracotta pencil. Then use a dark grey pencil to indicate the shadow thrown onto the surface of the plate by the lemons.

6 Slide a plank of wood between the paper and the drawing board. Scribble onto the paper over the wooden plank with a yellow ochre pencil. Once one strip of wood has been coloured in, reposition the plank and fill in the next one. Repeat the process until the whole of the surface of the paper is covered.

7 Once the impression of the wood has been completed, spray the work with fixative to avoid losing the effect by possible smudging. Then use a black pencil to draw in the gaps between the wood and the shadows on its surface. Note how the shadows include a little reflected colour from the objects.

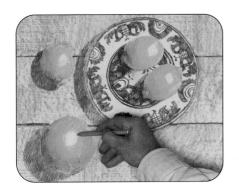

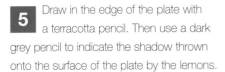

8 Add more colour to the various pieces of fruit to give them greater form and make them appear more solid.

The finished drawing

The texture of the table top works convincingly without overpowering the rest of the drawing. It would have been difficult to recreate it as effectively simply by drawing, and it would also have taken far longer.

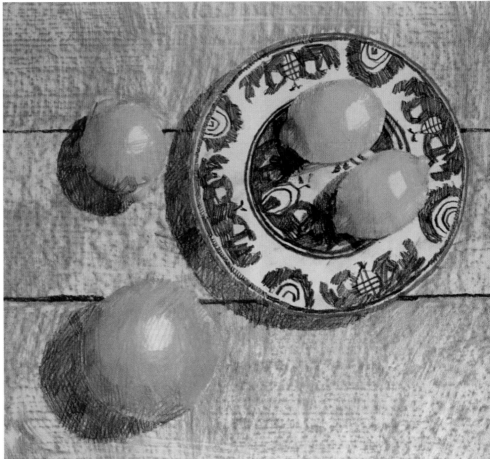

watercolour

Watercolour is renowned for its luminosity and translucency, but it requires careful planning and handling. This chapter takes you step by step through all the techniques you need to know, from simple washes and using masks to preserve the white of the paper to textural techniques that will give your work real impact.

understanding watercolour

Watercolour is renowned for its translucency and the way the paper shines through the paint: good watercolour paintings can convey a feeling of light and airiness that is unmatched by any other medium. Yet that very quality of translucency imposes certain technical restraints that you need to be aware of.

From light to dark

If you apply a second colour on top of paint that has already been laid down, for example, particles from the first layer will still show through. You must always work from light to dark: you can overlay light areas with dark colours, but not the other way around. This means that you have to plan your watercolours carefully and work out where the lightest areas are before you pick up your brush and start to paint.

Another thing to remember is that true watercolour uses no white paint; if you want white in your painting, you have to use the white of the paper. You must train yourself to leave areas of paper free of paint, and either paint around them or protect them by using a mask (see page 126) so that they aren't splashed with unwanted colour. You can use white gouache for highlights (see page 111), but it is opaque and can look too heavy: there is a risk that you will lose the feeling of translucency that makes watercolour so appealing.

Mixing colour on paper

You can mix colour on paper by laying wet colour over dry paint. This enables you to exploit the translucency of watercolour paint. When dry, each layer allows the particles from the previous layer to show through. You can mix two colours in this way to produce other hues.

Colours too light?

Watercolour always looks lighter when it is dry. Either test your mix on scrap paper and leave it to dry so that you know in advance what the final colour will be, or build up tones gradually until you get the effect you want.

1 Brush cerulean blue onto the paper with a flat brush, using even strokes, then rinse out your brush. Allow the paint to dry completely.

2 Add a second flat wash of cadmium yellow on top of the cerulean blue. Take care not to go over the same area of paper twice with this wash.

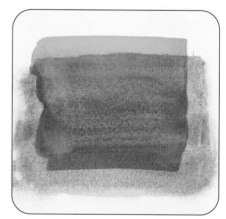

3 As the cadmium yellow begins to dry, it becomes translucent and allows particles of the blue paint to show through. Although both colours are apparent, they mix optically, producing a secondary green tone.

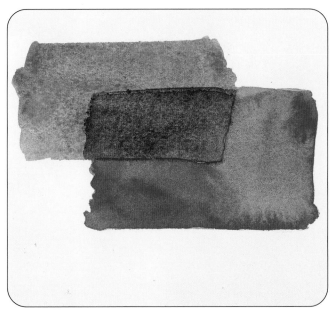

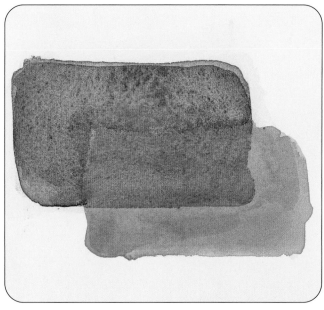

Blue on crimson

Here, a flat wash of alizarin crimson was painted onto the paper and allowed to dry. Next a flat wash of cerulean blue was applied, overlapping the crimson. Where the colours meet, a secondary violet colour appears.

Yellow on green

Here, a flat wash of Hooker's green light was painted onto the paper and allowed to dry. Next a flat wash of cadmium yellow was applied, overlapping the green. Where the colours meet, a yellow-green tone appears.

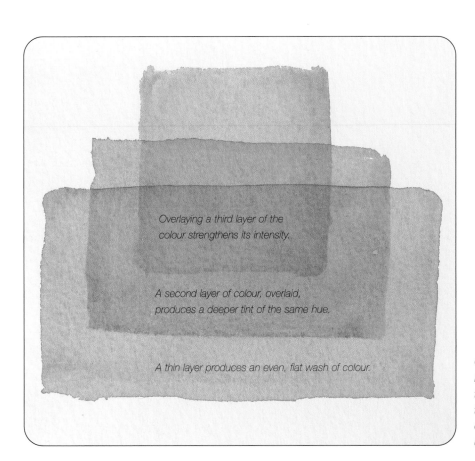

Overlaying a third layer of the colour strengthens its intensity.

A second layer of colour, overlaid, produces a deeper tint of the same hue.

A thin layer produces an even, flat wash of colour.

Overlaying layers of the same colour

Layer upon layer of one hue can be built up to achieve a darker tone. The effect is similar to placing several layers of tissue paper over one another, as the translucent paint allows underlying layers to show through.

Mixing colour on a palette

You have more control if you pre-mix colours on a palette. A partitioned porcelain palette, like the one shown here, is useful for mixing colours. Place one colour in the first trough, another in the second, and then mix the two in the third to create the colour you want. Always mix more paint than you think you will need and have a jar of clean water at hand so that you can wash out your brushes.

1 Spread a little watercolour paint (here, cerulean blue) from a tube into the first slanted section of the palette. Put some clean water into the round well at the bottom of the partition.

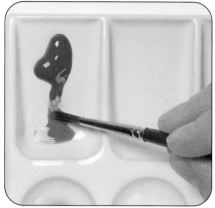

2 Wet your brush in the water and touch it into the paint so that the paint dissolves slightly and begins to run down to the bottom of the slanted section. Pull down more paint with the brush.

3 When you have achieved the intensity of colour that you want, wash out your brush.

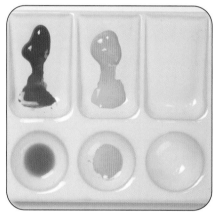

4 Repeat steps 1–3 in the second slanted section, using another colour – here, cadmium yellow. Again, wash out your brush.

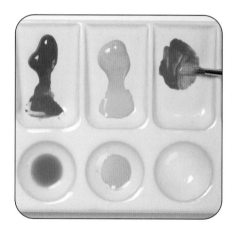

5 Dip the brush in the blue pool and then move to the third slanted section. Place the paint there, rinse your brush again, then add yellow. Mix the colours together.

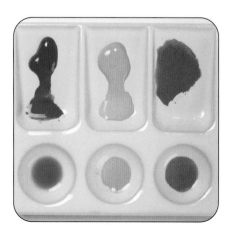

6 As the two colours mix, green will emerge. The colour will vary as you change the relative amounts of blue to yellow or of water to paint.

Light on dark

Like watercolour, gouache is water-soluble. Because it is opaque and dense, however, it will completely cover any underlying colour, allowing you to paint a light colour over a dark one.

White watercolour over a dark wash creates an inconsistent and watery finish.

By using Chinese white gouache instead, a strong block of opaque paint renders the area bright white.

Still life with dried flowers

The parchment-like, dried sunflower heads in this still life offer the perfect opportunity to practise working from light to dark: the petals contain a number of tones, from pale yellow to a deeper, richer, yellowy-brown, which you can only create in watercolour by painting the darker tones last. You will also need to take great care to leave any gaps between stem and flowerhead untouched by paint, so that they remain completely white.

You will need

Stretched NOT watercolour paper
H pencil
Medium flat and round sable brushes
Watercolour paints: Naples yellow, raw umber, burnt umber, burnt sienna, sap green, raw sienna, Payne's grey, ultramarine blue
Paper towel

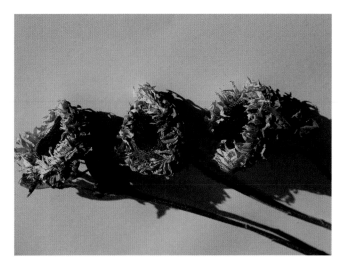

The subject
Arrange the flowers on a white surface, angling the heads so that they point in slightly different directions to add visual interest. The light colour of the petals contrasts well with the flowers' seedheads, while strong shadows throw the flowers into sharp relief.

1 Begin the work on a stretched sheet of watercolour paper with an H pencil. This sketch needs only to be light and loose, and will act simply as a guide for the subsequent washes.

2 Using a light mixture made with Naples yellow and raw umber, paint in the dried yellow petals of the sunflowers. Use the flat chisel-shaped brush, as the marks it makes are perfect to suggest the twisted, angular nature of the dried petals.

3 Use a mid-toned wash of burnt umber, reddened with a little burnt sienna, to wash in the colour of the flower centres with the medium round brush. Note how the yellow petals cut across these centres, and work around the shapes accordingly.

4 Make a green mix using sap green and a little burnt umber, then paint in the dull green leaves and stems. Use the flat brush, as its shape makes a mark that corresponds well to the shape of the areas being painted.

5 Prepare a mixture of raw sienna and raw umber and paint in the darker yellow petals.

6 Use burnt umber to make up a darker version of the brown used for the flower centres. Tap the brush to spatter this mixture onto the flower centres to represent the dried circles of seeds. Blot up stray blobs with a clean sheet of paper towel.

Test your colour mixes

When mixing colours, test them on scrap paper to assess their strength and colour before committing yourself to the actual painting.

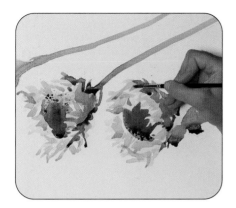 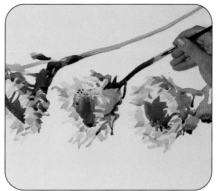 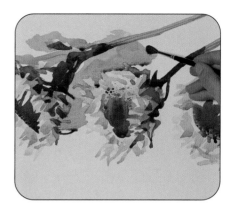

7 Add water to lighten the same as before, and then paint in the darkest petals at the base of the flower head around the stems.

8 Mix sap green, Payne's grey and burnt umber together to indicate the shadows on the stems and leaves. Use the point of the round brush to make the linear marks on the stems.

9 Cut in carefully around the shapes of the leaves and petals to indicate the dark, cast shadow. Use Payne's grey mixed with ultramarine blue to give the colour a bluish tone.

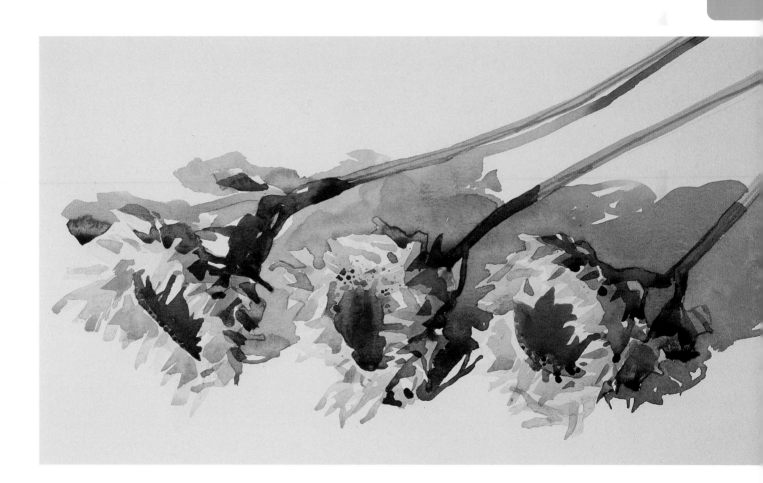

The finished painting

The result is a work that, although using a limited range of relatively neutral colours, has depth and a luminous intensity. Never overwork watercolours, and always try to achieve the desired effect by using a maximum of three layers of overlying washes.

washes

A wash is a solution of paint and water. The term also describes a film of watercolour paint. You will need to stretch all HP papers and paper up to 300 gsm (140 lb) in weight before applying a wash (see page 21).

Laying a flat wash

A flat wash is an even application of one colour that dries with little or no variation in the tone. It is a technique that is commonly used with both watercolours and acrylics and is often used to create a toned ground for acrylics or gouache.

Laying a wash is not a difficult skill to master. The secret is to work quickly and confidently, touching each area of the paper with just one stroke of paint. If you hesitate or repeat a stroke, the paint will not dry evenly. The fewer strokes you use, the more even the wash will be – so use a large mop brush if you want to cover the whole paper.

If you stop in the middle of laying a wash to mix more paint, the paint that you have already put down will dry with a hard edge. To avoid this, mix your paint in a deep palette or a jar, and always mix more colour than you think you will actually need. You can also let the paint itself do some of the work for you: tilting the board at a slight angle will allow the wash to flow down smoothly.

1 Load the brush with paint, tilt the board so that it is lying at a slight angle and lay the first stroke of paint across the top of the paper.

2 Work quickly backwards and forwards as shown, picking up fluid paint that gathers at the base of the previous stroke. Squeeze the fibres of the brush semi-dry and blot up any excess paint that has pooled at the bottom of the paper.

3 Allow the wash to dry naturally, with the board still tilted; if you lay it flat, paint will flow back and dry with a hard edge. Don't worry if the wash looks a bit uneven when wet, as the tone will even out and become lighter as it dries.

Dry or damp paper?

To begin with, you may find it easier to dampen the paper with a brush or sponge before applying the wash, so that the paint spreads quickly, leaving no hard edges. If you wet the paper too much, however, it will buckle and the paint will spread unevenly – so mop up any excess water with a sponge before you apply the paint.

Laying a gradated wash

A gradated wash is applied in exactly the same way as a flat wash – but rather than using the same flat, even colour, you lighten or darken the colour as you work. Gradated washes are especially useful for painting skies and landscapes, where you may want to use subtle variations in tone to convey an impression of distance.

1 As with a flat wash, lightly lay the first stroke of colour across the paper.

2 Work quickly backwards and forwards, down the paper. To make the wash lighter as you work down the paper, when the paint runs thin, add more water to the brush rather than more paint.

3 Allow the wash to dry naturally, as for the flat wash, opposite. It should appear to gradate in tone. The wash should appear even: the paint should not dry in streaks.

working wet into wet

Working 'wet into wet' means applying watercolour paint to damp paper and allowing the paint to spread. It is a slightly unpredictable method: the paint will spread and blur to varying degrees depending on how wet the paper is.

The technique allows you to apply one colour over another so that the colours blend together. You can also apply another layer of the same colour, creating areas of darker tone without any hard edges. Use a high proportion of paint to water in your mixes, otherwise they will look watery and weak when dry.

To achieve a degree of control, allow one layer to dry before applying the next.

When working wet into wet, use a heavy paper that will not buckle under the weight of the water. If you use a lightweight paper, it is important to stretch it before you start painting (see page 21).

Different wet-into-wet effects

The drier the paper and the more pigmented the paint mix, the more control you will have and the more definite the marks you create will be.

Applied to very wet paper, the paint bleeds and feathers.

When the paper is damp, the paint blurs at the edges but remains controlled.

With only slightly damp paper, the effect is confined and controlled.

Pepper painted wet into wet

The surface of this red pepper is glossy and undulated, so it needs to be unevenly painted in order to convey the variations in form. Wet into wet is the perfect technique, as you can apply a second layer of paint to the damp paper for the darker areas, where the surface of the pepper turns away from the light.

You will need

Heavyweight watercolour paper
Medium round brush
Watercolour paints: cadmium red, alizarin crimson, Hooker's green light, cadmium yellow, Payne's grey

The subject
Arrange the pepper on a plain white background, then set up a table lamp to one side and slightly above the pepper, so that it casts a shadow; this will help to anchor the pepper on the background. The light also picks out two bright highlights, which emphasize the form and three-dimensional nature of the subject.

1 Using a medium round brush loaded with clean water, brush in the shape of the pepper on your paper. Leave two spots free of water for the highlights; do not 'paint' the stem.

2 Load the brush with thick cadmium red paint and touch it onto the damp paper. Allow the paint to spread and blend randomly. It should not spread beyond the dampened area of paper.

3 Any variation in the paint colour will add depth to the surface, so do not worry if the finish is uneven. Try not to let the paint spread into the areas you left empty for the highlights.

4 Leave the paint until it is almost but not quite dry. Now dip the brush into alizarin crimson and gently touch it into areas of the pepper that appear paler than others. The paint should blend and bleed slightly.

5 By now you should have created a variation of shades across the surface of the pepper. Alizarin crimson is a cooler, more recessive hue than cadmium red. Allow the paint to dry.

6 Wet the stem of the pepper with clean water. Drop in some Hooker's green light and allow the paint to drift and fill the wet paper.

7 Touch some cadmium yellow into the damp green stem and allow it to blend and merge to create contrast and depth.

The finished painting

The cadmium red and alizarin crimson have merged and blended slightly on the paper, creating a three-dimensional effect that suggests how the light hits some facets of the pepper while leaving others in shade. The pepper appears glossy and the white highlight areas give an illusion of depth. A shadow of Payne's grey around the bottom edge of the pepper enhances the three-dimensional effect.

Simple skyscape painted wet into wet

This moody scene of a stormy sky at sunset is the perfect opportunity to practise working wet into wet: the limited colour palette and simple shapes of the foreground trees allow you to concentrate on getting a feel for how far the paint spreads on damp paper. Knowing how wet the paper should be is something that only comes with practice, however, so don't worry if your first attempts do not turn out exactly as you expected.

You will need

Heavyweight watercolour paper
2B pencil (optional)
Medium round brush
Watercolour paints: Naples yellow, cadmium orange, dioxazine violet, Winsor blue, burnt sienna, raw sienna
Paper towel

The scene
This moody sunset, with its brooding storm clouds, makes a dramatic subject for a watercolour sketch. Although the landscape beneath is so dark that virtually no detail is discernible, it sets the scene in context and anchors the painting.

1 If you wish, sketch the foreground trees and main cloud shapes using a 2B pencil. Keep your pencil marks very light, however, otherwise they may show through in the finished painting. Wet the whole of the paper with clean water. Touch very dilute Naples yellow into the sky area around the heaviest cloud mass, changing to cadmium orange towards the base of the sky.

2 Dab or stroke a scrunched-up piece of paper towel onto the paper to wipe off paint in the very lightest parts of the sky and create the effect of sunlight coming through the clouds.

3 Mix a dark purple-blue from dioxazine violet and Winsor blue. While the paper is still damp, brush in the basic shape of the dark cloud.

Controlling wet into wet

Your paper must be evenly wet for wet-into-wet techniques: if it is too damp, blot up any excess liquid with a scrunched-up piece of paper towel. If a wash goes where you don't want it to go, lift off the colour with a clean, damp brush or by blotting it with a paper towel.

The finished painting

This loosely painted skyscape is full of atmosphere. Although the silhouetted foreground takes up only a small part of the final image, it balances the composition and provides a context for the skyscape above. The billowing, soft-edged cloud mass dominates the painting and has a lovely sense of energy.

4 Add burnt sienna to the violet/blue mix from the previous step and touch in the darker parts of the cloud. Use the same mix to brush in the silhouetted foreground; to make the scene more interesting, the artist decided to change the flat horizon line in her reference photo to a small hill.

5 Drop tiny patches of neat raw sienna into the foreground to create some tonal variation and a sense of depth. Now that you've put in all the very dark tones, the lightest areas may appear too light: if necessary, dampen the sky area again with clean water and intensify the yellow and orange tones.

working wet on dry

Much of the charm and enjoyment of using watercolour lies in its unpredictability. The paint can, however, be controlled by working in layered washes, allowing each one to dry before the next one is applied; this is known as working wet on dry.

Works made using this technique are crisp and have a sharp focus, as (unlike the wet-into-wet technique) the paint does not spread beyond the area to which you apply it. To avoid the results looking too hard and clinical, mix tones and colours carefully, separating the work into carefully considered light, medium and dark tones; soften any edges that look too hard by re-wetting and allowing the paint to subtly blend one colour into the next.

Still life with anemones

Anemones are an excellent still-life subject, as they are very colourful and offer a precise and challenging shape to paint. Using a wet-on-dry technique ensures that the distinctive shape and colour of each flower remains separate.

You will need

Stretched NOT watercolour paper
6B pencil
Medium round brush
Watercolour paints: Payne's grey, yellow ochre, alizarin crimson, sap green, cadmium red, monestial (phthalo) blue, Winsor violet, burnt umber
Hair dryer

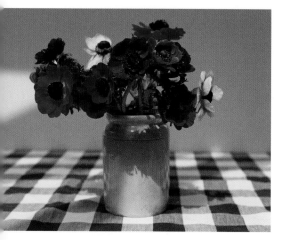

The subject
The background colour has been carefully chosen to harmonize with both the red and blue flowers. The simple perspective of the pattern of the checked tablecloth gives immediate depth to this uncomplicated arrangement.

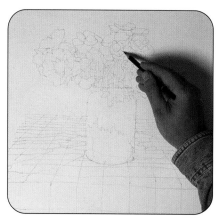

1 Make a precise drawing, not only to indicate the position and shape of the flowers and pot, but also to show the shadows and details on the petals.

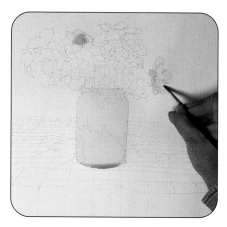

2 Mix Payne's grey and yellow ochre for the petals of the palest anemone, then paint a thin dilution of Payne's grey into the centre of the flower. Use a mix of yellow ochre and water for the pot, and block in the pink on the right with a mix of alizarin crimson and the grey and yellow wash used on the first flower.

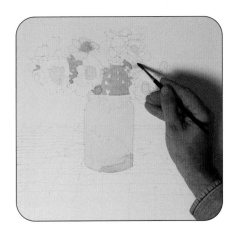
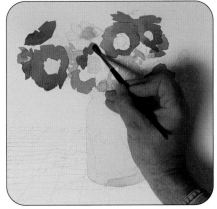
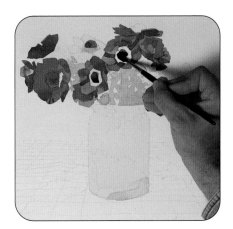

3 Establish the petals and stems using a pale green made by mixing together sap green and yellow ochre with plenty of water. Allow this to dry; you can speed up the drying process by using a hair dryer.

4 Next, paint the light base colour of the petals: cadmium red and alizarin crimson for the red flowers, monestial blue and alizarin crimson for the blue and alizarin crimson with a little Winsor violet for the pink.

5 Allow the flowers to dry before working over them with a midtone. In each case, the mixes are intensified by adding more of the same colours plus a little Payne's grey. Once this work is dry, add the dark centres of the flowers using neat Payne's grey.

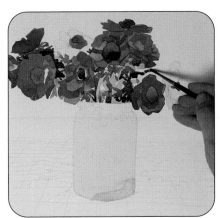

6 Now paint the darker green foliage with a mix made from sap green, Payne's grey and yellow ochre.

7 Use the mixes for step 5 with a little added Payne's grey for the darkest flower tones. Use careful, precise brushwork to paint the shadows. Darken the flower centres with an intense mixture of Payne's grey with a little burnt umber.

8 Wash a mixture of yellow ochre, burnt umber and Payne's grey beneath the rim of the pot and on the side away from the light, allowing it to puddle around the base of the pot. To soften the transition from light to dark, scrub a little water into the centre of the pot.

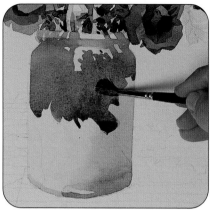 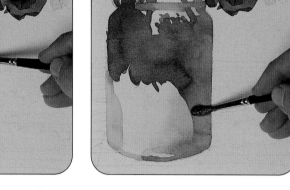 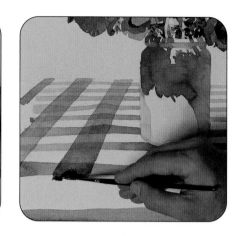

9 Dry the painting thoroughly with the hair dryer. Using a dark mixture of burnt umber, yellow ochre and a little Payne's grey, paint in the dark shadow cast onto the pot by the anemones.

10 While the wash is still damp, wet the brush and run in a little water onto the right side of the pot away from the light source. This has the effect of lessening the intensity of the shadow. Allow to dry.

11 Use a medium-intensity mix of Payne's grey, burnt umber and water to paint in the pattern on the checked tablecloth. Paint in the horizontal lines first, allow them to dry, and then paint in the lines that run from front to back.

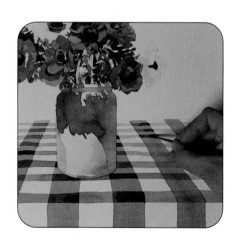 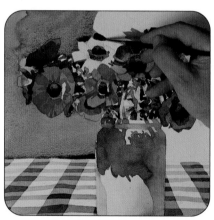 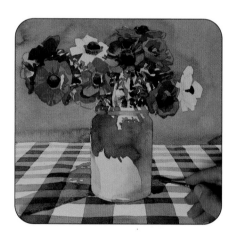

12 Once the patterns are dry, darken the darkest squares still more by painting them with Payne's grey mixed with a little more burnt umber to make a black.

13 Paint the background to the flowers using an intense mix of Payne's grey and water. Work carefully to cut out the precise shape of the flowers. The colour of the flowers seems immediately brighter when it is viewed against the dark background.

14 Complete the work by painting in the shadow cast onto the checked tablecloth by the flowers and pot.

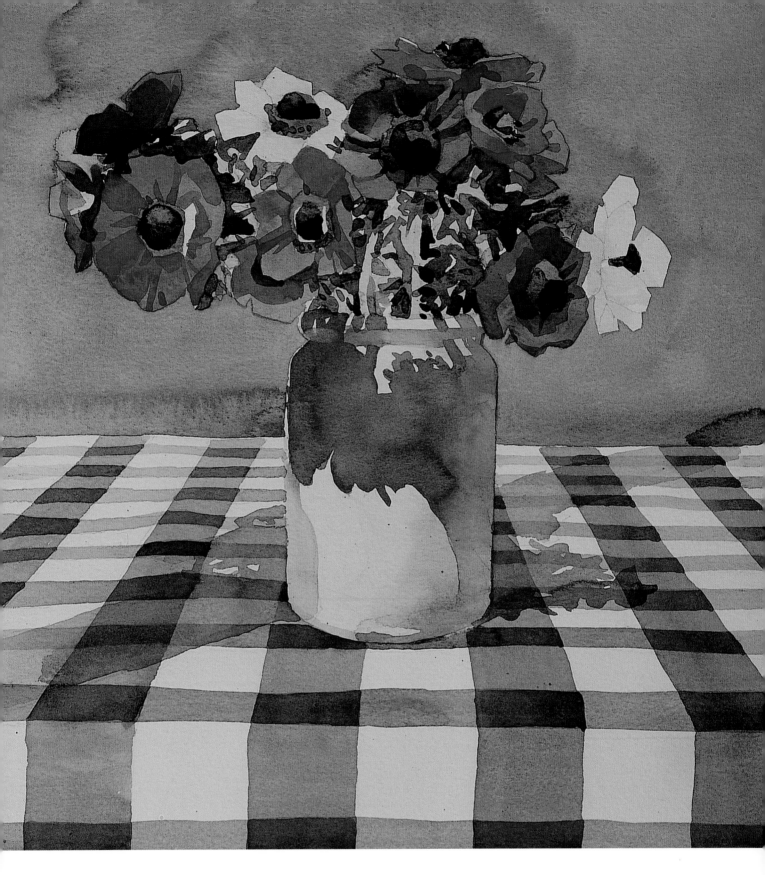

The finished painting

The wet-on-dry technique allows the individual flower heads
to stand out from each other and from the background, creating
a colourful and vibrant still life.

watercolour glazes

A glaze is a thin, transparent layer of paint applied over a previously painted area. Glazes are used on top on one another to build up depth and modify colours.

Capturing skin tones in watercolour

The translucent nature of watercolour paint makes it an ideal medium for capturing the subtle changes of hue that occur in a child's skin, as you can build up layers of thin paint until you achieve the correct tone. The traditional watercolour technique of working from light to dark should prevent you from painting colours that later prove to be too dark, or even painting them in the wrong place. Note that in this demonstration, the cluttered background of the reference photo, which could easily distract from the immediacy of the portrait, has been omitted – a necessary bit of artistic licence!

You will need

NOT watercolour paper
4B pencil
Medium round brush
Watercolour paints: yellow ochre, cadmium lemon, Naples yellow, cadmium red, burnt umber, Payne's grey, ultramarine blue, raw umber
Gum arabic
Paper towel

The subject
Children find it difficult to sit still for long, so, unless you are making a sketch, you may find it easier to work using a photograph as reference.

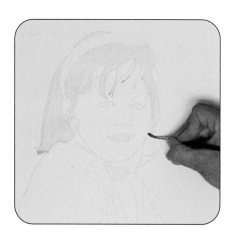

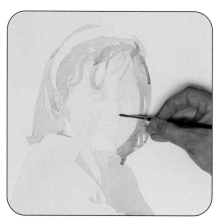

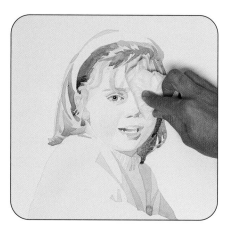

1 Draw in the shape of the girl's head, using a 4B pencil. Try to keep your marks as light as possible, otherwise they may show through the later watercolour washes. Mix yellow ochre and a little cadmium lemon to make a suitable light tone for the hair. Use the brush to paint in this wash.

2 Mix Naples yellow with a little cadmium red to make light washes for the face. Darken the hair using burnt umber and yellow ochre, and paint the sweater with a mixture of cadmium lemon and yellow ochre.

3 Add a little gum arabic to the increasingly darker mixes that develop the colours and tones. Paint in the detail around the eyes and mix Payne's grey and ultramarine blue together for the iris.

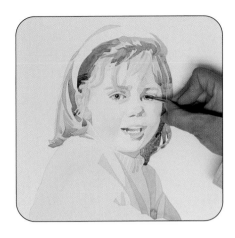

4 Once the iris is dry, paint the dark part of the eye with a mixture of raw umber and a little gum arabic. When this is dry, touch a little water into the dark of the eye to loosen the paint.

5 Use a paper towel to blot off the dissolved paint, leaving a highlight in the eye. Carefully lighten each iris in the same way.

6 Work darker glazes into the shadows and the hair. If you think any areas are too dark, lighten them using the same blotting-off technique described in step 5.

Gum arabic

Once they have dried, water-colour paints cannot always be easily removed by re-wetting. However, adding a few drops of gum arabic to your paint mixtures ensures that the paint can be removed. The gum also adds impact to the colour, which can look duller when dry that it did when wet.

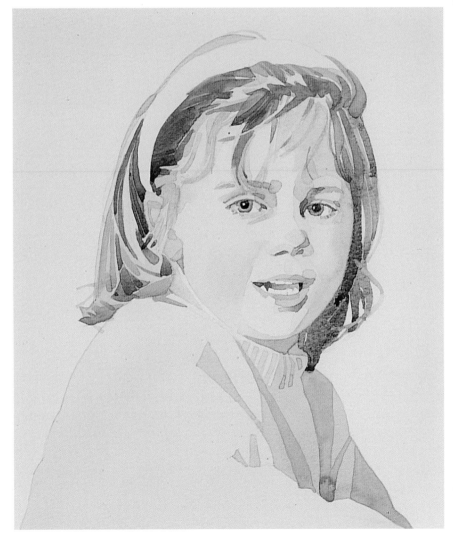

The finished painting

The subtle changes of hue in skin are ideally suited to the delicacy of watercolour glazes. The combination of crisp, wet-on-dry and softer, wet-on-wet washes works very well. Adding gum arabic increases the intensity and translucency of the colours and allows them to be manipulated by re-wetting.

masking

Very often in watercolour painting you need to preserve the white of the paper, as traditionally no white paint is used. To do this, mask off the areas that you want to remain white, using masking tape, masking fluid or even small pieces of scrap paper torn to roughly the right shape.

Chard leaves in watercolour

Leaf stalks, veins, and other markings are often much lighter in colour than the rest of the leaf. It would be very fiddly to paint right up to the edges of the stalks and veins – but by using masking fluid you can apply a wash of colour over the whole leaf, yet still preserve the white of the paper.

You will need

NOT watercolour paper

3B pencil

Plastic eraser

Masking fluid

Old brush for masking

Fine-nibbed dip pen

Watercolour paints: viridian, lemon yellow, Prussian blue, alizarin crimson, burnt umber, cadmium red, ultramarine blue

Medium and fine round brushes

Paper towel

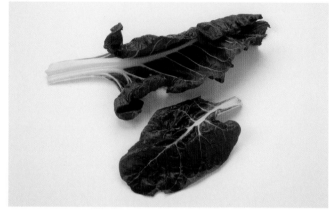

The subject
Arrange your chosen leaves on a plain white background and position a small lamp to one side so that they cast a light shadow on the surface. Although you do not want the shadows to become too dominant, a hint of shadow will help to anchor the leaves on the surface and make them look more three-dimensional.

1 Using a 3B pencil, sketch the leaves, indicating the folds in the leaves to help you map out the light and dark areas. Very lightly indicate the veins; once you're happy with the placement, knock them back with an eraser so the lines don't become muddied when you apply the masking fluid.

2 Using an old brush, apply masking fluid to the main veins and stalks of the leaves.

Masking tape

Buy low-tack masking tape instead of the heavily gummed tape used for office applications; it will not damage the surface of the paper when applied. Masking tape is good for covering large areas. By cutting the tape into sections, you can create sharply defined shapes and areas; by tearing it, you can create softer edges, as the paint will move more freely within the tear lines and a little paint may even seep under the tape.

 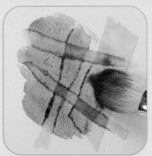

1 Tear or cut masking tape and place it down firmly on the paper over the areas you want to cover.

2 Apply a wash of colour over the paper, including the tape, and leave it to dry completely.

 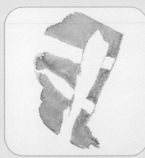

3 When the paint is dry, peel off the masking tape.

4 The areas that were under the tape remain completely white.

Masking fluid

Masking fluid is available in clear and slightly toned versions; the benefit of the latter is that you can see it even when you have painted over it. Apply it with an old brush in exactly the same way as you brush on paint; you will find that you can create any thickness or shape of line that you want. You can even spatter masking fluid onto the paper (see page 132); this is a good way of creating sparkling highlights on water. Masking fluid must be allowed to dry completely before you paint over it or the effect will be ruined. Remember, too, that the fluid can ruin your brushes. Keep old brushes just for use with masking fluid and always wash them out in warm, soapy water immediately after use.

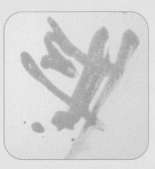

1 Brush masking fluid onto the paper in exactly the same way as you brush on paint and leave it to dry completely

2 Apply a wash of colour over the paper and leave it to dry completely.

3 Gently rub off the masking fluid with your fingers.

4 The areas that were under the tape remain completely white.

watercolour

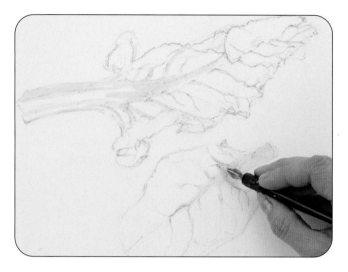

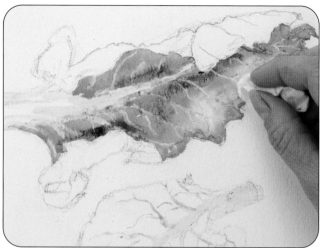

3 Complete the masking on the finer veins, using a fine-nibbed dip pen, twisting and turning the nib to create irregular lines, then leave the masking fluid to dry completely. Be sure to wash the brush and nib in warm, soapy water immediately after use.

4 Mix a mid-green from viridian and lemon yellow. Using a medium round brush, paint the light- to mid-toned greens, adding a touch of Prussian blue to the mix for the shadows around the central vein of the top leaf. Dab off paint with a scrunched-up piece of paper towel to bring out some highlights.

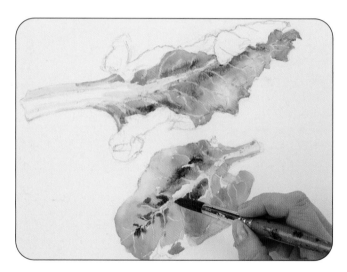

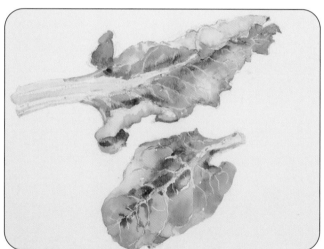

5 Paint the lower leaf in the same way, varying the proportions of the colours in the mix to create some tonal variation: the leaves are not a uniform, flat colour. Add a touch of alizarin crimson to darken the mix in places, and touch in neat Prussian blue, wet into wet, for the darker areas.

6 Continue layering the colours to create the density of tone that you want and build up some form on the leaves. Note that the undersides, where the leaves curl over, are more crinkled in texture and also more blue. Use a fine round brush to paint the shadow on the stem of the upper leaf in a mix of very pale viridian and burnt umber. Leave to dry completely.

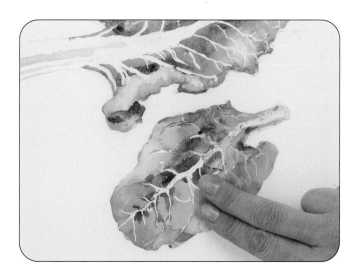

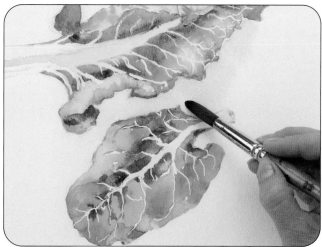

7 Using your fingers, gently rub off all the masking fluid.

8 Paint the central vein of the top leaf in a very pale mix of viridian and lemon yellow; some colour is reflected down onto it from the overhanging curled leaf. Touch in the cut, slightly brown ends of the stalks with a very pale mix of burnt umber and cadmium red. Mix a pale shadow colour from alizarin crimson and ultramarine blue. Wet the cast shadow with clean water, then drop the shadow mix into it, wet into wet, so that it spreads and blurs without leaving any obvious brush marks.

The finished painting

Without the use of masking fluid, it would have been almost impossible to preserve the very delicate, twisting white lines of the leaf veins. A second classic watercolour technique – wet into wet – has also been employed to good effect here, allowing the paint to spread and blur naturally, creating texture and tonal variations with no hard edges in the crinkled leaves.

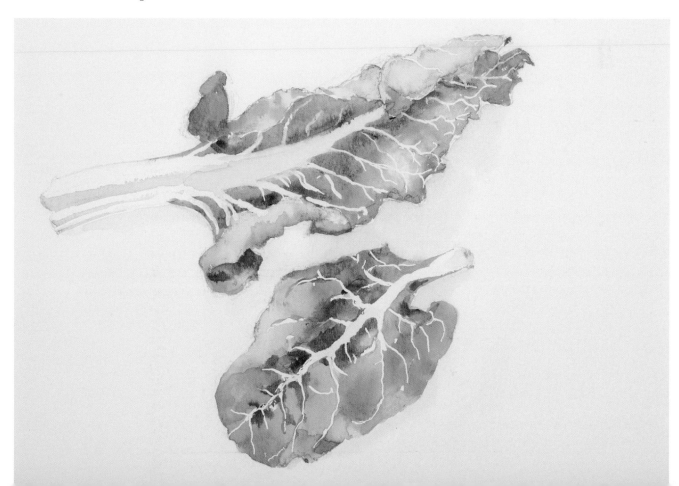

creating textures
in watercolour

There are a number of ways of creating texture in your watercolour paintings. The key is to strike the right balance and not overdo it: less if often more!

Sponging

Applying paint with a sponge rather than with a brush is a very simple way of creating texture and tone. A natural sponge is more randomly textured than a synthetic one and creates a more varied finish.

Sponging may be done on wet or dry paper and over wet washes or ones that have dried. On damp paper, the marks will merge together. On dry paper, the marks are more sharply defined. If the paper is too wet, however, the sponge will not create a texture.

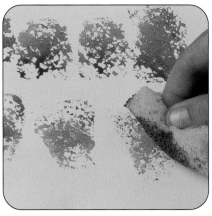

Synthetic sponge on dry paper
Dampen the sponge in clean water, squeeze it almost dry, dip it into paint and gently blot it onto dry paper. The result is textured but soft. Some areas of the paint dry to a crisp edge, while others blend into one another.

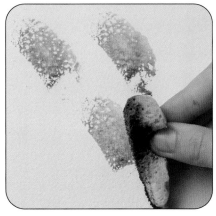

Natural sponge on dry paper
With a natural sponge, the result is coarsely textured, with the paint sticking like granules to the surface of the paper.

Sponge textures

The mottled texture produced by applying paint with a sponge is ideal for suggesting clumps of foliage or worn, weathered stone. Try applying one colour on top of another, either wet or dry, to create interesting tonal variations

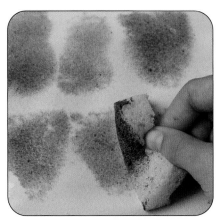

Synthetic sponge on damp paper
Paint a dilute wash over the paper. While it is still damp, sponge another colour of paint onto the paper, as before. The paint blurs and mingles with the underlying wash to produce a softer effect than on dry paper.

Natural sponge on damp paper
With a natural sponge, the result is softer than that of sponging on dry paper, but crisper than that of using a synthetic sponge on damp paper.

Applying paint with newspaper

Newspaper (or any absorbent paper – a paper towel also works well) can also be used to apply paint. The result is more random than when using a sponge. You will find, however, that the paper soaks up lots of paint very rapidly.

Scrunched-up newspaper

Scrunch the paper up in your fingers to create a surface with random pits and troughs, dip it into reasonably thick paint and press it onto the paper. The result is unpredictable, but a useful technique for creating the texture of rocks.

Improvised paint applicators

Try applying paint with other materials to see what textures you can create: plastic food wrap, fabric, pieces of card, and even leaves dipped in paint can all produce interesting textures and shapes on your paper.

As a variation on this, try using the same materials to remove paint from your paper. This is a version of tonking, a technique named after the British artist Henry Tonks (1862–1937) and used in oil painting for removing excess oil paint or oil from a canvas by blotting it with a sheet of absorbent paper such as newspaper or paper towel. By scrunching the paper or fabric up and using it to dab off wet paint, you can create texture in an area of wash.

Stippling

Stippling is a technique in which dots of colour are applied to the paper with the tip of a brush. You can use just one paint colour to produce subtle gradations of tone, simply by altering the size and weight of each dot that you make, or you can combine different-coloured dots in patterns. The less space you leave between the dots, the denser the colour will appear. The technique is particularly effective for painting small textured objects such as pebbles and stones.

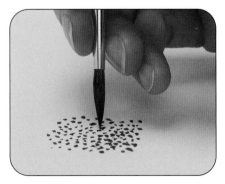

Even stippling
To produce even stippling, dip an almost dry brush into a thick mix of watercolour paint, making sure that you keep the bristles in a point. Hold the brush vertically and dot the surface of the paper, applying very little pressure.

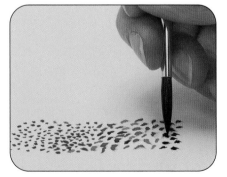

Less definition
Repeat the exercise using a wetter mix of paint. The dots are not as sharply defined and the tone varies from one to another. There is also more variation in the size of the dots.

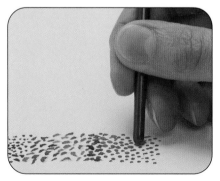

Flatter results
To produce flatter, more rounded and even results, turn the brush upside down and dip the end of the handle into a thick mix of paint. Quickly but firmly dot the handle down onto the paper.

Spattering

Spattering is done by loading a toothbrush with paint and pulling a palette knife, piece of plywood or card, or your thumb over the bristles so that they flick, or spatter, paint onto the paper in a random spray. The further away from the paper you hold the toothbrush, the wide the area you will cover. You get larger marks from a very wet mix of paint.and from spattering onto damp paper, as the paint specks will spread. A light, even spray from a toothbrush held high above the paper is perfect for depicting sandy beaches; a heavier spatter from a more heavily loaded brush is good for pebbly or rocky terrains.

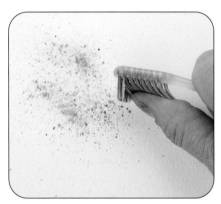

Spattering with your thumb
Using a broad, flat brush, apply paint to the toothbrush bristles. Then simply pull back the bristles of the toothbrush with your thumb. This method gives you a lot of control over the direction of the spray.

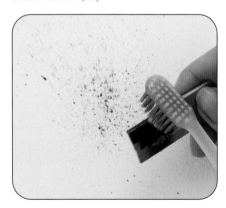

Spattering with a piece of plywood
Here, a piece of plywood is dragged over the bristles of the paint-loaded toothbrush.

Drybrush

In this technique, paint is applied with an almost dry brush carrying very little paint to create crisply defined masses of lines. On rough paper, the technique creates a textured effect, with the paint marking only the bumps in the paper and leaving the troughs free of paint. On a non-textured paper, you will achieve a smoother look. Drybrush is particularly useful for painting features such as tree bark or the grain in wood.

Drybrush
Dip a completely dry brush in reasonably thick paint, taking care not to coat it too heavily; you may want to wipe off excess paint on scrap paper or the side of the palette before you apply it to your work. Drag the brush across the paper. Here, a fan brush is being used; you can achieve the same effect with a flat brush by splaying out the bristles with your fingers.

Sgraffito

The term sgraffito comes from the Italian *sgraffiare*, meaning 'to scratch'. It involves scraping through a top layer of dry paint to reveal the underlying paper and is often used to create surface texture or highlights such as sunlight sparkling on water. Two common sgraffito tools are shown below, but you can use anything sharp – your fingernails, the tip of a paperclip or needle, even a comb.

Sgraffito with a craft knife
This is one of the most popular sgraffito tools, as the point can be used to scratch out minute details and fine lines. Simply drag the blade across the paper, or use the tip to lift off small highlights, taking care not to dig too deeply and cut through the paper.

Sgraffito with sandpaper
Sandpaper is a useful tool when you want to work sgraffito over a wide area. Just drag or rub it over the paper surface, depending on how much paint you want to remove. Experiment with different grades to find out what effects you can create.

Seashore scene

Landscapes of all descriptions provide countless opportunities for experimenting with textural techniques. The soft texture of mosses and lichens can be conveyed with sponging; small pebbles and sand by spattering paint; and cracks and crevices in rocks by scratching into the paint with a sharp-tipped implement.

The most important thing is not to lose sight of the landscape as a whole: texture is only one aspect of your painting and textural techniques should not be allowed to dominate.

You will need

NOT watercolour paper
3B pencil
Masking fluid
Old brush for masking
Watercolour paints: alizarin crimson, raw umber, ultramarine blue, Prussian blue, burnt umber, cadmium yellow, cadmium red, lemon yellow, permanent white gouache
Mop, large and small round, and small flat brushes
Wooden cocktail stick
Small piece of natural sponge
Cotton bud
Newspaper
Old toothbrush
Paper towel

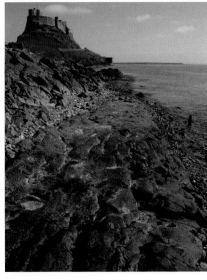

The scene
The rocky shoreline and the line of orange lichen-covered rocks on the left both point in towards the focal point of the image – the castle on the headland – while the relatively low viewpoint adds drama to the composition.

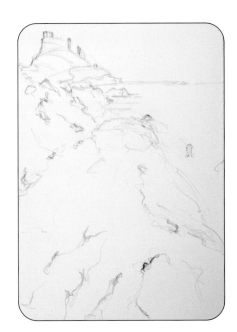

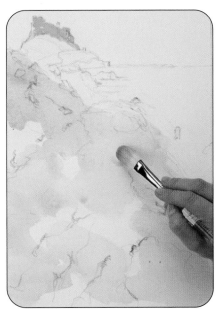

1 Using a 3B pencil, lightly map out the main sweep of the composition, putting in the horizon, shoreline and the castle on the headland. Put in the main lines of the foreground rocks so that you can use them as a guide later in the painting: don't draw every single one, but put in just enough to indicate the directional lines of the various strata.

2 Using an old brush, mask out the castle on the headland and leave to dry completely. Mix a pale purplish-brown from alizarin crimson, raw umber and ultramarine blue. Using a mop brush, wash the colour loosely over the foreground rocks, adding a little more ultramarine when you get to the water-covered rocks right on the shoreline.

Keep it light

Don't cover all the paper; leave some white showing, and vary the proportions of the colours in the mix to get some tonal variation.

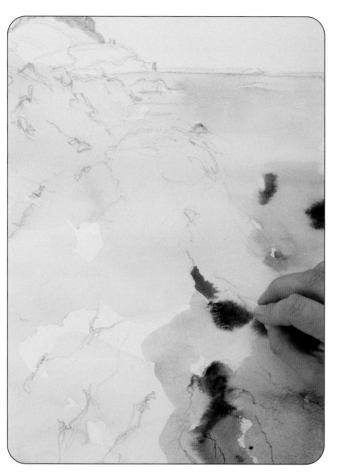

3 Using a large round brush, apply a wash of ultramarine and Prussian blue over the sea, using horizontal strokes to echo the flow of the waves. Add alizarin crimson to the mix as you get down to the foreground water. Brush burnt umber loosely over the foreground rocks, then touch a mix of burnt umber and ultramarine into the darker side of the rocks to suggest their rounded shape. Using a wooden cocktail stick, draw into the wet paint, pulling out a fine, squiggly line to suggest some of the cracks and crevices in the rocks.

4 Mix a muted green from cadmium yellow and ultramarine with a hint of burnt umber and brush in the grassy area on the headland. Dip a small sponge into the mix and dab it onto the foreground rocks to give an impression of lichen.

Use the brush shape

The flat brush echoes the shape of the rocks, making it easier to create their slab-like forms.

5 Mix a reddish brown from cadmium red, burnt umber and a little cadmium yellow. Using a small flat brush, paint the rocky headland on which the castle sits and the slabs of rock in the top left of the image. Mix a dark purple from ultramarine blue, alizarin crimson and a little raw umber and paint the shaded sides of the rocks.

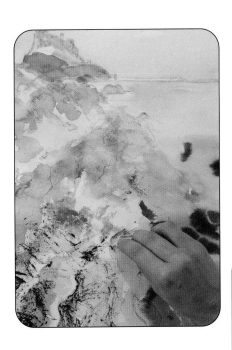

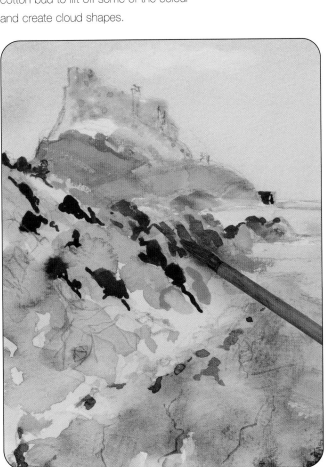

Texture tips

Keep turning the cotton bud around in your hand as you work, so that you don't accidentally apply colour to the cloud shapes.

It's surprising how much paint the newspaper soaks up; you will find you need to press quite hard to make your marks.

6 Mix a bright blue from ultramarine and Prussian blue and paint the sky. While the paint is still wet, use a cotton bud to lift off some of the colour and create cloud shapes.

7 Mix a dark blue from ultramarine blue and raw umber and wash it over the rocks in the middle distance. While the paint is still wet, draw into it with the cocktail stick to create some of the cracks and crevices. Mix a dark blue-black from alizarin crimson, Prussian blue and burnt umber and, using a small round brush, put in the darkest crevices in the foreground rocks. Scrunch up a piece of newspaper, dab it into the same mix, then dab it randomly onto the foreground rocks to create some texture.

8 Mix a dark brown from burnt umber and ultramarine blue and, using a small flat brush, scumble in the dark, shaded sides of the rocks in the middle distance, so that you begin to develop some form. Don't overdo this area: it's important to keep the bulk of the textural work in the foreground in order to keep a sense of the scale and perspective of the scene.

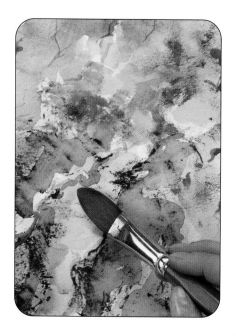

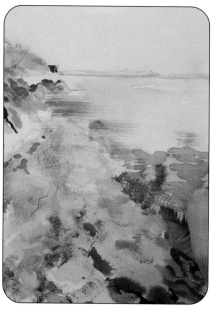

10 Drybrush a thick purple mix of alizarin crimson and ultramarine over the left-hand edge of the sea to suggest ripples as the waves approach the shore. Note how the white of the paper suggests sunlight sparkling on the water. Use a small round brush and the same purple mix to put in some rounded shapes in the water near the foreground to suggest submerged rocks. Mix an opaque mid-toned brown from lemon yellow, permanent white gouache and burnt umber, and dab and spatter this mixture over the shoreline for the lighter-coloured rocks.

9 Add a little permanent white gouache to the previous blue-black mixes and apply to the foreground rocks to intensify the washes and build up some form in this area.

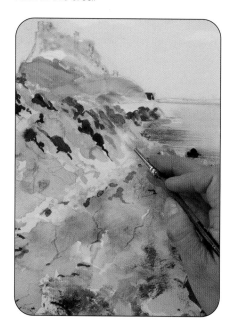

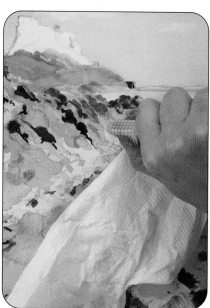

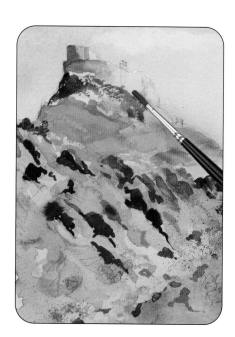

11 Add permanent white gouache to the previous mixes and apply small strokes of colour to build up the light facets of the rocks in the middle distance.

12 Rub off the masking fluid. Place a piece of paper towel over the foreground rocks and spatter the dark purple mix from step 10 over the base of the rocks in the middle distance to create the impression of small stones.

13 Mix a very dilute orange from cadmium red, burnt umber and a little lemon yellow and brush it over the whole of the castle. Leave to dry. Paint the shaded side of the castle with a purple mix of ultramarine, alizarin crimson and burnt umber.

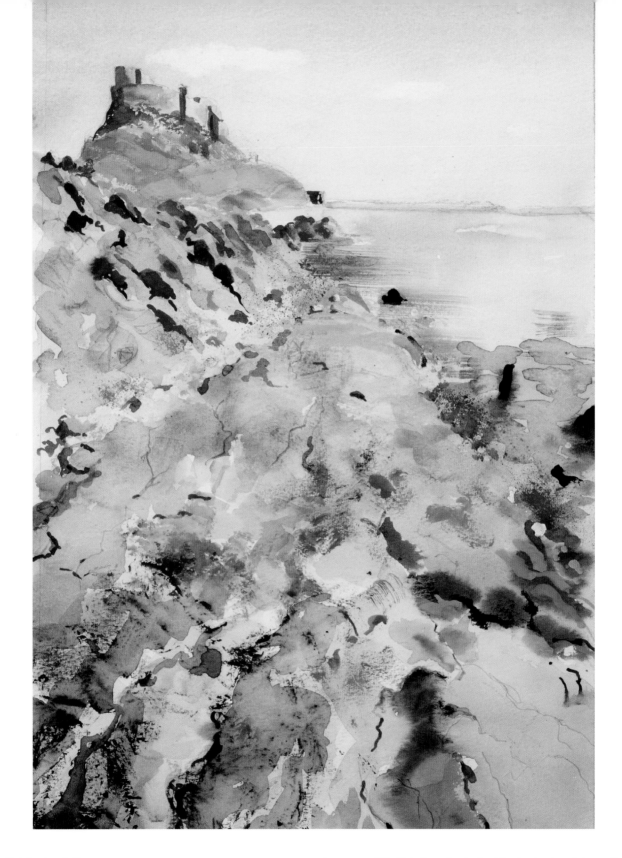

The finished painting

Several textural techniques have been used in this painting – sponging, spattering, sgrafitto with a wooden cocktail stick, drybrush work and applying paint with scrunched-up newspaper – yet none has been allowed to dominate the image. The artist has also made good use of the principles of aerial perspective (see page 48). Note how the bulk of the textural work is confined to the foreground: this helps to establish the different planes of the image and give a sense of distance, as the eye assumes that any textured areas are closer. Tones, too, are darker in the immediate foreground. The result is a light, airy depiction of a coastal scene.

oils and acrylics

Oil paints have been around for centuries while acrylics are a relatively recent innovation, yet the two media share certain characteristics and techniques. Explore those techniques in a series of carefully designed step-by-step projects that will soon have you painting with confidence.

understanding oil and acrylic paints

Certain techniques are common to both oil painting and acrylics, but the two mediums have very different characteristics – most noticeably their drying time.

Oil paint dries slowly. This might sound like a disadvantage, but in fact it makes oils a very forgiving medium: you have plenty of time to scrape off paint and make corrections if necessary.

The exact drying time of oil paints depends on the pigments used and can range from two to twelve days. Flake white, for example, which contains pigments derived from lead, dries very rapidly while titanium white, which contains pigment derived from titanium oxide, dries very slowly. Adding Liquin (see page 17) can

halve the drying time. Thickened linseed oil can also be used and will speed drying by about 10 per cent.

Acrylic paint, on the other hand, dries very quickly – usually within 15 to 20 minutes, even when the paint is applied thickly. Paintings built up of layers of paint, whether thickly or thinly applied, can be completed in a single sitting. If you find that the paint is drying too quickly and becoming unworkable on the palette, add a little acrylic retarder medium to it.

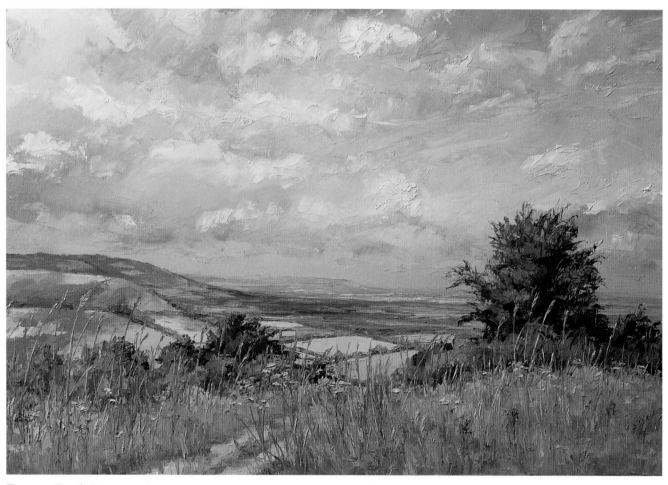

The versatility of oils
This painting (see pages 240–245) demonstrates the wide range of techniques that can be used with oil paints, from smooth colour blends in the far and middle distance of the landscape to thicker applications of paint on the overhead clouds and foreground plants, which creates wonderful textures.

The quick drying time of acrylics
Because of their fast drying time, acrylics are a wonderful medium for working freely and spontaneously, particularly for capturing the transient effects of light and weather or a fast-moving subject such as waves or flowing water.

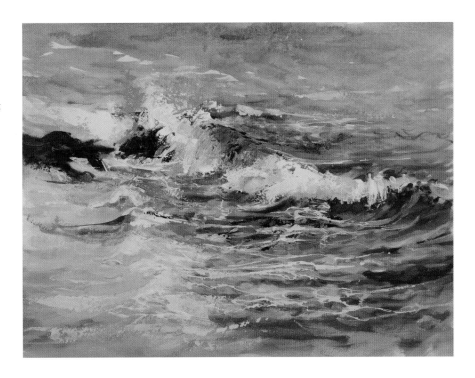

Working 'fat over lean'

The accepted wisdom in oil painting is that you should always paint 'fat over lean' to reduce the risk of the paint cracking. 'Fat' oil paint is oil paint straight from the tube, or with an oil medium added, that is flexible when dry. 'Lean' oil paint is oil paint mixed with more thinner than oil or oil paint mixed with a fast-drying oil. Lean paint dries faster than fat paint – so if lean paint is applied over fat paint, it will dry first, making the lean layer of paint prone to cracking when the fat layer underneath it dries. The theory, therefore, is that every layer in an oil painting should be a little fatter, or have a greater proportion of oil in it, than the previous one.

However, if you use Liquin as a medium rather than oil, there is no need to add oil to increase flexibility in successive layers. When painting in layers, just add more Liquin or reduce the amount of thinner.

Thinning and mixing oil paint
To thin oil paint for techniques such as scumbling and glazing, dip your brush in the thinner and then in the paint, and blend in the centre of the palette. Add more paint or thinner to adjust the consistency.

'Oiling out'

Sometimes you may find that an oil painting has 'sunk' (become dull) because oil from the upper layer has been absorbed by the lower layers or the ground. Another reason for this happening is using too much solvent. If sinking occurs, when the colour is dry, dilute thickened linseed oil with 50 per cent white spirit and rub the mixture sparingly into any sunken areas with a clean cloth. Wipe off any residue and leave to dry for a day or two. If necessary, repeat the process until the painting has regained an even sheen.

using acrylics

Acrylic paint is a relatively new invention, and was only first offered for sale in the early 1960s. Its versatility and quick drying time mean that it can borrow many techniques from both oil and watercolour painting.

The main attribute of acrylic paint is the speed with which it dries, coupled with its ability to be used both thick as an impasto and thin like watercolour. Once the paint is dry, it becomes insoluble and cannot be removed. It does, however, have very good covering power and mistakes and alterations can easily be rectified by overpainting. In recent years, manufacturers have introduced a range of additives that alter the characteristics of the paint, thus extending its versatility even further.

Still life with pears

This simple still life gives you the opportunity to use acrylic paint both thickly, as an impasto, and thinned down with water. Note how well the thick paint, in particular, holds the mark of the brush strokes; match your marks to the shape of the subject you are painting, as it will help you convey their form.

You will need

Canvas board
3B pencil
Small and medium flat brushes
Acrylic paints: phthalo green, sap green, cadmium yellow, titanium white, cadmium red, yellow ochre, burnt umber, Payne's grey, alizarin crimson
Acrylic matt medium

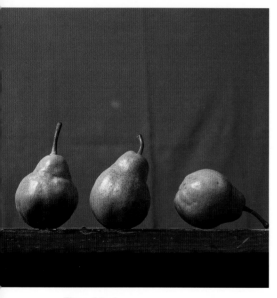

The subject
Arranging the pears separately on the table top gives them an almost sculptural quality, and placing the third pear on its side complements the upright position of the other two. The arrangement also avoids the more conventional manner in which fruit is usually painted in a still life. The red cloth background provides maximum colour contrast to the green of the pears.

1 Using a 3B pencil, make a simple drawing on the canvas board. Use the paint directly from the tube, mixing it with water and a little matt medium. Mix phthalo and sap green together with cadmium yellow, titanium white and a little cadmium red for the pears. Apply the paint in a creamy consistency, using a medium flat brush.

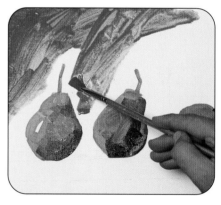

2 Use the same brush to paint in the colour of the background with a thinner mixture of cadmium red.

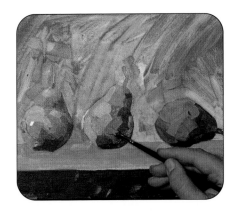 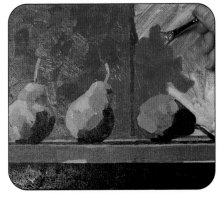 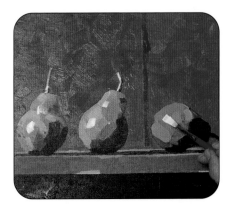

3 Mix yellow ochre, cadmium red, burnt umber and titanium white for the wooden table top. Paint the dark area beneath it with a mixture of burnt umber and Payne's grey. Using a small flat brush for greater control, paint in the contrasting colours on the skins of the pears with a series of green mixes and small, single brush strokes.

4 Paint in the shadow beneath the table, and also the dark red shadow on the red cloth, with a mixture of alizarin crimson and Payne's grey. Mix cadmium red and alizarin crimson together into a fairly thick consistency and apply to the background, using multi-directional strokes. Brush strokes that lead in one direction tend to lead the eye in that direction, too.

5 Paint in the detail on the stalks and the small highlights on the pears with a small flat brush, which aids control and precision.

 Visible brush marks

Thick acrylic paint dries with the brush marks visible, so be aware of their direction, and try to match these marks to the shape of what you are painting.

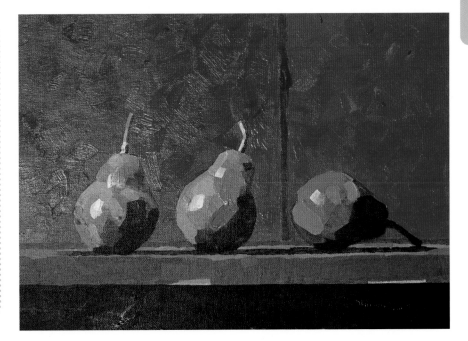

The finished painting

The thick impasto work on the surface of the pears conveys their form well, while the thinner paint on the red background ensures that it does not overpower the main subject. The quick drying time of the paint enables overpainting in a matter of minutes. The dynamic use of complementary colours and the strong composition have helped to create a dramatic work from a deceptively simple subject.

using a toned ground

Painting on a coloured, or toned, ground rather than on white canvas is a long-established tradition in oil painting – and the technique is just as useful for acrylics.

There are two benefits to using a toned ground. The first is that it makes it easier to judge colours – particularly in the early stages of a painting, where you've got very little other than the glaring white of the canvas to relate your colour mixes to. Against the white canvas, colours may seem darker than they really are, and there's a temptation to compensate for this by mixing subsequent colours lighter than they need to be.

The second benefit is that, if you allow the ground to show through in places, you can use it to establish an overall colour key, or mood, for your painting – a soft, muted green or a warm earth colour for a summer landscape, perhaps, or a cool blue-grey for a winter snow scene. Whatever you choose, opt for a tone that is mid-way between the lightest and darkest tones in your subject.

The most important thing to remember is that the ground should be completely dry before you begin painting your picture. Acrylic paints dry very quickly, so many oil painters start with an acrylic ground: you can paint oils on top of acrylics, but not the other way around, as it is very likely that the paint will crack.

Still life on terre verte ground

Choose a mid-toned colour that occurs in the subject itself, as you can then use the ground as a way of unifying the whole painting: here, the terre verte of the ground is a thinned-down version of both the background fabric and the green glaze of the bowl.

You will need

Canvas board
Oil paints: terre verte, ultramarine blue, titanium white, cadmium red, cadmium orange, cadmium yellow deep, raw sienna, cadmium scarlet, lemon yellow, cadmium yellow, Venetian red, viridian, cadmium orange deep
White spirit or turpentine
Rag or paper towel
Selection of hogshair and bristle brushes

1 Add white spirit or turpentine to terre verte paint to create a thin mix. Using a large round brush, scrub the paint onto the canvas, varying the direction of your strokes.

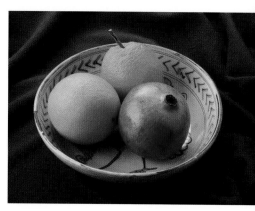

The subject
A dark green fleece jacket provides a soft-textured background to the still life and contrasts well with the vibrant oranges and reds of the fruits. The overhead viewpoint is slightly unusual, but it allows us to look directly down into the bowl. Note that there are three fruits in the composition: an odd number generally makes for a more satisfying composition than an even number.

Establish a colour key

You don't need a flat, even coverage, as the ground will largely be covered over in the subsequent painting. All you're trying to do at this stage is establish an overall colour key of warm green.

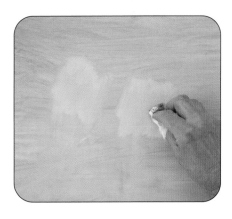

2 Using an old rag or piece of paper towel and a circular motion, wipe off paint in the areas where the fruits are going to be. There's no need to be very precise: a rough approximation of the shapes is sufficient, just so that the underlying green of the ground is not as strong in these areas.

3 Put in the green rim of the bowl, where visible, in a mix of ultramarine blue and titanium white. Establish the overall shape of the pomegranate with cadmium red and begin blocking in the darker parts of the oranges with cadmium orange, adding a little cadmium yellow deep for the mid-toned areas.

Tonal areas

Don't worry about the shape of your brush strokes at this stage, as you can blend the paint wet into wet later to smooth out the transitions of tone: just look for the mid- and dark-toned areas and put them in as rough slabs of colour.

oils and acrylics

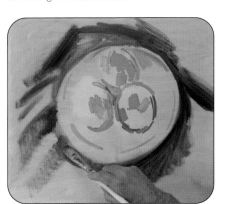

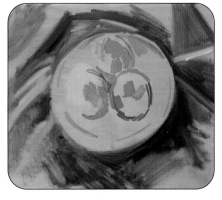

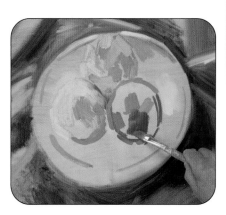

4 Look for the very darkest folds in the background fabric and put these in using a dark green mixed from terre verte and raw sienna and a blue-purple mix of ultramarine blue with a little cadmium scarlet, scumbling the paint on quite vigorously.

5 Add a little lemon yellow and titanium white to the terre verte for the lighter greens.

Move around

Keep moving between the fruits and the background, so that the whole painting develops at the same pace.

6 Block in the light- and mid-toned parts of the oranges with cadmium yellow and cadmium yellow deep, and the darkest parts of the pomegranate with Venetian red. Already, these slab-like applications of colour are helping to imply the form of the fruits.

7 The surface of the pomegranate is quite shiny and light is reflected into it from overhead: mix a purplish-pink from cadmium scarlet with a little titanium white and brush in the highlights, taking care not to obliterate the colour of the ground. Add ultramarine to the mix to paint the dark calyx. Mix a dark blue-green from terre verte and ultramarine and put in the shadows between the fruits, echoing the dark shadows on the background fabric.

8 Continue working on the background fabric, using mixes of terre verte/raw sienna and viridian/ultramarine and varying the proportions of the colours as necessary. Begin putting in the pale green colour behind the chevron pattern around the edge of the bowl, using a mix of terre verte and lots of titanium white.

9 Begin painting the chevron pattern on the bowl using viridian with a little ultramarine. Apply more of the ultramarine and viridian mix to the shaded areas of the fabric, using more ultramarine underneath the bowl where the shadows are strongest and blending the colours wet into wet in order to smooth out the brush marks.

10 Adjust the tones on the fruits, applying cadmium orange deep to both the oranges and the pomegranate and smoothing out the transitions in tone as you go, working wet into wet. Note how effective these small blocks of colour are at conveying a sense of the form of the fruits.

11 The right-hand side of the bowl is slightly more in shade; complete the chevron pattern here, using ultramarine, which is cooler than the viridian/ultramarine mix used earlier.

12 Working wet into wet, smooth out the colours of the background fabric to create an impression of the soft texture of the fabric.

The finished painting

This is a bold, free interpretation of a simple subject, with
blocks of colour conveying the form of the fruits very effectively.
The background has been put in quite loosely, with broad brush
strokes, but allowing some of the pale terre verte ground
to show through gives the painting a luminous feel and helps
to unify it.

working alla prima

Alla prima, or 'direct', painting is a technique that allows the oil painter to complete a picture in a single session. It is especially useful for capturing transient light effects.

The traditional method of oil painting is slow, as the paint film is built up from successive layers and each layer needs to dry before the next is applied. The alla prima method uses oil paints applied in a single opaque layer, often thickly impastoed. It is ideal for working out of doors: you can complete the painting on the spot and work wet into wet back in the studio. Because the colours are applied in one painting session, there is effectively only one layer of paint – so you tend not to get the same problem of the paint surface cracking that can occur with oil paintings that are done in layers (see page 141).

To work alla prima, you must organize your thoughts before you start. Have your canvas already primed. Lay out your colours on the palette and avoid complicated colour mixing: a limited palette will give the painting an inherent harmony. Use a clean brush for each new colour: this saves times and ensures that your colours stay fresh. Finally, take photos of the scene: they will provide useful reference if you decide to do a more resolved study later in the studio.

Alla prima sunset

Alla prima painting is especially useful for capturing transient light effects such as a sunset, where the colours ebb and flow as the sun disappears. Work briskly, scumbling the colour onto the canvas. Start with quite thin paint and then build up the impasto.

You will need

Primed canvas

Oil paints: lamp black, yellow ochre, French ultramarine, alizarin crimson, Prussian blue, cadmium lemon, cerulean blue, titanium white, cadmium red, cobalt blue, cadmium yellow, cadmium orange

Turpentine

Brushes: small long flat bristle, small filbert bristle, small round bristle, medium round bristle, medium filbert bristle, medium soft synthetic

Cotton rag

Be prepared

With scenes like this sunset, you have only a limited amount of time in which to work – so careful preparation is essential. Set yourself up at a good viewing point about a quarter of an hour before the sun starts to set, with a primed canvas on an easel, and make sure that you have all the paints, brushes, thinner and other equipment that you need close to hand.

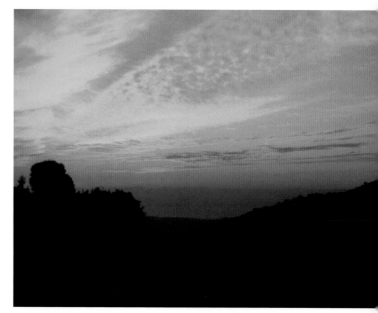

The scene
In this glorious sunset, the delicate pinks and mauves on the horizon are set off by complementary shades of orange and gold. The contrast between the dark, silhouetted foreground and the bright sky enhances the sense of light.

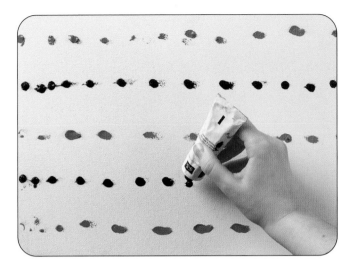

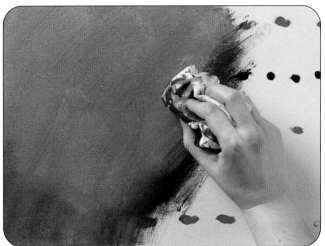

1 Start by laying a medium tone on your canvas. This simplifies and speeds up the painting process and makes it easier to judge your tones. Apply dabs of lamp black and yellow ochre directly from the tube in alternate rows across the canvas.

2 Using a cotton rag dipped in turpentine, blend the paint on the surface to give a medium tone. By manipulating the paint, you can create darker areas that correspond to the land mass at the base of the image.

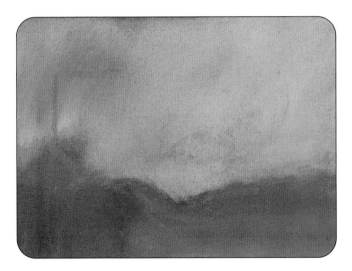

3 To lighten the toning in the top part of the painting, wipe off the paint film with a clean piece of rag dipped in turpentine, suggesting the outline of the hills in the foreground.

4 With a small, long flat brush and a violet mixed from French ultramarine and alizarin crimson, delineate the dramatic silhouette of the land seen against the setting sun. Use lean paint thinned with turpentine for these early stages, as it is easy to paint over. Work freely and loosely – the underpainting is merely a guide and will not be part of the finished image.

5 The setting sun is so dazzling that the land appears as simple silhouetted forms. Block in the foreground with a mix of Prussian blue, cadmium lemon and alizarin crimson. By adjust the proportions of this mix, you can create a range of warm and cool dark tones. Apply the paint quickly, scumbling it in with a medium filbert brush. For the slate-grey passage in the centre, add cerulean blue to the mix.

6 Block in the sky using a sharp yellow mixed from cadmium lemon and titanium white. Scumble this colour on, working briskly with the medium filbert brush. Work across the canvas, but allow the underlying toning to show through to create a lively optical mix.

7 Once the sky and land mass have been established, you can concentrate on the colours of the sunset. Using a mix of titanium white, cadmium lemon and cadmium red, apply a salmon-pink blush just above the horizon. Add more yellow for a tangerine shade or more red for a deeper orange. Add wedge-shaped segments of white where the blue of the sky shows between the radiating fan of clouds. Use a small filbert brush loaded with white paint to locate the sun.

8 Skim a mix of cobalt blue, cerulean blue and white where the sky shows through. Use Prussian blue mixed with cadmium yellow for green, and with alizarin crimson to develop the foreground. Scumble on details of the mackerel sky with a mix of cadmium lemon and cadmium orange.

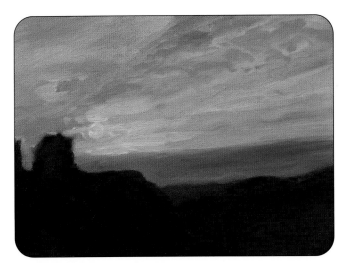

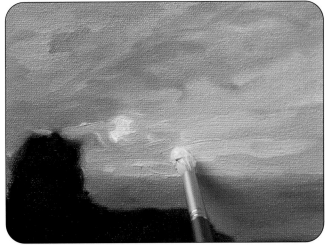

9 Mix a dark blood-red from cerulean blue, alizarin crimson and cadmium orange, and apply a band of it just above the horizon.

10 With a mix of cadmium lemon, cadmium orange and white, and using a medium round brush, start to apply the paint more thickly. The texture will enhance the effect of scattered light around the sun.

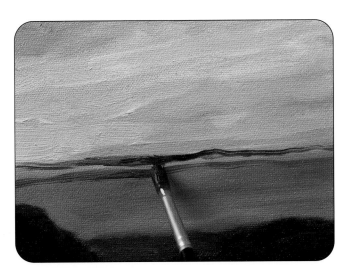

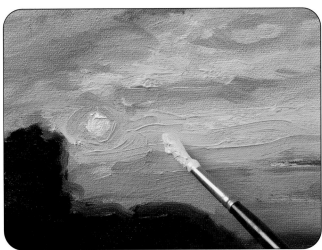

11 Add intensity to the slivers of blue sky with a mix of cerulean blue and white. Load a soft synthetic brush with alizarin crimson and drag it across the top of the paint surface to create streaks of colour.

12 Continue to build up the mackerel sky. Add pink-orange highlights with the mix from step 7. The focal point of the picture is the area around the sun. Continue to build up the impasto, using a creamy mix of cadmium lemon and titanium white. Try to ladle the paint on, rather than scrubbing it on: the colour should be fresh rather than overworked.

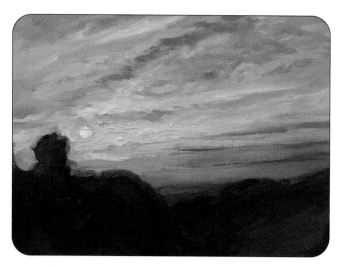

13 Intensify the orange tones on the underside of the clouds and drag streaks of orange back through the crimson near the horizon. Soften the edges of the sky areas with a duck-egg blue mixed from cerulean blue, cadmium lemon and white.

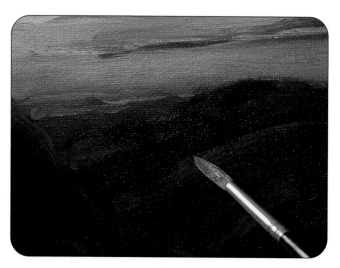

14 Apply a red-brown mix of alizarin crimson, cadmium orange and cobalt blue where the sun catches the edges of the hills.

The finished painting

In this alla prima sketch, the paint was scumbled on at great speed in response to the changing effects of the light. Thick impastoed passages in the sky express the energy and speed with which the image was created. The diagonals of alternating sky and cloud radiating out from the sun give the composition a sense of dynamism.

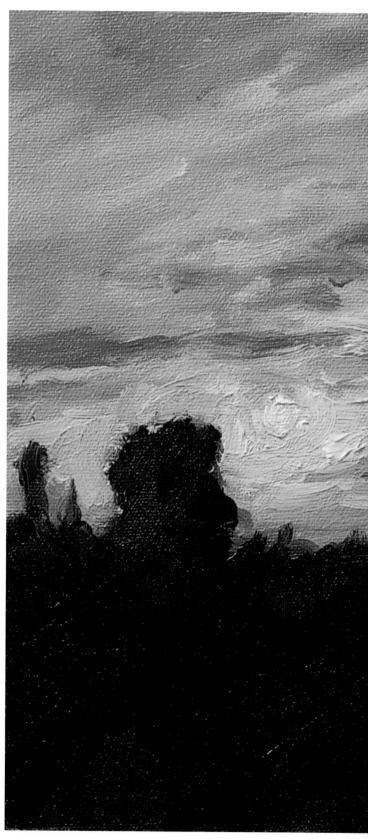

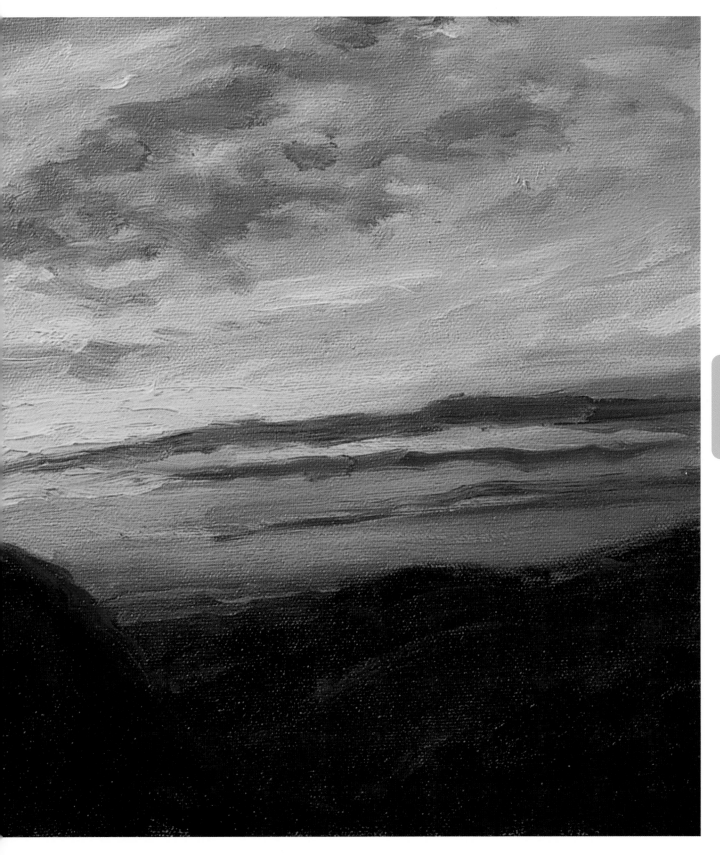

impasto work

Impasto work can be done in both oils and acrylics and involves building up the paint into a thick layer. It is wonderful for rough textures – rocks, scrubby vegetation, and tree bark, for example – as the paint holds the mark of the brush or painting knife used to apply it.

As the paint is applied thickly in impasto work, you will find that you use a lot, even for a relatively small painting. One way to make your paint go further (especially if you are using artist's quality oil paints, which can be very expensive) is to add a medium that is especially designed for impasto work, which adds bulk without affecting the colour. Impasto mediums for oil paints also speed up the drying time and allow the paint to dry at a uniform rate, even if the thickness varies from one part of the painting to another. Acrylic paints can be bulked out with texture pastes and heavy gel medium.

Paint used directly from the tube is generally the right consistency for impasto work. You can either squeeze it straight onto the canvas or onto a palette and then apply it with a brush or a painting knife.

The important thing is not to overdo the impasto: always try to include some flatter, thinner areas, particularly in the background, for the viewer's eye to rest on.

Mediterranean landscape in acrylics

With its scrubby vegetation and spiky cypress trees, this Mediterranean scene is ideally suited to an impasto treatment. Apart from the underpainting, this exercise is painted entirely with a painting knife.

You will need

Canvas board
Acrylic paints: phthalo gteen, alizarin crimson, titanium white,
 ultramarine blue, cadmium yellow, cadmium red, bright green
Medium round brush
Selection of painting knives
Acrylic texture medium

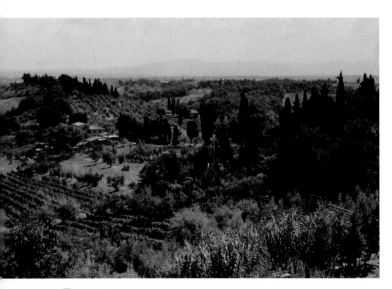

The scene
This is a classic composition, with the sky taking up roughly one-third of the picture space. The line of cypress trees on the right and the vines on the left lead the eye towards the centre of the image. The sharp, jagged outlines of the cypress trees also provide a strong vertical element that contrasts nicely with the relatively low vegetation elsewhere in the scene.

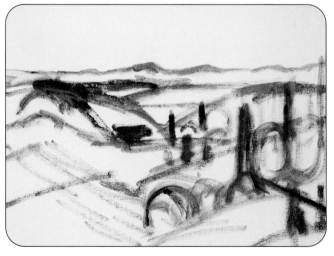

1 Mix a very dark green from phthalo green and alizarin crimson; as this is for the underpainting, the paint should be quite thin. Using a medium round brush, put in the main lines of the composition – the outlines of the hills, the lines of the fields and some of the tall cypress trees.

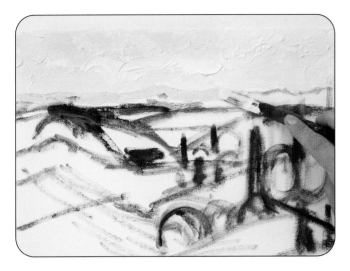

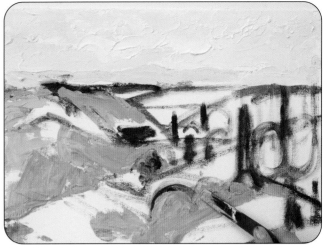

2 Mix a thick, pale blue from titanium white, ultramarine blue and just a hint of alizarin crimson and put in the sky, using a painting knife. Pull the paint up into small peaks with the tip of the knife to get some texture, and leave some areas of the canvas white for the very lightest clouds. Mix a slightly darker blue from titanium white and ultramarine and put in the distant hills, smoothing the paint on with the knife.

3 Mix a terracotta colour from cadmium yellow, cadmium red and titanium white and put in the patches of bare earth and the underlying orangey-brown of the bushes, adding phthalo green to the mix for the more distant fields, which are cooler in tone. Add acrylic texture medium to the mix for the rounded shapes of the foreground trees.

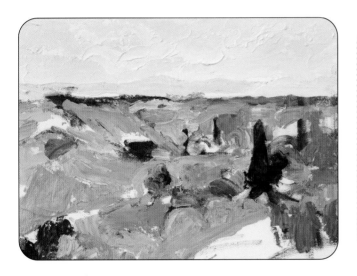

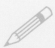
Don't overmix the colours

Don't mix the colours too thoroughly on your palette: if you allow them to retain some of their individuality, you will obtain a much more lively looking result.

4 Block in the different colours across the painting, keeping the paint quite smooth at this stage; you will build up the textures later on. Vary the mixes as appropriate: phthalo green, ultramarine and white for the bluer fields in the distance; bright green and cadmium yellow for the more vibrant greens in the middle distance; and phthalo green and a touch of cadmium red for the very dark green of the trees in the foreground.

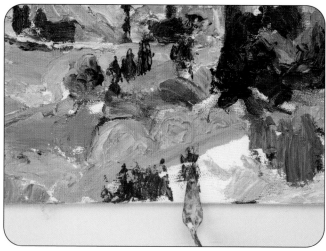

5 Add more ultramarine to the pale blue mix from step 2 and put in the hills in the middle distance; as they are nearer, they are a little darker in tone than those in the far distance.

6 As you build up the different textures, start to use the paint more thickly. Use a small painting knife to block in the dark greens of the bushes and cypress trees on the horizon and in the middle distance. Use the tip of the knife to 'draw' the elongated shapes of the cypress trees. The direction of your knife strokes should echo the direction of the trees' growth.

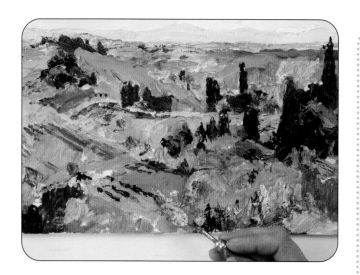

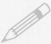

7 As you near the end of the painting, refine the details, blocking in the colours of the fields and the distant buildings. Pay careful attention to light and shade on the buildings, varying the tones so that they look three-dimensional. Use the dark green from the previous step to draw in the lines of the fields of vines, dragging the knife over the surface of the canvas and making the colour darker in the foreground. Because this area is further away, the texture is not so evident. Build up textures on the foreground trees and fields, using the same mixes as before.

General impressions

Try to see your subject as blocks of colour and tone, rather than trying to put in too much precise detail. Also bear in mind the rules of aerial perspective: keep the applications of paint flatter and smoother in the background and middle distance to help create an impression of distance.

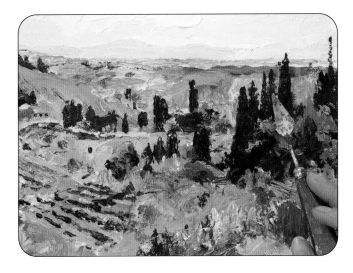

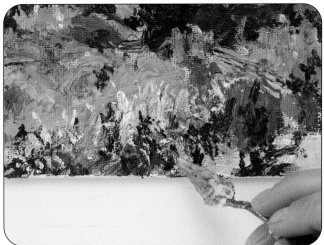

8 Add more texture to the tall cypress trees on the right-hand side of the image, dragging the paint out with sideways flicks of the knife. At first glance, these trees look as if they're a uniform mass of the same dark green – but look for variations in tone within the foliage mass to help convey a sense of form.

9 Mix a pale green from cadmium yellow, bright green and acrylic texture medium. Using the tip of the knife, put in the leaves of the light-coloured plants in the immediate foreground, matching the angle of the knife to the direction of the leaves. Use both the side of the knife and the tip to get thin, straight lines.

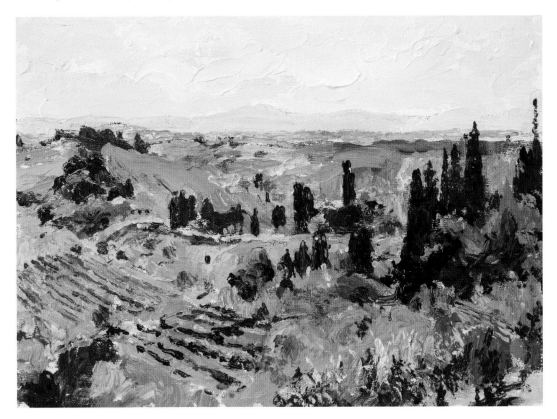

The finished painting

This painting, with its bold blocks of colour, has a very spontaneous, lively quality that is enhanced by not overblending the colours on the palette but allowing them to retain their individuality. The energetic impasto work in the foreground is offset by the thinner applications of paint in the middle and far distance, which help to create a sense of distance and also provide a calmer area on which the eye can rest.

glazing

Glazing is a traditional technique in both oil and acrylic painting in which semi-transparent layers of paint are laid one on top of the other, with each one being allowed to dry before the next is applied. The technique is similar to the wash technique used in watercolour.

With oils, the technique takes a long time to complete, as each layer needs to be completely dry before the next is applied. Acrylic paint, on the other hand, dries very quickly, so a glazed painting can be completed in one sitting.

Light colours can be glazed over darker ones, but the best effects are generally achieved when lighter colours are glazed first, with each subsequent glaze becoming progressively darker.

Glazed paintings have a very different feel to them than paintings made using only opaque or impasto techniques. Glazing is often used over opaque or impasto work as the colour combinations created by placing a glaze of one colour over a glaze of another are completely different from the effect that would have been achieved had the two colours been physically mixed together.

A glaze of a suitable colour can also be used over the entire painting once it has been completed, which has the effect of harmonizing the whole work. It can also be done to tone down overly strident or powerful, vivid colours without the need for repainting.

The subject
Position your subject so that side lighting brings out some structural detail in the spine. Including a cushion not only gives the model something comfortable to lean on, but also gives a strong area of colour to the composition. Placing a large-leaved plant in the background gives extra visual interest to the figure study without detracting from the main subject.

Seated nude

Glazing can produce works that possess a depth of colour and a luminosity that is impossible to achieve using other methods; it is the perfect technique for bringing out the subtle changes of hue that occur in skin tones. The nude back view shown here is a classic pose that, if well lit and positioned, can reveal some wonderful shapes, which the technique of glazing can help to bring out and emphasize.

You will need

Canvas board
2B pencil
Small and medium soft synthetic brushes
Matt acrylic medium
Acrylic paints: cadmium red, cadmium yellow, titanium white, Payne's grey, ultramarine blue, alizarin crimson, yellow ochre, sap green, burnt umber, phthalo green

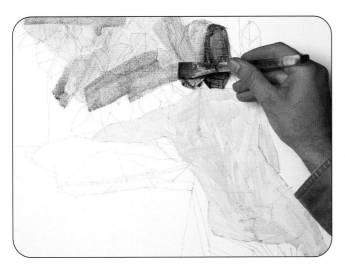

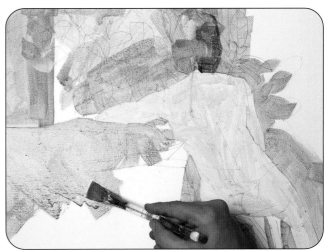

1 Establish the basic composition, using the 2B pencil. The angle of the figure, the complex shape of the plant and the bulk of the red tablecloth all help to keep the eye moving centrally around the picture.

2 Mix cadmium red, cadmium yellow and a little titanium white together. Add water and a little matt acrylic medium. Using a small brush, wash this loosely over the figure to establish the basic colour of the skin.

3 Using a medium brush and a mixture of Payne's grey and ultramarine blue, paint in the shadows cast by the plant and the figure itself. Apply the same mixture to the dark right-hand side and base of the head.

4 Use cadmium red and alizarin crimson to establish the red cloth and cushion, bringing the red over the area in shadow on the right-hand side of the cloth.

oils and acrylics

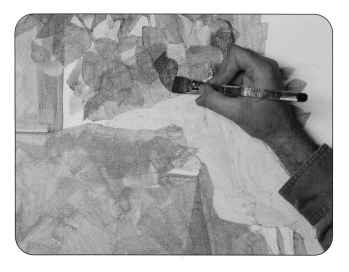

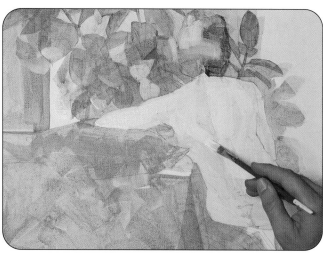

5 Add yellow ochre mix to the shadows on the striped cloth and use a sap green and ultramarine blue mix for the leaves of the rubber plant.

6 Apply a coat of titanium white to the background; this cuts out the shadow shapes of the leaves. Then work over the lighter sections of the figure using a pale pink colour mixed from cadmium red, cadmium yellow and titanium white.

7 Define the hair using a dark mix of Payne's grey and burnt umber and paying attention to the shape of the thin plait of hair down the back.

8 Mix a darker skin colour from cadmium red, cadmium yellow, a little burnt umber and white. Redden the mixture slightly around the model's buttocks and down the legs.

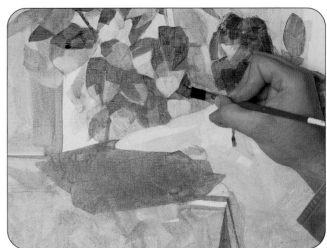

9 Use a dark red made from cadmium red, Payne's grey and a little burnt umber for the cushion, the shadow on the red cloth and the linear pattern on the cloth beneath the figure.

10 Paint the dark shadows on the leaves with a mixture of phthalo green and Payne's grey.

11 Darken the skin mixture from step 8 and redefine and darken the shaded areas on the model. Work around the buttocks and the leg, the right arm and the left underarm and the centre of the back; these glazes help to make the underlying structure of the figure more apparent, making it appear more three-dimensional.

12 Once dry, darken the flesh colour further and glaze in the darkest colours on the skin.

13 Add the patterns on the cloth next, using mixes of cadmium yellow, cadmium red and Payne's grey.

14 Intensify the colour of the red cloth with a dull red mixture of cadmium red and alizarin crimson.

15 Consolidate the background using titanium white, cutting it in carefully around the shadow shapes and leaves.

Glazing mediums

Acrylic paint for glazing can simply be diluted with water, but adding an acrylic medium increases the transparency of the paint and makes the paint flow more easily. Oil paints should be thinned with a glazing medium. There are so many oil and acrylic mediums on the market that it can be very difficult to know which ones to use; check the manufacturer's specifications to find out which ones are recommended for glazing.

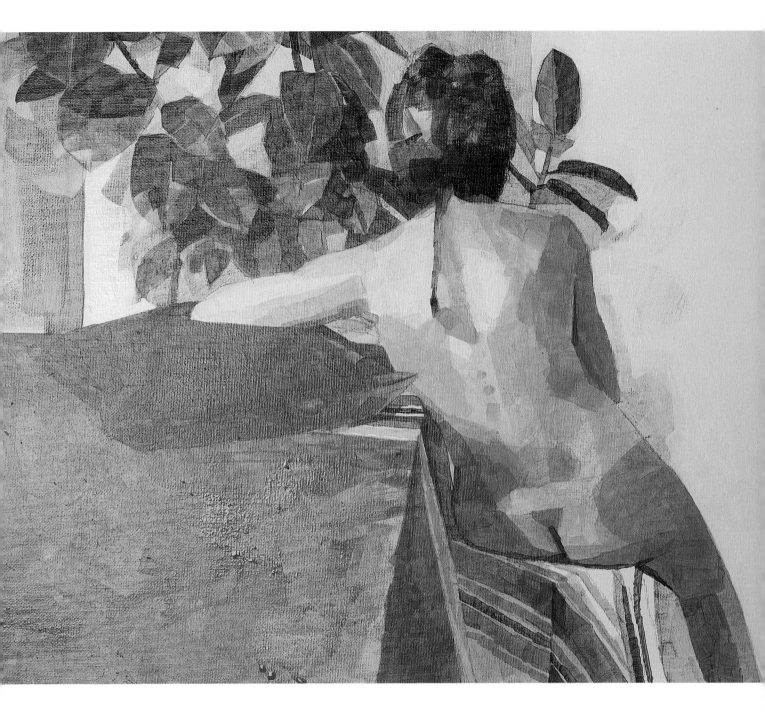

The finished painting

The painting has a wonderful feeling of light and shade, created by carefully observing changes in tone and building up layers of colour to the right density. In compositional terms, the figure is positioned 'on the third' (see page 59), with the strong diagonal tilt of both the body and the cushion on which the model is resting helping to direct the eye into the centre of the image. The use of complementary colours (red and green) gives a dynamic feel to a deceptively simple subject.

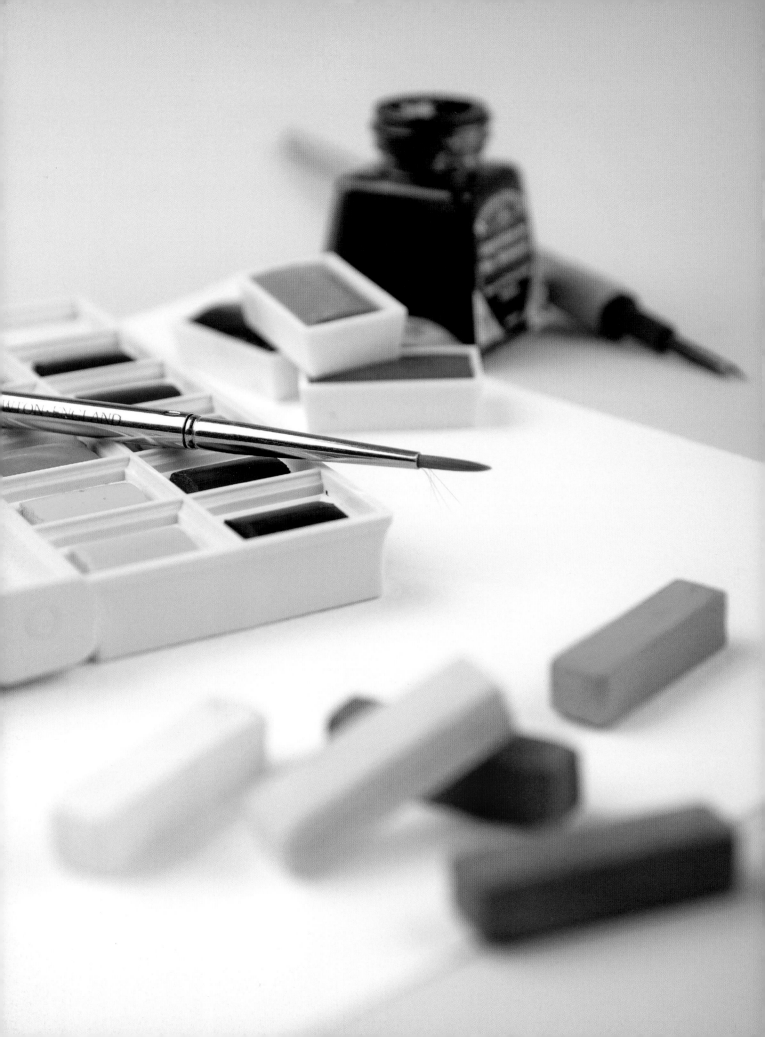

mixed media

Combining different media in the same work of art –
watercolour with soft pastel, acrylic paints with collaged
elements, for example – opens up all kinds of possibilities for
creating exciting textures and contrasts. In this chapter, you
will find a range of ideas that you can use as a starting point
for your own artistic explorations.

charcoal and chalk

Few materials go together as well as charcoal and chalk. Coupled with a mid-gray paper, works of remarkable subtlety and realism can be achieved.

Using a toned ground is far easier than trying to judge the depth of a tone against white and is a technique that can be practised in all mediums except watercolour.

The toned ground plays a major role in this project and stands for the mid-toned areas of the subjects, leaving relatively little for you to actually draw. The light and dark tones are applied using different marks, including scribbling, hatching and using a stick of chalk on its side. The actual amount of detail included is surprisingly small, with what little there is being made with sharpened black and white pastels. Take care not to overwork the piece. Keep the marks open and loose, and allow the support to show through and work for you.

You will need

Mid-grey pastel paper	Kneaded eraser
Medium charcoal stick	White chalk
Pastel pencils: black, white	Fixative

The subject
Any combination of clothing, hats, bags or shoes arranged carefully on a hook or chair, or even thrown casually on the floor, offers a readily available and interesting still-life subject. The fall of light on the folds and creases, the pattern and texture of different fabrics, and the variety of shapes all offer an enthralling challenge.

1 Using light charcoal marks, loosely sketch in the hat, coat, bag and chair. The drawing can be corrected if desired at a later stage using either the flick of a cloth or a stiff brush.

2 Search out and scribble in the darkest shadows, using a medium-sized stick of charcoal. Follow the shape of these shadows carefully as they curve in and out of the folds of the hat, coat and bag.

3 Hatch in the mid tones using the charcoal stick and a black pastel pencil.

4 Pay particular attention to the washed-out effect on the seams of the denim jacket. These tones can be lightened using a kneaded eraser.

5 Still using the black pastel pencil, work up the detail on the hat and bag. Hatch in the tones lightly at first, then gradually apply more pressure to darken them. Always angle the scribbled marks to match the direction of the cloth.

6 Concentrate on the wooden chair and metal legs and work up the tones on both. Make sure you are satisfied with the work so far and then apply a spray of fixative.

7 Using the stick of charcoal, scribble in the shadows that are cast on the ground beneath the chair. These are not as dark as the shadows on the clothes and bag, so keep the marks much lighter.

8 To soften the tone, gently blend the charcoal marks with the tip of your finger.

9 Using a white pastel pencil, draw in the fine highlights on the hat band, the jacket buttons, the seams, the detailing on the bag and the legs of the chair.

10 Block in the lightest tones on the canvas bag using the side of a stick of white chalk. Apply only light pressure so that chalk is just glazed onto the paper surface. Make sure that the marks follow the folds of the bag. Once the drawing is complete, apply a coat of fixative to prevent smudging.

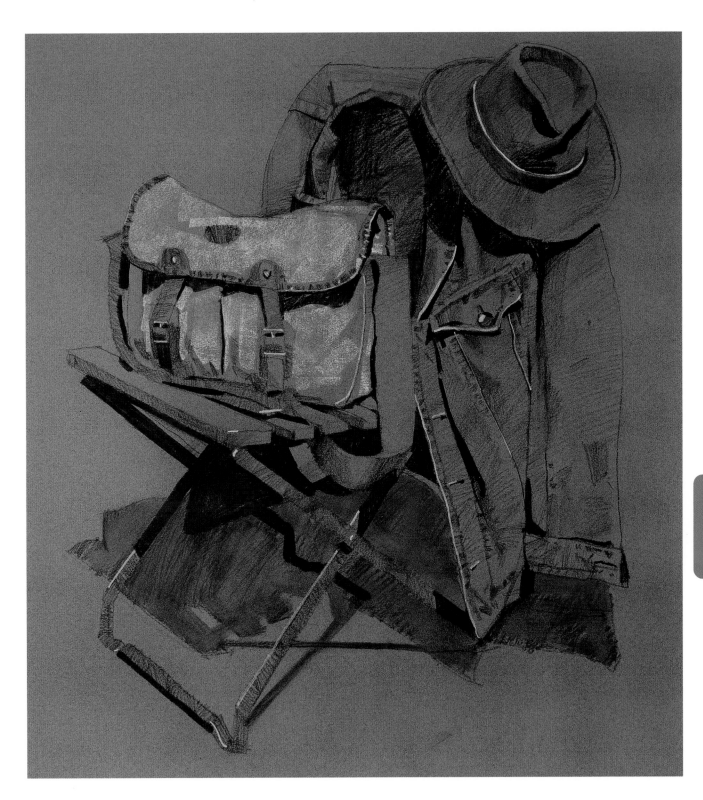

The finished drawing

This is a relatively quick drawing, but by paying careful attention to the fall of light and the different tones, the artist has a created a convincingly three-dimensional representation of a simple subject. The chalk and charcoal complement each other well, with the chalk being used to block in the light tone of the canvas bag and pick up sharp, crisp highlights, particularly on the edges of the chair, and the charcoal to scribble in the very darkest areas of tone in the cast shadows under the chair. The mid-toned grey colour of the support plays a crucial role in bringing the whole drawing together.

boats in line and wash

In this project, the precision of line work is combined with fluid watercolour washes to create a painting that is light and full of atmosphere.

This project is also a useful exercise in adapting your reference material to make a stronger, more satisfying work of art. At first glance you could be forgiven for thinking that this harbour scene, with its peripheral clutter and rather jumbled background, is far too confusing to make a good painting, but your task as an artist is to interpret what's there in your own way, not make a slavish copy of it. The fact that you're working from a photograph does not mean that you have to adopt a photorealistic approach in your painting, and there's no need to render every single detail: things such as railings, cars and people who are not the main focus of attention can be left very loose or even omitted altogether. Colours, too, can be adjusted, and intensified or knocked back as you see fit. Concentrate on what you feel is most important to the scene, rather than trying to put everything in with 100 per cent accuracy.

You will need

Rough watercolour paper

Fine-nibbed dip pen

Waterproof inks: peat brown, canary yellow, vermilion, ultramarine blue, black

Scrap paper and masking tape

Old toothbrush

Watercolour paints; raw umber, ultramarine blue, cadmium red, black, burnt sienna, cobalt blue, Payne's grey, Indian yellow, raw sienna, turquoise, cerulean blue, cadmium orange, alizarin crimson, sepia, black, lemon yellow, cadmium yellow

Medium round brush

The scene
The weathered boats, tilting in towards each other, form the focal point of this scene. The strong cast shadows add interest and depth, while the coiled ropes and pebbled foreground provide an opportunity to experiment with textural techniques.

1 Using a fine-nibbed dip pen and various dilute mixes of peat brown and canary yellow waterproof inks, set down the basic shapes of the boats and those elements of the background that you want to include. Don't attempt to draw the scene in detail – all you need is enough for you to be able to see where things lie in relation to each other, so that you can find your way around the painting. But take your time and make sure you get the angles of the boats and the overall shapes right.

Line and wash tips

As you make these first marks, measure carefully and look to see how each element relates to the rest of the scene.

With waterproof ink it's very difficult to correct mistakes, so when you're first searching out the shapes of your subject, make your initial marks little more than dots and dashes.

2 Once you've mapped out the overall shapes and composition to your satisfaction, you can start putting in some more precise line work. Using neat brown ink, put in the ribs inside the left-hand boat. Note how they appear both smaller and closer together as they recede from view: observe and measure things carefully, as this will help to give the scene a sense of scale and perspective.

3 As you develop the line drawing, switch from one colour of ink to another as required: the colours don't have to be completely true to life, merely an approximation of what's there.

4 Now you can start to develop some texture in the foreground of the image. Mask off areas such as the boats, which you want to protect, with scrap paper. Load an old toothbrush with brown, yellow and red ink in turn and spatter the ink over the foreground to create an impression of the pebbly ground. Leave to dry, then remove the paper masks.

mixed media

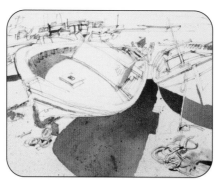

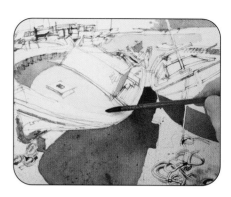

5 Mix a warm shadow colour from raw umber and ultramarine blue watercolour paints. Using a medium round brush, block in the shadow under the left-hand boat, adding more raw umber and a touch of cadmium red towards the edge, where the shadow is warmer. Note how the dry ink spatters underneath remain crisp and clear. Mix plenty of paint for this! There's nothing more frustrating than running out of a mix halfway through.

6 Add a little black to the mix, then block in the shadow under the right-hand boat, painting carefully around the rope that's trailing on the ground. Paint the shadows cast on the ground by the rope using burnt sienna.

7 Mix a pale wash of cobalt blue and paint the sea in the background, then block in the background colour of the mountains in a mix of cobalt blue and Payne's grey. Paint the blue paintwork inside the left-hand boat with very pale cobalt blue. Leave to dry.

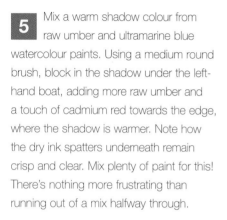

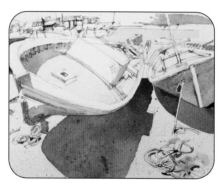

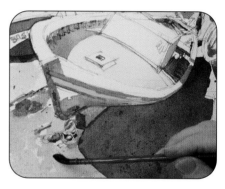

Order of work

There's no strict order in which to work with a scene like this: when you have a particular colour on the brush, look around to see where else you can use it – as long as you can do so without disturbing any wet paint that's already there.

8 Paint the faded orange exterior of the left-hand boat with Indian yellow plus a touch of raw sienna. Paint the shaded area under the ribs with a mix of ultramarine and raw umber. Mix a bright blue from turquoise and a little ultramarine and paint the stern of the right-hand boat, taking care to paint around the rope. Leave to dry. Mix ultramarine and cerulean blue and paint the cast shadows on and under the right-hand boat.

9 Mix a very dilute wash of raw sienna and cadmium orange and apply it over the pebbly foreground, keeping the coverage loose and random.

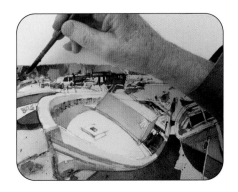

10 Paint the shaded side of the wheelhouse on the left-hand boat with a pale purple mixed from ultramarine and alizarin crimson. Mix a dark brown from sepia and black and block in the background boats. Loosely block in some clumps of green (made from varying proportions of ultramarine blue/lemon yellow and ultramarine blue/cadmium yellow) to imply background foliage.

11 Darken the faded orange of the wheelhouse on the left-hand boat with Indian yellow with a touch of raw sienna, to match the colour on the exterior of the boat.

The finished painting

A dip pen, with its rather scratchy nib, gives the line work a spontaneous and energetic quality that could not be achieved with a technical pen. The line work – done in several colours of waterproof ink – underpins the whole image, while the fluid but carefully controlled watercolour washes add colour and luminosity. Note how the white of the paper has been used to impart a wonderful feeling of light to the scene: the whole image seems to sparkle in the bright sunlight. Note, too, how the rather messy, cluttered background of the scene has been painted in an almost impressionistic way, so as not to detract from the main subjects.

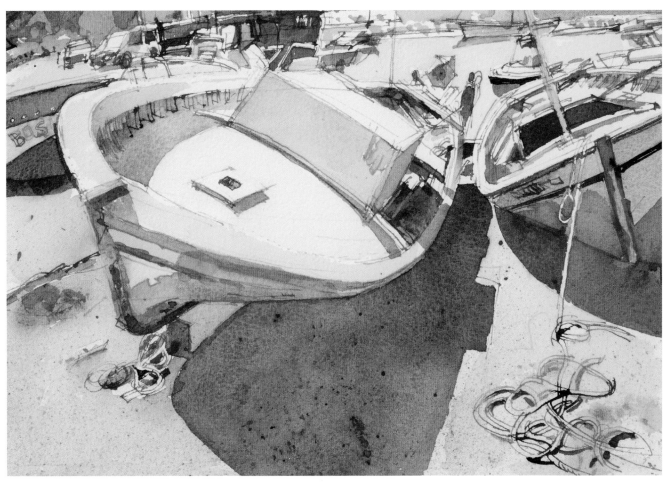

landscape in paint, graphite and collage

A collage is made by assembling assorted materials, such as paper, fabric or dried leaves, and gluing them onto a flat surface to create a picture. In this project, acrylic paints are combined with torn paper and graphite line work to create an exciting interpretation of limestone cliffs.

Handling pieces of paper or other collage objects forces you to be bold: you cannot refine details in the same way as you can when painting or drawing. When planning the composition, you have the freedom to move the different elements around, assessing the impact of shapes, texture and colour relationships. You can cut, tear, add and take away right up to the final gluing stage.

Collage images can be built up quickly and, because the technique is direct and spontaneous, they rarely look laboured. First paint your chosen surfaces in a range of colours; alternatively, print patterns using crumpled paper or a sponge, or spatter paint on with a brush (see pages 130–132).

You will need

NOT watercolour paper
Prepared papers for collage
Acrylic medium as an adhesive
2B pencil
Graphite sticks
Acrylic paints: Payne's grey, sap green, cobalt blue, Winsor blue, yellow ochre, sepia, cadmium red
Brushes: Medium hake, small flat, medium and large round, mop
Piece of stiff card
Small sponge

The scene
The jutting headland, funnel-shaped cove and striated rock forms of this coastline provide a textural and structural challenge.

1 Collect scraps of discarded paper and paint textures and patterns onto them. For this image a range of greens and ochres is most useful. Brush a rich green mixed from Payne's grey and sap green onto watercolour paper. Scraps of other papers, such as tissue paper and watercolour paper, will also be useful.

2 Pencil in the main outlines of the scene on a sheet of watercolour paper. Indicate the water in the inlet, the crescent of the beach and the layers of rock. Work freely to develop the shapes and patterns.

3 Mix a wash of cobalt and Winsor blue for the sky and apply it with a mop brush, leaving gaps to represent clouds. Use the same colour for the water in the inlet, then drop a touch of sap green into the wet blue paint.

4 Using the mop brush, lay a wash of yellow ochre and sepia over the land area. Add a touch of cadmium red to yellow ochre and scrub on this mix, working wet into wet for a variegated effect. The pale ochre mixes help to reduce the glare of the white paper.

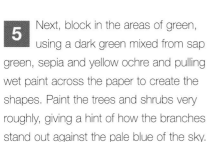

5 Next, block in the areas of green, using a dark green mixed from sap green, sepia and yellow ochre and pulling wet paint across the paper to create the shapes. Paint the trees and shrubs very roughly, giving a hint of how the branches stand out against the pale blue of the sky.

6 Make a large amount of a neutral grey-brown mixed from yellow ochre, sepia and Payne's grey. Using a medium round brush, start to lay in strips for colour for the patterns of the striated rocks. Sometimes use the tip of the brush, sometimes the flat, to create a variety of stripes. Work confidently and quickly to ensure that the lines are even. For the foreground, use a large round brush with broad strokes. Allow to dry.

7 The deep, blue-green water of the inlet is the focal point of the painting. To give this area more emphasis, lay bands of colour using a small flat brush and a wash of cobalt and Winsor blue. Before you lay each band, add a bit of water to the mix so that the bands grade from dark to light as the water gets shallower. Leave a tiny gap between each band of blue.

mixed media

 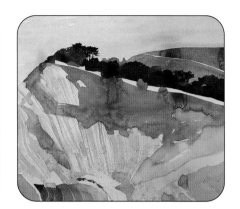

8 Add further detail to the rocks using a piece of stiff card dipped in a mix of sepia and a little cadmium red. Hold the card steady and use the thin edge to 'draw' a line.

9 To create the line of the seaweed on the shore, mask the edge of the beach nearest the sea with pieces of torn scrap paper. Using a sponge, dab a narrow line of sepia along the curved edge of the mask. Allow to dry, then remove the mask.

10 Paint the shrubs on the headland with a dark green mix of sap green, sepia and Payne's grey, using the tip of the medium round brush to create their underlying outlines and suggest the tracery of branches. The main elements of the composition are now established.

 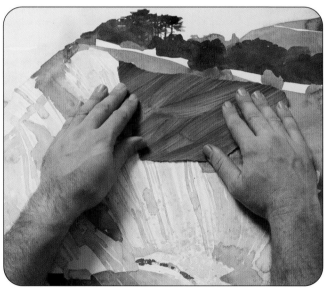

11 Now you can begin to elaborate the texture of the bare rock and the undulating grassed areas. Tear prepared papers into pieces that are roughly the size and shape you need; do not use scissors, as torn edges have a softer, organic feel.

12 Lay the torn paper on the picture and move the pieces around until you are happy with the position. Visualize the headland as a series of planes that abut each other. Overlay strips of paper to create interesting patterns. Tear more strips of paper than you need, so that you can select those that work best. Try to achieve a good balance: too few collaged pieces will look sparse, while too many may look contrived.

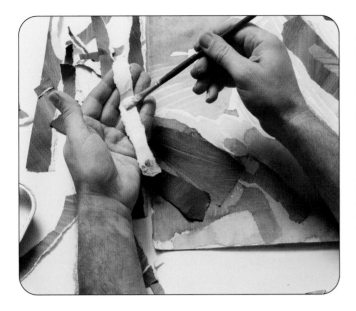

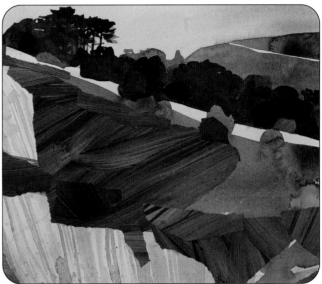

13 When you are satisfied with the placement of the collage pieces, stick the strips of paper down, using a small flat brush to apply acrylic medium or adhesive. Continue to add paper to the slopes of the headland, experimenting with different patterns and shapes.

14 Add tree and shrub shapes in the form of torn papers in darker shades of green. Collage makes the picture look more abstract and gives the surface a decorative quality.

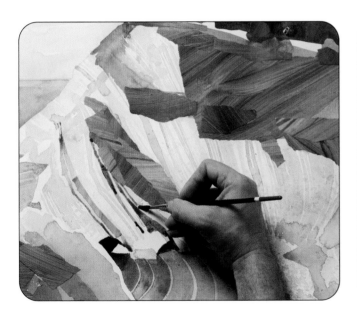

15 Next, develop the surface of the rocks to keep pace with the rest of the picture. Add painted texture with a dark version of the rock colour from step 6. Using a medium round brush, paint in strips alongside the pieces of collage.

16 The linear nature of the rock formations lends itself to a linear medium. Graphite stick has the sensitivity of a pencil, but feels more direct and chunky. Hold the stick loosely in your hand to create a naturally flowing line, twisting the stick to create random thick and thin lines.

17 Tear small pieces of white tissue paper and lay them on the sky. When they are glued in place, they will become transparent and modify the underlying blue very subtly. Stand back and assess the effect: you could create clouds by building up more layers of tissue.

18 The rocks are such a strong feature that they could be enriched further. Using a graphite stick, embellish the rocks with a variety of thick and thin lines to delineate the rough edges of the exposed strata.

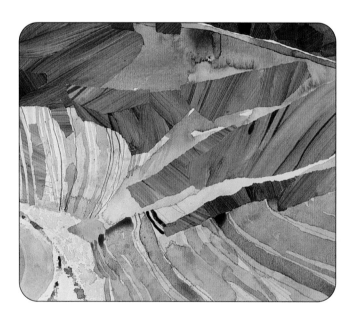

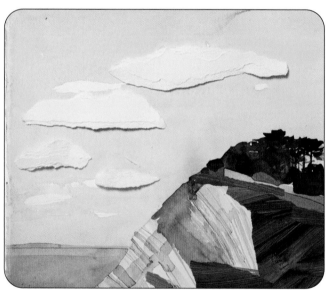

19 For a similar effect, apply bands of warm ochre mixed from yellow ochre, sepia and cadmium red acrylic paints to the foreground.

20 Add clouds to balance and complete the composition. Use thick watercolour paper and differing sizes and tear the edges. The three-dimensional quality of the torn edges suggests the fluffiness of the clouds.

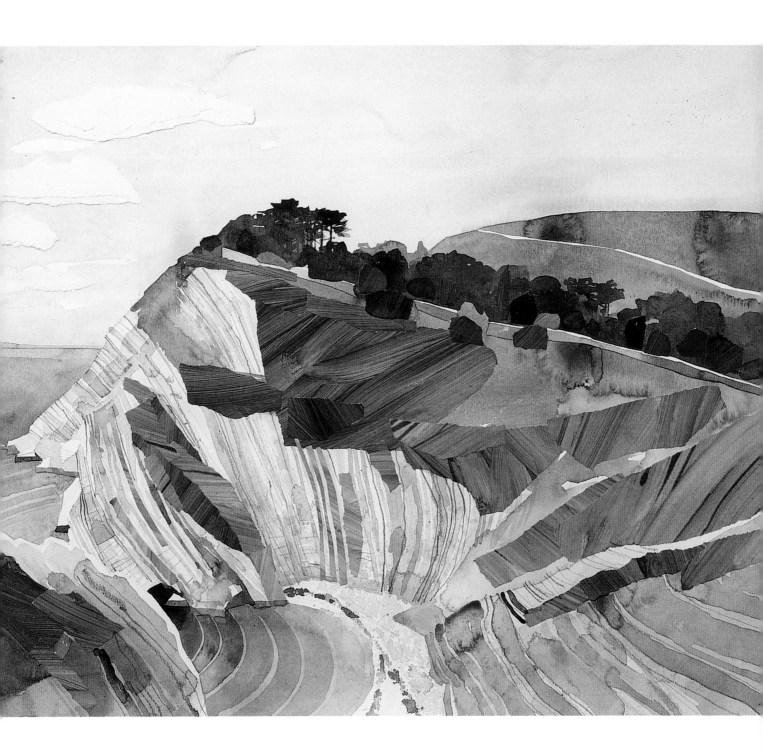

The finished painting

The unique geology, bold landmasses and varied but strong textures lend themselves to a combination of paint, graphite and collage. The collage process has allowed the artist to accentuate and to simplify so that, although the finished image is a recognizable depiction of this area of coastline, it has a quality that could not have been achieved in any other way.

landscape in watercolour and soft pastel

Using watercolour in conjunction with soft pastel allows you to combine the fluidity and luminosity of delicate washes with a range of textural marks that would be impossible to achieve in paint.

The Mediterranean sea scene shown here is perfect for the watercolour/soft pastel combination: thin, translucent watercolour washes are ideal for the sky and sea, while the pebbly foreshore and foreground trees are much more textured and can be simply but effectively rendered in soft pastel. Soft pastel is also a wonderful medium for depicting the effects of sunlight on water as, by applying the pastel very lightly and just skimming it over the surface of the support, you can gradually build up to create a film of broken colour that positively shimmers with light.

Try using a rough watercolour paper so that you can incorporate the texture of the paper into the painting: the 'tooth' of the paper will pick up the soft pastel pigment while the 'troughs' will not.

You will need

Rough watercolour paper

4B pencil

Watercolour paints: ultramarine blue, Prussian blue, viridian, raw umber, alizarin crimson, lemon yellow, burnt umber, white gouache

Brushes: large mop, medium and small round

Soft pastels: purple-blue, bright blue, olive green, dark green, peach/off-white, yellow-green, terracotta, dark brown, dark purple

Paper towel

Fixative

The scene

With its warm blues and greens, this is an attractive scene, but the composition is a little jumbled: there is a lot of empty space in the sea on the left of the image while the main subject (the yacht) is right in the centre and does not stand out well against the background. A little artistic licence was required: the artist decided to move the yacht to the left in her painting, positioning it more or less 'on the third' (see page 59) to make a more balanced composition.

1 Using a 4B pencil, lightly sketch the scene to give yourself a guide to where to apply the paint, putting in the general shapes of the foliage, the line of the water and the boats. Don't make your pencil marks too strong, or they may show through the watercolour washes.

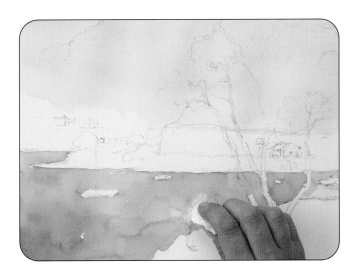

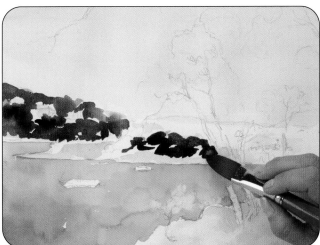

2 Mix a pale blue from ultramarine, Prussian blue and lots of water. Using a large mop brush, wash it over the sky area. Add viridian to the mix and wash it over the sea, leaving the boats and the tree trunks untouched. Vary the proportions of colours in the mix: the sea is not an even, uniform tone. Dab off some of the paint with a scrunched-up piece of paper towel to create even more variation in the tone.

3 Mix a sandy brown from raw umber and alizarin crimson and dab it loosely over the land area, again dabbing off some paint with a paper towel. Mix a dark green from Prussian blue and raw umber and dot in the greens on the distant hillside; the trees here are quite rounded in shape, so try to echo this in your brush strokes.

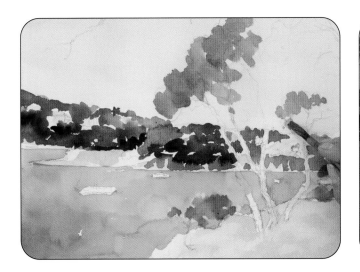

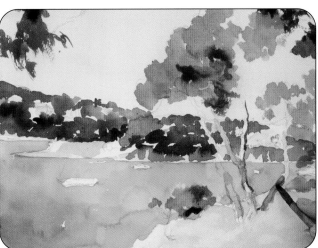

4 Mix a bright olive green from raw umber, lemon yellow and a tiny amount of Prussian blue. Using a medium round brush, block in the foliage of the foreground trees and bushes.

5 Add more Prussian blue to the mix and touch in the darker areas of foliage, wet into wet (see page 116), so that the paint blurs and spreads. Paint the shaded areas of the trunks in a pale purple mix of Prussian blue and alizarin crimson.

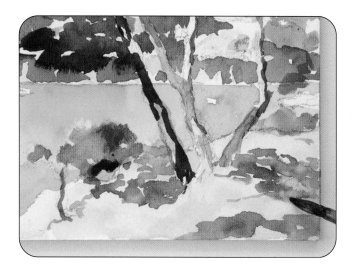

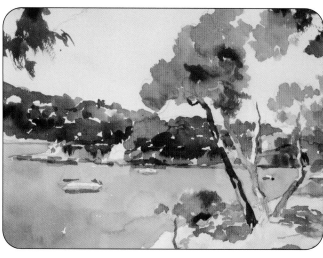

6 Paint the dark brown areas of the trunks with a mix of burnt umber and alizarin crimson. Use the purple mix from the previous step for the shadows that the trees cast on the ground.

7 Darken the distant shoreline with the Prussian blue and viridian mix from step 2. Touch the purple mix from the previous step into the spit of land that juts out from the shoreline. Paint the hull of the large yacht in ultramarine. The watercolour stage is now complete.

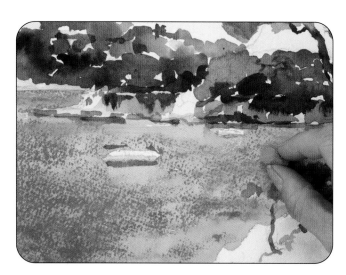

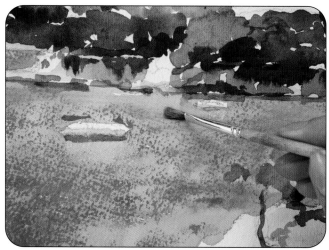

8 Using the side of a purple-blue pastel, lightly apply horizontal strokes that echo the direction of the ripples over the sea, allowing the underlying watercolour to show through. Repeat the process with a brighter blue. Note how pastel picks up the 'tooth' of the paper to create texture in this area.

9 Lightly blend the pastel marks with a small brush or your fingertips.

 Don't overblend the pastel

Don't overblend the marks or you will clog up the tooth of the paper with pigment and end up with a flat, lifeless image.

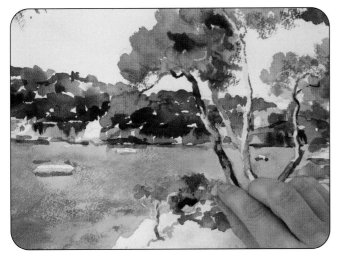

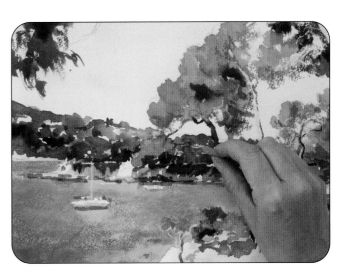

10 Using small dots and dashes, apply olive green pastel and dark green over the foreground leaves. Scribble in the highlights on the trunks with peach/off-white. Scribble on a bright yellow-green for the brightest areas of the foreground foliage.

11 Scribble in the terracotta roofs of the houses on the far shore. Put in the mid-green of the distant trees with the olive green pastel.

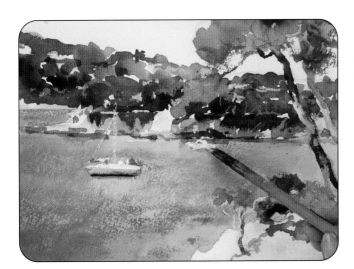

12 Using white gouache and a medium round brush, paint the white areas of the boats. Because the gouache is opaque, it will cover up any watercolour or pastel that you may accidentally have applied to areas that you want to remain pure white.

13 Draw in the overhanging branch at the top of the picture with a dark brown pastel, with peach/off-white for the highlights, then use a dark green pastel to scribble in some textural marks for the leaves.

14 Use the tip of a dark purple pastel to scribble in the deep shadows in the foreground and dot in peach/off-white for the sun-bleached, pebble-strewn ground. The pastel picks up the tooth of the paper and prevents this area from looking completely flat. Spray the painting with fixative to prevent the pastel marks from smudging.

The finished painting

This simple painting captures the feeling of a hot summer's day on the Mediterranean very effectively. By applying several blue and green soft pastels very lightly to the support, so that the colours retain their identity, the sea positively shimmers with light. The bleached-out ground and the deep shadows convey the warmth and intensity of the sunlight. The trees and foreshore form a frame for the scene, leading the viewer's eye around the picture space to end up on the focal point – the yacht.

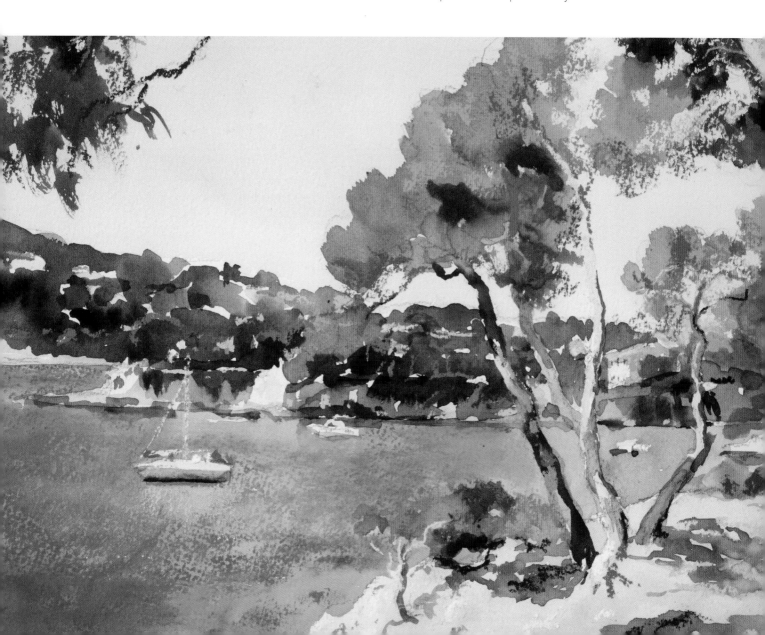

daisies in Conté crayons and watercolour paints

This drawing combines a background of semi-abstract, wet-into-wet watercolour washes with the dense, opaque qualities of Conté crayons. The hardness of the Conté crayons allows for finer lines and more control than could be achieved using soft chalk pastels, while the watercolour creates fluid, luminous washes that cannot be matched in any other medium.

Conté and soft pastel drawings are often done on coloured paper, but as the background to this image is done in watercolour, a semi-rough watercolour paper is recommended: this allows the whiteness of the paper to be reflected up through the watercolour washes, thus exploiting the transparency and luminosity for which watercolour is renowned. The semi-rough 'tooth' of the paper also makes it possible to create some texture in the Conté marks.

The shapes of the flowers and stalks are done in Conté crayon. Be very careful not to overwork the Conté colours – the end result should be a fresh and spontaneous rendition of simple flowers in dappled light.

You will need

Semi-rough watercolour paper
Large oriental brush
Watercolour paints: selection of greens, blues and yellows
Conté crayons: white, mid-blue, pale blue, orange, yellow, mid/dark green, mid/dark blue

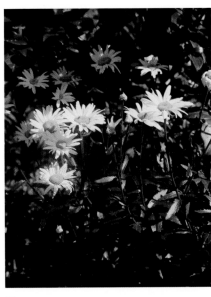

The scene
The white daisies stand out clearly against the dark green background leaves and stalks, and the top flowers cast dappled shadows on those below, adding interest to an otherwise very simple scene.

1 Using a large oriental brush and very fluid washes of various greens, vigorously apply a broken background onto pre-stretched watercolour paper. Work wet into wet, adding blues to the darker shadow areas and yellows for the flower centres. Cover most of the paper, giving a range of different colours, textures and tones.

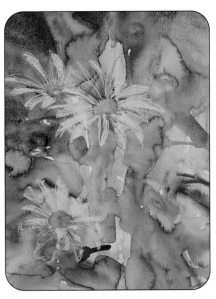

2 When the washes are thoroughly dry, work around the loose areas of the flower centres, drawing in the shapes of the main petals with a white Conté crayon. Draw freely, capturing the irregular shapes of the flowers. Using mid- and pale-blue Conté crayons, add the shadow areas to the petals.

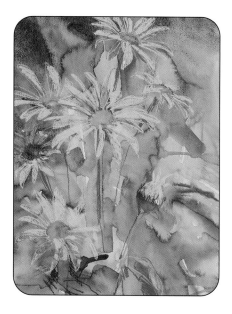 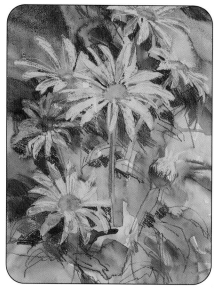 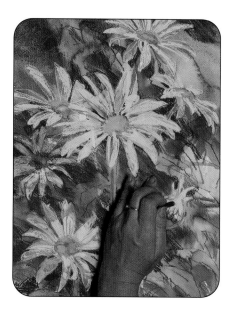

3 Draw in the top flower at an angle to the picture plane. Sharpen and define the pollen-filled centres of the flowers using a mixture of orange and yellow crayons. Continue until all the flower heads and the overall composition are established – the abstract areas of the watercolour background now take on pictorial meaning.

4 Using the slightly darker tones of the background colours, draw around the flowers to give them greater definition and bring them forward out of the surrounding areas – in effect, treating them as negative shapes (see page 34). Use the Conté to draw in individual leaf and stem shapes, too.

5 Continue drawing the background, defining the leaf and stalk shapes as you go. The dappled light sharply defines brightly lit areas, whereas other shadow areas melt into the background. Soften areas of shading using the edge of your finger – this allows the pastel drawing to blend in with the watercolour background.

The finished drawing

This is a lively and spontaneous-looking drawing that exploits the characteristics of both mediums well: the wet-into-wet watercolour washes provide a soft, muted background, while the Conté crayons and semi-rough paper give a texture that could not have been created through the use of watercolour alone.

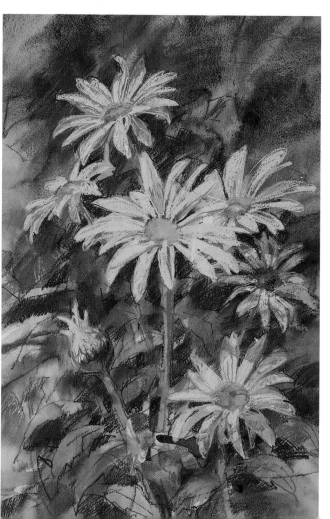

dried flowers in Conté crayons, oil pastels and watercolour inks

Using a combination of mediums means that your method of working may change. Putting in both the lightest and darkest parts of a picture from the start is not standard procedure, but the mediums used here make this the most effective solution.

Take your time setting up the still-life arrangement and look at the negative shapes as well as the positive ones (see page 34), as they contribute a lot to the overall balance of the compositiion. The wonderful twisting shapes in the twigs and seedheads cry out for a linear treatment, and you should try to work boldly and confidently: it really won't matter too much if some of the shapes and lines are not 100 percent accurate, but too tentative an approach will rob the image of its spontaneity and freshness.

The golden rule with this type of drawing is not to overwork it, or to try to add too much background. Once the tonal values work and the shapes are satisfactory, stop!

You will need

Heavyweight watercolour paper
3B pencil
Conté crayons: black
Oil pastels: creamy yellow
Watercolour inks: blue, grey, purple, brown, light brown, yellow ochre
Large oriental brush
Reed pen

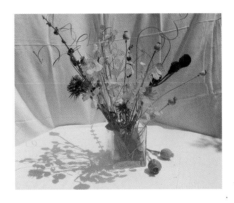

The subject
The dried flowers and seedheads are arranged loosely in a glass vase set on a white table top, with white fabric behind as a backdrop so that nothing distracts from the still life. A light positioned to one side casts strong and interestingly shaped shadows on the table top, while placing two seedheads on the table balances the composition and adds a welcome splash of colour.

1 Using a 3B pencil, draw the set-up, including the shapes of the shadows on the table. Use the pencil lightly and don't draw into the darkest areas at this stage – Conté crayons don't go well over pencil. Work very lightly with black Conté crayon to find the thinnest lines – this is the only time black is used. Use creamy yellow oil pastels to highlight the lightest parts of the papery seed-heads, blending the marks to achieve gradations of colour.

2 Mix a blend of blue and grey watercolour inks and use a large oriental brush to apply pale, diluted washes. Draw around the shapes already on the paper, varying the depths and tones, and suggesting some of the background. Add a little purple to the mixture and draw the shadows on the table top.

mixed media

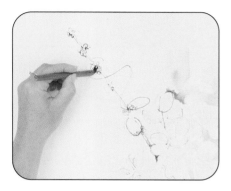

3 Use a reed pen and brown watercolour ink to draw in the darkest petals and swirls at the top of the paper – the brown ink makes muted tones that are far more effective than using black.

4 You can now work in two ways with the pen – quite loosely for the larger shapes, where you can add some hatching for tone and volume, and tighter to capture the linear stems and spikes. Use blends of light brown and yellow ochre for the lighter shapes and look for the contours as well as the lines. Add the first basic shapes in the vase.

5 Blend and dilute the inks as you go, and use the white of the paper for the very brightest highlights.

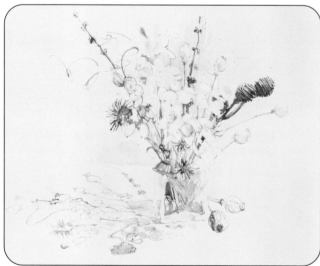

6 Use the oriental brush and ink to fill in some of the white areas and add the tonal values across the whole drawing. The purple and blue washes give a cool shadow effect, in contrast to the warmer browns and yellows. Switch back to the reed pen and use the cool mixtures to create the cast shadows.

7 Fill in the blues and purples of the cast shadows with the oriental brush, then build up the lines and colours in the vase. This forms a pivotal base to the composition. Draw in the cast shadows on the right-hand side and refine and darken the ones on the left.

The finished drawing

The confident line and brush work give this drawing a lovely
sense of spontaneity, while the relatively cool and restricted
colour palette is very calming. The delicate washes of watercolour
ink that are used in the background and for the shadows add
colour without overpowering the main subject.

still lifes

The joy of still lifes is that everything is under your control: the subject doesn't move around, you don't have to worry about the weather, and you can take as long as you want setting up the lighting and composition. This chapter looks at a comprehensive range of still-life subjects, from metal and glass to fabric and wood; by following the projects step by step, you will gain a sound understanding of how these elements can be incorporated into your own work.

kitchen still life in water-soluble pencils

Still lifes can be as simple or as complex as you choose to make them. Why not start with everyday items that you have around your home and progress from there?

The beauty of still lifes is that everything, from your choice of subject to the composition and the lighting, is under your control. Nothing moves, you're protected from the vagaries of the weather and you can take as long as you like.

When you're choosing what to include, decide whether you want to have some kind of thematic link between objects or to put very different objects together to create something unexpected. Look for interesting contrasts of shape and texture – perhaps shiny metal on soft velvet, or a textured fruit such as a pineapple in a smooth china bowl.

The key to success lies in taking plenty of time to arrange your subject. Try out different compositions and viewpoints. Make quick sketches of the composition, or even take a photo on your mobile phone, and assess whether it really works – and don't start drawing or painting until you're happy with the arrangement.

You will need

Heavyweight watercolour paper
2B pencil
Water-soluble pencils: cadmium yellow, cadmium orange, cadmium red, blue-grey, burnt sienna, spruce green, light ochre, dark ochre, brown ochre, carmine, purple, ultramarine blue, violet
Medium brush
Paper towel

The subject
The knobbly texture of the gourd and the spiky tomato stem contrast well with the smoothness of the wooden board. Note the triangular nature of the composition: the viewer's eye is led from the tip of the board through the tomato stalk to the gourd, and then back down and across to the starting point again.

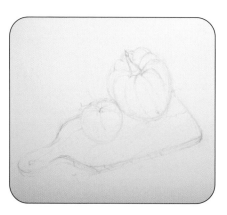

1 Using a 2B pencil, lightly sketch the subject. Put in the segments of the gourd and some of the markings on the wooden board to use as a guide later, when you come to apply the colour.

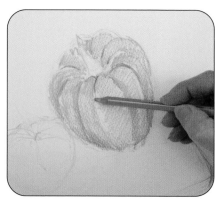

2 Scribble on the underlying yellow colour of the gourd with a cadmium yellow water-soluble pencil, leaving a few white areas in places where the yellow does not need to be quite so intense, then put in the orange markings between the segments in cadmium orange.

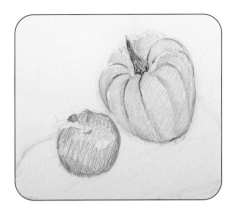

3 Block in the tomato, using cadmium orange on the lightest parts and cadmium red on the darkest, leaving the highlights white. Colour the stalk of the gourd in blue-grey and burnt sienna.

4 Colour in the tomato stalk in spruce green, pressing quite hard on the pencil to get a deep coverage. Strengthen the red of the tomato so that you begin to develop some form. Loosely scribble in the wooden board, using light ochre.

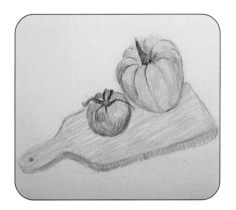

5 Scribble in the shaded side of the board in dark ochre and brown ochre. Apply the same colours to the shaded left-hand side of the gourd.

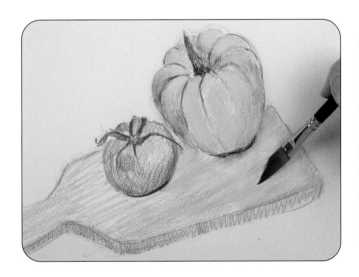

6 Dip a medium-sized brush in clean water and brush over the gourd, making your brush strokes follow the contours of the gourd and leaving some white patches showing through. Brush over the wooden board in the same way.

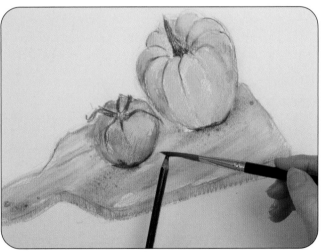

7 Brush over the tomato in the same way to create a wash. Load the brush with clean water and flick it over the top of a burnt sienna pencil to spatter colour onto the wooden board.

Mask with paper

If you're worried about spattering colour onto the tomato, gourd or surrounding paper, protect these areas with a paper mask (see page 126).

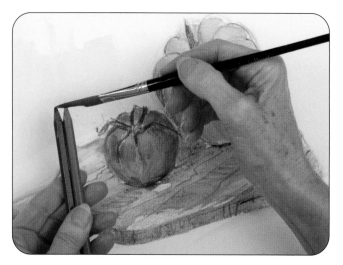

8 Scribble cadmium orange over the base of the gourd while it is still damp; this area is darker in tone than the rest. When the wash on the board has dried, draw in the linear markings with a light ochre pencil. Strengthen the colour on the tomato with more cadmium red, plus carmine on the darkest parts, and wash over with clean water. Brush over the tips of a purple and a burnt sienna pencil, then apply the colour to the background.

9 Apply ultramarine blue under the board and vegetables for the shadow. As the paper is still damp, the colour will blur and spread. Scribble light ochre over the gourd, taking care not to cover the bright yellow at the top, which receives the most direct light.

10 Now build up some texture on the gourd with linear markings. Scribble some cadmium red onto the shaded side of the gourd, where a hint of the colour is reflected from the tomato. Hatch the right-hand side of the gourd with a violet pencil. Brush a little more ultramarine onto the background.

11 Dampen a scrunched-up piece of paper towel in clean water, squeeze it almost dry and use it to dab off some colour on the tomato, to create highlights.

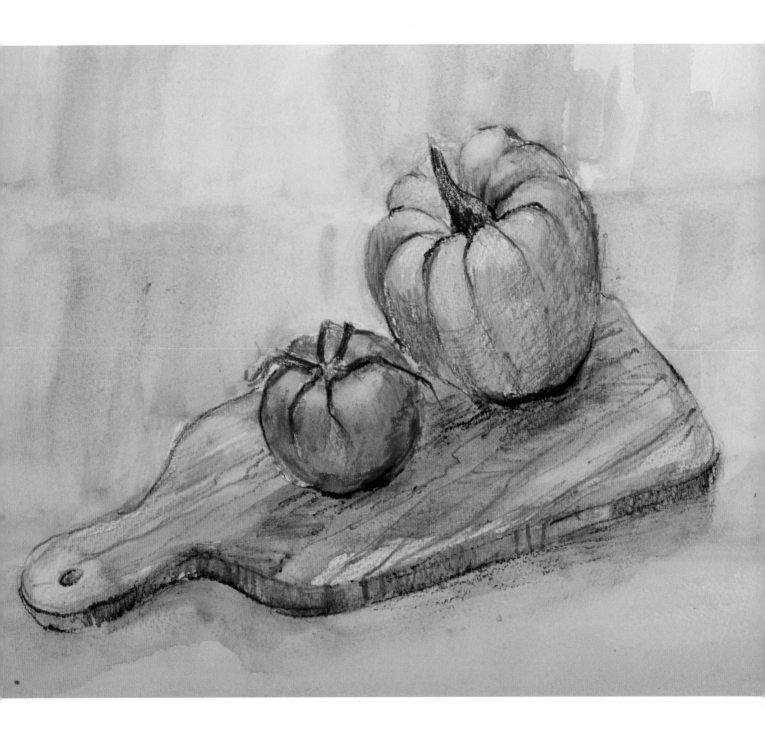

The finished painting

The use of water-soluble pencils has allowed the artist to combine the fluidity of washes with precise linear detail and a good depth of colour. The warm reds, oranges and yellows are offset by the cooler blues of the shadows and background.

glass objects in watercolour

Watercolour is a wonderful medium for painting glass, as you can build up the correct density of tone by applying layer upon layer of delicate washes that complement the transparent nature of the subject.

Although the shapes of the objects themselves are relatively straightforward, there is a lot going on in this still life: shapes and tones are distorted when viewed through glass and the numerous highlights and areas of reflected colour confuse things still further.

Careful observation is essential. Look at the subtle differences in tone between the highlights, the mid tones and the shadow areas, and at the shapes reflected in the glass. The key is not to be overly analytical: if you try to put in every single highlight and reflection, your painting will rapidly become overworked and there's every chance that you'll lose track of exactly where you are. Paint only those tones and highlights that really seem to matter and keep the lines of each area sharp and crisp.

Here the artist has departed from the usual watercolour convention of working from light to dark – but with so many reflections and shapes seen through the glass, it's often a good idea to get some really strong colours down first, so that you can judge the rest of the painting against them.

You will need

HP watercolour paper
2B pencil
Watercolour paints: black, Payne's grey, vermilion, ultramarine blue, raw umber, alizarin crimson, raw sienna
Medium and small round brushes

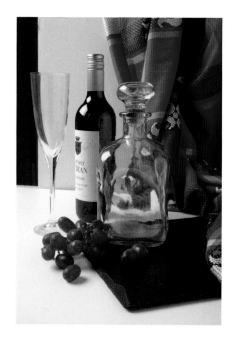

The subject
This still life was set up in the artist's studio, although you could easily do something similar in your own home. Note how the wine glass has been positioned partially against the sheet of black cardboard in the background, both to provide reflected colour and to break up the large expanse of white behind the objects. The slate platter on which the decanter sits has been placed at a slight angle, and some grapes overhang the edge, which breaks up the straight lines; both these compositional devices add visual interest.

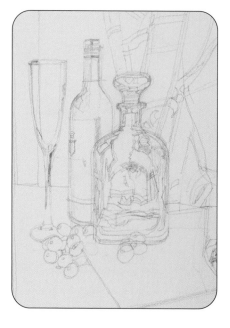

1 Using a 2B pencil, sketch the arrangement. Make use of the negative spaces between the objects (see page 34) – the space between the wine bottle and the decanter, and the wine glass and the bottle – to help you position them correctly. Look at how the glass of the decanter distorts the shape of any objects seen through it. Put in the most important highlights on the grapes and in the glass objects – in fact, put down anything that will help you when it comes to applying the paint. Making an analytical drawing like this is rather like testing a scientific theory: put down what you think is correct, and then test it (by measuring and crosschecking one part against another) to see if it's wrong. If you can't prove that what you've done is wrong, you've probably got it right!

 Knock back some of the pencil lines with an eraser if necessary, so that the underdrawing will not show through the watercolour – but make sure you retain any highlights. Mix black and Payne's grey and, using a medium round brush, put in the dark strip on the left-hand side of the image, behind the wine glass. Add more water to the mix, and put in the colour seen through the wine glass: it is slightly paler in tone. Take care to leave a very fine unpainted strip on the rim and left-hand side of the wine glass, to denote the edges.

 Use the same mix on the wine bottle, leaving the highlights untouched. Note that there is some tonal variation in the bottle: adjust the amount of water in your mix as necessary to achieve this. Using vermilion, put in the dark reds of the cloth seen through the decanter: don't worry if some of it runs into the still damp black mix.

Softening black

It's rare to use pure black in a watercolour, as it is very harsh: the addition of Payne's grey to the mix softens it and warms it up a little.

Keep glass edges sharp

The shapes seen through the decanter are distorted due to the uneven, slightly dimpled surface of the vintage glass. Follow their shapes as precisely as you can, as this will provide clues to the form of the decanter – but keep the edges of the shapes crisp and sharp.

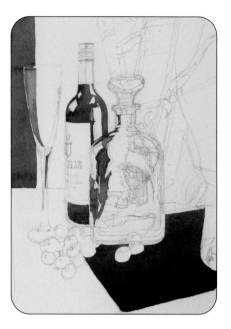 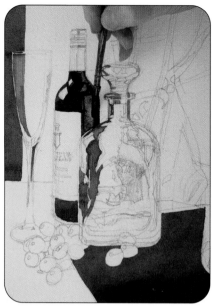 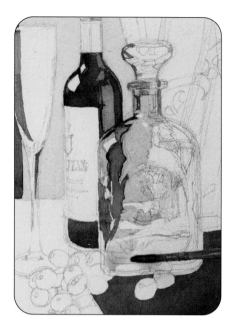

4 Add a little ultramarine blue to the black/Payne's grey mix and, while the other dark colours are drying, put in the black of the slate platter, taking care to work around the grapes. Tilt the board so that the paint can flow down.

Adjusting tones

Watercolour looks lighter when dry, so you will probably find that you need to darken the slate colour later.

5 There's a rectangular-shaped strip on the right of the bottle, where light is reflected from the decanter. Mix a dark blue-black from ultramarine blue and raw umber and apply it to this area: immediately, you can see how this tone intensifies the effect of the really dark tones already there.

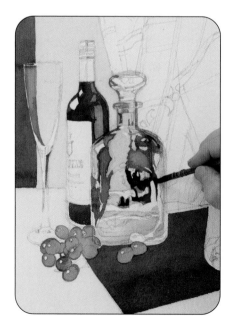

6 Mix a very pale blue-grey from ultramarine blue and Payne's grey and apply it to the white background behind the still life; this area is not a pure white, as it's slightly in shade. Use a slightly bluer version of the same mix in the decanter, where the background can be seen through the glass, working carefully around the highlights. Add even more water to the mix and wash over the foreground, working around the grapes and any highlights on the stem of the wine glass.

7 Working around the highlights, paint the grapes with a pink-purple mix of alizarin crimson and vermilion. Brush in the red of the fabric seen through the decanter, using vermilion. Then, while the vermilion is still damp, add a little alizarin to the ultramarine/raw umber mix from step 5 and touch the brush wet into wet into the vermilion so that the paint spreads, creating an impression of the patterning and darker tones in the fabric.

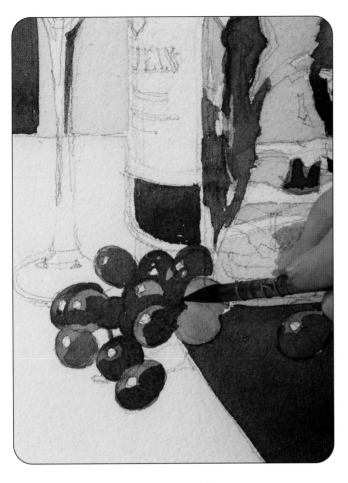

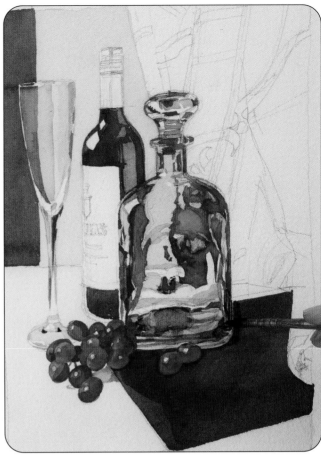

8 Mix a darker mauve from vermilion, alizarin crimson and ultramarine blue and apply it over the grapes, working around the highlights as in the previous step. Leave some of the paler pink-purple mix from the previous step showing through in places to create some tonal variation.

9 Inside the decanter and on the edges of the glass, there are some thin, dagger-like shapes of reflected colour from the wine bottle. Put these in using a fine brush and a bluer version of the grape colour from step 10. Use the same colour and a broader brush to put in the colour of the slate that can be seen through the bottom of the decanter.

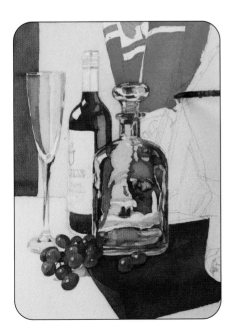

10 Now paint the red of the background cloth with a bright vermilion, leaving the white stripes in the cloth untouched. Leave to dry.

Speed up drying

You can speed up drying time by using a hair dryer if you need to – but be sure to have it on a low setting and to hold it well away from the painting, so that the force of the hot air doesn't blow trickles of wet paint across the paper.

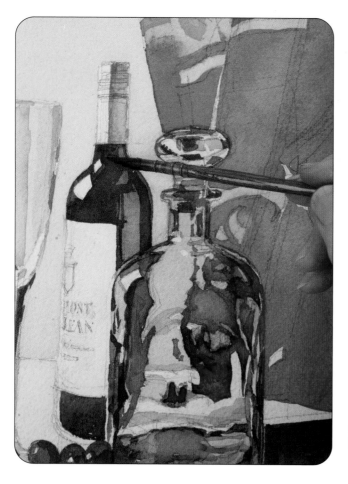

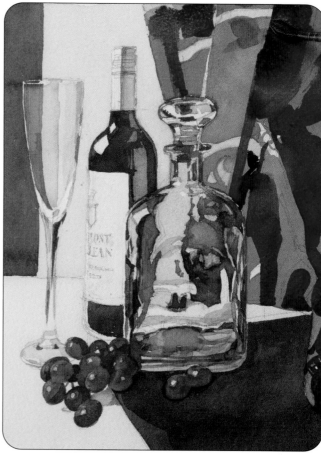

11 Wash a very pale vermilion over the white stripes in the cloth. Paint the gold foil of the wine bottle top in raw sienna, making the colour more intense on the right-hand side, which does not catch the light. Darken the tone on the wine bottle if necessary, using the same blue-black mix as before.

12 Darken the folds in the background cloth with a mix of vermilion and Payne's grey. Use broad brush strokes: if you try to be too literal and put in all the detail of the cloth, it may start to take over from the main subject of the still life and the work will lose its spontaneity.

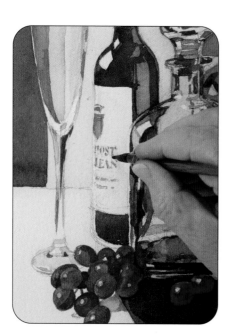

13 Paint the gold lettering and crest on the wine bottle label in raw sienna. As in the previous step, don't try to be too literal: put in the serifs and broad style of the lettering without copying every single detail exactly. Anchor the grapes by painting the cast shadows in a very pale wash of blue-grey.

The finished painting

Although this painting uses a relatively limited colour palette, red and black is a strong, dynamic colour combination. The grapes in the foreground echo the colour of the cloth in the background, balancing the composition. Note how few of the highlights are actually the pure white of the paper: nonetheless, the crisp shapes and carefully observed tones give this still life a real sparkle.

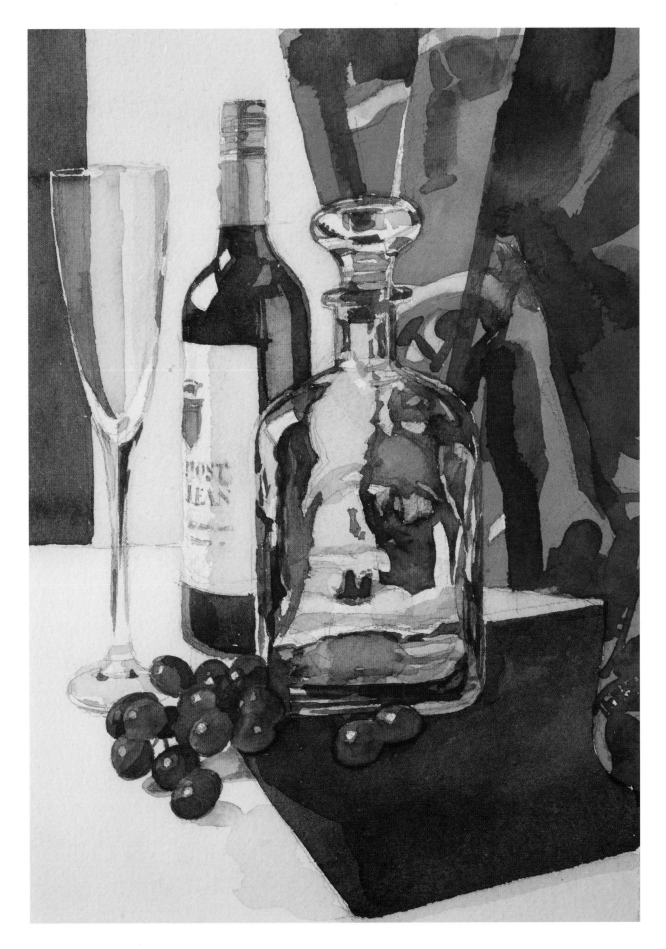

flowers and fruit in acrylics

Flowers and fruit are very traditional subjects for a still life and acrylics are a wonderful medium for capturing their vibrant colours. Use all the textural techniques at your disposal.

Although the subject of this demonstration looks very simple, it's worth taking your time setting it up. Even very small adjustments, such as where you place the strawberries in relation to each other and the vase, can have a big impact on the overall composition. Look at the spaces between the different elements, as well as at the items themselves; they can help to balance the composition. Think about how the flowers relate to each other: do you want them to overlap or to be totally separate? To make things more interesting, try turning the flowers around in the vase so that some of them are face on and some are viewed from the side. Arrange the flowers at different heights, too, to create a more varied composition.

It's a good idea not to cram in too much: often, 'less is more'. If the composition isn't working, try removing objects until you feel you've got the balance right. Do not position your subject right in the centre of the picture space: off-centred arrangements are generally more satisfactory. Remember also that odd numbers of objects (such as the three strawberries in this demonstration) usually look better than even numbers.

Clean up!

Clean the masking fluid off your pen or brush immediately after use.

You will need

Heavyweight watercolour paper

2B pencil

Ruling drawing pen, dip pen or old brush

Masking fluid

Selection of round and flat brushes

Plastic painting knife

Acrylic paints: light blue violet, burnt sienna, titanium white, light and dark olive green, cadmium yellow, cadmium orange, cadmium red, alizarin crimson, ultramarine blue, violet, deep turquoise, lemon yellow

The subject
The poppy, strawberries and painted vase make a colourful composition while the background concentrates attention on the main subject.

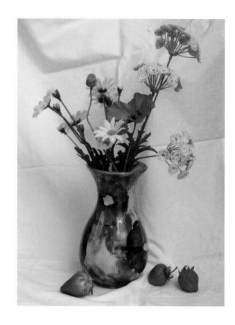

1 Using a 2B pencil, lightly sketch your subject, taking care to get the angles of the flower heads and the spaces between them right. Using a ruling drawing pen, dip pen or old brush, mask out the very lightest parts of the subject. Leave to dry.

2 Although the background is white, a dilute wash of an appropriate colour will bring out the white of the flower heads more effectively. Mix a very pale, dilute blue from light blue violet, a tiny amount of burnt sienna and titanium white. Scumble the colour over the background.

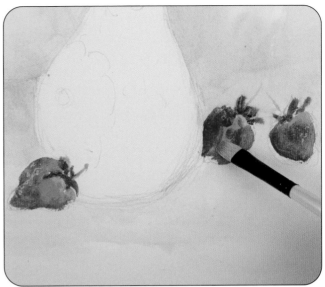

3 Put in the greens of the flower and strawberry stalks and leaves, using light and dark olive green, mixed together if necessary. The petals of the poppy are not a uniform colour: apply cadmium yellow, cadmium orange and cadmium red as appropriate, making your brush strokes follow the striations in the petals. Use an almost dry brush, so that some of the underlying colour comes through in places.

4 Paint the strawberries in the same way as the poppy, taking careful notes of the differences in colour across the surface of the fruits. For the darkest parts, use alizarin crimson mixed with a tiny amount of ultramarine blue.

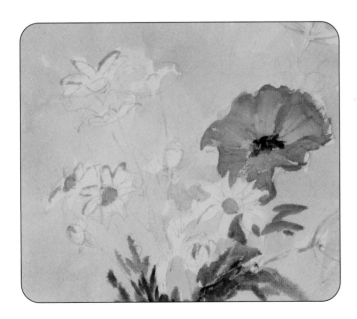

Flower centres

Look carefully at the shapes of the flower centres: because of the angle from which you're viewing them, they are not all complete circles. Note, too, how varying the tone makes them look more three-dimensional.

5 Paint the centres of the daisies in cadmium yellow, adding a touch of cadmium orange towards the base of each flower centre. Paint the poppy centre and the shaded parts of the daisy leaves in a dark, blue-black mix of ultramarine blue and violet, dotting the colour on with the tip of the brush.

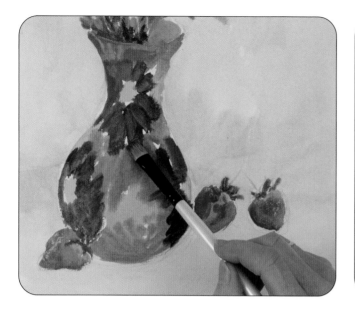

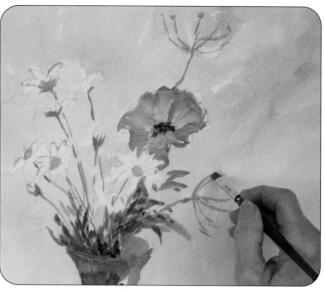

6 Now paint the pattern on the vase using a rich green (mixed from deep turquoise and lemon yellow), a dark blue (mixed from ultramarine blue and light blue violet) and yellow (cadmium yellow).

7 Using the flat end of the brush and the rich green mix from step 6, paint the stalks of the daisies and cow parsley.

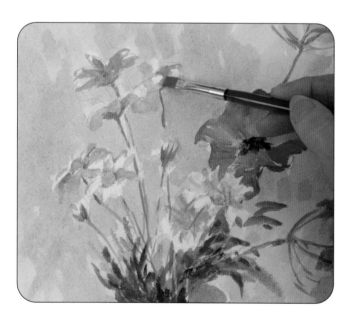

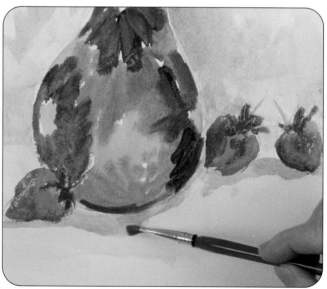

8 Mix a very pale brown from titanium white and burnt sienna and touch in the shaded parts of the daisy petals.

9 Paint the cast shadow under the vase and strawberries, using a slightly thicker and bluer version of the background colour from step 2.

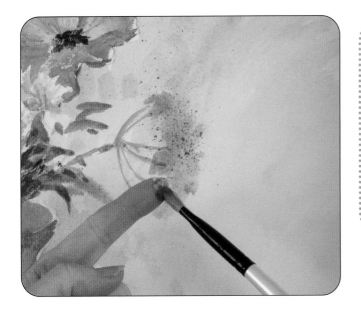

Mask the surrounding area

If you're worried about spattering paint over too wide an area, place a paper mask (see page 126) around the flower head.

10 Spatter (see page 132) dark olive green paint over the cow parsley flower heads. Spattering is the perfect technique for creating an impression of the tiny cow parsley flowers and helps give the work a spontaneous feel.

11 Using your fingertips, rub off the masking fluid.

12 Paint the lightest parts of the daisies in thick white paint, using the shaped tip of a plastic painting knife. The artist also decided to put in a small poppy bud on the left-hand side of the painting at this point, to balance the composition; don't be afraid to make adjustments like this, even at a relatively late stage of the painting, if you feel things aren't working.

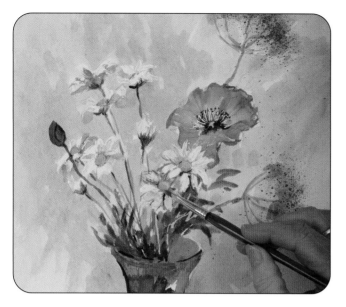

13 Now that you've built up some form on the flower petals, the flower centres look rather flat in comparison. Using the dark, blue-black mix of ultramarine blue and violet from step 5, put in some stamens and darken part of the poppy centre. Apply touches of cadmium orange to the daisy centres.

14 Dab tiny spots of cadmium orange onto the lighter parts of the strawberries, where they catch the light.

15 Spatter white paint over the cow parsley flower heads, as you did in step 10.

The finished painting

This informal flower arrangement makes a deceptively simple-looking painting, but both the composition and colour scheme have been carefully planned. The red strawberries take up only a small part of the image, but colourwise they balance the poppies in the vase and counteract the pale, cool blue of the background; they also help to anchor the composition. The complementary colours of red and green make a dynamic, exciting combination.

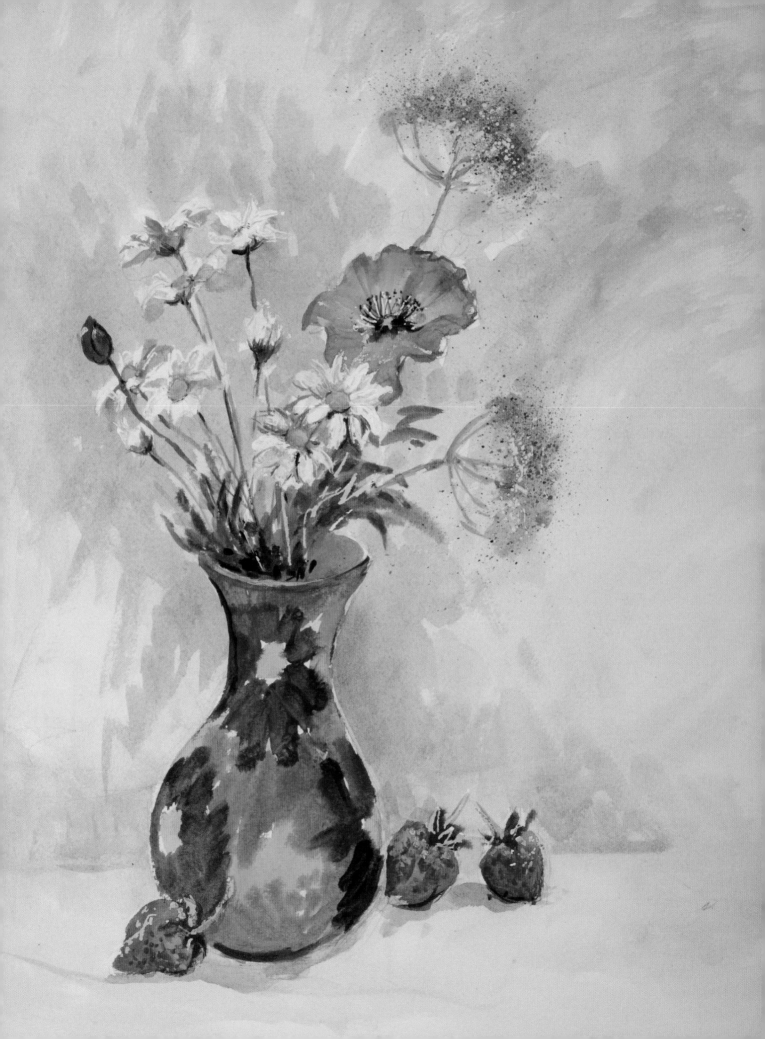

shell on fabric in soft pastels

This project is an exercise in texture – the hard, shiny shell against the softly draped fabrics. Soft pastels are a wonderful medium for this kind of work, as you can blend the colours to create subtle transitions of tone that capture the folds of the fabric while using the tip of the pastel to make strong, bold marks for the ridges in the shell's surface.

One of the most important things with a project such as this is to spend time getting the composition right. Make sure that the fabric drapes well so that you have some interesting contrasts of light and shade; without these folds, the background will look flat, with no sense of form.

Try out different placements for the main subject – the shell. Place small boxes or even piles of books under the fabric to create 'shelves', so that the shell is raised off the table top and you have different planes within the image.

Although you're often advised to place your subject off-centre, the central positioning works well here and contributes to the calm mood of the scene. This calmness is offset by the strong diagonal line that runs through the image, from the burgundy velvet in the top left to the embroidered fabric in the bottom right, which gives a more dynamic thrust to the composition.

Soft pastels come in such a huge range of hues that it's very difficult to be precise about the colours used. Trust your eyes and blend the colours on the support to get the shades that you need.

The subject
Select your background fabrics carefully to complement the main subject. Here, a soft, burgundy velvet picks up the pink tones with the shell, while the delicate lace contrasts with the hard, spiky shell. The embroidered patchwork of fabric in the foreground provides both colour and pattern.

You will need

White pastel paper
Soft pastels: selection of pinks, reds, browns, greys, yellows, greens and blues, black
Kneaded eraser

Assessing tones

Half closing your eyes will make it easier for you to assess the shapes and see the subject as blocks of colour and tone.

1 Using the side of the pastels, loosely block in the main shapes of the composition. Indicate any obvious changes of tone, such as the dark folds in the lace and the shaded sides of the velvet and the embroidered fabric in the foreground. Lightly put in the orangey-pink tone that runs along the centre of the shell and the more darkly shaded interior.

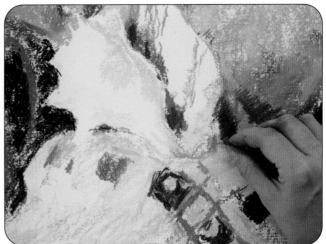

2 Apply black over the very darkest patches of the velvet. You can scribble on the colours quite roughly at this stage. By 'cutting in' with the pastel and using the negative shapes (see page 34), you can start to define the edges of the shell a little more clearly.

3 Begin blocking in the background colours of the squares of embroidered fabric, noting carefully how the lines of the pattern change direction depending on how the cloth is draped. Carry on scribbling in the darker folds in the background fabrics.

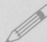

Look for alignments

Use the pattern on the embroidered fabric as a guideline to check you've got everything in the right place: here, for example, the first dark blue square sits almost directly beneath the right-hand tip of the shell.

4 Scribble a brighter pink onto the horizontal plane of the velvet and the highlighted vertical folds.

Alternate between light and dark

Developing a sense of form on the background fabrics is a gradual process of refinement: alternate between the light and dark areas as you work on the painting, continually checking the tonal relationships.

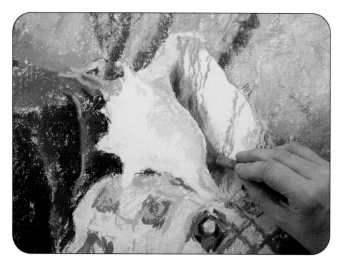

5 Now apply some colour to the shell: the colour is very subtle here, so use the tip of the stick and light strokes of dusky pink, yellow and orange on the outer shell and darker pinks and burgundies inside. Blend the dark tone inside the shell with your fingertips, but leave the colours on the exterior unblended to convey something of the shell's slightly ridged texture.

6 Put in the dark folds of the lace with brown pastel and use a pale grey on the more brightly lit areas, rolling and twisting the pastel in your fingertips to create free-flowing lines to imply something of the lacy pattern.

Don't overwork the background

Don't attempt to draw the lace pattern precisely or you'll overwork this section of the image at the expense of the main subject.

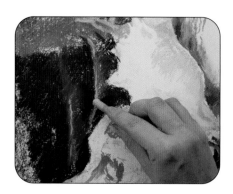 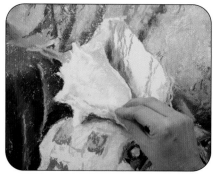 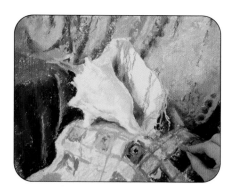

7 Scribble more burgundy over the darkest areas of the velvet and reinstate the highlights on the vertical fold in the velvet by applying bright, pale pinks.

8 The colour temperature varies: where colour is reflected into the shell from the velvet, use warm greys; on the upper surface, use cool blue-greys. Put in the local colour of the shell with pale peach and warm grey, making your strokes follow the direction of the ridges on the shell.

9 To create an impression of the sparkling sequins on the embroidered patchwork, overlay pale blue on the more brightly lit side and green on the shaded side. Define the grid pattern more clearly if necessary, using orange or reddish-brown.

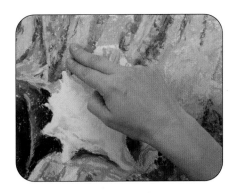

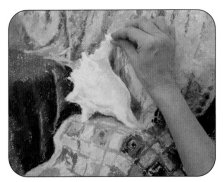

10 Finger blend the dark folds in the lace to soften them and blend them into the lighter grey. Allow some of the underlying white paper to show through to enhance the sense of light and give an impression of the lacy pattern.

11 Use a kneaded eraser to clean up around the edges of the shell and define its shape more clearly.

The finished painting

This painting exploits the potential of soft pastels: softly blended passages contrast with sharper, more linear marks, while allowing the underlying white paper to show though in places gives the image a lovely luminosity and sparkle. Although the arrangement looks deceptively simple, it has been carefully composed for maximum effect. The colours, too, have been carefully selected, with the warm reds, pinks and greys offset by the small but vibrant patches of blue and green in the foreground.

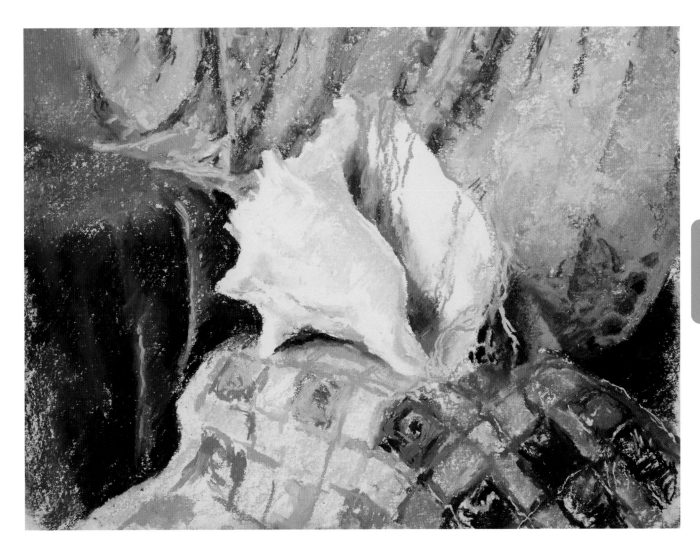

metal objects in oils

Metal objects are an exciting and challenging subject to paint, as you have to contend not only with the colours of the objects themselves but also with the myriad reflections contained within them.

Different metals are made up of different colours. Stainless steel objects tend to be made up of cool blue-grey tones, while brass objects contain warm tones such as sienna and umber. Copper items may contain both warm and cool tones – warm reds and oranges alongside cool blues and greens.

Like glass, metal is reflective – but rather than putting in every single reflection exactly as you see it, it's often best to simplify things: concentrate on the main reflections so that the reflections do not become more important than the metal itself. Observe the highlights carefully, too, as they will give you clues to the form of the metal object – whether it's rounded or angular.

Because metal is so reflective, pay particular attention to your lighting set-up. If the main light source is directly overhead, you will find that light bounces off the metal in all kinds of curious and unexpected ways, creating a potentially confusing array of reflections, highlights and shadows. Side lighting, on the other hand, will throw interesting shadows that you can incoporate into the composition.

Before you start painting, work out which colours – both real and reflected – are visible on the metal surfaces. Train yourself to see things as blocks of colour, rather than trying to work out what is a reflection and what is 'real'; if you're too analytical, you can get bogged down in the detail, which stops you from seeing the subject as a whole.

One of the joys of using oil paints for an exercise such as this is the slow drying time, which allows you to work wet into wet and create subtle, but very precisely placed, transitions of tone and blends of colour.

You will need

Canvas board
Oil paints: ultramarine blue, titanium white, Venetian red, Mars violet deep, cadmium scarlet, cadmium red, raw sienna, cadmium yellow, crimson, viridian
Selection of small and medium flat and filbert brushes
Turpentine or white spirit

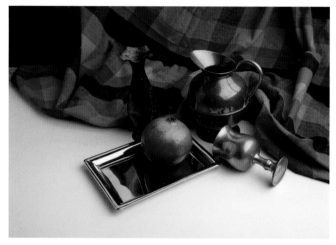

The subject
The metal objects in this still life have differing degrees of reflectivity: the stainless steel platter is highly reflective, while the pewter vase behind it picks up hardly any reflections. The pomegranate and checked cloth in the background have been chosen for their warm tones, which help to offset the predominantly cool tones of the metal.

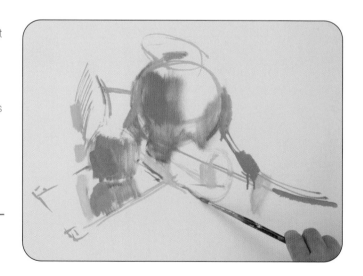

1 With a small flat brush, start mapping out the composition, using thin mixes of colours that approximate to those of the objects. Look at the basic shapes of the objects (see page 32) and be aware of them as rounded, three-dimensional forms rather than simply putting down an outline. Use the negative spaces between the objects (see page 34) to help you place them accurately on the canvas.

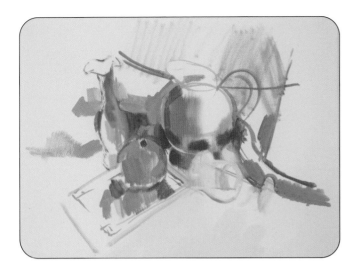

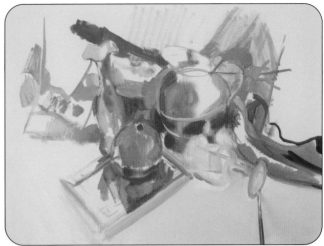

2 Continue with the underpainting until you have established the shape and position of all the items in the still life. Scrub in the pewter vase and some of the blocks of colour in the background cloth, varying the tones in your mixes as appropriate. Block in the white table top with a very pale mix of white and cadmium yellow.

3 Carry on building up blocks of colour to establish the objects and their reflections. Here, for example, the artist has added viridian to his initial ultramarine/white mix for the darker areas of the pewter vase and its reflection. Use the shadows under objects to help define their edges: the shadow under the stainless steel platter is a pale ultramarine/white mix and the shadow under the goblet a pale violet. At this stage, your mixes should still be quite thin.

Look for colour rhythms

Don't try to be too methodical in your approach, finishing each area or item before moving on to the next: when you're applying one colour, look around the painting to see where else you can use it. Look for rhythms of colour within the painting.

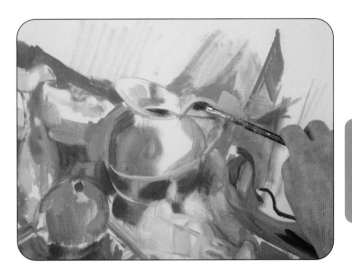

4 Put in the interior of the copper vase with a mix of cadmium yellow and cadmium red, leaving the highlights untouched, and use the same colour for the brightest part of the handle. Define the edge of the handle using the dark violet colour of the cloth behind.

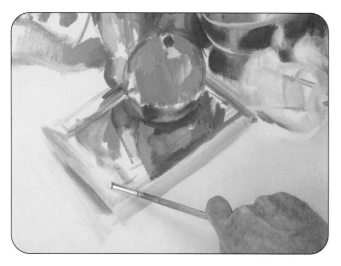

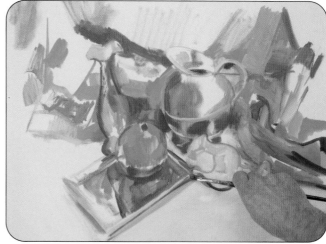

5 The stainless steel platter is the most reflective item in the still life and the very brightest highlight is almost pure white. Use titanium white (with a hint of ultramarine if necessary) to block in the large highlight on the left-hand side; titanium white has good covering power, so even if you've made a mistake with your colours earlier on, you can easily rectify it.

6 There are several areas of cool blue-grey tone within the goblet; put these in with varying mixes of ultramarine and white, and use a cadmium yellow/white mix for the highlights. As before, use the shadow and background colours to help define the shapes of the objects – here, the lower edge of the goblet and the stainless steel platter are defined by a blue-violet version of the dark tones used in the pewter vase.

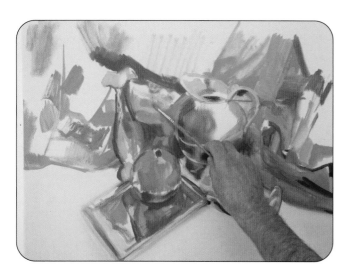

7 Keep alternating between the still-life objects and the background, so that the whole painting progresses at the same rate, using the colour that happens to be on your brush wherever you see it. Scrub on the colours of the background cloth quite vigorously, varying the tones as necessary; oil paints dry slowly, so you will have plenty of time later to smooth out your brush strokes and the transitions from one tone to the next.

8 Block in the large highlight on the pomegranate with a pale mix of cadmium yellow, a tiny bit of cadmium red and white. Use a more orange version of the mix to paint the space between the stainless steel platter and the copper jug, as this area receives some warm, reflected colour from the jug. Use the same colour for the highlights on the jug itself, observing their shapes carefully.

9 Paint the red reflection of the pomegranate in the copper jug using a bright cadmium red, then paint the darker tones inside the jug with a cool mix of raw sienna and viridian, blending the colours wet into wet with those that are already on the canvas.

10 Now that you're nearing the end of the painting, take the time to stand back and view it as a whole: you will almost certainly need to refine and adjust certain colours in relation to others, darkening some so that the highlights appear bright enough and lightening others. This is also the time to blend blocks of colour at their edges, both to smooth out brush strokes and to soften the transition from one tone to another.

11 Using the same dark blue mix as before, paint the shaded interior rim of the pewter vase. Put in the small yellow-white highlights on the pomegranate.

12 Scrub on the remaining colours of the background cloth to complete the image. There's no need to replicate the patterning on the cloth exactly unless you really want to; it's not the main subject of the painting and an impression of the pattern will suffice.

The finished painting

This painting exploits the reflectivity of different metals to good effect, the more matt finish of the pewter vase and copper jug contrasting well with the highly reflective steel platter. By painting the objects as blocks of colour, the artist has avoided falling into the trap of trying to put in every single reflection and highlight; instead, he has been able to concentrate on what is really important to the image.

13 Mix a yellow-green from viridian and cadmium yellow and paint the slightly cool green interior of the pewter vase.

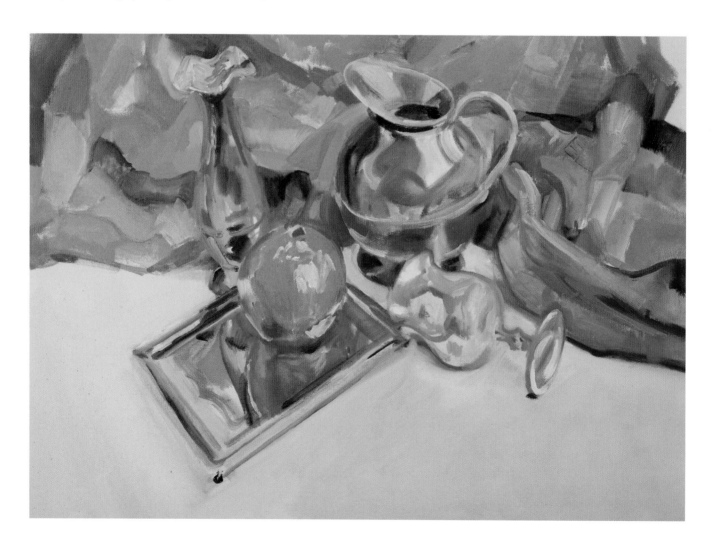

'found' still life in dappled light

Even the most mundane subjects can make a wonderful still life, so keep your eyes open for interesting groupings. Tools in a shed or workshop, children's toys in a bedroom corner: the list of possible 'found' still lifes is endless! Garden pots filled with colourful plants make an attractive display under any circumstances; bathed in dappled light, as here, the subject is transformed.

Soft pastel is an ideal medium for depicting light. Small dabs and dashes gradually build up to create a film of broken colour that shimmers with light.

The secret of this technique is to start by applying the pastel very lightly and thinly, carefully dusting off any surplus powder if the colour becomes too dense. Once you have established the broad forms of the image, the patterns of light and dark, and the main areas of local colour, you can start to apply the pastel with more pressure, creating areas of solid, vibrant colour.

Garden still life

This picturesque cluster of pots and colourful plants was visible from the artist's studio. The sunlight falling across the pots and paving, and the shadows cast by the trellis and vegetation behind them, add interest to the scene.

You will need

Warm grey pastel paper
A range of soft pastels
Piece of bread
Clean tissue or cloth
Fixative

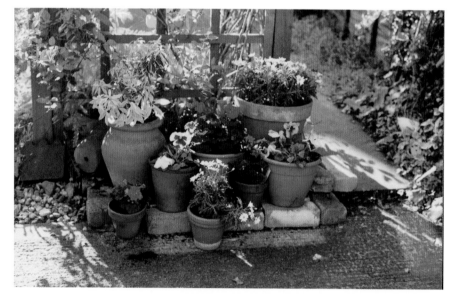

1 Half close your eyes in order to isolate the darkest tone – the shaded areas between and around the pots. Lay these in using a dark green-grey pastel. As you lay in these areas of dark tone, the locations and shapes of the pots will begin to emerge.

Compositional decisions

Choose your viewpoint and eye level carefully and spend time thinking about how much of the surroundings you're going to include.

2 Lightly indicate local colours. Use a pale straw pastel for the bamboo in the large pot, dark green for the foliage, pale burnt sienna for the terracotta pots and touches of cadmium red and magenta for the flowers.

3 If there is too much build-up of pastel, you can reduce it by lightly dabbing the surface with a piece of tissue. This softens and blurs the colour, and ensures that the whole painting progresses at the same pace.

4 Add dark tones at the base of the plants. Apply strokes of light yellow for the warm highlights on the pots. If the colour becomes too dense, you can lift it off with a piece of bread. Bread is softer than an eraser and will not damage the paper surface.

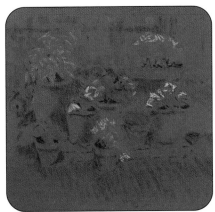

5 Work across the entire picture surface, adding dabs and dashes of local colour for the flowers and foliage, stroking on the colour with delicate touches of the pastel stick. Indicate the location of the trellis in the background. Add a glaze of yellow to the front edge of the step.

6 With a dark green-grey pastel, touch in the dark shadows around the foliage, using the negative spaces to define the leaf shapes. Don't press too hard – lay on a thin film of colour over which you can develop succeeding layers of colour. By now, the underpainting is broadly established, setting the tonal range for the picture and providing an indication of the main areas of local colour.

7 Work over the entire picture surface, noting where the local colour is reflected in the shadows. Start to develop the background through the trellis. Work tentatively, as this area should sit back when the picture is finished.

8 Add touches of dark colour, such as burnt sienna, under the rims of the pots. Use a lighter colour where the light reflects off the rims. Develop the areas at the sides of the picture, adding a pale blue for the flowers on the right and a cool blue-green for the foliage.

9 Lay in patches of dappled sunlight, using an intense cadmium yellow to define the shadows cast by the trellis. Skim the pastel to create 'broken' coverage. Working over the entire surface, apply the pastel with more pressure. The pastel marks should suggest, in a simplified form, the shape and direction of growth of the leaves of each plant, and from a distance should describe the overall texture of each plant.

10 Use a bright green pastel to create the effect of sunlight filtering through the foliage. The splashes of light in the foreground should relate to the light falling across the plants and pots.

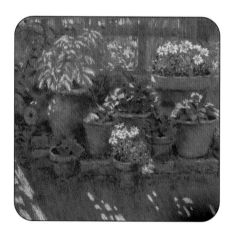 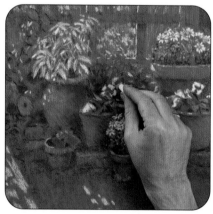 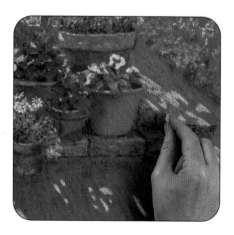

11 Develop the shadowed area in the foreground by adding contrasting touches of warm and cool colours – olive green, pink, lilac and blue. These streaks of colour vibrate in the eye, giving the shadows depth and luminosity.

12 Use cadmium yellow pale to depict where the sunshine splashes onto the foliage.

13 Apply touches of solid, vibrant colour to the flowers, pressing the pastel onto the paper to achieve a rich impastoed effect. Develop the cool tones in the shadow on the path with a light blue. Apply the pastel with feathery strokes to create a delicate mesh of broken colour.

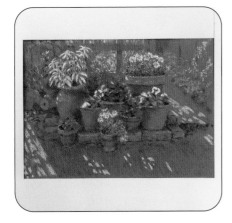

The finished drawing

In this evocative image, the artist has captured the warmth and stillness of a sunny summer's day. By cropping in tightly to the worn and weathered terracotta pots, he has created a closed and intimate world. Sunlight filtered through trellis and foliage creates a dappled pattern that emphasizes the ground plane and provides a clue to linear recession within a relatively shallow picture space. Optical colour mixing is perfect for this subject, with individual touches of pure pastel colour coalescing in the eye to re-create shimmering light.

14 At this stage, the artist placed a frame made from two L-shaped pieces of cardboard around the image to assess the overall impact of the colours and tones. The pale, neutral colour of the frame made the colour of the paper read as part of the painting and helped to isolate the image from its surroundings.

15 Continue working over the entire picture surface, intensifying the colours wherever you feel it is necessary. Overlay patches of sunlight on the ground and the sides of some pots with cadmium yellow pale, to suggest the transparency of light and prevent the lit areas from looking too solid.

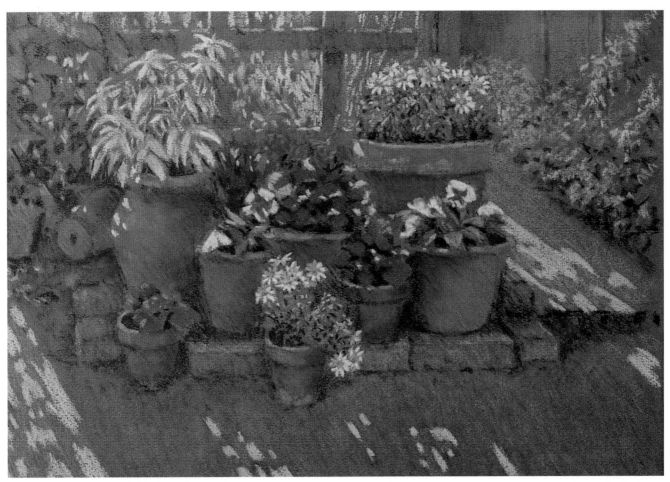

landscapes

Landscapes are perhaps the most popular of all subjects for artists, but they bring with them challenges such as coping with the constantly changing weather and light and creating a sense of scale. From simple studies of skies and foliage to full-scale panoramic landscapes, this chapter will provide you with a really solid grounding in the subject.

skies and clouds

The sky is arguably the most important element in a landscape painting. Even if it takes up only a small part of the picture space, it is the source of light and the weather, which together determine the whole mood of the painting.

The first thing to consider is how much space to devote to the sky. In a really dramatic sunset or a painting of storm clouds, the sky could take up two-thirds or even more of the picture space, with the land being reduced to a small sliver at the base of the image. If you are more concerned with portraying the effect of light and shade on the landscape, however, those proportions might be reversed. Generally speaking, it's not a good idea to place the horizon line in the very centre of the picture, as it cuts the image in two.

Whether the sky is the main subject or not, always think of it as an integral part of the landscape, and not simply as a backdrop.

Because of the laws of aerial perspective (see page 48), the sky is paler towards the horizon line. Clouds, too, are governed by the laws of perspective, so make them smaller in size and cooler in colour as they recede towards the horizon.

As skies and clouds are such an important part of landscapes, it's worth taking every chance you can to practise observing and drawing them. Carry a sketchbook with you whenever you can and fill it with sketches of different cloud formations and light effects.

Making clouds look three-dimensional
Clouds are not just flat wisps of white: in order to make them look convincing, you need to make them look three-dimensional. First, analyse the shape of the cloud – you may find that it helps to think of it as a group of spheres (top left). Then describe the overall shape of the cloud, looking at where the light falls: here, the top receives the most light, while the base receives the least and the sides are a mid tone, in between the two (top right). Finally, do your drawing, remembering that clouds should have soft edges (bottom).

Watercolour: wet-into-wet skyscape
The wet-into-wet technique (see page 116) is perfect for capturing soft transitions of colour in skies and clouds, as the paint blurs and spreads on the paper without leaving any hard edges.

Charcoal and blue chalk: aerial perspective
This sketch demonstrates how the rules of aerial perspective (see page 48) apply to the sky as well as to the land: the sky is a fairly deep blue at the top, but paler towards the horizon, while the glowering storm clouds appear large directly overhead but much smaller in the distance.

Watercolour on toned ground: top-lit clouds
This sketch was done on a pale yellow paper, which gives a lovely warm undertone to the scene. The dark underside of the clouds was painted by applying layers of blue watercolour, wet into wet, while white gouache was drybrushed onto the tops of the clouds for the brightly lit areas – a simple but effective way of giving the clouds volume.

Soft pastels: storm clouds at sunset
As the sun gets lower in the sky, the base of clouds may catch the light, as in this soft pastel sketch. This scene works in part because of the use of complementary colours – the dark blue of the evening sky against the warm orange glow imparted by the setting sun. A dark sliver of land at the base of the image provides an anchor for the scene.

trees and foliage

Trees are an important element in many landscape paintings, adding colour, texture and a sense of scale. To portray them convincingly, you need to know a little about different growth patterns.

Start by concentrating on the underlying form – the structure of the tree. Is the overall shape rounded (like an oak) or columnar, like a cypress or poplar? How many boughs come off the main trunk? Do the branches spread out like a chestnut or droop down like a willow? Use a simplified outline as the basis for a more detailed drawing or painting. Although you may not feel like painting outdoors in the depths of winter, this is a great time to see the 'skeletons' of deciduous trees that have shed their leaves, so take a sketchbook or a camera to your local park or woodland and record different tree shapes and growth patterns for future reference.

Remember that trees are living things with roots! You need to convey the feeling that they grow up out of the ground and are not simply stuck on top, so always give some indication of the roots at the base of the trunk.

Unless the trees are in the immediate foreground, don't try to put in the fine detail of the foliage and bark: instead, show them as a broad mass. If the trees are in the far distance, you may only be able to make out patches of colour or tone – but this reduction of detail with distance is one of the things that will give your painting a convincing sense of recession.

Look for areas of light and shade within the foliage mass, as this will help you create a three-dimensional effect. Look at the negative shapes, too – the gaps between the branches through which you can see the sky or background – as this will add to the sense of realism.

Rounded shape
Many trees, including oak, beech and maple, have rounded tops and branches that radiate out from the main trunk.

Narrow, upright shape
In poplar and cypress trees (seen in many French Impressionist paintings) the branches are all of similar length and grow upwards from the trunk.

Lozenge shape
This tree shape, which is seen in the elm and some conifers, consists of several lozenges above each other, narrower at the top of the tree than in the middle and bottom, with the lozenges alternating in direction.

Broad, spreading shape
Here the main branches radiate out symmetrically from the main trunk, tapering in size so that the top branches are narrower than those at the base.

Painting foliage masses

This project demonstrates how your approach to painting trees needs to differ depending on how far away from you they are. The tree and flowers on the left bank in the foreground need to contain the most detail, those in the middle distance should be seen as broad areas of tone, while those in the far distance are little more than patches of colour, with no detail discernible. The project also gives you the opportunity to practise mixing different shades of green.

You will need

Heavyweight watercolour paper
2B pencil
Medium round brush
Watercolour paints: cerulean blue, olive green, Winsor blue, cadmium yellow, burnt sienna

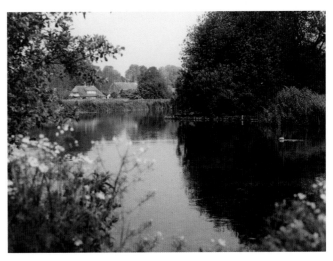

The scene
With the trees and bankside grasses reflected in the gently rippling water, this tranquil riverside scene cries out to be painted. Note how the trees on either side of the image 'frame' the river and draw the viewer's eye in towards the centre of the painting.

1 Using a 2B pencil lightly sketch the scene, putting in just enough detail to serve as a guide when you come to apply the watercolour. Mix a very dilute wash of cerulean blue. Using a medium round brush, apply the colour over the sky and water.

2 Mix a blue-green from olive green and cerulean and brush in the shapes of the trees in the far distance and their reflections, as well as the large clump of reeds on the right-hand side of the image.

Creating form in foliage

Look at where the darkest patches of foliage are: these are the areas that require the application of a second tone.

3 Mix a darker blue-green from olive green and Winsor blue. Wet the bank of trees on the right of the image and its reflection with clean water. Drop in the colour wet into wet, allowing the paint to blur and spread. While the paper is still damp, go over the bank of trees again with small dots of paint to begin to develop some texture and tonal variation. Leave to dry.

4 Add cadmium yellow to the previous mix. As the leafy branches on the left of the image are closer to the viewer, we can see them in more detail and they appear larger; use small flicks of the brush to convey the general shape of the leaves, allowing some of the underlying cerulean blue to show through for the sky. Vary the proportions of the colours in the mix, too: some parts are more yellow than others.

5 Using the tip of the brush (so that you can make fine, calligraphic strokes) and a yellower version of the mix from step 4, put in the stems of the foreground flowers. Use the blue-green mix from step 3 for the bankside trees in the middle distance and their reflections.

6 Although the foreground flowers are white, they are partially in shade, so the white of the paper would be too stark. Paint the flowers in varying strengths of cerulean blue, making your brush strokes follow the direction of the individual petals.

7 Go back to the blue-green mix from step 3 and put in the reeds on the bankside in the middle distance. Add more olive green to the mix and dot this colour into the darkest patches of the bank of trees on the right to give it a little more form.

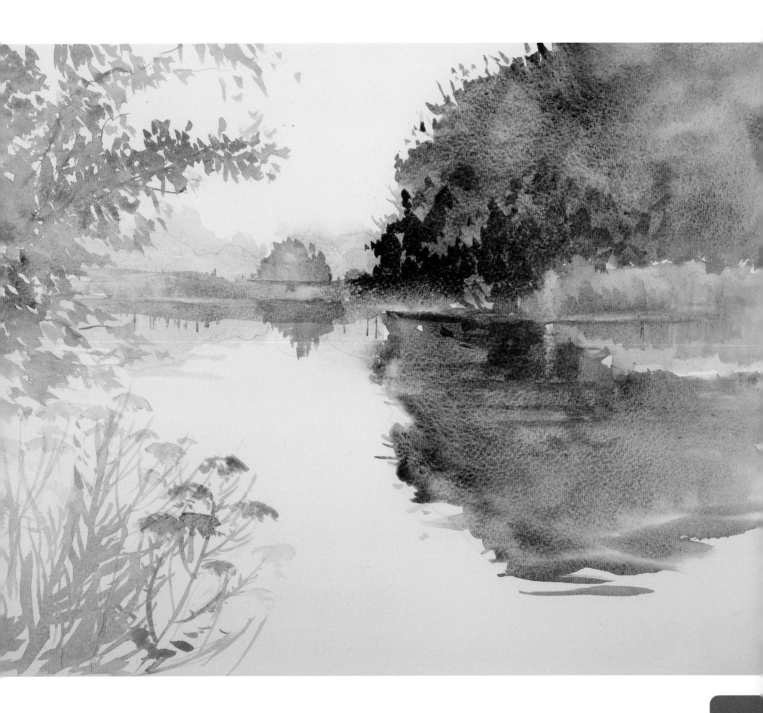

The finished painting

This painting uses several techniques to convey masses of
foliage. On the left of the image (which is closest to the viewer
and therefore requires more detail), the artist has used deft dabs
and flicks of the brush to create the impression of quite large,
pointed leaves. In the middle distance, repeated applications
of paint have built up tone to convey the dark shadows within
the foliage mass and create a convincingly three-dimensional feel.
The trees in the far distance are pale patches of colour: only the
shape tells us that they are, in fact, trees.

light on the landscape

For many artists, the most interesting landscapes are not those that are bathed in bright sunlight but ones where the sun breaks through intermittently, illuminating some features and leaving others in deep shadow. Capturing such fleeting effects of the light is a fascinating challenge.

The reference photo from which this painting was developed was taken in late afternoon, when the sun was low in the sky. See how the light rakes over the tussocky clumps of bracken, revealing the uneven terrain, while trees that are out of shot cast long, dense shadows on the ground. The dark, brooding sky provides a stark contrast to the sunlit areas and adds to the drama.

Even if you opt for a more photo-realistic approach than the one shown here, don't feel that you have to put in every single detail: generalized marks (cone-shaped marks for the conifers, slightly curving brush strokes for the clumps of bracken) are enough to give a good impression of the terrain and type of vegetation.

To avoid getting caught up in too much detail, half close your eyes as you look at the scene, as this will make it easier to assess the tones. Above all, try to see the landscape as blocks of colour rather than as lots of individual features.

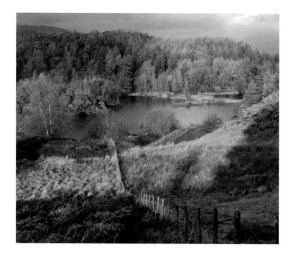

The scene

This image is made up of bands of light and dark – the menacing sky and shaded trees at the top left of the image, the sunlit lake and bracken in the centre, and heavily shaded base. The line of the fence pointing in diagonally from the bottom right of the image helps to lead our eye through the scene.

You will need

Heavyweight watercolour paper
Acrylic paints: ultramarine blue, alizarin crimson, raw sienna, cadmium yellow, bright green, titanium white
Brushes: large mop, medium and small round

1 Start by making a tonal underpainting. Mix a purple-blue from ultramarine and a little alizarin crimson. Using a large mop brush, wash it over the mid-toned areas, leaving spaces for the sunlit patches.

2 Add more alizarin to the mix and put in the darker tones of the most heavily shaded areas. Apply raw sienna to those areas that are browner and less dense in tone.

 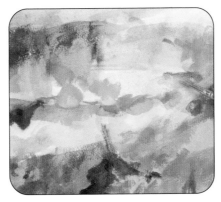 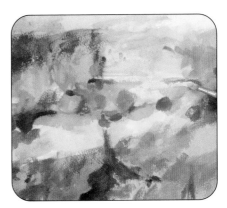

3 Mix cadmium yellow with a touch of raw sienna and put in the base colour of the sunlit foreground areas. Add more raw sienna and a little alizarin crimson for the darkest patches of rust-coloured bracken in the foreground. Use a slightly watered-down version of the mix for the sunlit area of trees on the far side of the lake.

4 Mix bright green with a little raw sienna. Put in the darker patches of green in the foreground and scrub the same colour on for the patches of mid-tone green on the far side of the lake. Mix a thick, deep blue from ultramarine blue and titanium white and put in the darkest patches of water in the lake. Try to see your subject as blocks of colour at this stage; the detailing will come later.

5 Use the blue mix from the previous step for the dull blues of the sky, varying the proportions of the colours as appropriate. Mix a dark blue-purple from ultramarine and alizarin and put the dark patches of water on the far side of the lake. Mix a pale orange base colour from cadmium yellow, raw sienna and titanium white and put in the sunlit patches of ground on the far side of the lake.

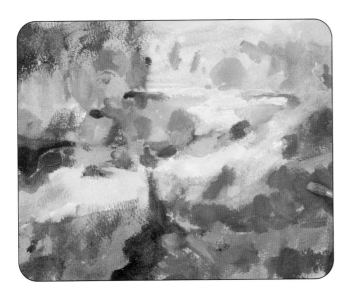 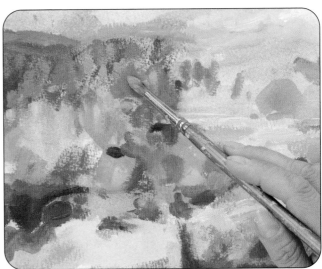

6 Mix a dark blue-green from cadmium yellow, ultramarine and bright green and dot in the darks of the trees on the far shore. Darken the bracken along the foreshore with a rust-coloured mix of cadmium yellow, raw sienna and white, scrubbing the paint on with short strokes to convey an impression of the texture. The shaded patch on the right of the image is darker still: use a mix of alizarin crimson, a bit of the blue-green mix and raw sienna for this.

7 Add ultramarine and a tiny bit of white to the blue-green mix from the previous step and put in the hills above the tree line in the top left of the image. Use a slightly thicker, bluer version of the sky colour from step 5 on the sky, refining the shape of the tree-covered hills as you do so. Using the tip of the brush and a mix of alizarin crimson and raw sienna, put in generalized cone-like shapes for the mid-toned trees on the left of the far shore.

8 Using the rust-coloured mix from step 6, dot in the shapes of the clumps of bracken in the foreground. Work over the whole foreground, alternating between lights and darks so that you keep the tonal balance of the painting right. Very little detail is discernible in the darkest areas, but putting the dark patches in really helps to build up a sense of light and shade and develop some foreground form and texture. Paint the fence posts with dark mixes of purple-blue, rust and green, as appropriate.

Assessing tones

You may find it easier to assess the tones if you half close your eyes as you look at the scene.

9 Using slightly paler versions of the mixes from step 7, put in more cone-like shapes for the trees on the right of the far shore. Change to a smaller brush and paint the water in a paler version of the pale blue from step 4, paying careful attention to where the tone changes. Use a fairly dry brush so that some of the underlying darker blue shows through, as this helps to create the effect of sunlight sparkling on the water.

10 Build up more texture in the foreground of the image, using small dabs and dashes of paint, looking carefully at where the tones change and at the shapes of the clumps of bracken. Don't attempt to replicate each clump exactly; instead, aim to give a general impression of the changing colours.

11 Using a purple mix of ultramarine blue and alizarin crimson, put in the wires between the fence posts. Don't make the lines of the wires completely solid: leaves small gaps in places to show where the sun catches them.

12 Adjust the blues and whites in the sky if necessary, aiming for a smooth coverage. You can smear the paint with your fingertips if you wish, to get rid of the brush strokes.

The finished painting

This is a fairly loose, impressionistic interpretation of the scene, but by carefully observing the different tones within the scene the artist has created an atmospheric painting that positively glows with light. The complementary colours – the dark blue of the sky against the vibrant orangey-golds of the bracken and grasses – add to the dynamism.

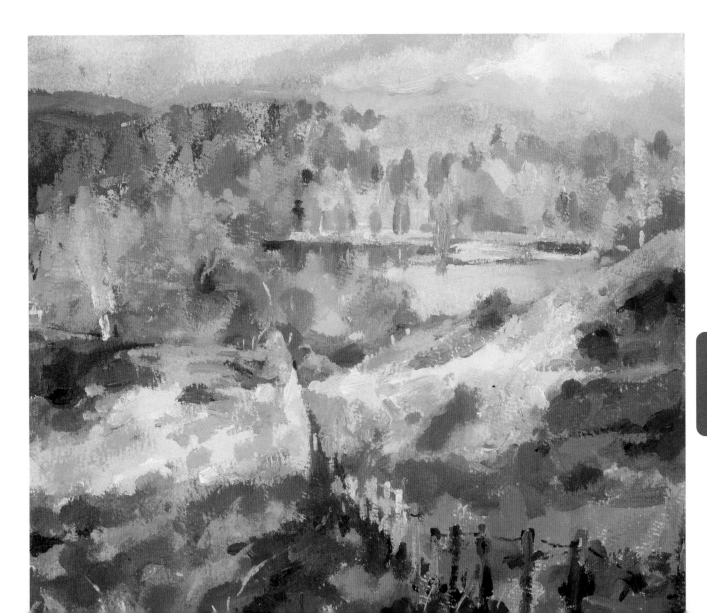

large-scale landscape in charcoal

Charcoal is the ideal medium for a large-scale project: it is easy to apply and is capable of a wide range of tones and marks. This project is intended to encourage you to work freely and spontaneously, using the full stretch of your arm to create bold, gestural marks.

When you're working on a really large scale, it is absolutely vital that you step back and assess the entire picture from time to time. It is very easy to pay too much attention to areas of detail and lose sight of the way the picture is developing as a whole.

Try not to follow your reference material slavishly – your aim should be to capture the spirit of the scene, rather than to make a drawing that replicates the scene in every respect. Draw on your memory and imagination so that the picture takes on a life of its own.

You will need

300-gsm (140-lb) HP watercolour paper
Willow charcoal in assorted thicknesses
Plastic eraser
Kneaded eraser
Graphite powder
Graphite sticks
Craft knife
Torchon
Sponge
Soft brush (optional)
Fixative

Reference material
Make a small, detailed sketch of a familiar scene and take photographs for reference. Make sure that the composition has a feature that will hold the viewer's interest and that there are focal points to lead the eye around the picture area: here, the snowy path in the middle of the picture draws the eye into the scene. Note, too, how the composition divides into three bands: the sky, the central band of trees and shrubs, and the snowy foreground.

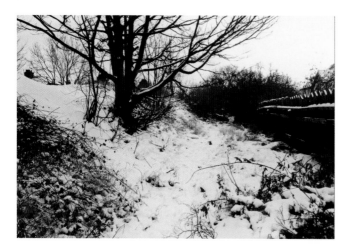
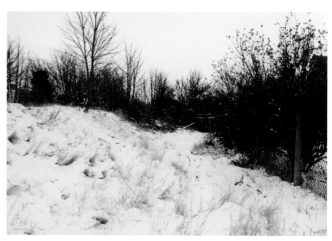

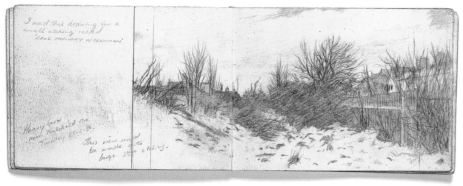

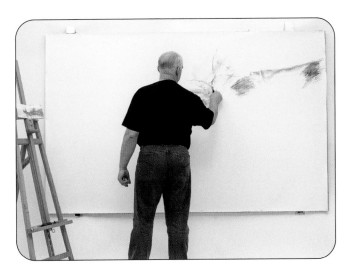

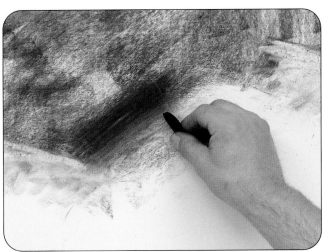

1 Firmly pin or tape a large sheet of paper to the wall; the paper used in this demonstration measured 1.5 x 2.4 m (approx. 5 x 8 ft). Place your reference material close by so that it is easy to refer to. Using a stick of charcoal, sketch the outlines of the central band of the composition and then start to suggest the main areas of tone.

2 Continue to establish the areas of medium and dark tone, using the side of a thick piece of charcoal to block in large areas of tone.

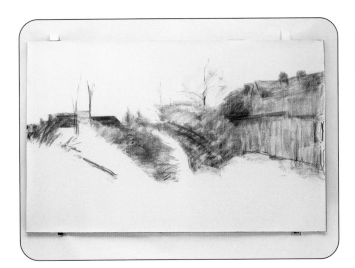

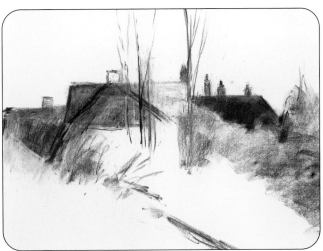

3 Block in the main masses of the central swathe of the drawing and indicate the verticals, using smudged medium tones for the bushes and crisper lines for the buildings and trees. Don't attempt to put in too much detail at this stage: you need to establish the overall shape and tones of the drawing first.

4 Next, indicate areas of darker tone to help to define the spatial relationships. The dark tones and crisp edges of the rooftops on the left bring this area forwards, while lighter tones and the blurred edges of the bushes appear to recede.

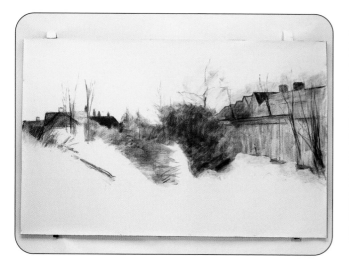

5 Continue to work up the dark tones all over the drawing. Develop the dark bushes alongside the snowy path in the centre, using broad strokes made with the side of the charcoal stick. Next, draw the saplings on the right, using the tip of a thin stick of charcoal.

6 Now you can start to add details such as the tree branches and the tufts of grass poking through the snow. Use a graphite stick to add small branches and twigs to the central tree. Because graphite is greyer than charcoal, it sits back in space, giving the canopy of the tree volume.

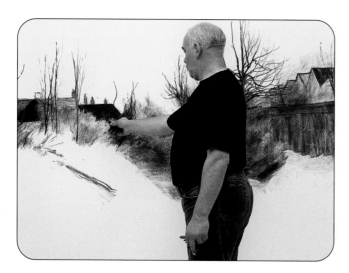

7 Continue to add detail, working over the entire drawing; it is important not to concentrate too much on one single area as this could lead you to overwork it. Here, the bushes in front of the house are defined by drawing into the dark roof behind. Use a thin stick of charcoal to indicate the pattern of roof tiles and to draw the saplings in front of the house.

8 Create the snow on the roofs and along the fence by working back into the charcoal with a kneaded eraser.

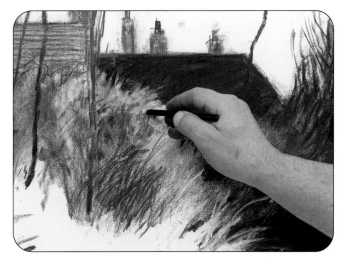

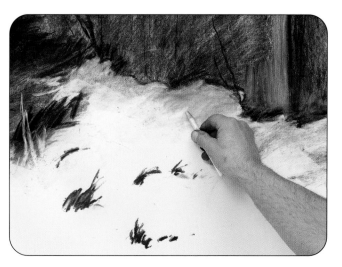

9 Using a graphite stick, draw details of twigs and leaves in the bush in front of the house. Use generalized textural marks that will read at a distance.

10 To suggest the shadow at the foot of the wooden fence, use a torchon to softly smudge and blend the charcoal, creating soft, medium tones.

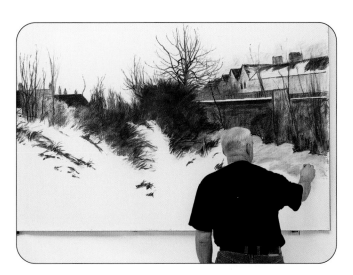

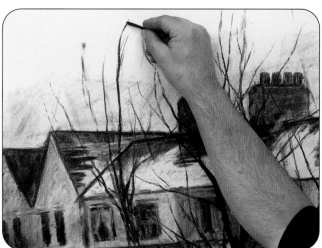

11 With a clean, plastic eraser, pull out details of snow-covered grasses from the dark tone to the left of the central mass. Use the same technique to draw back into the grass, so that the white paper stands for slivers of snow.

12 Using a small stick of charcoal, add more windows to the houses on the right, then 'draw' suggestions of frames, curtains and reflections with a kneaded eraser. Draw sinuous charcoal lines for the screen of branches.

landscapes

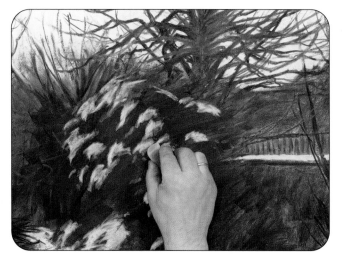

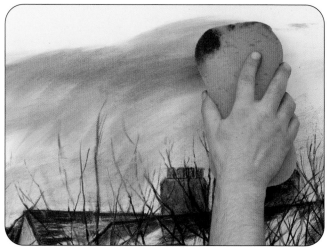

13 For the snow trapped on the bushes, press a clean, plastic eraser onto the paper, then twist and lift it to pull off the charcoal. If the eraser gets clogged with charcoal dust, cut off the dirty section with a craft knife.

14 Add tussocks of grass. If they appear too strong or distracting, soften them by rubbing gently with your finger to suggest shadows and ensure that they blend in with the rest of the drawing.

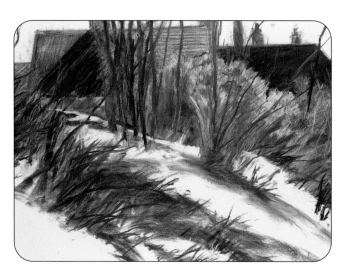

15 Add more detail to the snowy path by drawing grasses and emphasizing the bushes on the left. Add snow to the central tree by using an eraser to remove charcoal.

16 The final stage is to put in the sky, which encloses the landscape and, with its dark, glowering clouds, sets the mood. Put some graphite powder into a dish, dip a large sponge into the powder and lay it on the paper. Here, the sky is dark and overcast on the right, becoming lighter on the left. This creates variety and the dark rooftops and trees against the light sky enhance the sense of recession into the background.

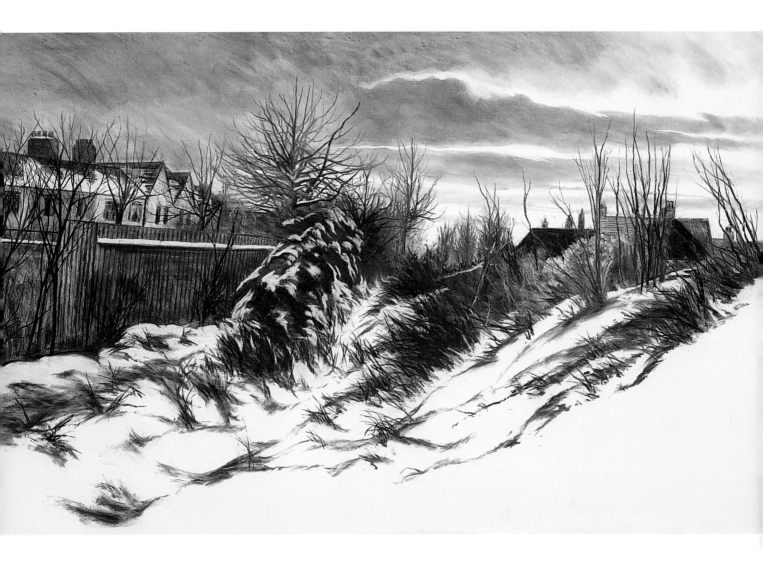

The finished drawing

This is an evocative description of a cold winter's day. The spatial relationships are clearly defined, leading the viewer over the hummocky ground and around the shrubs to the houses beyond. The picture exploits the versatility of charcoal to the full, setting passages of velvety black tone and dark calligraphic lines against softly gradated greys.

17 Use a plastic eraser to lighten dark areas, create crisp edges and define the shapes of the clouds. Take out slivers of graphite powder to suggest the cold, silvery light in this part of the sky.

18 When applying the graphite powder, you will almost inevitably smudge some twigs and branches that are silhouetted against the sky. Redefine them with a thin stick of charcoal.

creating a sense of space

Flat or rolling terrain, such as prairie or marshland, offers few obvious clues to recession. To capture the unique character of these wide open spaces, you need to exploit all the devices of linear and aerial perspective (see pages 44–49).

Try to think of the landscape as a series of overlapping planes: most landscapes naturally fall into foreground, middle distance and distant bands. In the nearest plane, objects appear large and contrasts of tone and texture are at their maximum intensity. The colours are warmest here and local colours are seen at their maximum saturation.

As the planes recede into the distance, objects become smaller, contrasts of tone and texture less obvious, and colours cooler and more muted. These contrasts may be subtle, but by being aware of, and even exaggerating, them you can create a sense of space even when there are few visual clues.

Before you begin even a preliminary sketch, look around you to find features that will enhance the composition, ignoring any that you find distracting. Remember that you do not have to reproduce the scene exactly as you see it: you can move elements from one part of the scene to another and paint them larger than they are in real life, put in clouds that were not there at the time to make a more dramatic painting, and exaggerate foreground textures.

You will need

Primed canvas board
Oil paints: titanium white, indigo, cadmium yellow, French
 ultramarine, Naples yellow, flesh tint, alizarin crimson, Winsor
 green, lemon yellow
Medium bristle brush
Selection of painting knives

The scene
The bottom photo is a wide-ranging panoramic view, while the other two home in on specific areas. In the painting shown on these pages, the artist chose to exaggerate the small tree on the right of the middle photo and to make a feature of the path alongside the hedge. He also added billowing clouds to the rather bland, featureless sky.

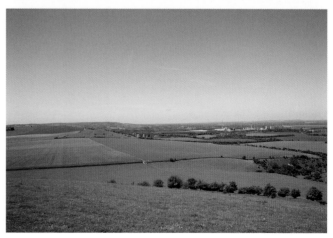

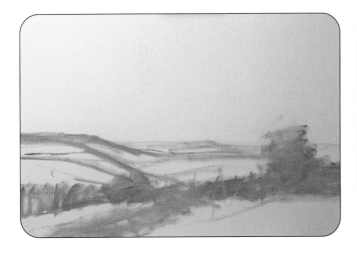

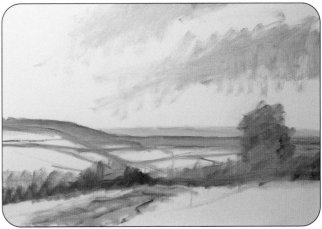

1 Locate the horizon approximately one-third of the way up the picture area and indicate the limits of the foreground and middle distance. By establishing these overlapping planes at an early stage, you build in a sense of structure and recession. Mix a cool, pale grey from titanium white and indigo. Roughly draw in the horizon line and the hill on the left. Add a little cadmium yellow to the pale grey mix for the hedge and tree.

2 Mix French ultramarine with titanium white and scumble colour loosely into the sky. Add a little titanium white to indigo and scumble a darker tone along the base of the hedge.

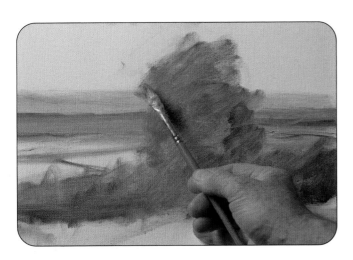

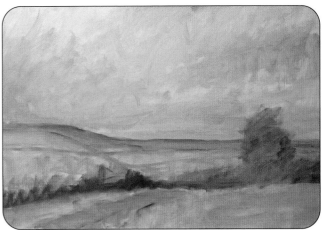

3 Twist and turn the brush to scumble the mix over the tree.

4 Mix a warm, neutral blue-purple from Naples yellow, flesh tint, indigo and titanium white and scumble colour into the sky, making it darker and denser on the left. Add cadmium yellow and more white to the mix and apply this colour thinly over the foreground and middle distance. The warm 'advancing' yellow in the foreground contrasts with the 'receding' blue in the background.

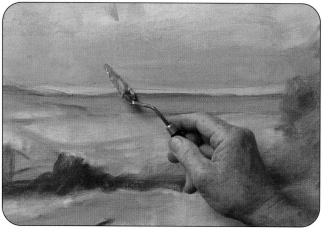

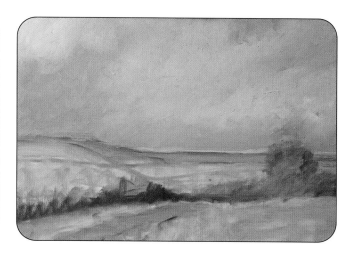

5 Change to a painting knife and start to build up clouds in the sky, using paint straight from the tube. Using a mix of alizarin crimson, French ultramarine and titanium white, use the flat of the knife to lightly spread colour into the wet paint surface. Apply the colour on the left of the painting and just above the horizon.

6 Block in the remainder of the image. Mix indigo, titanium white and flesh tint and apply the mix to the clouds with the knife, working diagonally across the picture. For the blue segments of the sky on the right, mix French ultramarine, indigo and a little Winsor green.

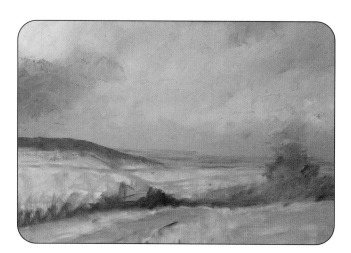

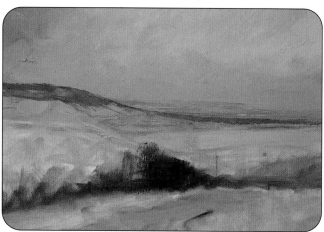

7 Mix a pale blue from French ultramarine and titanium white and lay a swathe of colour for the land along the horizon. This helps to establish the distant transition between the sky and the land. It is important to get this right if the landscape is to recede convincingly.

8 Working down the picture, lay in the distant landscape using the side of the knife to apply narrow bands of colour. Use a mix of indigo, flesh tint and titanium white to define the shadow on the hilly outcrop on the left. Block in the bush in the middle foreground with indigo. This dark tone sets a key for the gradation of tones into the distance.

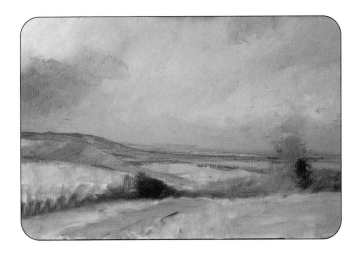

9 Mix indigo and cadmium yellow and apply patches of colour to the hillside on the left of the picture. Vary the mix to achieve shades from pale yellow to moss green.

10 To describe the sun shining on the landscape, lay in a pale yellow version of the mix. Use the side of the blade to stroke on slivers of paint.

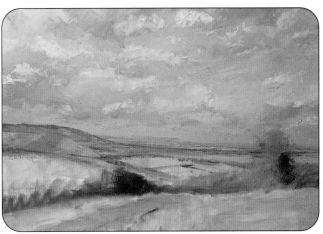

11 Mix French ultramarine and titanium white with a touch of indigo and develop the sky. Look for the dark areas under the clouds and lay in swathes of the grey mix. Be bold and apply the colour with a light touch of the painting knife.

12 Continue to develop the three-dimensional qualities of the sky by smearing touches of white impasto onto the upper margins of the clouds, where they catch the light. As you spread the paint across the wet paint on the canvas, the colours blend to create a range of greys.

Sky and land together

The sky is integral to the landscape, so keep the two progressing in tandem.

landscapes

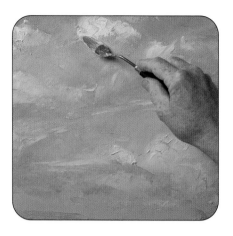

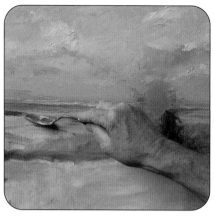

13 In some places, skim pure white paint onto the clouds.

14 The centre distance is a key focus of the painting, so add more detail here. Mix indigo with alizarin crimson and lay it on with the side of the knife to suggest patches of woodland. Make the colours bolder than in the far distance, as they are nearer the front of the picture plane. Grade the scale of the knife marks to emphasize the way the landscape moves into the background.

15 Now start to work up the foreground area. The hedge is a key element in the composition of the landscape: block this in with a dark green mixed from indigo and cadmium yellow. Work broadly and boldly: this paint layer will provide a base for working in the details of foliage.

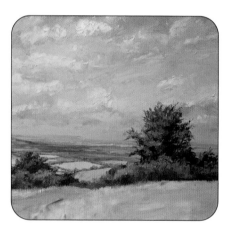

16 To suggest shafts of sunlight on cornfields, mix Naples yellow with titanium white and lay in broad bands of thick, creamy paint in the centre of the foreground, using the flat of the knife. This patch of light colours draws the eye along the pathway and leads it up and into the picture. Use the paint to create a definite V-shaped gap in the hedge to represent a path cutting through the bushes.

17 Using greens mixed from various blends of indigo, lemon yellow and Naples yellow with titanium white and a touch of Winsor green, start to put in the details of the small tree and the hedge. Use the side and the tip of the knife for the branches and twigs and the flat of the blade for clumps of foliage. You will find that the painting knife is a responsive and flexible tool.

18 The areas under the tree branches and the hedge will be in shadow. Use a darker tone along the base of the hedge to give it form and anchor it to the ground plane.

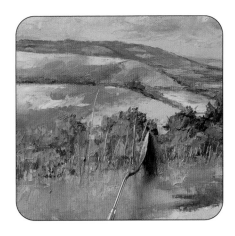

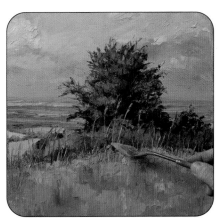

19 Foreground texture – here, in the form of dry grasses – is an important component in the creation of a sense of space. Use warm, muted greens and dirtied yellows to suggest the grasses. With the side of the knife, create grassy shapes using a combination of sgraffito (see page 132), where the knife cuts into the wet paint, and impasto.

20 Using pure cadmium yellow applied with the tip of the knife, touch in details of wild flowers, smearing the paint randomly to suggest that they are being seen through overlying layers of grasses, with crisp touches of paint to lead the eye in and out of the grassy area.

The finished painting
By observing the rules of aerial perspective, the artist has created a wonderful sense of space and distance. Grasses and wild flowers add textural interest in the foreground, while the hedge defines the end of the foreground plane; the dark foliage in the foreground also establishes the fact that it is close to the viewer. In the middle distance, far less texture is evident, helping to reinforce the fact that it is further away. The sky becomes more muted in colour towards the horizon. Finally, simple yet classic compositional devices – the path leading the eye into the centre of the painting, the tree positioned roughly 'on the third', the lowering sky (which, at its deepest, takes up two-thirds of the picture space) – all combine to create an attractive and beautifully textured landscape.

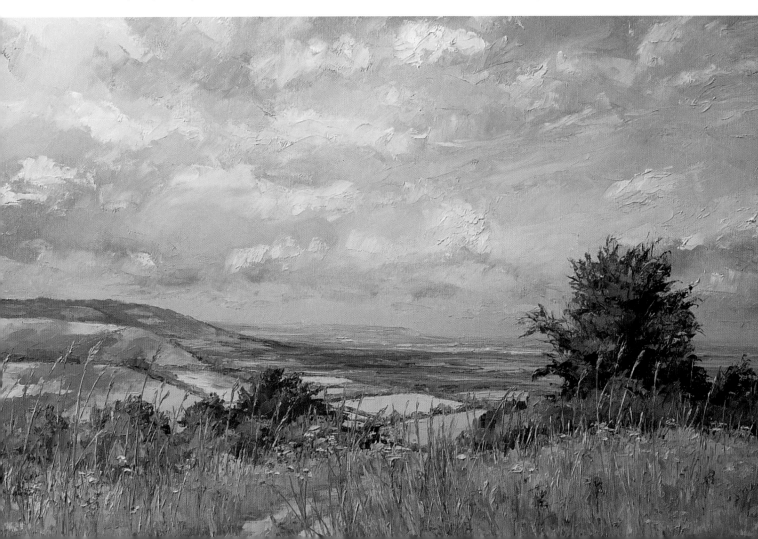

waves in acrylics

Moving water – whether it's a waterfall, breaking waves or even jets of water from a fountain – makes an exciting subject for a painting. Use bold, vigorous brush strokes and textural techniques such as spattering and impasto to capture the energy of the scene.

A scene such as this changes from one second to the next, so you might feel that it's impossible to paint in situ. But even if you decide to work from reference photos, do try making a few quick sketches on location: the very act of concentrating on sketching will help you get a feel for the rhythm of the waves.

With both acrylics and watercolour, you can use masking fluid to preserve the white of the paper (see page 126). Use flowing, calligraphic lines for the swirling foam and spattering (see page 132) for the fine spray coming off the rocks. Bear in mind, however, that with acrylics you can paint a light colour over a dark one – so if the masking fluid doesn't create quite the effect you want, you can always apply white paint on in the final stages.

There are many different colours and tones in the water. There's no need to be too specific about the colours, but look for the lights and darks, as this will give the waves a sense of form. Think of the waves as solid, three-dimensional objects, with a light and a shaded side.

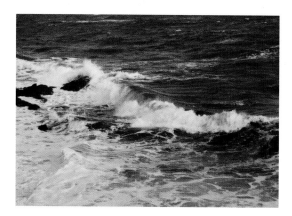

The scene
The breaking waves form a diagonal line that runs from the top left towards the bottom right of the picture space: this creates a much more dynamic composition than a straight, horizontal line. The rocks provide a necessary point of solidity in the image.

You will need

Heavyweight watercolour paper
2B pencil
Ruling drawing pen, dip pen or old brush
Masking fluid
Selection of round and flat brushes
Acrylic paints: light violet blue, light olive, cobalt blue, raw umber, yellow ochre, titanium white, powder blue, burnt sienna
Plastic painting knife

1 Using a 2B pencil, make a light underdrawing of the scene, putting in the rocks and the lines of the most important waves. Note how the waves swell to a crest and then break – there are two distinct facets and you need to convey this in your painting. Using a ruling drawing pen, dip pen or old brush, apply masking fluid over the areas that you want to remain white. Clean your pen or brush thoroughly before the masking fluid dries.

Capture the energy

Keep your lines loose and spontaneous so that you capture something of the energy of the water.

 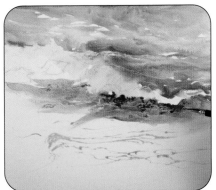 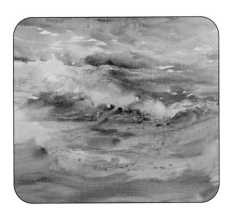

2 Using short, undulating strokes to echo the movement of the water and allowing some of the underlying paper to show through, apply light violet blue acrylic paint over the blue sea in the background. Where the water is darker, add light olive to the mix.

3 Use cobalt blue for the very darkest parts of the water, under the waves, so that you begin to give this area some sense of form.

4 Continue putting in the colours of the water, varying the colours and the proportions in the mixes as necessary; the water is not an even, uniform tone.

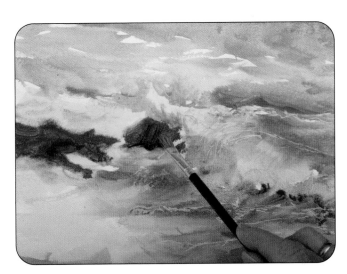 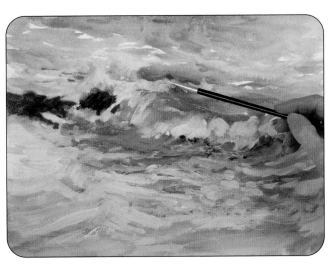

5 Mix a dark, warm brown from raw umber and yellow ochre. Using a short flat brush, block in the exposed areas of rock. Keep the paint quite thick to convey something of the texture, and add a little cobalt blue for the darkest areas so that you begin to develop something of the form of the rocks.

6 Mix a pale blue from titanium white and powder blue and brush in the blue-white foam of the waves – those areas that are light but not a glistening, pure white.

landscapes

7 Intensify the darks in the foreground, using the same olive green and cobalt blue mixes as before. With a scene like this, you have to continually assess the tones in relation to each other.

8 Wash a very pale, light olive green over all the exposed whites to knock back the glare of the paper and leave to dry. Using your fingertips, rub off the masking fluid.

9 Using titanium white paint straight from the tube and the tip of a small plastic painting knife, stroke paint onto the rocks to convey the impression of the foaming waves. Look at how the waves break and make sure your knife strokes run in the same direction.

10 Continue using the painting knife and thick mixes of the previous sea colours to build up more form and texture in the waves.

11 Add more texture to the rocks in the same way, using varying mixes of raw umber, burnt sienna and cobalt blue. Although the rocks are a long way away and the sun is overhead, you can enhance the three-dimensional impression by making one side of the rocks darker than the others, so that it appears to be in shade.

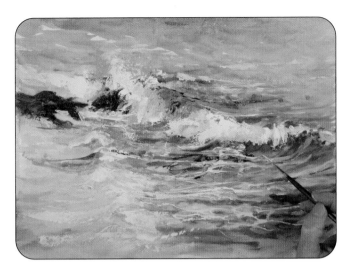

12 Finally, using a thin, round brush, 'draw' trails of white in the sea for the swirling lines of foam.

The finished painting

This is a fairly loose, impressionistic painting, but its bold brush strokes and spatters of paint capture the force and energy of the sea well. Impasto work on the rocks and foreground waves contrasts with the smoother, flatter applications of paint in the background, which helps to create a feeling of distance.

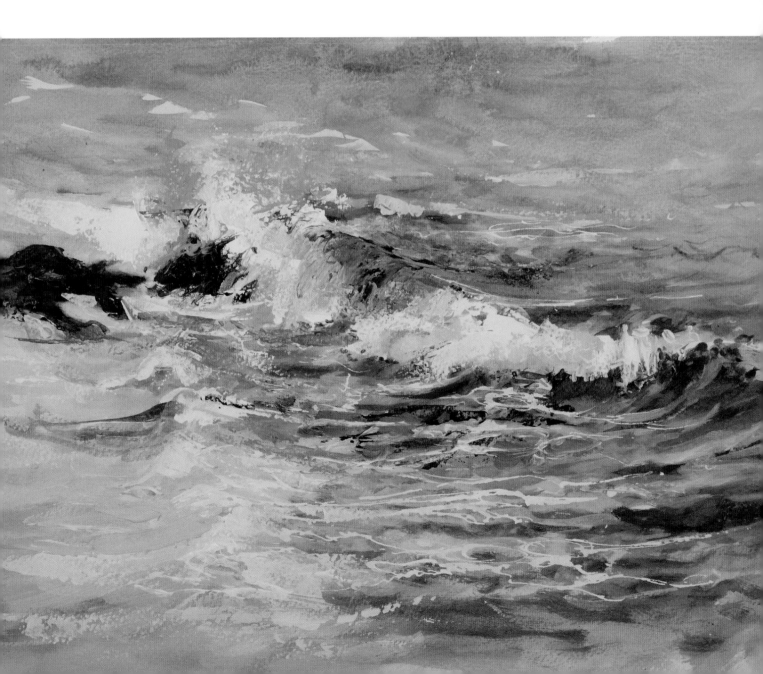

portraits
and people

Many people are put off attempting portraiture and figure drawing, because they fear that they are technically difficult. This chapter takes the mystique out of the subject by explaining how to get the proportions of the head and figure right, before moving on to a series of more ambitious projects including full-scale portraits and nude studies.

drawing the head

Every head is different, but there are some general guidelines that you can use to get the shape right and position the facial features correctly – although careful measuring is essential, too.

The basic head shape

Start by drawing the head from straight on. From this viewpoint, it looks more like an egg shape than a circle. Instead of starting with an outline and then filling in the detail, build up the shape gradually by making a series of curved marks that go around and across the head, so that you begin to get a feel for the head as a three-dimensional form.

1 Starting from the inside and working outwards, draw a series of curved lines and more spherical movements to get a feel for the head as a three-dimensional form.

2 Add ovals and spheres for the features.

Positioning the facial features

The exact position of the eyes, nose and mouth varies slightly from one person to another, so it's absolutely essential to take careful measurements when drawing a portrait. However, these general guidelines (which apply only when the face is viewed straight on) are a good starting point. It's very useful to put in these 'construction lines' lightly at the beginning of a portrait.

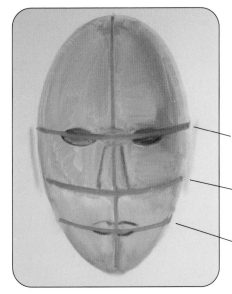

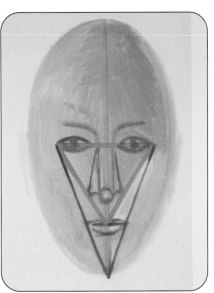

Draw a line down the centre of the face from top to bottom; the features are positioned symmetrically on either side of this line. Then draw a series of lines across the face to mark the position of the facial features – the corners of the eyes, the top and bottom of the nose and the corners of the mouth.

The corners of the eyes are more or less level with the tips of the ears.

The bottom of the nose is approximately halfway between the eyes and the base of the chin.

The mouth is less than halfway between the bottom of the nose and the base of the chin.

To double-check that you've placed the features correctly, join them up in an inverted triangle. You can either draw the triangle between the outer corners of the eyes and the top of the mouth (shown in red), or between the outer corners of the eyes and the base of the chin (shown in blue). In most people, the features will fall within the triangle so you can use the triangle to check, for example, that you haven't made the mouth too wide – although, of course, you must measure too.

The planes of the head

If a face is lit from the front, the sides will be in shadow and you will need to apply a darker tone in these areas; this is what makes your subject look three-dimensional. To make your portraits look really lifelike, therefore, you need to take into account the transitions between different planes. These transitions may be very abrupt (for example, from the top to the underside of the nose) or gradual (for example, across the curve of the forehead). You don't need to replicate every single one, but being aware of where they occur will help you make your portraits more realistic.

You may find that it helps to lightly indicate the major planes of the head at the start of your drawing, to help you place the areas of light and dark tone more accurately.

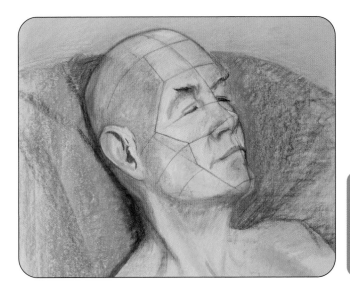

proportions of the human figure

Proportions vary almost as much as people's character, but artists often use the head as a unit of measurement when assessing the proportions of the human figure.

The average adult is roughly seven and a half heads tall, although some people may be six heads high and others as much as eight or even nine. As always in drawing, there is no substitute for careful observation and measuring – but if you know the 'norm', you will find it easier to work out how far your model conforms to (or departs from) that norm, simply by comparing the size of their head against other sections of the body.

Another thing to remember is that proportions change with age. In a young baby, both the head and the legs occupy roughly one-quarter of the total height; in an adult, the head takes up a much small proportion of the whole while the legs make up nearly half the total height. As we reach old age, we may lose up to half a head in height.

In these sketches, you can see how the proportions of the body change with age.

'Landmarks' and alignments

In addition to careful measuring (see page 42), put in 'landmarks' such as the nipples or collarbones to help you check that you've placed limbs and other features correctly. And look at how whatever you're drawing relates to other parts of the subject: for example, if your model is standing with her hands on her hips, what part of the torso does the elbow align with?

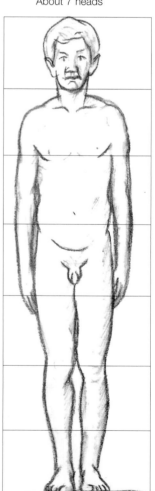

Age 14
About 7 heads

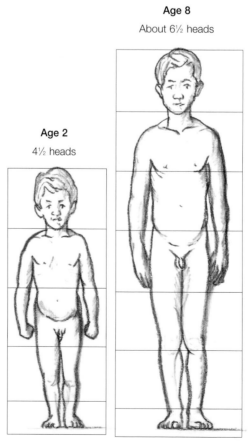

Age 8
About 6½ heads

Age 2
4½ heads

Baby
About 4 heads

Other useful guidelines

Generally speaking, in an adult standing figure with the arms hanging loosely by the sides:
– The navel is roughly halfway between the nipples and the crotch, and halfway between the bottom of the ribcage and the top of the pelvis. A common mistake is to place it too low.
– The pubic area is just below the mid-point of the body.

– The legs make up nearly half the total height.
– The arms are around 3½ heads long.
– The forearm is approximately 1.7 times the length of the hand.
– The fingertips reach roughly halfway down the upper leg.
– The elbows are more or less level with the waist.

Age 40
About 7½ heads

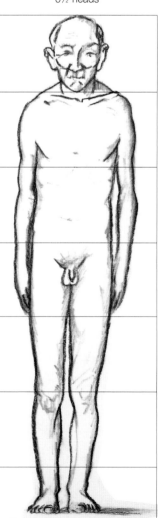

Age 18
About 7½ heads

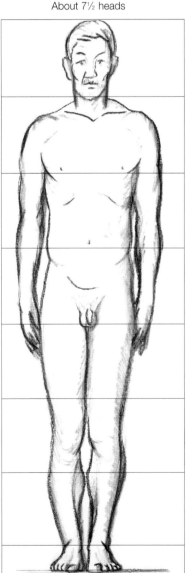

Age 80
6½ heads

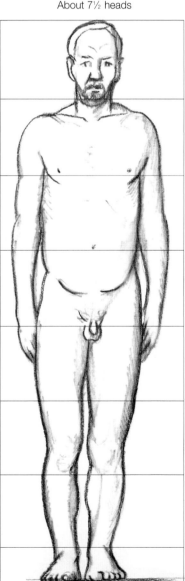

hands

Apart from the face, hands are often the most expressive part of a portrait. They can tell us a lot about the sitter's mood and personality, so it's worth taking time over them.

One common mistake is to make the hands too small. If you stand in front of a mirror and hold your hand up in front of your face, you'll see that it is roughly the same length as the face from chin to hairline.

Another common mistake is to think of the fingers as individual appendages, rather than trying to draw the hand as a whole unit. If you start by concentrating on details such as the fingers rather than the overall form, you'll give them too much prominence and you may well end up with something that looks more like a bunch of small bananas than living flesh! Instead, try

to see the whole hand as a basic shape: a clenched fist, for example, is a rough cube shape (see page 32). Start by simply looking at your own hand and working out where the changes in plane occur: rest your wrist on the table top, allowing your fingers to bend naturally, and you will see that there are major changes in plane at the knuckles and at the individual finger joints.

Once you've established the basic structure, you can then look at details such as the veins and any wrinkles or folds in the skin – but do not make them too dominant, or you will lose any sense of the underlying form.

Underlying bone structure
Although only light shading has been used on this sketch, the underlying bones are very near the surface of the skin so the underlying structure of the hand is very clear. Note how the phalanges (the individual sections of the fingers) are foreshortened (see page 47) from this viewpoint.

Cube of the fist
A clenched fist is basically a cube shape: note how the knuckles form an uneven ridge across the top of the cube.

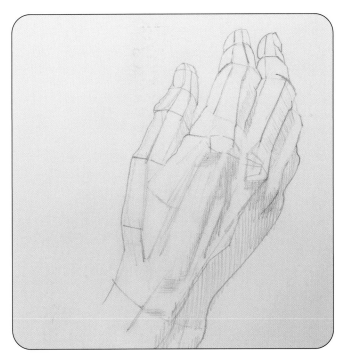

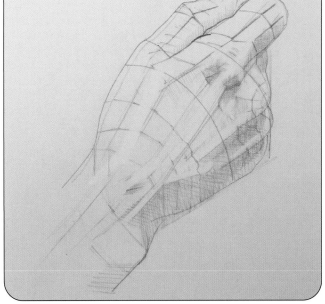

Changes of plane

This sketch shows more of the minor changes of plane within individual digits. Here, the side of the hand is angled towards the viewer, which means that only the first phalange of the third and fourth fingers can be seen. Note how the amount of fingernail that we can see varies according to whether the fingers are angled towards or away from us.

Size and foreshortening

From this viewpoint, we cannot see three of the four fingers and, if you did not take careful measurements, you might think that the first finger looks disproportionately large. Always trust your eyes and draw only what you can actually see!

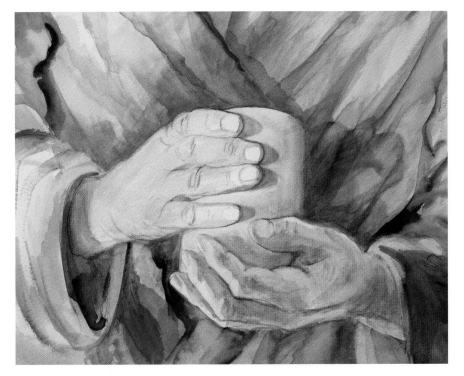

Tonal transitions

Subtle changes in tone convey the shape of the hands and the transitions in plane as the fingers curl around the coffee mug. Note, too, how the deft brush marks of alizarin crimson/ultramarine mixes have been used to depict the small wrinkles and folds in the skin: the skin texture is understated but very expressive and tells us something of the age of the model.

bold figure work

Invariably every subject has a particular inherent strength. This may be its colour, texture, composition or shape. In this example the light, together with the strong negative and positive shapes, demanded an uncompromising treatment.

Texture was almost non-existent. Colour was ignored and, given the sharp contrast between light and dark, the tonal scale was drastically reduced.

The large, solid shape of the piano and the human figure stand out as silhouettes devoid of detail in the glare of light from the large windows. However, the lighter, negative shapes around these more positive elements are of equal importance.

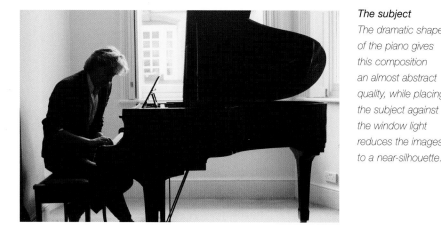

The subject
The dramatic shape of the piano gives this composition an almost abstract quality, while placing the subject against the window light reduces the images to a near-silhouette.

You will need

Good-quality drawing paper
Medium charcoal stick
Scrap paper
Fixative

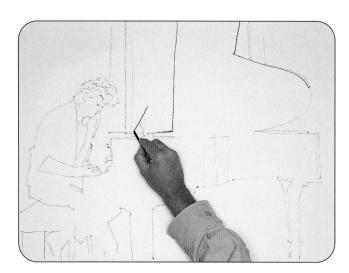

1 Using a medium charcoal stick, draw in the main elements, noting the spaces around the subject and working lightly to facilitate corrections. Once the drawing is correct, apply fixative.

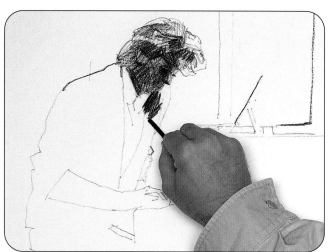

2 Draw in the features on the face and hair using heavy strokes. Then apply a darkish tone over the top.

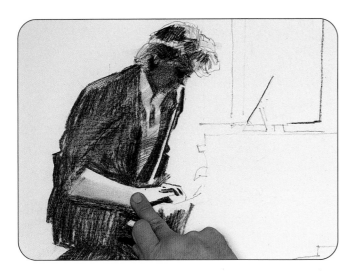

3 Using fairly dense scribbling, draw the body merging into the stool and the piano with the same tone. Create the lighter tone on the back of the pianist's arm simply by rubbing your finger over the clothing and then down the arm to transfer some of the charcoal dust.

4 Bring the dark tone across the body of the piano. Pay particular attention to those areas hit by the light, as their shape gives important clues as to what is happening in the black, scribbled areas.

5 The body of the piano catches the light at the point where it curves into the background. This point could be scribbled dark, but then it would look like a flat shape. Using your fingers in a rubbing motion, make a slight suggestion of light reflections that will help to create the appearance of a curved piano body.

6 Draw in the window and its folded-back shutters as soon as you have established the dark mass of the piano. Scribble in the tone on the wall with light and loose movements. Use scrap paper as a mask to keep the scribbling loose, but make a straight line where the tone ends.

7 Alternatively, transfer charcoal dust from a heavily scribbled area onto your finger. Then rub down the mask, leaving a lightly toned line on the drawing.

The finished drawing

This is a strong composition that, despite its apparent simplicity, hints at greater complexity. You can use this technique for dramatic, finished drawings as well as for capturing the essence of a scene without the need for a time-consuming study exercise.

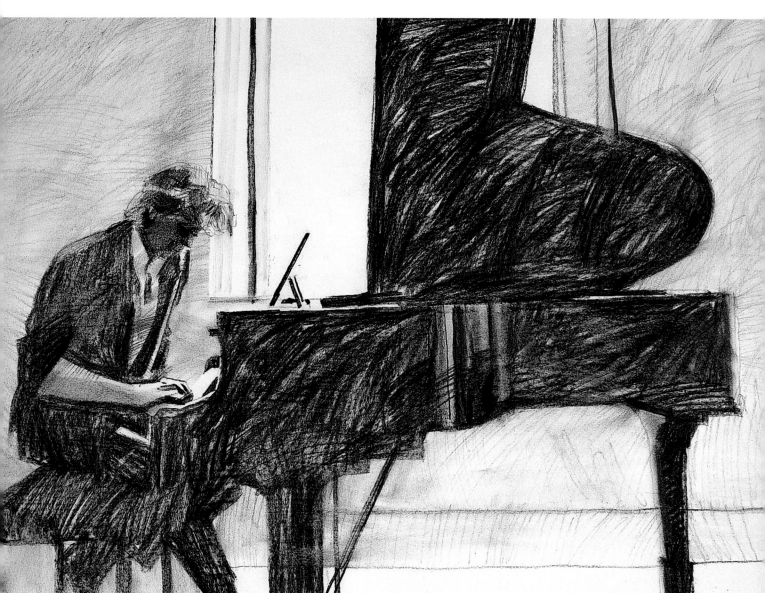

balance and movement

You don't need to know a lot about human anatomy to draw figures – keen observation is the key. Finding the balance of the pose is crucial.

Whenever you draw a figure, whether it's moving or at rest, you need to find its centre of gravity, or line of balance. There are two reasons for this. First, you need to avoid your figures looking as if they are tilting to one side. Second, figures need to look balanced in order to have a sense of mass and weight.

To find the line of balance, drop an imaginary plumb line down to the point on the ground on which the body's weight falls. If you're viewing a figure from the front, take your imaginary line down from the hollow space at the base of the neck, between the collarbones. From the back, take it from the middle of the base of the neck. From the side, take it from the ear hole. The point at which the line meets the ground should coincide with the point of the figure that bears the weight. Lightly draw the line of balance on your sketch.

Then look at the lines of the hips and shoulders: a movement on one side of the body is generally counterbalanced by a movement in the opposite direction on the opposite side of the body. If, for example, someone is running, at the moment his or her left foot lifts up off the ground, the right shoulder will tend to tilt downwards. The angle of the head is something else to look for: it tends to run counter to the movement of the shoulders – so if one shoulder is tilting down to the right, the head will tilt to the left so that the figure can maintain its balance.

Practice makes perfect

Although studying stills photos is a good way to learn about movement, try not to rely on photos too heavily. It's really important to make quick sketches from life, so that you get used to picking out the essentials of a pose or movement and to observing how the body instinctively adjusts its balance. Don't worry if your initial attempts are nothing more than a few generalized marks: the whole process is as much about sharpening your powers of observation as it is about drawing.

Start by asking a friend to walk slowly across the room, then turn and walk back again. As they do so, make quick sketches concentrating on one aspect of the body at a time. You might, for example, start by looking at the tilt of the shoulders in your first few sketches, and then move on to looking at the position of the head in relation to the weight-bearing foot, or the tilt of the hips,

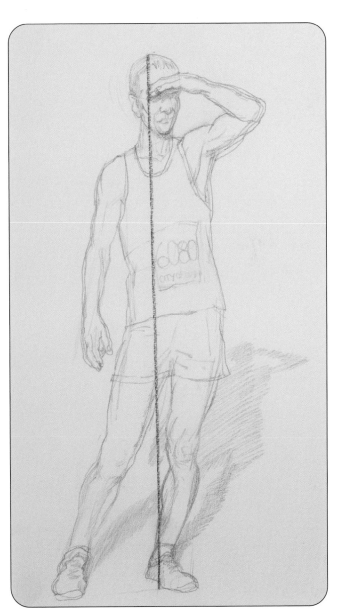

In this sketch, the weight of the figure is mainly on the left foot, causing the upper body to shift over this leg and the left hip to tilt upwards. The right shoulder tilts down to compensate for this and the fact that the left arm is raised.

or the swing of the pelvis, or how the foot lifts off the ground. All this will help you understand the action and speed up your reactions as an artist.

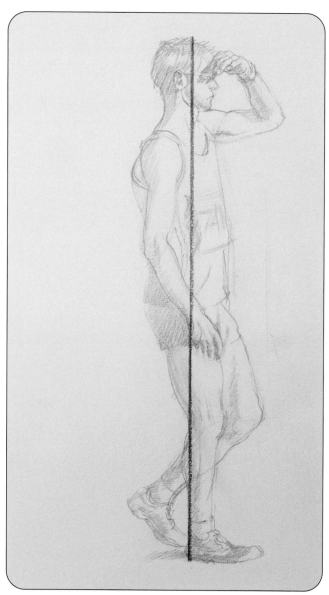

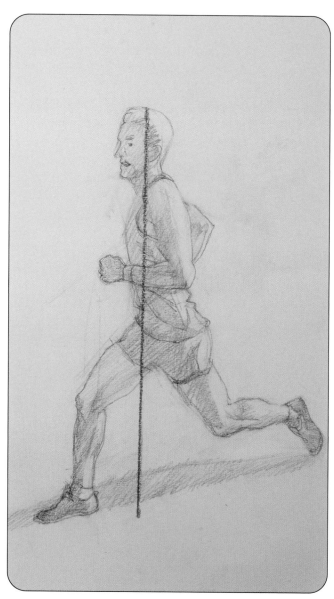

Here, the weight is on the right leg. The left leg is in the process of being raised off the ground, so the right shoulder tilts down to compensate and maintain the body's balance. The balance line runs through the centre of the weight-bearing leg.

Here, the weight is distributed between the feet. As the right foot pushes forwards, the left shoulder goes back to balance the body.

female portrait in watercolour

Your skill at organizing and manipulating thin washes, and the exact mixing of colours and tones for skin, is tested to the full when it comes to painting detailed portraits in watercolour. Start with a good drawing: this will act as a guide and enable you to concentrate on mixing and placing your washes correctly.

Even though only head and shoulders are shown in this project, try to use the area of the paper in a creative way. Placing the subject centrally, facing full on, is seldom a good idea. Look at the clothes that the model is wearing and simplify fabric patterns if necessary so that they do not detract from the main subject. Also consider the background; here, too, it may be a good idea to merely suggest what is there rather than to paint it in too much detail.

Try to avoid flat lighting, as nothing reduces interest in a face more than bland, regular light, which flattens out the features. Look out for warm and cool colours; these can often be exaggerated to great effect and add interest to the deep shadows. Try to position highlights correctly, but make sure you avoid overstating them.

You will need

Stretched NOT watercolour paper
2B pencil
Small round brush
Watercolour paints: Payne's grey, brown madder alizarin, Naples yellow, yellow ochre, ultramarine blue, burnt umber, cadmium yellow, sap green

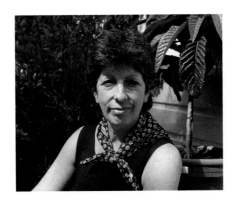

The subject

Full-face portraits, with the features arranged regularly, often look awkward and lack any convincing sense of depth. In contrast, a three-quarter light source, as used in this portrait, throws strong shadows, which allow the nose, chin and hair to push forward into relief.

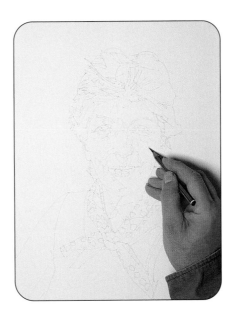

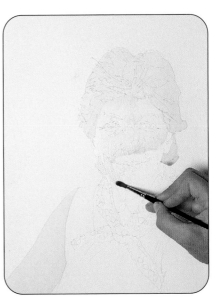

1 Using a 2B pencil, lightly sketch your subject. If you are using a grid, work very lightly, and avoid too much erasing, as the surface of the paper can become disturbed and have an effect on how flat the washes dry.

2 Using a small round brush and a mixture of Payne's grey and brown madder alizarin, apply the first wash on the hair. Cover the entire skin area, including the whites of the eyes, with a mixture of brown madder alizarin and Naples yellow.

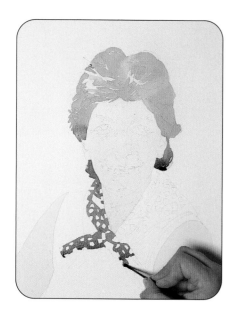

3 Remix the hair colour, adding more Payne's grey, a touch of brown madder alizarin and a little yellow ochre. Repaint the hair, working around and cutting out any highlighted patches or wisps of hair. Working around the white pattern, paint in the scarf with a mixture of Payne's grey and ultramarine blue.

Simplify patterns

To make life easier for yourself and help prevent overworking what is a very small part of the portrait, simplify the pattern on the scarf – but do make sure the pattern echoes the shape and creases of the scarf as it curves around the neck and sits on the model's shoulders. This, along with the darker tones in the shaded areas of the fabric, will help to give it some form.

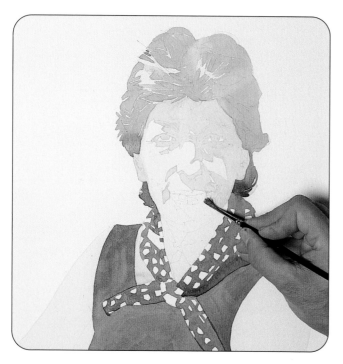

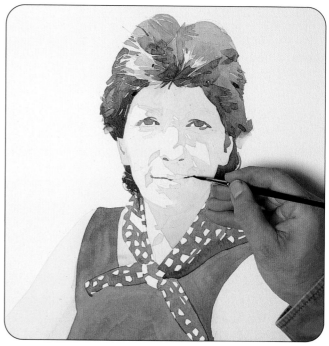

4 Add more Payne's grey to the mix and paint the model's blue top. Add a second light tone, made from brown madder alizarin and Naples yellow, to the face. This tone should follow and define the extent of the shadows. Work the mixture onto the neck and arms.

5 Mix a darker grey, using Payne's grey and burnt umber. Repaint the hair, working around and cutting out the highlights and lighter strands of hair. Then add more burnt umber and some brown madder alizarin to the mix. Paint in the upper eyelids, the eyes and a few lower lashes, the dark insides of the ears, the nostrils and the line of the mouth.

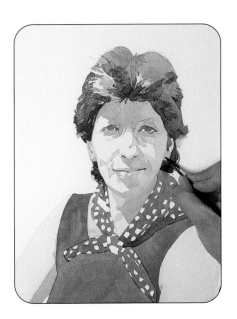

6 Create a darker tone for the skin by mixing brown madder alizarin, cadmium yellow and ultramarine blue. Work across the shadows on the forehead, around the eyes and ears, and below the nose, mouth and neck. Then make the mixture redder and paint in the dark of the lips and ear lobes.

Softening transitions

If the transition from light to dark appears to be too sudden, soften any paint edges with a brush and clean water.

7 Remix the hair colour, adding more Payne's grey, a touch of brown madder alizarin and a little yellow ochre. Repaint the hair, working around and cutting out any highlighted patches or wisps of hair. Working around the white pattern, paint in the scarf with a mixture of Payne's grey and ultramarine blue.

8 Using a range of red tones, paint in the details in the lips and around the mouth.

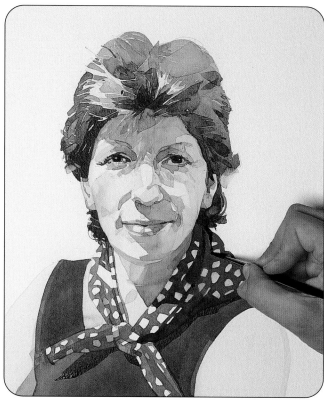

9 Mix brown madder alizarin and ultramarine blue together for the very dark shadows. Closely observe the linear shadows from the hair, and those around the nose and mouth and on the neck.

10 Use a dark mixture of Payne's grey to create a shadow beneath the scarf. Apply a mid-grey wash over the scarf, and allow it to dry well before you add a mix of Payne's grey and ultramarine blue for the dark shadows in the folds of the scarf.

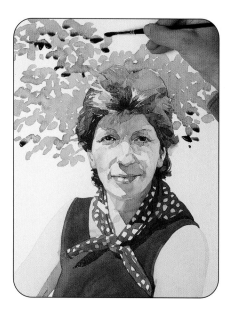

11 Once the portrait is complete, fill in the area above and around the head with a wash of sap green. This places the figure in some kind of context and gives the work extra depth.

The finished painting

The delicate washes that have been used to build up the skin tones give this portrait an attractive, luminous quality. If the background had been more fully realized, this would have softened the outline of the figure so that is blended more into its surroundings.

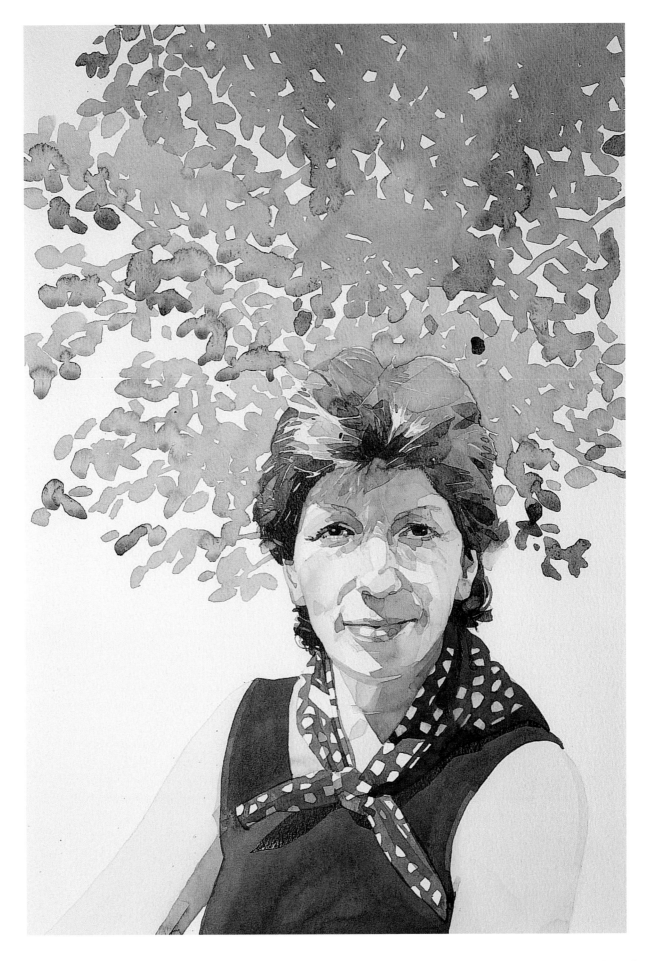

sleeping figure in acrylics

If you're new to figure drawing and painting, it's a good idea to start with a pose that the model can comfortably hold for a long period of time, giving you the opportunity to work at your own pace without having to worry about the model changing position. A reclining pose such as this one is ideal.

When figure painting, it can be challenging to mix and use convincing skin tones and colours. If you use a white background the task is made more difficult, as a single colour is greatly affected by the colours that surround it and we rarely, if ever, see colours in isolation.

There are several ways of overcoming this. You can work on a toned ground that has been stained or tinted to a colour sympathetic to the overall colour of the work (see page 144). You can work over a monochrome underpainting that establishes the colour tonally. Or you can do as the artist did in this demonstration, which is to block in the work relatively loosely in order to establish the image, and then work over it, manipulating the colour and tone until you are satisfied with the result. Acrylic paint is ideal for blocking in, as it dries so quickly.

You will need

Canvas board
4B pencil
Small flat brush
Acrylic paints: burnt umber, Payne's grey, cadmium red, cadmium lemon, yellow ochre, white, ultramarine blue, opaque green, alizarin crimson

The pose
The reclining nude is a classic pose that can be held for long periods of time. Here, the shape of the bed provides a pleasing framework in which to place the figure. The pale bedclothes can be converted to three tonal areas: highlight, mid tone and soft shadow, while the subtle tonal changes over the model's body can be simplifed and reduced to broad areas.

Working with a model

It might seem like a good idea to get family or friends to pose for you, but you'll probably get better results with a professional model, as he or she will be used to working with artists and will feel comfortable in that scenario.

Tell the model in advance what the session will entail and how long it will last, and agree a fee.

If you're hiring a model privately, it's a good idea to contact one you've already met in a life-drawing class. That way, you know they've got life-modelling experience and they know you're a bona fide art student.

Make sure the room is warm and that they have somewhere private to change and undress. Make sure the model is comfortable holding the pose you want: unless it's a reclining pose, even experienced life models will probably need to stretch their legs after half an hour or so and poses where they're twisting their body can only be held for a few minutes.

1 Using a 4B pencil, loosely draw the figure on the canvas board. If you do not fix the drawing at this stage, the soft pencil marks may be moved around by the initial layers of paint. However, this presents no problem, as the drawing is only there to act as a guide for the final painting.

2 Block in the headboard, using a mixture of burnt umber and Payne's grey. Then block in the figure with a mixture of cadmium red, cadmium lemon, yellow ochre and white.

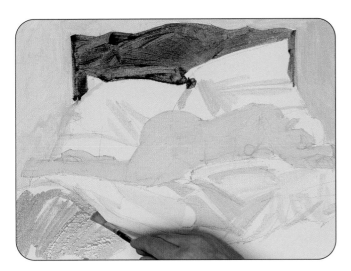

3 Mix Payne's grey, white and yellow ochre for the wall. Paint the creases on the sheets with a mix of Payne's grey, white and ultramarine blue. Opaque green, white and Payne's grey produce the bed cover.

4 Paint in the hair with a mix of Payne's grey and burnt umber, then use burnt umber for the darker shadows beneath the arm, breast, stomach and legs. Make a dark skin tone from alizarin crimson, yellow ochre and burnt umber mixed with a little white.

portraits and people

5 Lighten the existing mixture with white, yellow ochre and a little cadmium red. This acts as a mid tone which softens the transition from the darker tones to the first, lightest tone used on the figure.

6 Repaint the bed cover with green into which ultramarine and white have been added. Then rework the shadows on the bed sheets using Payne's grey, ultramarine and white.

7 Finally, redefine and pick up the highlights using white.

Keep checking!

As you work, continually assess each tone in relation to the others in the painting; you're glazing one colour on top of another to build up the tones to the right density and adjusting a tone or colour in one area may mean that you will need to adjust others to achieve the right balance.

The finished painting

The painting was quickly and convincingly established using a few simple colour mixes; even so, the blocks of tone convey the changes of plane across the model's body very effectively. At this stage, you can decide whether to leave the work as a sketch, or continue working over it and bring it to a finer finish.

finishing touches

After all the hard work you've put into creating your drawing or painting, it's only natural that you'll want to display it for others to see. Although the choice of mounts and frames is very much a matter of personal taste, you do need to think about how they can complement your works of art.

protecting your pictures

After all the time and effort you've put into creating a drawing or painting, the last thing you want is for the piece to be damaged in transit or in storage. Here are some useful guidelines.

Transporting artwork

If you attend art classes or work on location, you will need a safe way of transporting your work home. Graphite and coloured pencil works are straightforward: place them in a portfolio case to keep them flat. With pastel or charcoal works, apply a fixative to prevent smudging and intersperse spare paper or acid-free tissue paper between drawings to prevent them from contaminating other pictures. Make sure watercolour and acrylic paintings are dry before you attempt to move them. For oil paintings, which can take days or even weeks to dry, use canvas pins or a canvas carrier (see below).

Portfolio case
Available in a range of sizes and styles, an artist's portfolio case is useful for carrying and storing loose drawings, pastels and watercolours.

Canvas pins
To protect the wet surface of an oil painting when in transit, place double-ended pins in the four corners of the canvas and place another canvas on top.

Canvas carrier
A canvas carrier holds two canvases, one on each side. Use it to bring home wet oil or acrylic paintings when you have been working on location.

Storing artwork

Keep all drawings and paintings flat – ideally in shallow drawers, where there is less chance of scuffing. Place clean paper or acid-free tissue paper between pieces. Do not store works made on paper with newspaper or corrugaged cardboard, as both can discolour and damage your work. You can also use special print storage boxes, made from acid-free or rag mountboard.

It is vital that you protect your work from light, heat and moisture. Direct sunlight will cause drawings and watercolours, in particular, to fade prematurely, while dampness and humidity will create mildew. Very dry conditions can be harmful, too, so take care not to place finished work and paper materials next to heaters or radiators.

mounting and framing

A painting is never truly complete until it has been mounted and framed. Although selecting a mount colour and frame that suit your picture is largely a matter of personal taste, there are some basic principles that will make your choice easier.

Cutting a bevel-edged mount

Making your own mounts allows you to choose exactly how you wish to present your images – and it is also considerably cheaper than having them cut by a professional framer. The most important thing is that your measurements are completely accurate: bear in mind the old adage, 'Measure twice and cut once'. Whatever bevel cutter you choose, make sure that it is well made and will cut accurately. Make sure, too, that your marking tools are accurate and sharpened: using a blunt pencil can ruin all your measuring.

Mount proportions

Traditionally, the standard proportions for mounts are that the base area is the largest, the sides next and the top smallest. There may be exceptions, but these are regarded as the most visually pleasing.

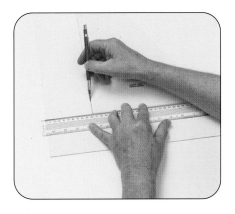

 1 On the reverse side of the mount, write any measurements and notes, then use a ruler and straightedge to measure and mark the first line overlength. Position a set square to a ruler on the line and mark the first right angle.

2 Measure and mark the other lines and right angles. Place a soft board beneath the mount and line up a straightedge with the first line. Use a bevel cutter to cut to inside the ends of the line.

3 Continue cutting the other lines, as in step 2. For a double mount, measure and mark up the board proportionally and cut as before. Make sure that you cut the corners as near as possible to the required size: use spare mount board for practice.

Practise bevel cutting

Not all bevel cutters work in the same way, so take the time to find out how to use yours properly.

Choosing a mount and frame

Always allow the picture to dictate the frame, not the other way around. The frame (and mount) should complement what is housed inside, but the viewer's eye should go straight to the image, regardless of what surrounds it.

 If possible, take your drawing or painting with you when you go to buy a mount or frame, as this makes it easier to visualize the finished result. Here, you can see the same watercolour framed in three different ways: each one is effective, but the mood created by the choice of mount and frame is very different.

Avoid direct sunlight

Never hang drawings or paintings in direct sunlight, as it will cause them to fade prematurely. Watercolours are particularly susceptible to fading.

Walnut frame and wash-line mount
Choose a frame that picks out one of the colours in your painting. Here, the plain walnut frame picks up and accentuates the rich brown tones in the rooftops; the wood also has an interesting texture in its own right. The cream mount is decorated with a beige wash line, which also picks up on a colour within the painting, adding a subtle 'frame within a frame' and helping to draw the eye into the image.

— *Polished walnut frame*

— *Cream mount*

— *Beige wash line*

Gold-leaf frame and lined mount

The gold frame has bevelled edges, which add depth and substance to the frame, yet the frame itself is relatively fine. The gold colour enhances the beige touches of watercolour in the painting. The cream mount is decorated with blue lines close to the picture, which draw attention to the blue of the sea and sky.

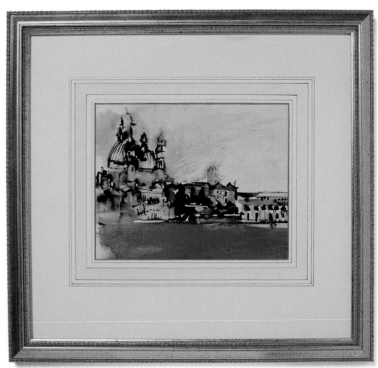

Gold bevel-edged frame

Cream mount

Blue pen-and-ink lines

Black painted frame and white mount

Black frames can deaden a painting if there are no black or intensely dark tones within the work, but they can also help to define the linear qualities in a painting. In this instance, the pen-and-ink work in the watercolour is enhanced by the simple frame. The clean white mount offers clarity and simplicity. The black keyline draws the eye into the centre of the mount and so into the painting.

Black painted frame

White mount

Black keyline

glossary

Additive
A substance that is added to change the characteristics of the paint. Additives can be used for many purposes, including speeding up or slowing down the drying time of the paint, making the paint flow more easily and or creating a more (or less) glossy finish.

Alla prima
Meaning 'at the first' in Italian, this term is used to describe a work – usually an oil painting – that is completed in a single painting session.

Colour
Complementary colours: These are the pairs of colours that lie opposite each other on the colour wheel – red and green, blue and orange, yellow and purple.
Primary colours: A primary colour cannot by produced by mixing other colours. Red, blue and yellow are the three primary colours.
Secondary colours: The secondary colours – orange, green and purple – appear when one primary is mixed with another primary.
Tertiary colours: A tertiary colour is created by mixing a primary colour with one of the secondary colours that lies next to it on the colour wheel.

Colour temperature
Colours are considered to be either warm or cool. No colour in your palette is pure: any red, yellow or blue has a warm or a cool bias. In order to be able to mix a full range of colours, you need to include a warm and a cool version of each of the three primary colours in your set of paints.

Composition
The way the elements of a drawing or painting are arranged within the picture space.
Closed composition: One in which the subjects are contained within the picture area.
Open composition: One that implies that the subject or scene continues beyond the confines of the picture area.

Contour shading
A shading technique that consists of drawing lines that follow the form of the object to denote the changes from one plane to another.

Crosshatching
A shading technique that consists of drawing two sets of parallel lines at an angle to each other to create an area of tone. See also Hatching.

Drybrush
A technique that involves dragging an almost dry brush loaded with very little paint across the paper or canvas to create textured marks.

Fat over lean
One of the fundamental rules of oil painting, designed to minimize the chances of an oil painting cracking. 'Lean' paint (paint that has been mixed with a fast-drying oil or with thinner) dries more quickly than 'fat' paint (paint straight from the tube or that has been mixed with more oil). If lean paint is applied over fat paint, the lean paint is likely to crack when the fat layer underneath dries and contracts – so the rule is that every layer in an oil painting should be a little 'fatter' than the previous one.

Form
A three-dimensional figure.

Frottage
A technique that involves placing paper over a textured surface, such as a piece of wood or stone, and gently rubbing over it with a soft, dry material such as soft pastel or charcoal, so that the paper picks up the texture of the object beneath.

Glaze
A thin, transparent or semi-transparent layer of paint applied over dry underlayers to build up depth or modify colours.

Ground

See Support.

Hatching

A shading technique that involves drawing a series of parallel lines to create tone; the closer together the lines are, the darker the tone will appear to be. See also Crosshatching.

Hue

A pure colour that has not been mixed with any other.

Impasto

Impasto techniques involve applying oil or acrylic paint in a thick layer. Impasto is wonderful for creating rough textures, as the paint holds the mark of the brush or painting knife used to apply it.

Line and wash

The technique of combining watercolour or ink washes with pen-and-ink work.

Mask

A substance applied to the support to prevent paint from reaching specific areas; the mask is removed once the paint is dry, revealing either an underlying colour or the colour of the support. Masking tape, masking fluid, masking film and paper torn or cut to the required shape can all be used as masks.

Medium

(1) The material in which a work of art is produced – watercolour paint, acrylic paint, pencil, line and wash, and so on.
(2) Any substance added to paint to facilitate its application or to achieve a specific effect.

Modelling

The depiction of a three-dimensional form through the use of light, shadow and colour.

Negative shapes

The spaces between objects in a drawing or painting. These are often (but not always) the background to the subject.

Palette

(1) A container or surface on which paint colours are mixed.
(2) The range of colours used in a particular painting or by a particular artist.

Perspective

A system whereby artists can create the illusion of three-dimensional space on the two-dimensional surface of the paper or canvas.
Aerial perspective: The way in which the atmosphere, combined with distance, influences the appearance of things. Also referred to as atmospheric perspective.
Foreshortening: A type of linear perspective in which the subject is angled towards the viewer, causing those parts of it that are farthest away to appear smaller than they really are. The term is usually used to refer to a single object or part of an object, rather than to a group of objects or a view.
Linear perspective: A system that exploits the way in which objects appear to be smaller the farther away they are from the viewer.

Positive shapes

The actual features (still-life objects, trees and so on) that are being drawn or painted.

Scumbling

A technique whereby a thin layer of paint is applied roughly over a dry underlayer with a dry brush, which allows some of the underlying colour to show through.

Sgraffito

A technique that involves scratching off paint to reveal either the support beneath or an underlying paint colour.

Shade

A colour that has been darkened by adding black or a little of the complementary colour.

Solvent

See Thinner.

Spattering

A technique that involves flicking paint onto the support to create small dots of colour – a useful textural technique.

Stippling

A technique in which dots of colour are applied to the paper with the tip of a brush.

Support

The surface on which a drawing or painting is made. Also referred to as the ground.

Thinner

A liquid such as turpentine or white (household) spirit that is used to dilute oil paint. Also referred to as solvent.

Tint

A colour that has been lightened by adding more water (in watercolour) or white paint (in acrylics and oils).

Tone

The relative lightness or darkness of a colour. Also referred to as value.

Tooth

The texture of a support. Some papers are very smooth and have little tooth; in others, the texture is very pronounced and can be incorporated into the drawing or painting.

Underdrawing

A light drawing, usually done in pencil, made as a guide to where to apply the paint.

Underpainting

In oil and acrylic painting, a painting made in thin paint to work out the composition and tonal structure before colour is applied.

Value

See Tone.

Vanishing point

In perspective drawing, a notional point towards which parallel receding lines converge.

Wash

A thin layer of transparent paint.
Flat wash: An even wash with no variation in tone.
Gradated wash: A wash in which the colour gradually changes in intensity.

Wet into wet

A technique in which paint is applied to a wet surface or on top of a wash that is still damp. In watercolour, the colour will bleed and blur; in oil painting and acrylic paint used thickly, the paint can then be blended on the support.

Wet on dry

The technique of applying wet paint to a dry support or on top of a wash that has dried completely.

suppliers

Manufacturers

If you are unable to find what you want in your local art shop, the leading manufacturers of paints, papers and brushes should be able to supply you with details of stockists in your area, as well as with information relating to specific products.

Daler-Rowney UK
Peacock Lane
Bracknell
RG12 8SS
Tel: 01344 461000
Fax: 01344 486511
www.daler-rowney.com

Daler-Rowney USA
2 Corporate Drive
Cranbury
New Jersey 08512-9584
Tel: 609-655-5252
Fax: 609-655-5852
www.daler-rowney.com

Derwent Cumberland Pencil Co.
Greta Bridge
Keswick
Cumbria CA12 5NG
Tel: 017687 73626
www.pencils.co.uk

H. Schmincke & Co.
Otto-Hahn-Strasse 2
D-40699 Erkrath
Germany
Tel: 0211/2509-0
Fax: 0211/2509-461
www.schmincke.de

Sennelier
Max SAUER SAS
2 rue Lamarck
BP 204
22002 Saint-Brieuc
France
Tel: 02 96 68 20 00
Fax: 02 96 61 77 19
www.sennelier.fr

Winsor & Newton UK
The Studio Building
21 Evesham Street
London W11 4AJ
Tel: 020 8424 3200
Fax: 020 8424 3328
www.winsornewton.com

Winsor & Newton USA
11 Constitution Avenue
Piscataway
New Jersey 08854
Tel: 800-445-4278
Fax: 732-562-0941
www.winsornewton.com

Stockists

United Kingdom
Ken Bromley Art Supplies
Unit 13 Lodge Bank Estate
Crown Lane
Horwich
Bolton BL6 5HY
Tel: 01204 690114
Fax: 01204 673989
www.artsupplies.co.uk

Hobbycraft
www.hobbycraft.co.uk
(More than 60 stores nationwide)

Jackson's Art Supplies
1 Farleigh Place
London N16 7SX
Tel: 0844 499 8430
Fax: 0844 499 8431
www.jacksonsart.com

Society for All Artists
PO BOX 50
Newark
Notts NG23 5GY
Tel: 0800 980 1123
Fax: 0845 300 7753
www.saa.co.uk

United States
Dick Blick Art Materials
PO Box 1267
Galesburg
IL 61402-1267
Tel: 800-828-4548
www.dickblick.com
(38 stores in 18 states.)

Hobby Lobby
www.hobbylobby.com
(More than 500 stores in 41 states.)

Michaels Stores
www.michaels.com
(More than 750 stores in 48 states.)

index

contributors

Many thanks to Ian Sidaway and Abigail Edgar, who painted the majority of the step-by-step projects in this book.

Ian Sidaway originally trained as a graphic designer and has been working as a freelance artist since 1970. He is the author of almost 20 art technique books, including The Instant Artist, which won the Artist's Choice Art Instruction Book of the Year award in 2001.

Abigail Edgar trained at Kingston and Central St Martins Colleges in London and has since exhibited widely, including several successful solo shows in St James's, London. Abigail has run art courses in London and Italy, and worked on several series of practical art magazines for adults and children and, with Sarah Hoggett, is the co-author of A Masterclass in Drawing and Painting Landscapes.

The publishers would also like to thank the following artists, whose work appears in this book: Brian Bennett, David Curtis, Wendy Jelbert, Vincent Milne, Melvyn Petterson, John Raynes, Polly Raynes, Stan Smith, Jenny Wheatley and Lucy Willis.

Thanks also to Louise Leffler for her clear design, to Martin Norris for the step-by-step photography, and to Jon Hibberd for permission to reproduce the photographs on pages 133 and 230.

Consultant editor Sarah Hoggett is a freelance writer and editor who specializes in practical art and craft titles, and the co-author of a number of practical art books.

Image on p272 © Businessman/Alamy.

Whatever the craft, we have the book for you – just head straight to Collins & Brown crafty HeadQuarters!

LoveCrafts is the one-stop destination for all things crafty, with the very latest news and information about all our books and authors. It doesn't stop there...

Enter our fabulous competitions and win great prizes
Download free patterns from our talented authors
Collect LoveCrafts loyalty points and receive special offers on all our books

Join our crafting community at LoveCrafts – we look forward to meeting you!

the ultimates

978-1-84340-411-8 978-1-84340-450-7 978-1-84340-502-3

This latest volume in Collins & Brown's bestselling Ultimate series reveals all the techniques of the masters in an easy-to-understand format, with detailed step-by-step guides to drawing and painting.

978-1-84340-563-4 978-1-84340-574-0 978-1-84340-672-3

The Ultimates are a growing series of comprehensive reference guides, with everything you could possibly want to know about a wide variety of craft subjects. Each title contains clear, concise text and step-by-step illustrations, making these books the perfect companion for both beginners and experts.

All titles retail at £25 and are available direct from the Collins & Brown website: www.lovecrafts.co.uk.